War Imagery in
Women's Textiles

War Imagery in Women's Textiles

An International Study of Weaving, Knitting, Sewing, Quilting, Rug Making and Other Fabric Arts

Deborah A. Deacon *and* Paula E. Calvin

McFarland & Company, Inc., Publishers
Jefferson, North Carolina

LIBRARY OF CONGRESS CATALOGUING-IN-PUBLICATION DATA

Deacon, Deborah A., 1952–
War imagery in women's textiles : an international study of weaving,
knitting, sewing, quilting, rug making and other fabric
arts / Deborah A. Deacon and Paula E. Calvin.
p. cm.
Includes bibliographical references and index.

ISBN 978-0-7864-7466-0 (softcover : acid free paper) ∞
ISBN 978-1-4766-1660-5 (ebook)

1. Textile crafts. 2. Textile design—Themes, motives.
3. War in art. 4. Art and war. 5. Women and war.
I. Calvin, Paula E., 1943– II. Title.
NK8805.D43 2014 746.082—dc23 2014018809

BRITISH LIBRARY CATALOGUING DATA ARE AVAILABLE

On the cover: *Still Life…With Bird*, handwoven tapestry
62" × 60", 2003 (courtesy of Barbara Heller)

Printed in the United States of America

*McFarland & Company, Inc., Publishers
Box 611, Jefferson, North Carolina 28640
www.mcfarlandpub.com*

To the women who have documented
the impact of war on their lives
through their textile production.
May they find peace through their work.

Table of Contents

Preface

This book is a continuation of the journey we began in 2001 with a graduate course on art as evidence and our personal interest in textiles. The journey first led to our 2003 exhibition *Stitches of War* at Arizona State University, which examined ways in which the impact of war is reflected in textiles, the traditional art form of women around the world, textiles often intended only for personal consumption. Our subsequent uncovering of more public art, created by American women in response to their feelings about war, resulted in our book *American Women Artists in Wartime, 1776–2010.* That book showed that, like their male counterparts, American women artists commented on war, showing their patriotic support of or opposition to a conflict, and documenting the impact of a violent event that affected their lives.

This book returns to the subject matter of *Stitches of War*, expanding the scope of that exhibition beyond its emphasis on modern American textiles, Hmong storycloths, Afghan War rugs, Latin American *arpilleras,* Navajo rugs and jewelry, and weavings from East Timor to include historical textiles produced by women in Europe, all of Latin America, Asia, Oceania and North America. The women in each of these regions have been subjected to the effects of war at various times in history, and in many cases they included images of war in the textiles they produced for their personal use, for public consumption, and for sale to help support their families whose livelihood was disrupted by the violence of war.

We are extremely grateful to the many people who have made this book possible through their kindness and generosity. The book required a significant amount of archival research, which was done with the assistance of numerous enthusiastic curators, collections managers, and archivists both in the United States and abroad, as we investigated the availability of information on textiles that were produced during times of political upheaval around the world. They include Dr. Sherry Harlacher, director of the Denison University Museum; Dr. Janet Baker, curator of Asian art at the Phoenix Art Museum; Keidra Daniels Navaroli, assistant director at the Ruth Funk Center for Textile Arts at Florida Institute of Technology; Diana Marks from RMIT University, Melbourne, Australia; Dr. Christina Lindeman from the University of South Alabama; Dr. Irina Bogoslovskaya, independent art historian; and Laurie Petrie-Rogers, independent scholar. Many of them recommended additional avenues for us to investigate in addition to sharing their expertise, for which we are very appreciative. A number of friends and colleagues generously shared their expertise, ideas and personal textiles with us, including Dr. Claudia Brown, Ms. Momoko Welch, Dr. Yasmin Saikia, and Dr. Christopher Lundry from Arizona State University; Lindsey Pedersen, Mesa Community

College; Amy Clague, Leena Ravel and Jackie Butler-Diaz from the Asian Arts Council at the Phoenix Art Museum; Marilyn Murphy at Cloth Roads, a Global Textile Marketplace; Carol James, Sash Weaver; Ramelle Gonzales; Ann Marie Moeller; Julie Kapok from Timor Treasures; and Marlys Anderson. A number of artists shared their thoughts about their own work, including Sarah Rahbar, Mary Tuma, Barbara Hunt, Barbara Heller, Barbara Todd, Frances Dorsey, Zita Plume, and Azra Aksamija. Ms. Iris Cashdan-Fishman gave us incredible encouragement throughout the entire process of writing this book and lent us a textile as well. Susan Chiaramonte provided us with invaluable emotional support and was extremely patient with our idiosyncrasies as she edited the manuscript and as always, Sam Calvin provided invaluable technical and moral support.

It is because of all of their generous support that we are able to tell a story we believe deserves to be told, that of the numerous women throughout history who recorded the impact of war on their lives through their art. We hope you are as inspired by their stories as we are.

Introduction

Feminist scholars have long agreed with the famed misquote of Virginia Woolf, who is alleged to have said, "For most of history, anonymous was a woman."[1] The axiom certainly applies to the creation of textiles by numerous women throughout history. For millennia, cloth production was an anonymous activity, seen in most cultures as the mundane work of women, part of the domestic sphere of hearth and home, not worthy of the maker's identification. Discussions of textile traditions are typically omitted from the histories of the development of art and culture in favor of the privileged painting, sculpture, and architecture. "Fine art, the 'highest' and 'purest' category, was identified with the male, the public, and the symbolic; decorative art was female, domestic and empty of deep meaning."[2] It wasn't until the Pop Art and Minimalism movements of the 1960s that textiles were seen as a medium for artistic expression. In 1962, the *Musée Cantonal des Beaux-Arts* in Lausanne, Switzerland, held the first International Biennial of Tapestry to promote international development in textile art.[3] Other such exhibitions followed. During the 1970s, feminist artists like Judy Chicago used textiles to examine women's roles in art, society and culture. Art textiles quickly became a political medium dominated by women. By the twenty-first century, the use of textiles to express political opinions had expanded to most areas of the globe, utilized by women in all walks of life.

The production of cloth actually played a fundamental role in the development of civilization, evolving before pottery making and sculpture. It also played a key role in the development of farming and the domestication of animals, as well as the move into permanent settlements. A significant effort is required to gather and process the materials necessary for textile production and it takes a significant amount of time to develop textile techniques and designs. Textiles established important political and social distinctions within a society, were important trade items, and even served as currency in many cultures, making them integral to the very fabric of civilized society.[4]

Warfare Traditons

War has traditionally been seen as a male activity. Men learned to hunt for food and each other to protect their territory and belongings, including their women, while women were seen as passive objects in need of protection, too weak to fight. The advent of permanent settlements resulted in farming and animal husbandry which was seen as men's work; how-

ever, man's need to fight continued. While women were responsible for child-bearing and child-rearing, men fought to protect their cities from enemies seeking to acquire territory and material goods. This division of duties according to gender is deeply rooted in most cultures—in their language, thinking, literature, mythology and art.

For millennia, men have left their homes and families to fight and die for their social group and its principles while their wives, mothers, and daughters remained safely at home, seemingly unaffected by war and violence, leading to the conclusion that war is a gendering activity. This activity also impacts the conduct of war. Prior to the second half of the twentieth century, women participated in home front activities that supported the war effort— voting for war, willingly accepting and adapting to the shortage of goods that results during wartime, rolling bandages for the wounded and assembling care packages for the troops, and joining the workforce to free men for war service. They also aligned themselves with the war effort and expressed their patriotism through their dress, by buying and wearing textiles that bore war motifs. During World War II, for instance, British and American women wore commercially produced scarves, fabric squares that featured dramatic military imagery such as aircraft, warships and the "V for victory" logo, while Japanese boys sported mass produced kimono that featured images of aircraft, weapons, and soldiers. These propaganda textiles served as public canvases that expressed the nation's political and military objectives and as ways for the wearer to show support for the cause.[5]

Modern warfare changed our ideas about the impact of war on society. In World War I, eighty percent of the casualties were military men; in World War II, only fifty percent were military men. During the Vietnam War, nearly eighty percent of the casualties were civilians, while in current conflicts around the world, it is estimated that almost ninety percent of casualties are civilian, primarily women and children.[6] Most of these conflicts involved a profusion of generalized violence that erases the safety of the "immune space" of home.

Throughout history, men experienced war, wrote about war, photographed war and painted war. Women, it was thought, did not. Yet a closer examination of the reality of war reveals that this is an incorrect assumption. Women in fact have always been directly affected by war and around the world they have expressed that impact through their art, including in traditional women's textile crafts such as weaving, quilting and knitting. This book explores the ways in which these women from around the world have expressed the impact of war on their lives using their traditional textile practices. The art they created can be seen as belonging to four broad categories: commemoration, documentation, support for a conflict, and protest art. Early American weavers created pieces with titles like *Lee's Surrender* and *Whig Rose* in support of America's position during a conflict, while in the 1980s Argentinian women wore headscarves embroidered with the names of their "disappeared" children who were murdered at the hands of the government. During World War I and World War II, British women knit scarves, hats, sweaters and socks for refugees, seeing the work as part of their patriotic duty. During the 1980s, Hmong women created embroidered pictorial cloths that documented their flight from persecution at the end of the Vietnam War. The works examined in this book are made using traditional textile techniques—sewing, embroidery, weaving, rug making and knitting, to name a few. Many of these women worked anonymously; some are famous for the art they produced while the names of others have been lost to history.

This book shows that women globally have always been affected by war and that many

women have expressed this impact in their art, but it by no means provides an exhaustive survey of all of the women who have created textiles about war. It provides a representative sample of women from across time and cultures who created art that recorded the impact of war on their lives. The contributions of those women who are not included here due to time and space limitations are in no way diminished by their exclusion. Rather, their exclusion is an indication of the depth and breadth of the impact of war on their own lives and the culture in which they lived.

Early Textile Production

While the origins of textile production are lost in the mists of the past, we do know that the first textiles produced by our Paleolithic ancestors were animal skins modified for warmth and protection. The first sewing needles, created by the European Graveltian culture (26,000–20,000 BCE) in central Europe, were used to join animal skins together. The first textile art, which dates to circa 38,000 BCE, includes decorative beaded necklaces of shells, stones and animal teeth, and the sinew cords used to hold stone axe heads and stone points to wooden handles and for hand grips on spears and other tools.[7] These earliest threads and cords were made from twisted strands of sinew and animal gut.

Wool was the first animal fiber made into cloth.[8] Sheep were domesticated in Iraq circa 9000 BCE. Based on spindle whorls, used to twist fibers into yarn and thread, and impressions of woven cloth on ceramic vessels, it appears that wool was woven into cloth by 7250–7000 BCE in Mesopotamia. In the Americas, alpaca and llama were domesticated by the third millennia BCE. Inca textiles, which date from approximately 3000 BCE and were preserved in dry sand burials, provide the longest continuous textile record.[9]

The earliest forms of vegetal weavings, which include baskets and nets made from domesticated hemp and flax, date between 6000 and 4000 BCE. During the Jomon era (10,000–300 BCE) in Japan, braided cord impressions are found on elaborate earthenware pottery.[10] Cotton was domesticated in India by 3000 BCE; at the same time, the Chinese domesticated silk worms, spinning the unwound cocoon strands into thread. By 1500 BCE, they had developed elaborate weaving techniques using multicolored silk threads to create gauze, twill, damask, brocade, and plain weave fabrics.[11] Additionally, embroidered and painted silk fabrics also became popular at this time.

Beginning in the third millennia BCE, textiles became important trade goods between Syria, Ur, the Indus Valley and Mesopotamia. During the time of the Roman Empire, cloth woven from both wild and domestic silk was exported from China to Europe using the Silk Road, which stretched from China to the eastern Mediterranean. Remnants of textiles found in Indus Valley (3300–1300 BCE) settlements feature geometric and figural woven patterns as well as embroidery.[12] Sculptural figures from the region are depicted wearing dimensional patterned clothing, most likely representations of dimensional embroidery. The Roman historian Pliny the Elder (23–79 CE) recorded that the Phrygians were the originators of embroidery, although in truth only one specific technique (the use of metal thread) can be attributed to the region.[13] Trade dispersed goods along many routes, providing evidence of metal embroidery and red-woolen embroidered cloth in the burial kurgans in the Altai Mountains which cross both Russia and Kazakhstan, both fourth century BC.[14] Findings in one kurgan included

a *shabrak*, or ornamental horse cloth appliquéd with cut up pieces of woolen tapestry, which may have adorned the horse of a warrior.

Weaving as women's work has been well documented in the historical record through art, religion, and literature. The Egyptian goddess Neith was portrayed as a weaver in Egyptian paintings and sculpture. Egyptian tomb art, both paintings and manquettes, from the Middle Kingdom (2160–1788 BCE) shows women spinning flax using distaffs and weaving on single heddle looms for their masters' use in the afterlife.[15] While women made cloth in their homes for their personal use, they also worked in weaving shops, making cloth for their armies and for commercial purposes.[16] The Greek historian Herodotus noted that by the fifth century BCE, Egyptian men were weaving in the home. By the Christian era, men were the primary commercial weavers, working on vertical looms while women continued to weave in the home.

As in Egypt, in Greece weaving was associated with women's work in art, religion and literature as well as in actuality. Greek women of all classes made textiles in the home. Wealthy women supervised the weavings of their female servants. In Greek mythology, the Fates are three crones who control destiny, said to spin the thread of life. Athena, the goddess of war, is also the goddess of weaving, combining the domestic and political spheres, a tie that proves prophetic in terms of the connection between textiles, women and war which is made in this book. She was said to weave plots as she intervened in the lives of various Greek heroes. On the island of Crete, Ariadne, the daughter of King Minos, used spun thread to help Theseus escape from her father's labyrinth and certain death from the Minotaur.

The story of Arachne, a Roman addition to Greek mythology, intimates that the origin of weaving lay in the imitation of a spider web. In the story, Arachne, a highly skilled mortal weaver famous in all of Lydia and beyond, boasts that she is a better weaver than the goddess Athena. When Athena, disguised as an old woman, tells Arachne to yield to Athena, Arachne proposes a weaving contest between herself and the goddess. Athena is offended by Arachne's cloth, which depicts the sins of the gods, and turns her into a spider. Ovid notes:

> Her usual features vanish'd from their place,
> Her body lessen'd all, but most her face.
> Her slender fingers, hanging on each side
> With many joynts, the use of legs supply'd:
> A spider's bag the rest, from which she gives
> A thread, and still by constant weaving lives.[17]

In Scandinavia, the stars in Orion's belt are said to represent the distaff with which Frigga, Odin's wife, spun the clouds.[18] In Baltic mythology, the sun goddess Saule is said to spin the sunbeams, while in Japan, Amaterasu is the Shinto goddess of both the sun and weaving.

The ties between textile production and women can also be found in more recent western literature and folk tales. The story of Vassilisa the Beautiful, a peasant who impressed the tsar so much with her needlework that he married her, is popular in Russia. Mother Goose, the teller of nursery rhymes, is often associated with spinning. In French legends, she was credited with spinning incredible tales that enraptured children. In the German fairy tale *Rumpelstiltskin*, a miller's daughter is given the impossible task of spinning straw into gold; the imp-like Rumpelstiltskin miraculously accomplishes the task on several occasions, but at a heavy price. In the fairy tale *Sleeping Beauty*, a princess falls into a deep sleep after pricking her finger on a spindle, the result of two spells cast on her as a baby.

Textiles as Communication

Feminist scholarship at the end of the twentieth century explored the definition of gender and gender roles in Western culture, positing that gender goes beyond the idea of male and female. Rather, it is a "continual, dynamic process rife with contradictory ideas."[19] An individual's role in society is often determined by the individual's gender. Throughout much of history, a woman's role has been rigidly controlled by social mores. Her work was dictated by the roles and hierarchies assigned to her by society. During the Victorian era, women's work was confined to the domestic realm, a soft, harmonious environment seen as fostering civilized moral lives for its inhabitants, a foil for the harsh external male world of business and commerce.

Textile production, spinning and needlework have been part of the woman's sphere since ancient times, overtly feminine acts that have often been considered beneath a man's dignity; however, they perform an important function within the family and the culture. A gendered activity taken on early in a girl's life, needlework has played a significant role in a woman's life for many reasons. As a vital part of a girl's education, it teaches obedience and patience. A woman's power to perform magic with a needle by transforming plain fabric into a work of art allows her to create beautiful and practical objects for her trousseau, such as linens, quilts and clothing.[20] These skills allowed her to provide herself with an economic livelihood and meet her family's needs while serving as a form of feminine performance, a way of making a personal statement. The act of creating a textile can establish a woman's place in society, provide a method of controlling social interaction and increase a woman's feeling of self-worth.

Textiles also are encoded with cultural values, reflecting history and cultural change. As Mary Beaudry noted, "Textile production and sewing of some sort have been tangled up with aspects of culture—technological, social, economic, ritual and so on—since early human history."[21] As such, they can serve as alternative forms of discourse. They can relay information about identity—social relationships, age, class, social status and religion. They can be necessities and luxuries, symbols of friendship and love, a non-verbal form of communication. They are also a form of rhetorical discourse, a coded communication which can be used as a political weapon in support of or in protest of a given event, such as war. They can document the atrocities of war and tell the stories of the participants in and victims of war, commemorating cultural heroes and their victories. The soft nature of textiles, as opposed to the "hard" subject matter of war, creates an unexpected juxtaposition that can surprise and intrigue the viewer. There is meaning in a textile and the practice used to created it. Textile production has been a vehicle used by the dominant (male) discourse for the definition of women and their roles in society. But it has also served as a vehicle for women to construct their own alternative to the dominant discourse, allowing them to expand their power and societal roles.[22] Women have traditionally used needlework as a way to build and solidify community through group activities such as quilting bees and knitting groups. Many of these groups took activist stands with the textiles they produced. For example, scholars theorize that a group of Norman women created the Bayeux Tapestry, which is discussed in Chapter One, to commemorate William the Conqueror's victory in England shortly after the conquest. During World War II, American women held quilting bees to create quilts that were raffled in support of the war effort. During most American wars, women knitted socks, sweaters and caps to keep the troops warm.

Art is a powerful tool for communication among members of a society. Art arouses emotion, identifies problems, and proposes solutions to those problems. It plays an important role in social movements, helping keep people committed to a cause or mobilize people in protest, often leading to behavioral or social change. Jacqueline Adams has noted that "art has political power that can support the status quo, act as a safety valve for discontent (and therefore be of benefit to the oppressor), or serve as an emancipatory force, challenging dominant institutions, and reinforcing subversion of existing systems."[23] And art can maintain its impact for long periods of time, eventually leading to societal change and serving as a reminder of what came before. The art of textiles links tradition to contemporary events, providing a non-threatening and easily accessible medium for transmitting ideas and opinions.

Workmanship is an important aspect of needlework and textile production. The methodology used in creating a textile is as important as the results. Tradition can also be important in textile production. The work of young women is critiqued in terms of color usage, adherence to traditional patterns and aesthetic and technical proficiency. While there is often an opportunity for creative variations in traditional patterns, color schemes or forms, significant novel variations can be accepted or rejected by a community.[24] In some cases, radical changes can be the result of contact with foreign cultures, as occurred with the Hmong development of figural embroidered story cloths in refugee camps following the Vietnam War, or as the result of conflict or conquest, as seen in the war rugs created by Baluch women during the Soviet occupation of Afghanistan. In many cases, it results from the clash between industrialized and non-industrialized nations. Often, women from the non-industrialized nations choose which aspects, such as the use of aniline dyes, they will adapt into their own work and which they will reject, creating new and unique pieces and traditions.[25]

In addition to giving a voice to women, textiles have been adopted as metaphors for the very fabric of society for millennia. The word weaving, meaning to bind or unite, is commonly referenced in speech, literature and art. The universe is often referred to as "a woven fabric where everyone and every thing has its place."[26] Disorder in society is seen as a tangle of matters, which must be put into its proper place. Among many cultures, the vertical warp threads on a loom are seen as masculine, while the horizontal weft is seen as feminine. Weaving unites the male and female in imitation of the life force. The phrase "distaff side" is used to refer to maternal relatives, as well as a woman's role in the household economy.

The Egyptian goddess Neith (Nit), the goddess of war, is also the goddess of weaving, said to have woven all of existence on her loom. Her symbol and part of her hieroglyph resemble a loom. The Greek Moirai, or Fates, were said to use yarn to measure out the life of a man; when the yarn was cut, life ended. The Greeks often used textiles as religious offerings, hoping for a favorable outcome from the gods. For generations, there was a dispute between the cities of Elis and Pisa for control of the Sanctuary of Zeus at Olympus, the site of the Olympic Games. In 668 BCE, the tyrant Pheidon of Argos captured the Sanctuary from Elean control for Pisa. The Olympic Truce returned the Sanctuary to Elean control and protected against military incursions that interrupted the Games, although it did not end the battle over control of the site. In the second century BCE, the traveler Pausanias documented another takeover of the Sanctuary by Pisa. As a way to heal their differences, after this battle, both sides agreed to a unique way to make peace. Each of the sixteen cities involved in the dispute selected one woman to work together to weave a robe for the statue of Hera at Olympia.[27]

In Book Three of *The Iliad,* the poet Homer uses weaving to tell of Helen's feelings about the war:

> She [Iris] came on Helen in the chamber; she was weaving a great web,
> A red folding robe, and working into it the numerous struggles
> of Trojans, breakers of horses, and bronze-armored Achaians,
> struggles that they endured for her sake at the hands of the war god.[28]

In Book Six, when the Trojans were threatened by Greek successes, Hector has his mother offer a beautiful peplos to Athena in exchange for her protection, a plea that was unsuccessful. In Homer's *Odyssey,* Penelope is depicted as a weaver who, during the day weaves a shroud for her father-in-law, and then unravels it every night to keep her suitors at bay as she waits for the return of her husband, Odysseus. Penelope seated at her loom was a popular depiction on Greek painted vases. In *The Odyssey,* both Circe, the nymph associated with magic, and Calypso, the daughter of the Titan Atlas, used weaving to enchant Odysseus and keep him from returning home.[29]

For the Greeks, the practice of weaving also served as a model for the examination of social organization. In Aristophanes' comedy *Lysistrata* (411 BCE), Lysistrata proposes a plan to correct the difficulties of the Athenian empire, which she articulates in terms of textile production, noting that the preparations for weaving are similar to the various groups who were working at opposition and must be detangled for the good of society:

> MAGISTRATE: But the international situation at present is in a hopeless muddle. How would you propose to unravel it?
>
> LYSISTRATA: Oh, it's dead easy.
>
> MAGISTRATE: Would you explain?
>
> LYSISTRATA: Well, take a tangled skein of wool for example. We take it so, put it to the spindle, unwind it this way, now that way [*miming with her fingers*]. That's how we'll unravel this war, if you'll let us. Send ambassadors first to Sparta, this way, then to Thebes, that way—
>
> MAGISTRATE: Are you such idiots as to think that you can solve serious problems with spindles and bits of wool?
>
> LYSISTRATA: As a matter of fact, it might not be so idiotic as you think to run the whole City entirely on the model of the way we deal with wool.
>
> MAGISTRATE: How'd you work that out?
>
> LYSISTRATA: The first thing you do with wool is wash the grease out of it; you can do the same with the City. Then you stretch out the citizen body on a bench and pick out the burrs—that is, the parasites. After that you prise apart the club-members who form themselves into knots and clots to get into power, and when you've separated them, pick them out one by one. Then you're ready for the carding: they can all go into the basket of Civil Goodwill—including the resident aliens and any foreigners who are your friends—yes, and even those who are in debt to the Treasury! Not only that. Athens has many colonies. At the moment these are lying around all over the place, like stray bits and pieces of the fleece. You should pick them up and bring them here, put them all together, and then out of all this make an enormous great ball of wool—and from that you can make the People a coat.[30]

In this case, the weaving of a garment symbolizes the end of a complicated period of war and hostilities.

During the Second Punic Wars (218–201 BCE), Rome was threatened by the armies of

Carthage under the leadership of Hannibal. After years of vicious fighting and many Roman defeats, a Roman matron dressed the cult statue of Juno in a woven cloak, seeking her help, a plea that was ultimately successful.

In the war-like Norse tradition, women and war are closely linked. In addition to Frigg being the goddess of weaving, Valkyries are depicted as women weaving on looms, using severed heads for weights, arrows for shuttles and human gut for the warp.

In the ninth century, Charles Dickens also closely linked women's production of textiles with war through his ruthless character Madame Thèrése Defarge, primary villain of his novel *A Tale of Two Cities*. She is the implacable wife of Ernest Defarge, a woman who never stops knitting. Her knitting pattern encodes the names of all of the people to be guillotined during the French Revolution.

In addition to literary references to weaving, weaving and spinning also played a role in the descriptions of warfare in the historical record. In the late fourth century CE, Theobald, the Marquis of Camerino and Spoleto, was known for his cruelty toward the Greek prisoners he had taken during the siege of a castle in support of the Byzantine Empire. As he was about to have them castrated, the proceedings were interrupted by a woman who likens the work of women to warfare. In describing the events, Edward Gibbon notes:

> The intrusion of a frantic female, who, with bleeding cheeks, disheveled hair and importunate clamours, compelled the marquis to listen to her complaint. "It is thus," she cried, "Ye magnanimous heroes, that ye wage war against women, against women who have never injured ye, and whose arms are the distaff and the loom?"
> Theobald denied the charge, and protested that, since the Amazons, he had never heard of a female war. "And how," she furiously exclaimed, "can you attack us more directly, how can you wound us in a more vital part, than by robbing our husbands of what we most dearly cherish, the source of our joys, and the hope of our posterity? The plunder of our flocks and herds I have endured without a murmur, but this fatal injury, this irreparable loss, subdues my patience and calls aloud on the justice of heaven and earth."[31]

George of Antioch (d. 1151/2 CE), the Admiral of Sicily, was a Greek employed by the Norman King Roger II during his conquest of the Mediterranean. Among the spoils of war taken after his capture of Corinth were weavers. Gibbon noted, "The silk weavers of both sexes, whom George transported to Sicily, composed the most valuable part of the spoil; and in comparing the skillful industry of the mechanic with the sloth and cowardice of the [Greek] soldiers, he was heard to exclaim that the distaff and loom were the only weapons which the Greeks were capable of using."[32]

Textiles and War

The twenty-first century began with images of war for millions of people around the world. War can be seen as a betrayal of a people's trust in their government, a period that transforms everyday life due to its brutality, leading to a loss of honor, family and community. It causes people to question their own humanity and the policies of their leaders. Women often take pride in their own ability to survive the destruction and violence of war, and in the actions of their friends and community. In many cases, they use textiles to provide a visual commentary on the impact of war, expressing their perspective on the events as well

as their concerns about life after the violence ends. In many cases, after the trauma of war, people are encouraged to forget about their experiences and remain silent, which allows society to create a more romantic view of the national triumph.[33] But memories do not really die. Rather they lie buried, only to resurface years later. Revelation undermines the power of trauma, making it visible, offering a vocabulary to discuss one's experiences, and eventually leading to healing. Textiles can serve as a bridge "between the internal and personal and the external and public spheres of the war," allowing those who view them to come to terms with the past, to move forward and to forge a new future.[34] They can also work as a form of resistance against the limitations of official history and present a different perspective on past events, serving as witness to events others do not want revealed.

War imagery on textiles draw out memories and stories of wartime experiences, restoring gaps in cultural history and allowing for the airing of war traumas, making them a legitimate artistic genre rather than just an erratic "blip" in textile production.[35] Women historically have been seen as guardians of cultural memory, yet they are usually relegated to a minor role in written history. These textiles provide women's perspectives of the events of war, serving as transformative spaces where a new narrative about society and humanity can begin. They provide help to their creators, telling their stories of survival. Like traditional war art, which often glorifies the winner and has typically been created by a male artist, textiles of war can also be seen as patriotic art, their visual symbols meaningful and compelling. Their use of national colors and often naïve imagery can initially distract the viewer from the seriousness of their message, although a closer look will reveal their true meaning. These memoirs in cloth can be disconcerting and disturbing, given their overt expressions of nationalism, militarism and aggression. As will be seen, these textiles take many forms, including clothing, home décor, and objects intended for sale to outsiders. As Ariel Zeitlin Cooke has noted, by wearing garments with war motifs, people are "wearing the battle on their bodies, the ultimate site of violence."[36] Decorating a home with war textiles brings the war into the domestic sphere, making it ever present in the residents' hearts and minds. The sale of textiles with war imagery can provide women with an important source of income in a time of great need. These textiles also become a form of public art, bringing details of the horrors of a specific conflict to light. Despite their public revelation, they still remain a personal, private memory for the woman who is telling her private story through her work.

Imaginary Warfare

Not all of the wars depicted by women in their textiles are historical. Women from numerous cultures have created embroidered, needlepoint, woven and quilted textiles depicting scenes of battles from fictional wars found in local mythologies and literature. This allows women to address their anxiety about warfare and express their opinions of actual war in a safe, non-threatening manner. In Europe, generations of women have embroidered scenes from epics such as the *Chanson de Roland,* the Arthurian legends and *Ivanhoe.* In China, woven *kesi* textiles depicting scenes of battles taken from popular literature and theatrical productions were made by women beginning in the Song Dynasty (960–1279 CE). In early twentieth century Bali, women in a few towns created embroidered banners that feature figures and scenes from the great Sanskrit epics, *The Ramayana* and *The Mahabharata,* includ-

ing some of the most important battle scenes from both stories. These are discussed in greater detail in Chapter Five.

In ancient Burma, the textile tradition *shwe chi doe,* also known as *kalagas,* developed during the early Pyu period (circa 500–860 CE) as gold decorated clothing worn by members of the royal family. Gold embroidered tapestries and elephant and horse accoutrements are mentioned in stone inscriptions dating between 1044 and 1167 CE at Bagan.[37] The tapestries were being made in the area around Mandalay when Europeans arrived in the region in the sixteenth century and continued to thrive under royal patronage until the British displacement of the monarchy in 1886. The focus of *shwe chi doe* production shifted to tourist items under the British administration of Burma, although over time it almost became extinct, taken up by artisans in India and Thailand who exported their products worldwide.

Shwe chi doe tapestries like the one shown in this book use appliqué, embroidery and embellishments of gold and silver thread, metal sequins and glass "jewels" to depict images from Sanskrit epics, Buddhist jataka tales and folk tales. While tapestries created prior to the twentieth century tend to feature a subdued color palette and painted imagery outlined in metallic thread, modern pieces feature bright colors and stuffed, raised figures done on velvet, decorated with hundreds of metallic sequins. Each piece contains hidden symbolism in addition to its visible image. The number of sequins in a leaf, the number of rows in a border, and the animals depicted all serve as reminders of cultural values, ethics, and the traditional code of conduct.

During the twentieth century, the tradition experienced a revival within Burma. Among the contemporary images depicted are secular scenes of court life, landscapes, the Shwedagon pagoda, and the zodiac, as well as religious scenes, celestial beings and mythological figures such as scenes from the *Yama Zatdaw* (Ramayana) (C1). Modern pieces are designed and drawn by men; the designs are implemented by young women with keen eyesight and small, nimble fingers. Large tapestries are created by groups of women working together. Large pieces of velvet are stretched taut on a frame that sits approximately eighteen inches off the floor. The design is drawn onto the fabric in chalk by the male artist. The figures to be stuffed and appliqued to the velvet are drawn, colored and embellished on separate smaller frames prior to cutting them from their fabric. Gold and silver wrapped cotton yarn is couched onto the figures which are then appliqued to the larger tapestry. Additional couching is done on the larger work, followed by the final application of sequins and glass jewels.[38] In addition to wall hangings, the technique is now used on tourist items such as purses, hats, vests and pillows made not only in Mandalay, but also in Yangong.

Shwe chi doe is not the only textile featuring imagined warfare made for the tourist industry in Asia. In Indonesia, traditional batik techniques are used to produce textiles for sale to tourists. While souvenir art is often seen as "ethno-kitsch," designed purely for profit, it actually can serve as a means of modernizing indigenous economies and cultures while ensuring the continuation of important visual artistic traditions.[39] Local artists adopt new materials and demands brought about by contact with other cultures, adjusting to the shifting cultural climate brought by globalization, while meeting with tourist expectations about "authentic" local art. The Indonesian sarong shown here is such an example. Done using aniline dyes on cotton fabric, it depicts two "primitive" warriors, remnants of colonial prejudices, playing to the romanticized ideas of the population's uncivilized nature.

This tradition of depicting imaginary wars occurs today in the west as well. Embroidered

images of the characters and scenes from science fiction franchises such as *Star Trek, Star Wars, Gundam* and others proliferate on the internet, as kits available for completion or as advertisements for their proud creators.

Textile Terminology and Production Techniques

The word textile comes from the Latin verb *texere,* which means to weave, braid or construct. It has been applied to baskets, fabrics and daub and wattle huts.[40] Textiles can be made from a variety of fibers using a variety of techniques. Native Americans in North America made clothing from the skins of animals, including bison, deer, antelope, fox, beaver and bear. Women would prepare the skins by scraping, smoking or rubbing them with oil to make them malleable prior to dyeing, tooling, cutting and stitching them into strong, long-wearing, warm garments. Women in Samoa, Indonesia and Polynesia made tapa cloth from the bark of the paper mulberry tree, which they beat into thin sheets of a tough, papery felt which was painted with plant dyes. In Africa, women make a similar papery felt from the bark of the fig tree. Other non-loom textiles are made by looping, knotting, interlacing, braiding, knitting and crocheting fiber cords or threads. Lace making and tatting are decorative elements often added to woven textiles. Felting is a technique for creating wool fabric that is used to make boots, coats, hats, rugs, bags, gloves, and tents in many cold regions around the world. In order to make this warm, water repellant fabric, animal fleece is beaten to remove any grit and burrs, after which it is then combed, carded and dyed. The fibers are then spread on a mat and soaked with hot water and rolled up in the mat, which is tied tightly. The mat is rolled repeatedly to remove the water. When dry, the resulting fiber is strong and dense.[41]

The origin of knitting and the creation of knitted garments or fabrics cannot be known with certainty. Mary Schoeser has noted that the first textile art was the creation of threads, yarns and cords, distinguished from one another by their diameters, from fine to thick.[42] The final step was the technique by which a knitted fabric was created. Knitting is a form of spiral construction or a looping of an overhand stitch initially worked loosely along a taut horizontal cord and thereafter in the row above. Knitting with one or two needles arose from this technique. Although certain New World native tribes developed their own indigenous knitted fabrics, the Mediterranean seems to have been the cradle of knitting, and traders and sailors spread the craft throughout Europe and to the rest of the world.[43] Knitted socks have been discovered in Egypt, preserved in the dry climate; the knit Fair Isle patterns common to Great Britain were once thought to have been learned from Spanish sailors who survived shipwrecks in the area; and the traditional Gansey patterns worn by English sailors supposedly identify a sailor's home port. In the Portuguese Azores in 1825 the fiber of the century plant, *Agave americana,* became the basis for a delicate knitting called "Azores lace."[44] In Spain, a pair of knitted cushions was found preserved in a thirteenth century tomb, with patterning of a strong Arabic influence, not surprising in Moorish-influenced Spain.[45] Unfortunately knitted fabrics have not survived in enough numbers to enable an accurate tracing of their origins and evolution.

While many cultures have made use of such textile techniques, by far the most prevalent method of textile production is weaving. As previously noted, there are two types of fibers

used in weaving—animal and plant. Animal fibers include the wool of sheep, goats and camelids (camels, alpaca, llama, vicuña, and guanaco), horse hair and yaks. Before they can be woven into fabric, animal fibers must be shorn, washed, carded, spun and dyed. The Romans are credited with inventing carding, the process of brushing fibers into alignment using sharp points on a wooden *carduus* (cross). Overtime, the *carduus* evolved into a pair of wooden blocks with rows of bent wire teeth. The wool is stroked between the blocks until the fibers align and then they are gathered into a bundle for spinning using a spindle.[46] In spinning, the fibers are twisted, or plied, into strands. While this can be done with a person's fingers, using a spindle gives uniformity and length to the thread. A spindle is a stick with a weight (whorl) which is suspended in the air or sits on the ground on its tip. As the fibers are spun, the yarn or thread is wrapped around the spindle. A clockwise turn of the spindle gives the yarn a "Z" twist, while counter clockwise turns result in an "S" twist. Spinning wheels first appeared in Asia in the eleventh century, their use spreading quickly to the west.

The earliest textiles made from plant fibers were bast fibers, taken from plant stalks. Linen, jute, hemp, ramie (from the nettle family), and abaca are all bast plant fibers used in textile production, including matting, netting, ropes, bags, and belts. Raffia, from palm fronds, is used to make skirts in tropical regions, as well as for basketry and sandals. Linen was the earliest textile made in Egypt. To prepare linens, the stems of the flax plant are soaked so they can be separated, a process called retting. The stems are then beaten to free them from the woody part of the stem. The fibers are combed, then spun into thread. The process is expensive and time consuming, so the wearing of linen garments historically has been restricted to the wealthy or for use on special occasions.[47]

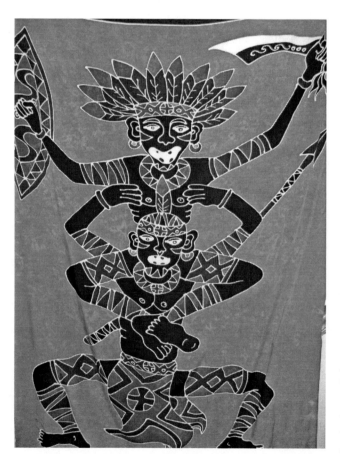

Sarong, Bali, Indonesia, late 20th century. Cotton batik. 61 in. long by 45 in. wide (collection of Deborah Deacon).

Like bast fibers, cotton takes a significant amount of effort to process before it can be woven into cloth. For domesticated cotton, the fields must be prepared, the cotton planted, tended and harvested. After the soft white bolls are picked, they are put through a gin to separate the seeds from the fibers. The cotton is then cleaned,

combed and beaten to fluff the fibers, and finally placed onto a distaff and spun.[48] A distaff is a pole used to hold fiber for spinning. The fiber is wrapped around the distaff and tied in place with a piece of ribbon or string. It is fed to the spindle as it is being spun. Because each cotton plant yields a significant amount of fiber, readily accepts dye and produces a versatile fabric, it has long been a very popular textile.

The production of silk was a closely guarded Chinese secret for centuries. Silk fabric's beauty lies not only in its softness and sheen; for despite its light weight, it is strong and provides excellent insulation against the cold. The production of silk fabric begins with the raising of the silkworm, *Bombyx mori,* which feeds on the leaves of the white mulberry. Raising silkworms is a cottage industry in China. After hatching, the grub is nurtured until it spins a cocoon, which is made from one continuous thread. The cocoons are dried in the sun to kill the pupae before it can begin to break out of the cocoon so it does not damage the thread. The cocoon is boiled in water to soften the gum on the filament, which is reeled onto a bobbin as one long thread. A number of filaments are wound together to make thread. The thread from wild or non-domesticated silk produces a coarser thread than that from a domesticated silkworm.[49]

Weaving is done on a loom, a wooden frame from which warp threads are suspended or stretched across. Weft threads are woven in and out of the warp threads from side to side, forming a selvedge on both edges. Looms may be vertical, horizontal or body tension (or strap), where the weaver controls the tension of the warp threads using her own weight.

A number of different types of weaves are commonly used in fabric production. A tabby, or plain, weave is the most common weave. It is produced by alternating the weft over and under the warp threads. In a twill weave, the weft crosses over two warp threads, under one, over two, under one across the warp. The next weft row is staggered to give raised diagonals, as seen in chevrons, herringbones and lozenges. Twill weaves produce a thick fabric. A satin weave, created by crossing the weft over one warp thread, under four or more warp threads, over one, produces a smooth loose weave where on the front side only the warp is visible, while on the reverse only the weft is visible. In a tapestry weave, the weft does not go across an entire row of warp threads. Additionally, differently colored threads are introduced to create a pattern. Tapestry weaves are used for decorative hangings and carpets. Damask weaves are reversible figured fabrics whose pattern is formed in relief, using satin weave to create shimmering, subtle patterns. Initially damask patterns were done in multiple colors; however, by the fourteenth century damasks were woven in a single color. Brocades are textiles with supplementary wefts, often done in silk with gold or silver weft threads. In supplementary wefts, the weft floats on the reverse side of the fabric, occasionally bound into the ground weave to maintain the piece's integrity. One side of brocade features a dark pattern on a light ground while the reverse features a light pattern on a dark ground.

In a warp faced weave, a pattern is created by changing the color of warp threads. The warp threads are densely tied onto the loom and the weft threads are not tightly packed when woven. Blankets and cloaks are typically woven using a warp faced weave. Weft faced weaves use thinner threads on the warp and the weft is more densely packed. In weft faced weaves, the warp is often cotton and the weft wool.

A supplementary warp features thicker and lighter colored weft threads laid over warp threads. Used extensively in Indonesia, patterns are created using a system of strings and sticks. Fabrics with complementary weft patterns use more than one weft, floating short dis-

tances on opposite sides of the fabric to create the pattern. In this case, the wefts are part of the selvedge, while in discontinuous weft textiles, the floating wefts used to create the pattern are not part of the textile's structure.[50]

From the earliest times, plants and minerals have been used to create dyes to color fibers. Indigo, which produces a deep blue color, was used as far back as in ancient Egypt. Creating indigo dye is a complex process. After the plant is boiled, the threads are dipped into the resulting liquid. The fibers are yellow as they are taken from the dye, oxidizing to blue in the air. Cochineal, derived from the parasites that grow on cacti around the world, produces a red dye, while purple, the color of royalty, is a secretion produced by a species of sea snail known as Murex.[51] The dye was first used by the ancient Phoenicians as early as 1570 BCE and was prized because the color did not easily fade, instead becoming brighter with weathering and sunlight. Industrialization led to the development of synthetic or aniline dyes, which provide more permanent, vivid colors. Their introduction around the world resulted in imaginative variations on traditional textile production and the creation of new textile traditions.

Fibers can be dyed in a variety of methods. An entire length of thread can be dyed the same color. Resists, such as tie dyeing, stitching, starch or wax, can be applied to either fibers or woven fabric to allow for the use of multiple colors and patterns. Ikat, produced by tying off portions of the warp, weft or both fibers, are then woven to form a design. Weft ikat, often done in silk, requires special attention in order to align the patterns. Fabrics can also be printed using a stick, brush or carved stamp of clay, wood or metal to apply ink or dyes to produce a multicolored pattern on a length of fabric.

Appliqué, the tacking of cut pieces of fabric onto a base cloth to form a design, has been popular in many cultures. A variety of fabrics including cotton and felt have been used to create decorations for clothing, rugs, blankets and household items. In reverse appliqué, designs are cut through a stack of fabrics from the top, revealing the various colored layers beneath. Cut pieces of fabric can also be sewn together to create brightly colored, uniquely patterned quilts.

An Overview

Throughout history the art-making tools most available to women have been some form of needle and thread. While women have used them to create functional items, such as clothing and linens, they have also been used to add embellishment, create a design or provide information. In modern times they have also been used to express and opine. While two previous textile exhibitions, our *Stitches of War* from 2003 and Ariel Zeitlin Cooke's *Weavings of War* from 2005, have examined some contemporary war textiles, there has been no comprehensive, historical, global examination of women's creation of textiles that address the impact of war on their lives. This book seeks to rectify that situation. Each chapter will address a region of the world and will reveal the works of women, many of which are little known in the West, which documented either their support for or opposition to the violence and unrest of war through their traditional art forms.

Chapter One begins the discussion of the Western tradition of depicting warfare in textiles by examining tapestries and embroideries such as the Bayeux Tapestry, produced by

aristocratic women to commemorate the heroic deeds of knights and kings. It continues with a discussion of the knitting campaigns of British women during World War I, World War II and the wars in Iraq and Afghanistan as they supported the troops fighting abroad and those displaced by conflict; samplers produced throughout Europe to document the military service of husbands, brothers and sons; needlepoint pictures of war heroes across the generations; quilts that depict the pride of the nation; and a rug created by Bosnian women to commemorate the impact of war on their lives and country.

Chapter Two investigates textile traditions in the United States, beginning with Betsy Ross and the hundreds of other women who sewed flags for the nascent country and continues with woven coverlets and quilts created during the Civil War and movement west which served as memorials to war heroes and patriotic reminders of home. The impact of this westward expansion is shown in the beading, embroidery and quilting of Native American women as they documented the changes war brought to their lives as well as the works produced by women as they participated in the settling of the west. In the twentieth century, women knitted stockings and sweaters for the troops, embroidered samplers, and quilted in support of the troops fighting abroad. The trend has continued to the present day, as some women knit caps and sew lap quilts for the troops while others use their needle skills to protest the conflict in Afghanistan.

Like their neighbors to the south, Canadian women have also documented their feelings about war by knitting, quilting and embroidering samplers in support of the cause. Chapter Three documents First Nation women who have also recorded their reactions to war in their traditional beadwork, used to decorate clothing made for their warriors to wear into battle. This same beadwork was used to decorate souvenir art the women created to support their families after conquest. The European settlers created rugs to decorate their homes and show their allegiance to their new country. Canadian women also offered support to fellow Allies during World War II by making thousands of quilts for families displaced by the bombing in England. And in modern times, textile artists all across Canada continue to use traditional skills to create statements of their reactions to wars worldwide.

Textile production has been considered to be women's work in many Latin American cultures for several millennia. As discussed in Chapter Four, textiles produced by Inca and Aztec women often included images of warriors and luxury textiles were frequently presented to warriors in honor of their heroism and were worn into battle. During the civil wars that raged throughout the nineteenth and twentieth centuries, women across the region produced embroideries and weavings that reflected the impact of war on their lives, including *arpilleras* produced in Chile and Peru that documented the "disappeared" under the regimes of Pinochet and Samoza, appliqued molas from Panama that reference the U.S. occupation during the twentieth century, dolls that depict the leftist Zapatistas from Chiapas, Mexico, and baskets woven by women from the Wounaan and Embera tribes in the Darien region of Panama and Colombia featuring images that refer to the hazards of drug trafficking in the region.

Chapter Five details the impact of contact with western imperialists on traditional women's textile production as can be seen in clothing produced in Java and Sumatra and in the weavings and embroideries of the ethnic minorities in mainland Southeast Asia who sided with America during the Vietnam War. Beginning with the Sino-Japanese War of 1894–5, Japanese women embroidered "thousand stitch" belts to be worn as protection by

loved ones beneath their uniforms as they went off to war. In China, women embroidered luxurious textiles called *kesi* illustrating real and imagined battles taken from history, mythology, literature and religious texts. Women in South Asia reacted to the warfare that resulted after the withdrawal of the British from the region by embroidering their colorful *kanthas* (blankets) with war images. More recently, they reacted to the acquisition of nuclear weapons by both Pakistan and India in quilts and embroideries. During the East Timor war for independence from Indonesia at the beginning of the twenty-first century, East Timor women weavers produced textiles that featured slogans written in Portuguese, the language of their original colonial oppressors, rather than the official language of Indonesian, as well as textiles done in United Nations blue and white, the colors of the observers who were present during the vote for independence.

Further to the west, women from Palestine modified their traditional embroidery to create souvenirs in appreciation of the Allied soldiers who protected them during World War II. Chapter Six explores the continued modification of their embroidery traditions as Palestinian women document the suffering and loss they have encountered during the forty-five-year Palestinian-Israeli conflict. Shortly after the invasion of Afghanistan by the Soviets in 1979, rugs containing images of tanks, helicopters, bombs and AK-47s began appearing in the markets in Peshawar. Woven initially by nomadic Baluch women as a means of dealing with the conflict around them, the traditional art form was soon modified for sale as souvenirs to Soviet soldiers, providing much needed income for those living in refugee camps in Pakistan. The tradition was revived with the resurgent warfare in 2003, along with quilting projects which encouraged war widows to express their feelings about the violence and loss.

A discussion of African textiles is noticeably absent from this work. During our research, we found that throughout the continent there has not been a tradition of women creating textiles. In pre-colonial times, the textiles worn and used by Africans were either raffia/plant based and featured abstract geometric patterns or animal skin, with little or no embellishment. In modern times, cloth has been produced either by men or imported from the west. Because they did not have native textile traditions, it appears that African women did not use textiles to express their reaction to war. The one exception seems to be a few memory cloths produced in the late twentieth century by a few women from rural South Africa under the auspices of the Amazwi Abesifazane Museum which reflect the impacts of apartheid on their lives. Most of these do not contain images of violence.

Despite the conventional wisdom that war is a gendered experience that only affected the men who fought but not women left behind, this book shows that women throughout the history of the world have been impacted by war and that they have expressed their reactions to war in their traditional textile art forms. Women from around the world have expressed their support for their troops through their traditional art forms of knitting, sewing, quilting, weaving and embroidery. Those same textiles have served to express opposition to war, as well as being used as a platform to document the horrors of war and to tell the stories of individuals and societies that have been torn apart as the result of war. These women, who frequently serve as the reservoir of their cultural history, serve as a conduit of information for the world, sharing their experiences with those who were not there in an effort to educate us all.

ONE

Europe

The countries comprising Europe today range from Finland in the north to Spain, Italy and Greece in the south, and from the British Isles in the west to the Ukraine in the east. They include forty-eight internationally recognized sovereign states, forty-four of which have their capitals in Europe.[1] With the break-up of the former Soviet Union, Central and Eastern Europe now include Estonia, Latvia, Lithuania, Belarus, Ukraine, Moldova, Romania, Bulgaria, Greece, Albania, Serbia, Bosnia and Herzegovina, Croatia, Hungary, Slovenia, Slovakia, Austria, Poland and Czech Republic.[2] Many of these nations were previously part of empires created as the result of war and conquest, which waged across the continent over the centuries.

The textiles that evolved in various European cultures developed at different times on the continent, the result of flexible borders that changed with conquest and foreign occupation. As one area or people were conquered, established traditions were overlaid or combined with new ones to create new societies and traditions. Change occurred periodically but similar techniques for textile production developed throughout the region, so most cultures had developed techniques for knitting, weaving, embroidery and quilting before modern times. Other means of such dissemination included religious pilgrimages, trade along the Silk Road and other land and sea routes, and the migration of people. Textiles were among the products impacted by this cross cultural contact. Many Asian silks are mentioned in medieval European church inventories, and Italian silks of the fourteenth century were clearly influenced by the motifs found on Chinese silks.[3] Many of the materials, techniques and forms used in ancient times remain in use today, both as essential aspects of production in many regions of the world and as ingredients in textile arts, where textile production has moved beyond utilitarian or ceremonial uses to become tools for self expression.[4] This self-expression can come in the form of pride of cultural identity, support of a political cause, commemoration of loved one lost during a time of conflict, and the documentation of the impact of war.

Textile centers flourished in various countries across the continent during the European Middle Ages (circa 500–1500 CE). Lucca, in Italy, in the late thirteenth century became the first center of Italian silk weaving, which was facilitated by its large Jewish population. During the eleventh and twelfth centuries, sericulture and silk weaving were established by Middle Eastern peoples in southern Italy and Sicily, where under Frederick II (1194–1250) fabric dyeing was a Jewish monopoly, as were silk processing and weaving.[5] Charlemagne, crowned emperor of France by Pope Leo III in 800 CE, established the pattern for textile use for

Christian courts, which included the use of lavish silks and embroideries.[6] His domain included large areas of Germany and Saxony, resulting in the concurrent spread of Christianity and French textile traditions into the region.

In northern Europe, the Vikings spread their vibrant textile culture, which included the creation and use of complex tablet-woven braids and hanging wrapped and woven tapestries, to settlements in the northern British Isles, Normandy, the Mediterranean, and the eastern Baltic.[7] Trade among these areas spread these textile traditions to the furthest edges of the continent. In Flanders, a region in the southwest corner of the Low Countries now divided among Belgium, France and the Netherlands, artists during the fifteenth century were known for their elaborate tapestries, embroidery and needlepoint.[8] Much of their production was centered on the creation of elaborate garments for the clergy. In the fifteenth and sixteenth centuries, male Flemish tapestry weavers were considered the best in all of Europe.[9] In addition to church clergy, European royalty, knights and soldiers were the largest consumers of these elaborate textiles. As noted by Mary Schoeser, the romantic notion of "magnificent warfare" owes much to the richly wrought textiles associated with military campaigns, garnered directly or indirectly as tribute items or booty.[10]

In the centuries following the Middle Ages, the creation and use of a variety of textiles continued to flourish and spread. Some areas that became known as centers for specific textiles continued to produce them well into the twentieth century, such as Italian silks and Flemish lace. As the Industrial Revolution developed mechanized means to create cloth, the production of hand-made fabrics, tapestries, rugs and embroideries declined and the prices rose, making them available only to those who could afford them. But hand-made textiles continued to be produced by individual crafts people and artists throughout Europe, often by women in their homes for personal and commercial use.

War and textiles have been inextricably linked throughout the history of Europe. In addition to death and destruction, among the impacts of such warfare were the inevitable spread of culture between peoples, the introduction and exchange of ideas, an increase in knowledge, and new ways of doing things.[11] The migrations and population shifts caused by the numerous battles, wars and invasions spread elements of various cultures across the region, increasing the speed of their dissemination beyond what would have naturally occurred during times of peace. Conquering armies often forced change in occupied areas, in part due to their demands for art to commemorate and celebrate their conquests. In all cases, armies had to be outfitted and required unique textiles to identify and separate them from opposing forces. Before industrialization, these textiles were most often produced by women.

Knitting

Knitting has played an important role for military personnel since the earliest times, providing the warm clothing required in cooler climates and at sea. While men may have been involved in knitting production in many European regions, women most certainly have produced the yarn and the majority of knitted garments for generations of military men. Knitting is a task that lends itself to being produced in quiet times around a hearth, while men were off hunting, fighting battles and exploring the world. Some of the earliest knitted

military garments were caps, which were felted, stockings and sleeve pieces. In 1571, a statute was passed in England ordering every man over the age of six, except those of high rank, to wear a knitted work cap, made in England, on Sundays and holidays.[12] The so-called Monmouth Cap, a felted knit cap, was first produced in the thirteenth century in Coventry and a version of it was still being made in the nineteenth century for soldiers to wear during the Crimean War.[13] At the end of the English Civil War, King Charles I of England is said to have been beheaded while wearing a fine gauge silk knit shirt, now preserved in the Museum of London.[14]

One famous group of French knitters, *Les Tricoteuses*, was mentioned in *A Tale of Two Cities* by Charles Dickens, and also existed in reality.[15] They were a group of women hired by the Commune of Paris during the French Revolution to witness the tribunals and beheadings of members of the French aristocracy. They allegedly knitted throughout the entire proceedings. At the time one of the symbols of the French Revolution was a red, wool-knit hat, known as a Phyrgian cap, named after the freed slaves of Roman times, or a Liberty cap. Presumably, the caps were knit by women. They were meant to symbolize freedom from the Old Regime and the new liberty for the common people.[16]

Knitting for Soldiers in Wartime

The epitome of knitting for a soldier is the knitted cap, meant to be worn alone or under a helmet. This tradition has been popular for centuries, and the Welsh town of Monmouth is well known for producing these caps. Monmouth lies on the Wye River, which flows into the Bristol Channel, allowing easy access to shipping. The nearby town of Archenfield became noted for its Rylan sheep, which produce wool which is excellent for felting. With the ready supply of wool and access to shipping, Monmouth became the center of a local knitting industry. The town benefitted in 1571 when Elizabeth I required men and boys to wear hand-knitted caps. When the law was repealed and civilian use of the caps declined the industry also declined, but the Monmouth caps continued to be part of the regular military uniform for the Army and Navy throughout the seventeenth century.[17]

The tradition of soldiers wearing hand-knitted caps continued throughout the centuries. During World War II in Great Britain women and children both "knit their bit" for the war effort. When their mothers served in the Armed Forces or worked in factories during the war, the children continued to knit wooly hats for soldiers and refugees.[18] Today the tradition of wearing hand-knitted caps has continued for soldiers fighting in Afghanistan and Iraq. Many individuals and groups have organized efforts to provide these caps. In Wales, Tina Selby from Penarth, in the Vale of Glamorgan, had posted almost 5,000 wooly hats to British regiments in Helmand Province, Afghanistan, as of March 2012.[19] What began as a response to a plea from a soldier in the local paper for "goody boxes" grew to include hats after Selby added one she had made to the first box. Her project quickly expanded to a box of hats only, and regular parcels of knitwear created by herself and her friends. By 2012, she had donations coming from people and groups from around the United Kingdom, with a total of at least 100 people knitting for the soldiers. This is consistent with similar stories in many countries around the world, including the United States, Israel and Canada. Women have found comfort and utility in knitting for soldiers, an act that has allowed them to contribute to the war effort by supporting the troops.

A similar spirit of generosity inspired women from France to respond to the kindness shown to them after the Second World War. American president Harry Truman began a program in 1947 known as the" Friendship Train" which gathered food, clothing and fuel from across America in railroad cars to send to France to help with their recovery from the war; ultimately $40 million in relief supplies were sent to both France and Italy in over 700 carloads. In response to the American act of kindness, French citizens sent one train carload of thank you gifts to each American state, forming what was known as the "Gratitude Train," or "Merci Train." The train cars arrived in New York Harbor aboard the Magellan, a French merchant ship, in February 1949. The 40 ET-8 box cars were the same type that had been used to transport captured American soldiers to prisoner of war camps and Jewish citizens and dissidents to concentration camps during World War II. Items sent in the reciprocal train included knitted hats and sweaters as well as other handmade textiles such as star-shaped pillows and cross stitch pillows, lace doilies, embroidered collars, baby bibs and linen hats. All of these were made during the post-wartime of limited resources and materials. Today, most states still have their boxcars, which are often on display in a park or museum setting, such as the one in McCormick-Stillman Railroad Park in Scottsdale, Arizona.[20] The State Capitol Museum in Phoenix has an extensive collection of the gifts sent to Arizona in its archives. The shields on the side of the boxcar represent the coats-of-arms of the forty

Merci Train, France, 1949. Boxcar built 1872–1885. McCormick-Stillman Railroad Park, Scottsdale, Arizona (photograph courtesy Suzanne Warchal).

provinces of France. Each boxcar also contains a plaque bearing the Merci Train symbol, a frontal view of a steam engine with a red, white and blue flower on the pilot, symbolizing the flowers found on Flanders Field, where many American World War I "Doughboys" are buried.

Knitting for Survival in Wartime

While knitting for soldiers has been a time-honored tradition for women, for some knitting for others was necessary to their survival during wartime. In some cases, the women did not intentionally knit to insure their safety; however, in other cases women used whatever skills they possessed to assure survival for themselves and their family. In some cases, their knitting served as a valuable means of exchange rather than merely meeting domestic needs.

Anna Munster, born in 1913 in Bukovina, Romania, attended medical school in France and became a doctor in World War II Europe. She was also Jewish and moved to both southern France and then to Switzerland to escape the Nazi persecution, finally settling in the United States in 1948.[21] In her homeland, which was part of the Austro-Hungarian Empire until after World War I, it was customary for girls to learn to knit at a very young age and Anna did so by age five. She continued to knit while in medical school, both for herself and others. After the Germans invaded France, Anna moved to the south and became known for her knitting skills. She knitted a pair of gloves for the nephew of one of her new friends, who happened to be a policeman. When he was required to round up Jews in the town for deportation, he made the decision to overlook Anna and her future husband. She was convinced, then and later, that it was the gloves she knitted for him which made the difference. Anna, whose daughter Ileana Grams Moog wrote about her life and wartime experiences, died in 2010.

In the case of Anna Vipulis Samens (1892–1979), her knitting machine and her skill in using it provided the means to preserve family and culture during time of war.[22] Anna and her family twice escaped their homeland, Latvia, once in 1941 to flee the German occupation of Riga, the capital city, and again in 1944 as the Soviets came to occupy the city. Both times Anna managed to take her knitting machine with her. During their occupation, Germany took control of the region's important businesses, including the Samen family's knitting factory. Throughout their ordeal, Anna was able to provide for the family's survival by making knitted items to barter for necessities. This continued when the family migrated to Canada after the war. Despite her initial inability to speak English, Anna was still able to utilize her knitting skills to find work, and towards the end of her life she used the money she earned knitting socks to finance her first trip back to Latvia since her escape. Knitting had provided a continuous narrative for her life, a narrative of memory and survival resulting from the turmoil of war.

Contemporary Knitting

Knitting has continued to be part of women's lives during the second half of the twentieth century and into the twenty-first century. But the art of knitting is no longer practiced just for utilitarian purposes; it has become a viable tool used to express ideas and opinions on a variety of personal, social and political issues. Handmade garments are now a luxury

item rather than a necessity and women often use their yarn and needles as artistic media. Sentiments about war appear in their knitting, and knitting is sometimes used to make a statement in favor of or in opposition to war.

Annette Streyl is a German artist who knits models of buildings, particularly famous, meaningful ones, such as Berlin's TV Tower and the Reichstag.[23] Three of her works hang in the Kunstalle art gallery in Hamburg, her hometown and her works are included in the collection of the Technical Museum in Berlin. In Streyl's pieces, the angular reality of German architecture can become sagging and formless, as it does in her knitted model of a massive domed hall designed by Nazi architect Albert Speer.[24] The building, which was intended to be the largest meeting hall ever built, was never actually constructed, so Streyl used the architect's plans to complete her design. Because the model is made of knitted fabric, when it inevitably sags and looks silly, Streyl has said that "the joke just happens.... The wool does just what it wants, so you see this proud eagle sitting on a globe suddenly hanging down like a dead chicken.... I believe you can read a very nice meaning into that."[25] Her work exposes the failure of the Nazi regime as an institution of political power. Streyl's models are visual representations of her own political opinions, which in this case are anti–Nazi.

In 2006, a video was shown at the Nikolaj, Copenhagen, Contemporary Art Center (now Nikolaj Kunsthal) as part of the exhibition "TIME," highlighting knitting as a form of protest art.[26] The subject of Marianne Jorgensen's video installation was a World War II combat tank, which was covered in more than 4,000 pink knitted squares, made by volunteers from Denmark, the United Kingdom, the United States and other countries. This covering represented a protest against these countries' involvement in the war in Iraq. When the tank was installed in front of the Nikilaj, volunteers, joined occasionally by passers-by, sewed the squares together, covering the tank in a field of pink.

Other knitters make their statement about war with a more traditional approach. Members of the Mother's Union in County Durham, England, knitted almost 3,000 teddy bears to send to Iraq and Afghanistan to be distributed to local children who have been the victims of war. Their intent was to bring comfort to the children who have been the victims of war.[27] On a larger scale, Knit for Peace International has groups of women around the world who provide knitted items for those in need. Both of these group efforts are a form of "craftivism," a form of activism that uses knitting and creativity to improve the knitter's life and the lives of others who have been impacted by war. This definition of knitting as a form of activism began in the first decade of the twenty-first century and is an increasingly popular idea that has coincided with both protest against and support of the wars in Iraq and Afghanistan.

Lace Making

Prior to the nineteenth century, lace making was done primarily in Europe, often as a cottage industry that provided necessary income for poor women. The materials required to make lace are minimal—thread and a needle or crochet hook—and a lace item could be completed comparatively quickly. In the nineteenth century several factors came together that lead to the development of crochet lace making in Ireland. In the middle of the century a devastating famine, caused by a potato blight, destroyed the agricultural mainstay of the country. Families were left destitute and devastated, with no means of employment. Although

there appears to be no one source for the sudden interest in lace making, the idea came along at the right time to provide much needed income for struggling women throughout the country. In Youghal, County Cork, the Sisters of the Presentation of the Blessed Virgin Mary, who were looking for a way to help families earn money to survive, began teaching lace making to the young girls attending their convent school. At the same time, other nuns who had fled to southern Ireland and England from France after the French Revolution (1789–1799) and who were highly skilled in needle skills, had also established schools in the region. The nuns made excellent teachers and the work from this region became very popular due to its intricacy and beauty.[28]

In 1846 Mademoiselle Riego de la Blanchardière published the first book of Irish crochet patterns and is credited with having invented the style that became known as "Pt. d'Irlande." This pattern book was used by both of the schools of crochet that sprang up and by the women who were part of the growing Irish crochet cottage industry.[29] Women and their daughters throughout Ireland quickly took up lace making as a way to increase their income. Their work could be divided by skill levels, with the more adept using the more difficult patterns over and over to create elaborate, intricate pieces, and the less skilled completing pieces that used the simpler leaf and stem patterns, for example. Irish crochet lace eventually became the most widespread handicraft in Ireland in the nineteenth and early twentieth century.[30]

As with many other forms of needle arts, women could use their skills to express more than beauty. They could use their art as a form of political commentary. The Catholic Emancipation Act of 1829 granted Irish Catholics civil rights and with this came a search for national identity among Catholics and Protestants alike as the Irish sought to determine their place and status in society. Many women used certain symbols and designs that were particular to their work. These symbols served as a signature and these were closely guarded to protect their income and reputation. Some women crocheted pieces that contained a combination of a shamrock, rose and the thistle, which indicated their support for the British Empire and loyalty to the crown during times of political upheaval during the British occupation of Ireland.[31] This subtlety was not necessarily noticeable to the purchaser of the lace goods, but the maker had the satisfaction of knowing she had made her personal political statement in support of the Crown. Those women who sided with the rebellion against the Crown included Celtic crosses and the claddagh in their work.[32]

Weaving

The most basic weaving technique involves interlacing two sets of threads at right angles to each other. One group of threads, the warp, is held tight and the second group of threads, the weft, is interlaced through the warp to produce plain weave. All other weaves are created by using variations of this basic weave. This straightforward process can be used to create a variety of fabrics, employing different types of fibers and techniques, including clothing, household goods and rugs. Some of the earliest woven materials, dating to approximately 1000 BCE, have been found preserved in a salt mine in the Austrian Alps.[33] During the time when this cloth was woven, the ancestors of the Celts were living in what is now Austria, Hungary and Southern Germany. By 400 BCE, the early Celts were beginning to fan out

across Europe, moving into France, Britain and Spain, where their descendants live today, and carrying their cultural traditions and knowledge of weaving with them. In Greece, the Amasis Painter (active circa 550–510 BCE) painted a scene of women engaged in various stages of wool working on a *lekythos* (small oil flask). In the center of the vessel, two women work at an upright loom that features weights tied to the ends of the warp threads to hold them taut. One woman pushes the weft thread, while her companion separates the warp threads with a heddle rod. The completed portion of the fabric is rolled up at the top of the loom. To the right of the loom, three women weigh the wool taken from a basket while another supervises their work. The depiction also includes images of four women spinning wool into yarn, while two others fold finished cloth.[34]

Beginning in pre-historical times, European women would have made the cloth for garments worn for everyday use, as well as that worn into battle. Legend has it that the Scots were able to outlast the English soldiers during times of battle warfare because the Highlanders would take off their kilt-cloths after dark, roll up in them three or four times, and remain warm enough to sleep out the night under any bush.[35] The items woven by their women ensured their survival, and victory in battle.

The Danish National Research Foundation's Centre for Textile Research is currently engaged in a project known as Textiles for War. The participants are studying the textiles found in the thousands of sites found in bogs, weapons deposits and burials throughout the region which date to the Bronze Age (1800–500 BCE) and early Iron Age (500 BC–400 CE). In most cases, textiles are too fragile to have survived from these period; however, thanks to the mineral content of the bogs, these have survived and can provide a great deal of information about their makers and their origins. The textiles are being analyzed for their weave type, thread type, colors and qualities in an effort to determine their original function. The analysis of textile remains from four Roman Iron Age weapon deposits has demonstrated that textiles were a substantial part of the ritual destruction of the enemy's weapons: soldiers' clothing and sacks were wrapped around the weapons before their deliberate ritual deposition, highlighting the importance of textiles, both for function and for purposes of ritual.[36] These textiles buried along with the weapons had special significance for the users, as evidenced by the special care that was taken in their burial.

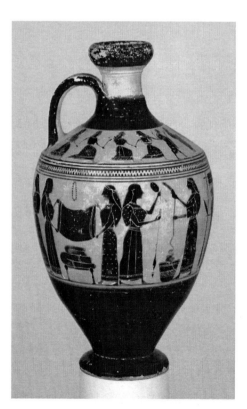

Lekythos, attributed to "Amasis Painter" (oil flask), Greece, sixth century BCE. Terracotta. Height 6¾ in. (image copyright the Metropolitan Museum of Art; image source: Art Resource, New York).

Extensive evidence of early textile use in Norway was uncovered in a Viking ship burial found dating to 834 CE. The Oseberg ship burial, located on a farm near Tonsberg in Vestfold County, Norway, was excavated by Norwegian archaeologist

Gabriel Gustafson of the University's Collection of National Antiquities in Oslo in 1904–5. The site served as a grave for two women of high social status. While the identity of the dead women is not certain, it has been suggested that one is Queen Asa, who ruled during the ninth century CE. Among the grave goods found in the buried ship were personal items for their use in the afterlife, including clothing, shoes, farming equipment, household items and a number of farm animals. Many of the objects, including the keel and bow post, were decorated with elaborate interlacing decorative carvings. It also contained the largest and most varied collection of textiles and textile making tools ever found in a single grave, including fragments of silk embroideries. The textile tools include several smaller looms, spinning tools and several loose spindles and whorls, providing evidence of Viking women's skill in the production of textiles. The walls of the burial chamber itself were hung with elaborate woven tapestries that include images of a battle scene as well as spear carriers standing outside two small houses featuring dragon heads on the gables.[37] Viking women outfitted their men for their journeys of exploration and battle, making them important participants in the Viking warrior culture. Anne Stine Ingstad has noted that "the Viking age women had a long, unbroken tradition behind them as far as textile production is concerned. Here they had a wealth of experience handed on from mother to daughter through many generations.... The whorl is one of the most commonly found tools in female graves of the Viking age. This shows that spinning must have been done by virtually every single woman in our country."[38] The cloth fragments, which included clothing, sails and tents, were woven in a number of different fibers and techniques, an indication of the skill of the women who created them.

Sprang

Sprang, a form of hand-weaving, is an ancient technique of plaiting or braiding fibers to create a fabric. This term "sprang" is of Scandinavian origin and it is similar to other techniques of creating cloth including plaiting, netting and interlacing, which involve the interlooping of fibers to create a flexible fabric. While making sprang, rods hold each successive twist until the next is in place. The technique was widely used from an early time, with the earliest surviving examples, found in Denmark date to circa 1400 BCE, while those from Peru date to circa 1100 BCE.[39] These early examples include a Danish Bronze Age hairnet and string skirts worn by women in various European countries including Romania, the former Yugoslavia, Albania and Macedonia.[40] In Greece, the traditional women's folk costumes included a special girdle known as a *zostra*, made of red wool sprang.[41] The technique was popular throughout Europe, often used to create narrow or small items such as belts and carrying bags. Based on imagery on Greek ceramic vases, Dagmar Drinkler has speculated that the Darius' army was wearing sprang as it invaded Greece in the sixth century BCE.

In the 18th and 19th centuries CE, military sashes created in a diagonal sprang pattern were popular uniform components in Denmark, Germany and France.[42] They could be made quickly at home by wives or mothers; one of the appealing features of this method of textile production is that in making a sash, as one half is woven, the second half is automatically created at the same time, speeding the sash's completion. Also, minimal tools are required to produce sprang—a frame, threads and sticks or rods. In the circular warp method, the

one most likely used to create the sashes, parallel threads of a warp that is fixed at both ends are manipulated. The threads are interlinked, interlaced or intertwined, and sticks or rods can be used to mark the weaver's place.[43] The resulting fabric is flexible and strong, ideal for a military sash since it was decorative but useful. It was the perfect size and shape to use to carry a wounded soldier from the battlefield.

Rug Making

Among the items women wove for their households throughout history were rugs. In various countries, women created carpets to provide warmth and comfort for both permanent and temporary dwellings, ranging from tents to castles. Carpets were often hung on walls as well as being used on floors, and were sometimes used as bed coverings to provide additional warmth to a room. For example, the Nordic *rya* rug was used originally piled on beds, to provide and trap warmth, in Sweden and Finland in the late fourteenth century.[44] Rugs were made by women from all levels of society, including by Birgittine nuns (the Order of the Most Holy Savior), the order founded by St. Bridget of Sweden, circa 1346.[45] Women in Sweden also wove rag rugs, and weaving skills and knowledge there were passed from mothers to daughters for generations, as they were elsewhere in Europe.

In Bosnia, many young girls were taught to weave and there was a long tradition of rug making in the region. The art of weaving has a long history in Bosnia and Herzegovina as well as in other Balkan countries. According to local legend, the people who taught the Greeks the technology, vocabulary and mythical lore associated with weaving must have been the "indigenous" inhabitants of the Balkans, skilled in weaving since the middle of the Neolithic, perhaps even 5,000 BC.[46] The country was part of the Turkish Empire at one time and although local rug making was influenced by Turkish traditions, the weavers developed their own designs and use of color.

While Sarajevo and Mostar were centers of commercial rug weaving, many women and girls in rural areas also wove. Domestic rug weaving was frequently disrupted during the long periods of war and unrest that interrupted their lives, destroying their normal routines and homeland. This has been especially true in areas that were part of the former Socialist Federal Republic of Yugoslavia, such as Bosnia and Herzegovina. In the aftermath of the war of 1992–1995, many Bosnian women left their homeland and tried to rebuild their lives elsewhere. After the murder of more than 7,000 Muslim men and boys in Srebrenica, the women were expelled from the city, not knowing if their family members were dead or what their future held. Several aid organizations have come to their assistance by teaching or encouraging weaving as a means of self-support. In 2003, the Advocacy Project, a Washington, D.C.-based human rights organization, worked to raise awareness and funds for Bosnian women victimized by the war. Some of these displaced women worked as weavers to support themselves and their children, and to save money to return to their homes. One of these women was Nura Suljic, a Bosnian widow and refugee, who weaves rugs of geometric designs and vivid colors. Another refugee, Munira Hadzic, founded Bosfam, Bosnian Family Association or *Udruženje Bosanska Familija*, a women's organization that trains suddenly destitute women from all ethnic backgrounds in such traditional handicrafts as weaving. In the Bosfam weaving center, Muslims and Serbs work together creating kilims, colorful geometric pileless

woven rugs that can take as long as two months to complete.[47] The sale of the rugs provides much needed income for the weavers.

Vanessa Pupavac, from the School of Politics and International Relations at the University of Nottingham, England, has studied the role of women as peace-keepers in former war zones, Bosnia in particular. According to her research, in the last 20 years, international conflict management approaches have taken up the idea of women's role in peacekeeping.[48] According to Pupavac, the idea of women as peace-keepers, or peace-weavers, is not new but is now being translated into action: "Whether in Afghan Women's Sewing Initiative, or African Amani Sewing and Reconciliation Project, or Burmese Weaving for Women Project, it is striking how many NGOs [non-governmental organizations] support women at the loom or needle." In Bosnia, hand woven rugs have been one of the microenterprise schemes that have been supported by such organizations to help create employment.

The art of weaving has a long history in Bosnia-Herzegovina and other countries in the Balkans. According to textile legend, the people who taught the Greeks the technology, vocabulary and associated mythical lore of weaving must have been the "indigenous" inhabitants of the Balkans, skilled in weaving since the middle of the Neolithic, perhaps even 5,000 BC.[49]

One Bosnian woman who used the art of weaving as a means of expressing the impact of war on herself and her culture is Azra Aksamija. Now an assistant professor in the Massachusetts Institute of Technology Program in Art, Culture and Technology, Aksamija fled her homeland during the 1990s war. She initially settled in Austria prior to coming to the United States. She started making art as a child after her grandmother, who was a knitter and collector of Bosnian embroidery, taught her about different crafts, opening up a whole world of inspiration. While the primary media of her work now is sculpture and textiles, her most recent work, *Monument in Waiting* (C2), is her first kilim weaving. This work is, according to Aksamija, "a collective testimony of the 'ethnic cleansing' in Bosnia-Herzegovina, carried out by nationalist forces during the war of 1992–1995."[50]

The motivation for this work arose from the process of territorial and cultural "decontamination" that occurred during the war, that not only involved evicting and killing Bosnians, but the attempted extermination of their cultural and historical traces. This included the targeting of places of worship, which eliminated the buildings, and included the destruction of a significant number of mosques as well as Christian churches.

The project began with the historical and archival research concerning 250 of the more than 1,000 mosques which were destroyed during the war. Of those 250, nine case studies were chosen for a more detailed investigation. Then interviews were conducted with a range of individuals, some of whom were involved in mosque building and rebuilding, to learn about their particular war experiences. The collection of this information also provided insight into mosque histories and design preferences. Aksamija subsequently turned the information into abstract symbols, each representing one destroyed building, which were woven into a tree of life design on a kilim rug. Each symbol combined personal and historical meaning, but their interweaving makes visible the collective memory of the Bosnian war experience. Each symbol on the tree of life signifies the political unrest, military aggression and threatened collectivity Bosnians experienced during the war, while providing a positive outlook into the future of the Bosnian nation.[51] The kilim was produced in collaboration with Amila Smajovic and her Sarajevo-based workshop "STILL-A," which employs refugee

women as weavers. The kilim borders are inspired by Afghan war rugs like those discussed in Chapter 6. As research is completed on newly discovered destroyed churches and mosques, the tree of life grows taller from the addition of new symbols.

Embroidery

The use of embroidery may have arisen from a desire to add decoration to a piece of cloth, or to create an identifying mark for the maker. Embroidery appears very early in the history of textiles throughout Europe, and evidence of its use was spread along trade routes. A purple linen-like undergarment decorated with red pile was discovered in a burial of a tribal chief at Tsarskaja in the Caucasus, and at the roughly contemporary royal tombs at Ur, dating to circa 2,500 BC. One way of creating such "false" pile is through a twined embroidery stitch.[52] While there is little evidence of embroidery found in early written records, the Roman historian Tacitus recorded that the Celtic warrior queen Boudicca was captured in 62 CE wearing a fur lined mantle of embroidered silks.[53]

In a long tradition dating from much earlier times, Greek women sometimes produced large storytelling cloths and some of these "tapestries" were kept in the treasuries of Greek temples, where they could be seen upon occasion.[54] Iron Age Greek story cloths are mentioned in classical literature and fragments of at least two have been found in classical Greek tombs in the Crimea.[55] Additionally, there is mounting evidence that noble Mycenaean ladies likewise recorded the deeds and/or myths of their clans in their weaving.[56]

As England emerged from the "dark ages," embroidery began to flourish there, with Christianity being the major stimulus of artistic expression. While embroidery was done by women of all social ranks, the majority of early embroideries that survive were made for members of the aristocracy. Most of the information on embroidery from this time comes from descriptions in manuscripts and from manuscript illuminations rather than from the actual textiles themselves. For instance, it has been recorded that in the seventh century CE, St. Augustine carried a banner embroidered with the image of Christ which he used to preach about Christianity to the illiterate population. In that same century, Aldehelm, the Bishop of Sherbourne, mentioned the embroidery and tapestry weaving done by English women in a poem. Until the height of the medieval period, embroidery was considered to be women's work.[57] During excavations of settlements and female burials of the period, loom weights and iron spindles have been found, an indication of its widespread importance. Spinning was also women's work and, except for high-ranking women, was a common occupation. While men were the primary embroiderers in medieval guilds, women of privilege, who had access to fine materials and leisure time, continued to create elaborate embroideries for use in a domestic setting.

While most embroideries from this period featured vegetal and geometric patterns, and occasionally figural images from Biblical and mythological sources, several are known to have featured images of war. A century before the creation of the Bayeux Tapestry, women were recording the deeds of men in battle in their embroidery. The Anglo Saxon noblewoman Ælflæd, wife of Byrhnoth, Earldorman of Essex, did so in 991 when her husband was killed while repulsing a Viking attack at Malden in Essex in one of the bloodiest battles in English history.[58] She gave the textile hanging to Ely Cathedral, Byrhnoth's final resting place.

Although the embroidered tapestry no longer exists, evidence of its existence comes from the *Liber Eliensis,* or *Book of Ely,* a twelfth century English chronicle and history of the cathedral written in Latin.

In 1991, members of the millennium movement in Maldon used the book as a guide to honor the 1,000th anniversary of the Battle of Maldon by re-creating the tapestry. The tapestry was designed by Humphrey Spender, an artist and photographer, who created the sketches and cartoons for the scenes to be depicted on the tapestry. He was assisted by Andrew Fawcett, Lee Cash who selected the colors and threads used for the piece, and Sheila Allen as well as eighty-six embroiderers from the Women's Institute and Crafts Association of Essex County. Working in a seventeenth century farmhouse, the re-creation took the women embroiderers more than three years to complete. Its seven panels combine to an overall length of forty-three feet and a width of twenty-six inches and feature scenes of the town's history, beginning with the 991 CE battle and continuing to modern times.[59] In addition to scenes from the original battle, images of military airplanes, trains, cars, ships, local flora and fauna, and famous townspeople are included in the piece, which is signed by all of the women who worked on the embroidery.

The Bayeux Tapestry

Despite its name, the Bayeux Tapestry is not a woven tapestry but an embroidered wall hanging that was made in England in the years following the Norman Conquest of 1066. In its 232 feet it depicts a series of continuous scenes that flow from left to right, and tell the story of the conflict between Harold, the Earl of Wessex and William, the Duke of Normandy. The continuous narrative concludes with the Battle of Hastings in 1066. It is not just a beautiful wall hanging but documentation of an historical event, including scenes of events not recorded elsewhere.

The Bayeux Tapestry continues a long tradition of women recording the impacts of war on their lives or their community or of telling the story of the war or a battle. In some cases, the woman herself has created the design of the work she will create, and it tells a very personal story. In other cases, the story affects an entire region or country, and there is a desire to create an historical record. As Howard Bloch has noted, the Bayeux Tapestry is a weaving together of the disparate cultures on both sides of the English Channel after the trauma of 1066, a treaty of peace, a social contract in written and visual form between the warring parties of a great territorial dispute.[60] It is not known who actually created the tapestry, although it may have been designed by men and embroidered by women. It is known that during the conflicts of the time, many noble women took refuge in the Wessex nunneries, including Harold's sister, the queen and one of his daughters.[61] It is most likely that all of these women, and also the nuns, would have been taught embroidery as women were at the time and been fully capable of producing work such as that seen in the Bayeux Tapestry.

The working conditions for the embroiderers who created the tapestry would have been less than optimal; the candlelight used for illumination would have been accompanied by smoke and other scents that accumulated in the room. The room itself would have had small, high windows which were often covered with wooden slats to keep out the elements. The women would have sat on cushioned wooden benches at tables that were boards resting

on trestles. They would have worked on long frames which held their work, which also likely rested on trestles. Their embroidery was done on linen which had been prepared and spun from plants which grew in the area at the time. The embroidery was worked on this linen ground with wool in laid and couched work, and chain, stem and split stitches. This type of work is also featured in Scandinavian and Icelandic wall hangings of the 14th to 16th centuries.[62] Because of its tremendous length, the ground fabric is not one continuous length of fabric; rather, it is pieced together in several sections. The seams used on the Bayeux Tapestry were clearly done by a group of expert needlewomen, for the joins are still strong and almost invisible a thousand years after it was created.[63]

The subject matter of the work includes the background events leading up to the Battle of Hastings as well as the battle itself. The narrative is divided into sections which include men and horses in various battle scenes, fighting to their deaths. Battle scenes depict fallen soldiers, crippled horses, soldiers stripping the dead of their armor and several decapitated bodies. The strong colors set against the plain background create a narrative that is clearly meant to record and tell the story of the event, not merely to serve as a decorative wall hanging. The beauty of the embroidery is not the point of the tapestry; rather, the needlework serves to tell the story in an early effort to preserve it for history. This section (C3) shows the Saxon cavalry under King Harold at the Battle of Hastings. Four mounted soldiers with lances in hand attack axe-carrying foot soldiers wearing chain mail. One foot soldier has fallen and one is in the process of falling. In the bottom border, several fallen soldiers lie under the feet of the horses, and one soldier has lost his head. The top border contains traditional motifs such as the vine and leaf pattern shown between pairs of sloping bars and the heraldic birds and lions in the larger sections between them. These were all popular depictions used in embroideries and weavings of the period. But it is the depictions of the men on horseback that draw the viewer's attention, with their grim expressions and the forward thrust of their attack. The embroiderers have captured the drama and emotion of such a battle throughout the entire embroidery through their inclusion of the smallest details.

In another example of "embroidered text," the Serbian poet Jefimija (1349-c. 1405 CE) used her embroidery skills to compose a praise-song to Duke Lazar after his death in the Battle of Kosovo in 1389. Lazar was a powerful ruler who attempted to unify the Serbians after the disintegration of the Nemanjic dynasty in 1373. While he had the support of the Church in his quest, the Serbian nobility did not support his reunification efforts. Lazar led an army which confronted a massive invading Ottoman army commanded by Sultan Murad I. Both Prince Lazar and Sultan Murad lost their lives in the battle, which while tactically inconclusive was devastating for the Serbs, who submitted to Ottoman rule in 1390. Jefimija, who had lived at the Duke's court, embroidered the song text onto a length of silk with golden thread which she intended for use as a shroud to be placed over the casket that contained the relics of St. Lazar. She became a nun after her own husband was killed in battle.[64]

During the medieval period, aristocratic English women continued to create elegant embroideries for domestic use. Heraldic imagery, including mythological animals, as well as florals and vegetal depictions were popular. During the Reformation, when many of the churches in England were closed by Henry VIII, much of the best English embroidery was destroyed. During the time of relative stability that followed, English embroidery became a more domestic occupation, seen as a suitable pastime for the ladies of the court. It was

especially popular in the court of Queen Elizabeth I (1533–1603).

Among those aristocrats who practiced embroidery was Mary, Queen of Scots, or Mary Stuart (1542–1587), a pivotal figure in British politics. The only surviving child of King James V of Scotland, she succeeded to the throne when she was six days old. Her life was full of political intrigue and unhappiness, including warfare. Her first husband died of an illness, her second marriage was unpopular and ended in murder and scandal, and her third marriage was even less popular, ending in forced abdication in favor of her infant son. She fled to England in 1568, hoping for help from her cousin, Elizabeth I. But the English queen had long been suspicious of Mary, fearing for her throne from

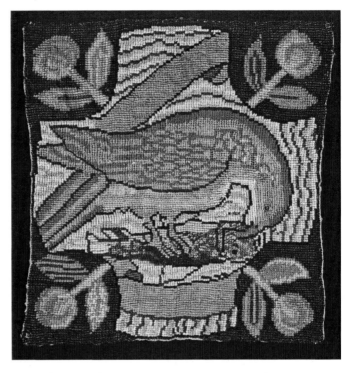

The Osprey, circa 1570, Mary, Queen of Scots, Elizabeth Talbot, Countess of Shrewsbury and members of her household. Linen canvas embroidered with gold, silver and silk in tent stitch (Victoria and Albert Museum London, V&A Images/The Art Archive at Art Resource, New York).

those who thought it belonged to Mary. So Mary was imprisoned in England for the next nineteen years, and was executed in 1587, only forty-four years old.

Mary created many embroideries between 1569 and 1585, during her imprisonment in England. Although the designs were copied from emblem books and natural histories, the motifs were chosen by Mary to express her private thoughts at a time when all of her written correspondence was being watched by her captors. She had help from women in her retinue who were professional embroiderers, as well as from Elizabeth (Bess) Talbot, Countess of Shrewsbury, whose husband was responsible for Mary. Many of her pieces had motifs which referred to political thoughts or commentary for specific people. One piece, called *The Hand and the Pruning Hook*, was originally sent by Mary to the Duke of Norfolk, with whom she had made wedding plans prior to her imprisonment. It seems to suggest that he would be better to choose the "fruitful" branch of the royal house, herself, as a wife, rather than Elizabeth, who was childless. Other designs comment on her previous husbands and her determination to survive and "rise from the ashes" of her imprisonment as does the phoenix which is featured on one of her pieces. In her embroidery *The Osprey,* a linen canvas embroidered with gold, silver and colored silk using tent stitch, Mary depicts this large bird of prey with a brown back and white markings. The bird may be her commentary on her captivity at the hands of Elizabeth, comparing her cousin to a predator. Although the bird is beautiful, it shows no mercy to its captive.

Mary sent many of her embroideries to family and friends, which was a fortunate decision that allowed them to survive. She also gave many items away the night before her execution. After her death, the English government ordered all of her possessions burned. One piece, preserved in the Victoria & Albert Museum in London, is a work known as the "Marian hanging," because the embroideries relate most directly to her. Originally believed to have been pillow covers, the current configuration is comprised of individual panels of stitching on coarsely woven linen, done in colored silk, silver and silver-gilt threads, which are mounted on green velvet. The central panel contains an inscription "Virtue flourishes by wounding" in Latin, as well as the royal coat of arms of Scotland and Mary's monogram, a reminder of her royal status. After Mary's death, the embroideries were given to Ann Dacre, Countess of Arundel, daughter-in-law of the Duke of Norfolk, who was executed in 1574 for his plot against Queen Elizabeth. It is thought that Ann Dacre's daughter-in-law put together the current arrangement of the wall-hanging. Passed down through that family's descendants, they were bought by the National Art Collections in 1955, and donated to the museum.[65]

The Overlord Embroidery

The English tradition of women creating embroideries that recorded the deeds of men in battle continued into the twentieth century. There have been two armed crossings of the English Channel since Roman times, and each has been recorded in embroidery. The first was the crossing by William of Normandy in 1066, commemorated in the Bayeux Tapestry. The second was a crossing in the opposite direction, from England to Normandy on June 6, 1944, commemorated in the Overlord Embroidery (C4). It is based on Operation Overlord, the code name for the planning and carrying out of the Allied forces landing on the coast of Normandy, France, during the Second World War. This second embroidery was commissioned in 1968 by Lord Dulverton of Batsford, England, to honor and record the efforts of the Allied forces to liberate Europe, as well as background events leading up to the invasion, including the London Blitz of September 1940 to May 1941. This detail, with its vivid colors, captures all of the drama and danger of the attack by the planes shown against the night sky and the resulting chaos in the streets of London. Fire and falling bodies are visible in the center section, while firefighters in the right corner hold a hose aimed upward toward a burning building. The diagonal composition and layered complexity of the scene give the viewer a feeling for the terror and destructiveness of the attacks and the impacts on the civilian population. The embroidery also contains detailed battle scenes and scenes of the capture of German soldiers. The embroidery traces the operation from the planning stages to the victory in thirty-four panels, each eight feet long and three feet high, totaling 272 feet in length, making it longer than the Bayeux Tapestry, which was its inspiration.

The Overlord Embroidery was designed and painted by Sandra Lawrence, using wartime photographs and the input of a specially formed Advisory Committee of three senior officers from the British Armed Forces to decide what should be included in the embroidery. She created thirty-four paintings for the design, each measuring eight feet long by three feet high. Once they were approved by the advisory committee, they were given to the embroiderers to use as a pattern for their work. The original paintings now hang in the Pentagon in Washington, D.C.[66]

The embroidery was created by twenty-five women from the Royal School of Needle-

work and took more than four years to complete. More than fifty different materials were used in the making of the embroidery, including fabrics taken from uniforms and headgear of soldiers from the three armed forces represented (army, navy and royal air force). In addition to images of British soldiers, the panels include images of both Canadian and American troops, as well as their aircraft and ships. The invasion of Normandy was a significant act of cooperation between the nations of the Allied forces, and the Allied Army consisted of one and a half million Americans and two million British, Canadians, and units representing the occupied countries of Europe.

The embroidery's panels were made by stitching pieces of cloth to a linen base stretched on a wooden frame. The image for each panel was traced from the cartoons and the outline was then perforated onto the linen base to form the background of the panel. Additional pieces of material were cut to shape, placed into position, sewn down and then finally edged with cord and embroidery thread. This technique is known as appliqué embroidery, and the technique gives a great level of detail to each panel.[67]

Unlike with the Bayeux Tapestry, the provenance of the Overlord Embroidery is well documented—the designers and the embroiderers are known, as are the details about how it was made. It is a fitting addition to the long tradition of women recording events with their needles and thread, using a medium that is easily read by everyone, and serves as a record, a teaching tool and a work of art.

Other Embroidery

On a much smaller scale, during World War I silk postcards and handkerchiefs were made by French and Belgian women, embroidered with different motifs onto silk strips which were then sent to factories for cutting and mounting on postcards. The postcards

Postcard, France, 1914–1915. Silk embroidery on gauze attached to embossed postcard. Postcard is 5½ in. by 3⅜ in., fabric measures 4½ in. by 2½ in. (collection of Deborah Deacon).

were bought as souvenirs by soldiers who were serving on the Western Front, including France and Belgium. Two kinds of cards were made, one a piece of embroidered silk mounted on a card, and the other had two pieces of silk sewn and mounted to form a pocket to contain a message. Some of the embroideries included war images such as battleships and the Allied flags, or the Imperial Japanese Army. The one shown here, which is the pocket type, features embroidered shields of Great Britain, France and the Russian Empire on the pocket, interspersed with a floral pattern in red, white and blue. Two four-leaf clovers are stitched beneath the pocket. The envelope contains a card which reads, "Forget me not" in italicized script. The card also contains an image of the flags of the allied nations and the phrase "Souvenir de la Guerre 1914–1915." This endeavor also provided a source of income for the women who were so greatly impacted by the war.[68]

A seamstress from Poland created embroidered panels, made over several years after World War II, to tell the story of her home which had been destroyed decades earlier during the Holocaust. Esther Nisenthal Krinitz had trained as a seamstress and dressmaker, and turned to embroidery to tell her story. The thirty-six panel series shows scenes from her life, including her large family being forced to leave their home for a concentration camp, scenes of Nazi soldiers and German military vehicles on the streets of her town, and people incarcerated in the camps, as well as a scene where she decided to present herself as a Catholic so she could work on a farm to avoid incarceration. Her little sister accompanied her in this deception after their mother ordered them to stay behind. That decision saved their lives. Sadly, they never saw their family again. Krinitz's daughters created the Art and Remembrance Foundation in her honor, which tours their mother's work around the United States.[69] Krintz's story is told in a book, *Memories of Survival*, and a documentary film, titled *Through the Eye of the Needle: The Art of Esther Nisenthal Krinitz,* both from the foundation.

While by the eighteenth century the role of men had increased in all aspects of professionally made textiles due to the rise of guilds, changing social norms and the amount of capital required to maintain high quality production, women continued to create embroidery for domestic use. Professional workshops had usually included both men and women embroiderers, but women continued to create embroidered textiles for use by themselves and their families. In many cases embroidery became a storytelling tool, duplicating the traditional artistic tools of paint and canvas, used to create records of events impacting women's lives.

Quilting

Quilting has long served as a medium for women's self-expression, used to embellish clothing and to create warm coverings. Styles, color usage and patterns are often unique to a particular place. One early quilted object is a linen carpet dating from the first century C.E., found in a Siberian cave tomb.[70] The central motifs were worked in a backstitch, the same stitch which was also used on spiral quilted slippers found in a rubbish bin in Samarkand, a major stop on the Silk Road. Quilting is believed to have originated in Asia sometime before the first century CE, and the discovery of these early quilted objects is indicative of the influence of trade and travel on the spread of needlework techniques among a variety of disparate cultures. Returning Crusaders have traditionally been credited with

bringing quilted items back from the Middle East, increasing the dispersal of the technique. A recent discovery from Germany uncovered a wool twill pall, a cloth spread over a tomb or casket, quilted with Egyptian cotton in a Merovingian tomb dating from the 5th century CE.[71]

One of the earliest uses of quilting was in the padded garments worn under armor. In addition to mail and plate armor, some European knights and men-at-arms wore armor made of fabric, many layered and heavily quilted body armor known as a gambeson (worn under mail and early plate armor), or a jupon (worn alone or over a mail shirt).[72] The men also wore quilted leggings and quilted garments of different lengths. Mail could not be comfortably worn without padded undergarments, and the quilting also provided cushioning against the weapons strikes taken by the wearer. This quilted body armor padding, which appeared in Germany, France, Italy and England was a professionally made garment, done in workshops where both men and women worked.

Quilting quickly became well established in Europe and soon began to appear in bedding and other household items. Production of white quilted furnishings existed in the Middle Ages throughout most of Europe, especially in France.[73] One of the earliest examples is the Tristan Quilt, made in Sicily, Italy circa 1360–1400 CE.[74] The imagery stitched in the quilt depicts episodes in the tale of the young knight in which he resolves a conflict between Mark, King of England, and Languis, King of Ireland. The story was part of a Norman narrative, a legend of imaginary warfare that appeared around 1150 CE and quickly spread across Europe, perhaps because it offered an example of knightly courage and diplomacy. The quilt borders depict the story in detail, from the arrival of Tristan at the court of Mark to the demand for tribute from Languis to Mark, the refusal and then the battle between Tristan and Languis' champion as the two fought to defend their kings. This imagined battle was a popular story across Europe and appeared in many textile furnishings of the time.

In Marseilles, professional needlewomen created "broderie de Marseilles," a form of three-dimensional textile sculpture using plain white cloth and white cotton cording, manipulated with needle and thread to reveal patterns highlighted by the resulting play of light and shadow on the textile surface.[75] The quilts focused on values contemporary to the time, including the Tristan legend, and heraldic devices and royal monograms.

Early documents reveal that members of French society with money, title or simply direct access to luxury goods, owned bed quilts.[76] Inventories of royal households often list quilts as valued objects. Kings had their own *courtepointiers* (quilt makers), and *tapissiers* (tapestry makers), who created bedcovers and wall hangings, many of whom were women, including Denise, a *tapissier du roi* to King Philip V (1292/3–1322), the preeminent ruler of the House of Capet.[77] Paintings of this period also offer evidence of the continued use of quilting in women's clothing, and of the presence of quilts as part of household furnishings.

Throughout the centuries, quilting was used for domestic purposes and quilted bedcoverings were intended both for beauty and function. Although many early forms of embroidery, including quilting, were created in convents or by those in a king's employ, secular workshops, employing both men and women, existed from 1000 CE and became increasingly important as towns grew, the guild system became established, and international trade developed. But there were differences between the quilts created for kings and the upper classes and those made for other members of society. And in some countries amateur seamstresses developed their own quilting styles. By the nineteenth century growing

numbers of middle class women were quilting, knitting and embroidering as a hobby as well as creating useful items for themselves and their families. Women in Wales and northeast England developed a particularly strong quilting tradition during the nineteenth century and many examples of their quilts can be found in the Quilt Museum in York, England.[78] The technological and social changes of the nineteenth century helped continue this trend as the idea of self-expression in the items one sewed took hold and quilting became part of a larger trend toward using personal textile art to make a statement. As the textile arts became personal, it became more common for the maker to identify herself.

Wartime Quilting

A quilt can be made by one person or a group of seamstresses. There are certain quilt patterns, such as patchwork, that lend themselves to construction by a group, allowing for individual as well as a collective creativity. Materials used for quilt making can vary, but the patchwork quilt allows for the use of materials at hand, including scraps of leftover materials. Created between 1860 and 1880, the Kent Uniform Coverlet was made from small squares of multi-colored military uniform wool arranged in blocks surrounding a central circular medallion and smaller circles within squares. The coverlet, which is backed by tartan fabric and has a blue wool fringe around the edge, is in the collection of the Quilt Museum in York, England.[79]

A pair of wartime quilts, the Suffolk Puffs table coverlet, was made in Trottiscliffe, Kent, in southeast England during the Second World War, probably in an air raid shelter. Suffolk puffs are gathered circles of fabric, sometimes known as yo-yos. According to the Quilt Association, a volunteer group which established a quilting center in Mid Wales and owns the quilt, the puffs were very popular during the early years of the twentieth century and are named for the Suffolk sheep whose wool was often used to stuff them. The puffs were ideal for using up small scraps of fabric or recycling old clothes, and could be made by children or beginning patch workers.[80] This type of construction is also easy to work in small blocks, and easily transported to and from an air raid shelter, providing the quilter with a welcome distraction during a stressful time.

A variety of war-related textiles have been created using the patchwork quilt pattern. One woman took the idea of patchwork and envisioned a colorful skirt, made from many pieces of cloth connected. Mies (Adrienne Minette) Boissevain-van Lennep (1896–1965) lived in Amsterdam until 1939. According to her family, she became involved in working with Jewish refugees as a resistance fighter and during the war even safeguarded Jewish children from deportation at the hands of the Nazis. But the events of the war eventually caught up with Mies and her family; her two eldest sons were shot by the Nazis, and she, her husband and her two younger sons were sent to concentration camps where her husband died. Mies was evacuated to Sweden in 1945 and eventually returned to Amsterdam. While interned in the concentration camp, she had experienced the solidarity among fellow women prisoners and wanted to express this feeling in her skirts, known as the National Commemorative Skirt or *Nationale Feestrok*. Each skirt was made from many pieces of cloth, embroidered with the women's names and other pertinent information from their life and experiences. The concept was derived from the slogans "unity in multiplicity, new from old, construction from destruction" and "unified in uniform." Her goal was for each woman to make a unique

skirt and for them all to wear their skirts on national commemoration days. Mies travelled around the Netherlands to promote the idea, and ultimately some 4000 skirts were registered with the *Nationaal Instituut* (now known as the International Information Center and Archives for the Women's Movement).[81] It is believed that more than 4000 skirts were actually made between 1945 and 1950, because on September 2, 1948, thousands of women participated in a "skirt parade" in Amsterdam to mark the Golden Jubilee of Queen Wilhelmina's coronation. In 1994, an exhibition dedicated to Boissevain-van Lennep's life, titled *Present, Past, Cheerfully Born,* opened in Gouda and in 1995, her skirt was presented to the Rijksmuseum in Amsterdam.

The Changi Quilts

When Singapore fell to the Japanese on February 15, 1942, thousands of Allied troops who had either been part of the Singapore garrison or who had retreated down the Malay Peninsula in the face of the Japanese advance surrendered to the Japanese. The Japanese were totally unprepared to house so many prisoners, and used many of them as slave labor. Also interned in Singapore were civilians who had not been able or had decided not to leave. Many women and children were evacuated from the city, but at the time of the surrender about 400 women and children remained in the region. Together with the civilian men, the women and children were crowded into Changi Prison, a building designed to hold about 600 inmates that was forced to accommodate about 2,400. There was a diverse group of women from a number of different countries; the British were the main group represented, along with the Netherlands, Australia, New Zealand, Canada and the United States.

During 1942, primarily between March and August, three signature patchwork quilts were made by the women interned in Changi Prison, which are often referred to as the British, Australian and Japanese quilts. The making of the quilts was seen as a way to alleviate boredom and provide a common activity, but the process was also used to pass information on to the men that the women and children were still alive. The original idea came from Ethel Mulvaney, a Canadian internee, whose previous experience with the Red Cross in Singapore led to her being chosen as the Red Cross representative in Changi. Her initial idea was that only the wives of soldiers should contribute to the quilt making effort, but as there weren't enough of them, all women prisoners were allowed to participate. Every woman who wanted to make an embroidered square was given a piece of plain white cotton and was asked to put her own stamp on her square. Many squares included messages but few women had husbands in the military camps to whom the messages could be passed. These women may have simply seen these quilts as patriotic and a way to pass their time.

One of the quilts, the Tenko quilt, was made in secrecy by eighteen Girl Guides as a present for their leaders. The hexagonal square that make up the six foot by three foot quilt were made from scraps of fabric scrounged by the girls around the camp—pillow cases, handkerchiefs, rags—over a two-year period. They unraveled worn out clothing for thread to sew the pieces together and backed it with calico flour bags. The names of the girls and their leader were embroidered on the quilt.[82]

The quilts were passed to hospitals in Changi and may have been seen by some of the prisoners being treated there. After the war, the Australian and Japanese quilts were eventually given to the Australian Red Cross and are in the possession of the Australian War Memorial.

The British quilt is housed at the headquarters of the British Red Cross at Guilford in Surrey, England.[83]

Contemporary Textiles

The role of women textile artists has changed from that of anonymous women working in workshops, convents and at home to that of artists who are known by name and reputation. Towards the end of the nineteenth century there was a move towards connecting design and the maker, partly in reaction to the mechanization and mass manufacture of textiles at that time. Social movements such as the Arts and Craft movement, which encouraged individual design and handwork, elevated the role of the maker. By the middle of the twentieth century, there was a movement against the idea of "bigger is better" in many aspects of life, including the creation of textiles, and support for the idea of the value of individually created hand-made items. This sentiment has continued and grown, expanding the idea of the maker as an artist, creating and communicating ideas through her creations, whether it be on canvas or the loom. The idea of what constitutes textile art has also expanded, continuing to include weaving, knitting and quilting, but also including many different types of "fiber art."

Magdalena Abakanowicz

Magdalena Abakanowicz was born to an aristocratic Polish-Russian family in 1930 on their estate in Poland. Nine years later World War II began, followed by the Soviet occupation of Poland, which lasted for forty-five years. These events influenced both her life and her art, and she has said she learned to "escape to her corner, to make the best of things, to use whatever was viable and even to make gigantic works in a tiny studio."[84] As an adult, under the Soviet system she and her husband were only allowed a one-room apartment, about 10 feet by 13 feet, which served both as their home and her studio. She painted watercolor canvases that could be rolled up since there was no room to store stretched canvas, and because there were no materials for sculpture available, she turned to fiber as a medium of expression. The first works she produced in fiber were cocoons, which were large enough for a person to walk into, made of ropes collected from along the docks of a nearby river. These were images of comfort and protection in a society that offered neither, but also a commentary on the size of the living space allotted to Abakanowicz and her husband by the Soviet regime.

Abakanowicz's earliest mature works are monumental, soft textile sculptures called Abakans, made primarily from burlap. She created several of these figures, up to eighty or more, and displayed them in groupings, as in *80 Backs* from 1978 to 1980, which featured eighty life-sized figures seated with their backs to the viewer, all exactly alike and anonymous, the same color and shape. These works are a direct commentary on the impact of war and occupation on the artist's life, an indication of the dire impacts of war on human individuality and humanity. The Soviet occupation created a continual war-like society in what had previously been a free country, with the result that the conquered people became anonymous, interchangeable objects. The entire body of Abakanowicz's work was directly shaped by the impacts of World War II on her country and herself.

Abakanowicz received acclaim at the First International Biennial of Tapestry in Lau-

sanne, Switzerland in 1962 for one of her Abakans, which was seen as a work that had changed the centuries-old craft of hand weaving from two dimensional tapestry to three-dimensional sculpture.[85] One of her most unusual works is titled *War Games,* a grouping of monumental structures composed of large tree trunks, their branches and bark removed. Partly bandaged with rags, the sculptures have a militaristic feel to them, and are often compared to artillery vehicles.

Rozanne Hawksley

Rozanne Hawksley was born in 1931 in Portsmouth, England, and now lives in Pembrokeshire, Wales. Portsmouth is a naval port, and Hawksley was a wartime evacuee during World War II at a time when many people she knew were mourning those lost at sea. Hawksley was profoundly influenced by her experiences as a child and one of the recurring themes in her work is the immorality of war and the abuse of power. During the 1950s she lived for several years in the United States and created designs for the Women's Home Industries, the post-war project created by Lady Reading. When she returned to Britain in the 1970s she took a textile course at Goldsmiths College and began using textiles and needlework as an art form.[86]

Hawksley did not become widely known until she was in her 50s and 60s, when she first began exhibiting. She held her first solo show at the age of seventy-eight. She creates composite assemblages, using materials she has found and collected over time. Gloves are recurring objects in her work, both lost gloves and found gloves, but a piece could also include ribbon, a doll, a ceramic hand holding playing cards, or a figure of a woman wearing a veil, her abdomen pierced with many arrows, as in *Our Lady of the Seven Sorrows* from 2000 to 2002. According to Mary Schoeser, this work references the vanitas style of painting associated with the Spanish Netherlands in the early part of the seventeenth century.[87] Vanitas paintings include symbols that are reminders of the futility and brevity of human life. *Glove on a Barbed Wire* is precisely what its title states—a glove perched on a piece of barbed wire. Hawkesley's piece *Veterans* is an installation of four small, ghostly, bloodstained figures clothed in soft gauze-like materials, the figures' mouths agape with pain. It is a vivid reminder of the high cost of war. Her *Pale Armistice* from 1991 takes the form of a funeral wreath created from assorted white gloves with plastic lilies and bleached bones attached. It was created in memory of Hawksley's grandmother, Alice, whose husband was killed during the First World War.

Both Abakanowicz and Hawksley were born shortly before World War II and their lives and their art have been greatly influenced by their experiences both during and immediately after the war. And both were practicing textile artists at a time of transition when their creations began to be recognized as art, worthy of exhibition and a place in art museum collections. They created their art as an expression of their experiences in wartime and their works reflect the ways in which the war affected their reaction and response to the world. It has continued to be relevant and to speak to others, imparting universal messages of war's impact on the lives of ordinary people.

There are many artists practicing today who continue to address the theme of war and its impacts through their art. The art of quilting has emerged in the past twenty-five years as an art form in its own right, a perfect medium for expressing ideas and opinions.[88] Sonja

Andrew, an English artist, created *The Ties That Bind II* in 2008, a triptych that reflects the consequences of her great-grandfather's Quaker beliefs during World War I and his imprisonment as a conscientious objector. The quilt is made from fabric that is digitally printed with actual images of her great-grandfather.

Liza Green, a Scottish textile artist, created *Tissue of Lies* in 2009. Her work is a metaphor for the rationale presented by Western governments as an excuse for invading Iraq in 2003. She used related newspaper clippings which were machine-stitched, distressed and treated to resemble camouflage. Another British textile artist, Jennifer Vickers, has created several war related quilts, including a memorial patchwork quilt honoring civilians killed since the beginning of the Iraq War. Her 2004 work *Yesterday's News* features newspaper clippings about the wars in Iraq and Afghanistan arranged in log cabin patterned squares.[89]

Artist Mirjam Pet-Jacobs of Waalre, The Netherlands, is considered to be one of the most innovative and important European textile artists working today. In her work, personal and emotional involvement is transformed into a more general, global level. Her images have metaphorical meanings. She describes her quilt *Think of the Mothers II-The Violence* as a social commentary on young women who are being trained as killers.[90] Her quilt includes photo transferred images of women in veils against a multi-fabric orange and red background, with the words "The Violence" at the bottom edge.

Charlotte Yde, a textile artist from Denmark, created a quilt titled *Dress Code Black (The Subversive Stitches)* in 2009 to comment on her love of democracy, individual freedom and freedom of speech. The quilt is also a testament to the idea that stitches seem subversive in the fine art world.[91] Using cotton, tulle and translucent organdy, figures of black-veiled women appear against a grey striped background, creating a commentary on the impact of the wars occurring in Iraq and Afghanistan on the lives of women in the region.

The art of the quilt is not the only medium where women textile artists have expressed the impact of war. Although tapestry-studio weaving remained an almost entirely male preserve until the mid-twentieth century, the spread of art education, the Art Fabric movement, the Lausanne Biennials and feminism have led to a situation where most woven tapestry practitioners today are women.[92] Tapestry artists today practice their art using new tools, including digital technology, but the concerns they express are timeless.

Ulrikka Mokdad, a Copenhagen-based tapestry weaver whose works have been exhibited in Denmark and abroad since 1997, bases much of her work on political imagery. She works in the classical tapestry techniques which are brought into the contemporary world through her themes and modern tools such as photographs. Her works normally express political opinions and she tries to tell stories in tapestry which she bases on sketches. One of her pieces, *Honour's Victim*, is based on the story of Ghazala Khan, a young woman of Pakistani descent who was killed by her elder brother in order to protect the family honor. Another piece, *Sans-papiers (Without papers)*, was inspired by a television program that showed the exploitation and abuse of illegal immigrants in Europe. Mokdad also says she was inspired by textile artist Hannah Ryggen, a Norwegian who wove tapestries against Nazism during the German occupation of the Second World War.[93] Both of these artists create works that make anti-war statements addressing the impacts of war on the lives of artists and others.

Hannah Ryggen (1894–1970) was born in Sweden but lived most of her life in Norway. A leftist pacifist trained as a painter, she was a self-taught weaver who has said, "I am a

painter, not a weaver; a painter whose tool is not the brush, but the loom."[94] She created tapestries dedicated to the executed German communist dissident Liselotte Herrmann and to the imprisoned left-wing humanist campaigner and Nobel Peace Prize winner Carl von Ossietzky, while her 1948 weaving *En Fri* was dedicated to workers. Many of her anti-war works addressed timely issues of the day including the invasion of Ethiopia by the Italians and the Vietnam War. For Ryggen, the practice of weaving offered a direct connection to her personal politics, both as domestic labor and as a medium for the expression of social dissent. Both Ryggen and Mokda have created beautiful works of art as past weavers did, but their medium is their way to express their views to the world, to make a statement, to connect and contribute to the modern world and its politics. These artists used their work to make anti-war, pro-peace statements on the world in the twentieth century.

European Textile Network

The European Textile Network (ETN) is a non-profit organization headquartered in Strasbourg, France, with a secretariat in Hanover, Germany. Informally the Network was set up in 1991 in Erfurt after the velvet revolution led to the fall of the Berlin Wall, eventually evolving into an international association modeled on Alsatian law in 1993 under the auspices of the Council of Europe as the Carrier Network for the European Textile Routes in the frame of the Council of Europe's Cultural Itineraries program. The group's goal is the development of European cooperation for the field of textile culture, the furtherance of East-West integration within all fields of ETN activities, and cooperation with non–European partners.

In 1999, a project under the guidance of the European Commission identified Textile Contact Points (TCPs), initially ten with plans to expand the number, which offered a virtual tour through the textile cultural landscape of a country's respective regions. European textile routes connect these points, and each Textile Contact Point provides information to the public both on its own regional textile network and other networks within the European Textile Routes. Geographic routes include Scandinavia, East Central Europe, West Central Europe, the Benelux countries, the British Isles, France, the Iberian Peninsula, the Italian Peninsula, South East Europe and East Europe (Non-European).

Members can include artists, crafts people and designers, as individuals or institutions, those who take care of cultural heritage (museums, etc.), and lecturers or institutions for education and research. The organization sponsors conferences and publications, which are intended to encourage the exchange of information and experiences among the membership. Their overall goal is to open up immobile cultural heritage by improving access to cultural goods and making the public more aware of their cultural heritage.[95] While in the past, trade and warfare has enabled and accelerated the spread of textiles and textile techniques across the continent, an established mechanism finally exists for the transmittal and sharing of ideas through peaceful, mutually beneficial means.

Two

The United States of America

While only one large-scale war has been fought on United States soil, the American Civil War of 1861–1865, American men and women have fought in wars around the globe beginning in the nineteenth century: the Spanish-American War, World War I, World War II, the Korean War, the Vietnam War, the First Gulf War (Operation Desert Storm), Operation Iraqi Freedom, and the wars in Iraq and Afghanistan. War and its impacts have long been a part of American life.

Prior to the twentieth century, Native Americans were involved in battles between tribes from their earliest times on the North American continent, and after the arrival of the Europeans began in the seventeenth century, they fought to preserve their homes and protect their people from the white settlers. As the native groups were conquered by American expansion across the country, they began to adapt their traditional textile patterns to include images of the American flag and cavalry soldiers into their designs. Beginning with the Spanish-American War of 1898, and as part of the regular ranks in World War I, Native Americans have fought alongside other Americans in every war in which the country has fought since.

From the earliest wars and battles, women have created textiles related to war, beginning with the garments to be worn into battle by men, and to commemorate their victories after the fighting ended. The former included such basic clothing as socks and knitted caps. But aside from creating much-needed utilitarian articles, women have also created textiles that serve as historical records, as inspirations in battle such as banners and flags, as commemorations and remembrances, and as expressions of the impacts of war on themselves and their families.

Native American women used materials they found at hand, such as hides, seeds, shells and bone to create shelter and clothing for their families. Later they adapted to new materials brought by the European settlers, such as glass beads and cotton and wool fabrics. European women brought traditional European textile skills to America, such as embroidery, quilt-making and knitting, which they used to create samplers, quilts, and garments for their families. As settlement moved westward across the continent, some of these skills were taught to Native American women by Christian missionaries. Settlers who moved to the southern United States and established farms and plantations that used African slaves to work for them also taught sewing skills to the female slaves.

From the initial colonization of the United States, a common language for women has been textiles, created both for utilitarian purposes and as a means of recording their feelings.

In modern times, beginning in the mid-nineteenth century, the creation of textiles by hand has resulted in their use mainly as a means of expression, as machine made textiles have become widely available and relatively inexpensive. But women have nonetheless chosen to continue to create textiles to tell their stories and the stories of their culture.

Native American Textiles

Indigenous people were creating textiles that expressed their culture, ideas and history long before Europeans crossed the Atlantic Ocean and landed on the North American continent. These native peoples used local materials to create clothing and housing, adding decorative elements to functional objects. Materials such as porcupine quills, feathers, seeds, teeth, sinew and shells embellished animal hides used to make tipis, shirts, leggings, moccasins, infant carriers and blankets. Buffalo and deer were abundant, along with the pelts of smaller animals, such as wolves and beaver, providing both fur and skins for clothing and domestic use. But in order to use these hides, the animals had to be hunted and skinned, and then prepared to adequate softness to make them pliable, using a variety of techniques, including smoking them. They were then cut and sewn with sinew, which they passed through a hole in the hide made with an awl.

For thousands of years Native American women have made beautiful and functional clothing for their families using these materials. Through their design skills they were also able to chronicle their history, creating items to be used to commemorate births, deaths, kinship, battles and esteem for members of their community. Clothing was made not only for function, but for ceremonial purposes, and as gifts. What a person wore could convey information about status, age, gender and role in society. Women also made clothing to be worn in battle, in dances prior to battle, and in ceremonies held after battle.

In Sioux society, the tradition of sewing predates non–Native migration and has been passed to women from generation to generation. The importance of sewing skills among the women is commented on by D. C. Poole in his account of everyday life among the Sioux. "The women are working and gossiping, always at a distance from the men ... the girls too small to carry burdens were playing with crude dolls or acquiring knowledge of the needle with dried sinews for thread."[1] The girls were being taught to use traditional materials at the time of his observations.

An example of Sioux workmanship can be seen in a woman's dress, which was made between 1900 and 1910, using hide, glass beads/beads and sinew, sewn with lazy/lane stitch. The dress, in the collection of the National Museum of the American Indian (NMAI), features American flags on the upper back on a field of medium blue beads which stretch from wrist to wrist. The blue field is edged with red and white beads, further emphasizing the colors of the American flag. Another full length dress, also in the collection of the National Museum of the American Indian, is sewn of cotton and wool cloth, and painted with battle scenes. It is similar in color to the dress made from hides, with the same shape but with less decoration. These two garments are evidence that women did not immediately switch to the Euro-American fabrics now available to them, but combined traditional and new materials or found occasion to use both. A vest in the collection of the National Museum of the American Indian, made around 1890, combined the use of hide with glass beads, sinew, por-

cupine quills, dye and metal cones. The decorations on this garment, which include figures and the name "Two Strike," as well as a figure of a horse on each side of the front, beneath a hand holding an American flag above. Similar images adorn the back of the garment.

A man's jacket in the collection of the Saint Louis Art Museum is also made of traditional materials, including hide, with beads for embellishment. This Western style jacket displays changes in clothing styles and women's artistic expression. The cut is more tailored and the geometric beadwork along the seams, collar, placket and hem imitate piping seen on military style jackets while reflecting Plains women's traditional geometric designs. The design includes pairs of crossed American flags down each side of the front. It is another expression of conquest and assimilation of portions of the dominant culture, the result of losses in battle by the Sioux. Rather than being able to create clothes to celebrate the warriors' successes, the clothing is an acknowledgment of the results of contact with Europeans.

Other examples of military style clothing adapted by Native Americans include gauntlet gloves (C3) which are modeled on those worn by members of the U.S. Cavalry. A pair of gauntlets in the collection of the Portland Art Museum is typical of the style, which typically measure approximately fifteen inches in length from fingertip to top of the long cuff, offering the wearer greater protection. This pair is made of brain tanned hide with a cotton lining, and the eight inch long cuffs are decorated with faceted glass bead flowers and leather fringe along the outside edge. They were made by women of the Yakama culture, who are part of the Plateau and Western Oregon tribes, circa 1900. This style of gloves was made by women of many Native American cultures at the turn of the twentieth century for the use by the men in their families, and not for sale to Euro-Americans.

War Shirts

War shirts were made to be worn by men after battle to commemorate their achievements in war. They were traditionally made of hides and decorated with beads, shells, quills and, in some cases, hair of both humans (scalp locks) and horses. They were considered prestigious articles of clothing and were worn with pride, signifying both prowess in battle and status as a member of the tribe. A man's jacket in the collection of the Saint Louis Art Museum shows the influence of Europeans and Anglo-Americans with its tailored cut and beadwork imitating the piping on military uniforms. Although war shirts had been worn for generations, the change in style demonstrates innovation in women's artistry. The piping on this jacket is beaded in the colors of the American flag, and small crossed flags decorate the jacket, which was made around 1890.

Two shirts in the collection of the National Museum of the American Indian were made earlier and in the more traditional, loose-fitting style that was based on the shape of the animal hide. Both of these shirts include the use of human hair in their composition. The earlier one was made in 1840 by a woman from the Pikune Blackfeet tribe, and the later one in 1860 by a Cheyenne woman. For many tribes the act of capturing human hair was an important act for young man, recognition of being a man.[2] Both garments were worn by conquering warriors, and neither shows the influence of assimilation or conquest. Both shirts include drawings of battle scenes on their surface; these representations were usually done by men, and were commonly found on these earlier shirts. They served as a record of a warrior's accomplishments in battle, and while the later shirts did not include such images, the pre-

dominance of flag imagery and the colors used in their creation serve as a record itself of the outcome of later, unsuccessful battles.

A non-military style object was also used to depict the exploits of the Minneconjou Sioux chief, White Swan. Made around 1880, and currently in the collection of the National Museum of the American Indian, this "possible bag" is made of hide and decorated with glass beads and metal cones which are sewn with thread and sinew. The design covering most of the rectangular shaped flap and bag depicts the chief on horseback, amid the tipis he is defending. There are several heads on sticks depicted in the blue background, as well as figures done in yellows, greys and reds. This object combines both utility and a historical record honoring an important member of the society.

Even a baby's cap in the National Museum of the American Indian's collection features crossed American flags on a white background, with red trim around the edges and red ties to fasten it. This 1900 Lakota Sioux design is also made of hide and is adorned with glass beads, a combination of old and new materials and serves as a visible acknowledgement of the tribe's subjugation at the hands of the United States government.

Materials

After the conquest of the Native Americans and their resettlement onto reservations, especially as white settlers moved west, Native American women were forced to use new materials and techniques in their textile creations. The abundant herds of buffalo disappeared, resulting in the loss of a traditional source of materials, as well as of food, especially for the Plains Indians. As trading posts were established, primarily for the fur trading business at first, they became providers of wool and cotton fabric, thread, needles and other supplies that could be used by the women to create clothing and household textiles. Often, skins and fur pelts were taken in trade for these items. Women adapted and used these new tools, continuing in their roles of seamstresses and creators of home comforts. But often the items they created reflected the European influences in styles such as frock coats, gauntlet gloves and men's shirts.

Flags

One of the roles women have traditionally been allowed to play during wartime is to create the garments and accoutrements that men take into battle. This has included sewing the flags and banners that serve as symbols, carried to identify the various participants in the conflicts. These symbols appear in art throughout the ages, including in Frans Hals' *Officers of the Haarlem Militia Company of Saint Adrian*, from 1627, where Hals painted a group portrait of members of a civic-guard organization, men in uniform with furled flags flying in the background. In the Eugene Delacroix painting *The Twenty-eighth of July: Liberty Leading the People*, from 1830, the figure of Liberty hoists aloft the tri-color flag of France against the stormy sky in her effort to motivate the troops to victory, while in Lady Elizabeth Butler's painting *The 28th Regiment at Quatre Bras*, from 1875, the regiment is depicted kneeling in a circular formation, under attack from all sides, with two British flags at their backs. According to Georgiana Harbeson, "Into these emblems have gone the thought and

purpose of countless women who have stitched each part and portion, worked the mottoes and legends, helped in their designs so that the symbols reflect a truly inspiring meaning."[3] These symbols were a necessary means of identification and communication prior to the availability of modern technology. The various types of flags women made include standards, which are military flags used by mounted troops; colors which are flags used by infantry troops; ensigns which are flags of a nation flown from the stern of a ship; and jacks which are smaller flags flown from a ship's bow.[4]

In one of the earliest conflicts in the United States, the Revolutionary War, government records contain the names of women who were employed as flag makers during that period. These include Margaret Manny, Cornelia Bridges, Elizabeth Ross, Anne King, Anne Ward and Rebecca Ward, all from Philadelphia.[5] Although the name Betsy Ross is usually associated with flag-making in the United States, there were countless other women who were involved in sewing these banners in the colonies. During the early days of the country, there were various flags flown, including the flag of New England, made in 1686, the pre–Revolutionary Pine Tree Flag, and flags for New Hampshire, New York and the other colonies; it was not until 1777 that the standardized stars and stripes flag appeared throughout the colonies.[6] During the Revolution and early years of the young nation, there would have been an increased demand for flags throughout the colonies and a need for many seamstresses to sew them. Until the invention of the sewing machine in 1840, all work would have been done by hand, with a resulting demand for many workers, most of whom would have been women. Flags were made by seamstresses at the Schuylkill Arsenal, established by the government after the Revolutionary War.[7] This facility is considered the predecessor of the Philadelphia Quartermaster Depot, a storage and distribution center for Army clothing, textiles, and equipage. The Flag and Embroidery Sections were established at the Depot at the beginning of the twentieth century, but seamstresses were employed there from the earliest days. These seamstresses made flags during the Civil War and World Wars I and II, including brassards, chevrons, guidons and other heraldic items. They have never made commercial quantities of flags, but rather supplemented the flag making capacity for the nation when necessary.

Mary Young Pickersgill, a resident of Baltimore, Maryland, was a flag maker during the War of 1812. The flag she made became the inspiration for Francis Scott Key's poem that has become the national anthem of the United States.[8] Although Mary Young later in life married and became a successful businesswoman, she learned flag-making from her mother, Rebecca, who made flags during the Revolutionary War. Mary established a flag-making business in her home after the death of her husband and successfully supported herself and her family. In 1814, she was commissioned by Major George Armistead, commander of the forces at Fort Henry, to make a flag to fly over the Fort so that the British could see it from a distance. When the British attacked Baltimore, Francis Scott Key saw Mrs. Pickersgill's flag while he was held captive on a British ship and was inspired to compose his poem. Pickersgill was also a philanthropist who addressed issues affecting women and children and had a lasting impact on Maryland's families, including creating a home for the aged that survives today.

Individual women also made flags when the opportunity arose. Ann Elizabeth Adkins Bills, born in 1829, made Oregon's first American flag in 1861 after deciding one was needed. Her husband, Cincinnati Bills, founded Portland's first hauling company, and one of his employees approached Mrs. Bills about making a flag for the upcoming July 4 celebration.

He assisted her in obtaining the materials, including cutting down a young fir tree from which to make the staff for the flag. The flag flew for the first time on July 4 1861, and is now in the collection of The Oregon Historical Society.[9] It features thirteen stripes, for the original colonies, and thirty-four white stars on a blue background, for the states of the Union at the time. Mrs. Bills would later remember, "Flags were not easily secured in those days, but I saw one was badly needed here, so I went right to work to supply the want."[10]

During the Civil War, women continued to make flags for the troops on both sides of the conflict. As the South geared up for war, patriotic women sewed Confederate flags that would fly throughout the war, as well as state flags and flags for military units to carry into battle. These individual seamstresses were very important in the region which in many cases did not have the means to purchase all the supplies they needed. But these were dedicated women who produced flags such as the Kilcrease Light Artillery Presentation Flag, which included embroidery and appliqué techniques, and the appliqué cavalry banner for the St. John's Rangers, Company B, 2nd Florida Cavalry of the Confederate States of America, often using personal textiles in their work. The Kilcrease flag shows a blue cross on a white field, with a green embroidered garland that frames the company name, the date 1863, and the company motto "Dieu et Mon Droit" embroidered in gold on the obverse, and a Cross of St. Andrew on the reverse. The St. John's banner carried thirteen white stars representing the Confederate states, stitched using silk thread on red silk fabric. The North Carolina

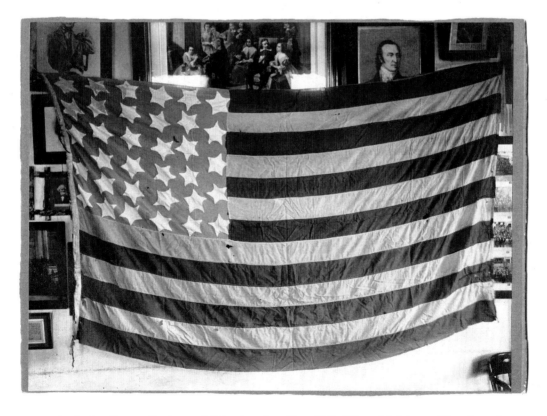

Ann Elizabeth Adkins Bills, Oregon's First American Flag, 1861. All wool delaine and French merino wool (The Oregon Historical Society, #bb010313).

Museum of History has more than one hundred Civil War-era flags in its collection, a significant number of which were handmade. Among them is the flag of the 12th Regiment, North Carolina, Cleveland Guards, and its own carrying box, made by the ladies of Shelby, North Carolina.[11]

Southern women were not the only ones to make flags to support the war effort. During the Civil War, sea captain William Driver, who was originally from Salem, Massachusetts, flew a Stars and Stripes standard at his home in Nashville, Tennessee. The twenty-four star flag was made by his mother and some young women from Salem in 1824 in honor of his captaincy of the Charles Doggett. He called the seventeen foot by ten foot banner "Old Glory," a term now applied to all American flags. The widowed Driver and his three children had settled in Nashville in 1837 at the end of his twenty year career as a merchant seaman. Prior to the war, he flew the flag on holidays on a rope from his attic window. In 1860, his second wife and daughters made repairs to the flag and added ten stars to the blue field. As the war began, the flag became a source of contention in the family divided between North and South. Local Confederate soldiers tried to remove the flag when Tennessee seceded from the Union, but Driver refused to give it up. Ultimately, the flag was sewn into a coverlet to hide it. Upon the liberation of Nashville, Driver gave it to General William "Bull" Nelson, who flew it from the flagpole at the statehouse. Shortly before the second battle for Nashville in December 1864, the original flag was replaced with a second handmade flag. One of the flags is in the collection of the National Museum of American History and the other is in the collection of the Peabody Essex Museum in Salem, Massachusetts.[12]

During World War I, a group of women worked together to make flags to support the troops of their adopted country. Born in Hungary, Galicia, Russia, Germany and Rumania, the women are shown sewing an American flag under the eyes of their flag-making instructor, Rose Radin. This photograph, in the collection of the National Archives, is part of the series "American Unofficial Collection of World War I Photographs, compiled 1917–1918."[13] This image is a potent symbolic representation of women from several nations who have come together to work on a joint project, one that signifies unity in their adopted country. While war was raging in their home countries, which they had fled to seek greater opportunity, late in life they were reaffirming their decisions to immigrate to America. They present a picture of patriotism during a time of war and chaos.

While many flags used during World War II were commercially produced, one handmade flag held a special significance for a number of Americans imprisoned by the Japanese in a prison of war camp in Baguio, Philippines. Despite the danger of being discovered by their captors, several women had worked together for several months to create the small symbol they used to bolster morale in the camp. On July 4, 1944, Ethel Herold wrote in her diary, "We women have slowly and lovingly buttonholed every star and sewed and re-sewed the seams just to be holding the flag.... Whatever becomes of this flag, it serves its purpose in here, by just being secretly looked at and dearly cherished."[14] When it became clear in December 1944 that the Americans would soon liberate the Philippines the Japanese moved their prisoners from Baguio to Bilibid prison in Manila. On the journey, Herold "hid in her bosom her few remaining items of value: family papers, money, jewelry, and the American flag that the women had secretly worked on."[15] As the Japanese evacuated Manila, the Baguio internees held up Ethel's flag and sang the national anthem and "God Bless America" to celebrate their liberation.

Samplers

Samplers are one of the needlework arts that provide a means for a woman to express herself in both words and pictures, and to create a record of a time and a place. Initially intended to showcase a woman's skills in creating many patterns and symbols, a sampler was a catalogue or "sample" of the stitches the seamstress could create. These elaborate patterns and symbols were used to adorn otherwise plain clothing and household items and were important evidence of a woman's worth as a wife. A knowledge of sewing was essential at the time in order for women to provide clothing for their families and linens for their homes. They eventually became, for some women, a work of art in themselves, and were used as pictures to embellish the walls of homes.

Many immigrant women brought a history of needlework to America from their homelands. The tradition of embroidery samplers dates is believed to the late fifteenth or early sixteenth century in Europe and the tradition was especially popular in England. In the colonies, samplers took hold in New England first and slowly spread south to the Middle Atlantic region over several decades. The trend was never as popular in the South.

In early America, sampler stitches were done with silk, linen, cotton, or wool thread,

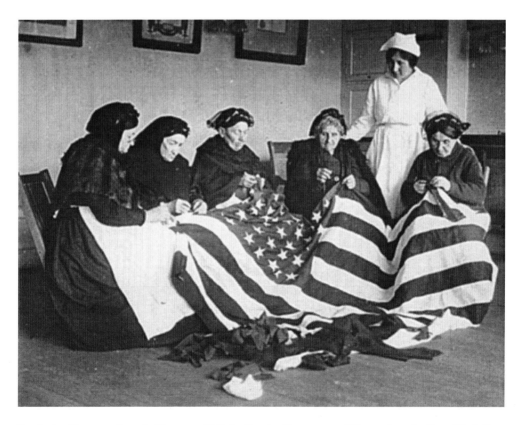

Patriotic old women born in Hungary, Galicia, Russia, Germany, and Rumania make flags. Their flag-making instructor, Ruth Radin, is standing. Underwood & Underwood, circa 1918. United States War Department. Part of Series: American Unofficial Collection of World War I (National Archives).

usually on a linen ground. Sometimes wool or muslin was used as the ground, and later canvas became popular. The intense desire of women of the period to do needlework, as well as the popularity of the activity, is reflected in the number of shops that were established to sell the supplies necessary for such work. These shops took out ads in newspapers and newsletters to advertise their wares, including one ad in *The Boston News Letter* on April 28, 1743, advertising "Shaded crewels, blue, red, and other colours of Worsteds."[16] Ads appeared in many other publications, and seem to have appeared regularly and widely.

The stitches used in samplers were often simple enough that they could be executed by a child, although experienced women usually worked more complex patterns. But sampler making was an art that lent itself to being taught to young girls, some only eight or nine years of age. The girls used a variety of stitches to create samplers many of which told a story through words and pictures. Samplers also provided a medium for affluent girls to practice their alphabet and spelling, while creating a permanent record of their skill and perseverance. The girls learned to make the samplers at school, often a neighborhood Dame school, similar to today's kindergartens, where the teachers were most often English women.[17] One of the first needlework schools in America belonged to Mistress Mary Turfrey, wife of the commander of Fort Mary, who advertised her courses in the Boston newspapers of 1706.[18] From this date until 1835, there were a number of schools located in several cities along the East Coast. Because so many girls learned their embroidery skills in these schools, the history of samplers also serves as a history of the education of girls in early America. Girls from less affluent families were taught needlework at home, but they nonetheless learned these skills which were essential for a young woman of the time.

The samplers created by the young girls usually recorded family births and deaths; sometimes they were illustrated with images of their homes, occasionally with an image reflecting larger events. In the 1770s, sensitive to political unrest within the colonies, many New England schoolmistresses echoed the defiance of the times by incorporating a new spirit of freedom into their work by creating more imaginative patterns for their students, resulting in the appearance of regional differences in their work.[19] These changes are reflected in a sampler created by Mary Canney in 1772, which incorporated figurative forms from the Boston area and added regional touches to the border design, moving away from the standard designs from England. This is an example of a teacher feeling the freedom to become more independent in the designs she taught her students and moving away from the "party line" of English design that such teachers had followed.[20] A small sampler reflecting the spirit of the times was cut in the form of a Liberty Bell, with a little ring at the top, done by Rocksalana Willes in 1783.[21] Although she embroidered only the alphabet onto the sampler, the shape of her canvas makes her work a statement of support of the newly formed country.

One symbol that began to appear occasionally in the young women's work was the American eagle. Although relatively rare, samplers with this national symbol are highly prized today. In a sampler created in 1825, inscribed "Elizabeth Wiert Aged 80 died 1825 Margaret Moss Aged 11 1825," the image of the eagle appears as an important figure. The central image is a large, three story home surrounded by trees and a large lawn or field. Included is a shepherd with a flock of sheep, cows, ducks, a beehive, children playing, and a man and a woman strolling along a lane. Above the house is a large eagle with a banner reading *E Pluribus Unum*, flanked by two cartouches with inscriptions. It would appear the pastoral setting is under the protection of the eagle, a symbol of the relatively new country.

This sampler, from the collection of the Cooper Hewitt National Design Museum, is done in silk embroidery on a linen foundation, and it is embroidered using satin, cross, stem, chain, and buttonhole stitches on a plain weave foundation. Assuming it was made by Miss Moss, it is a fine example of her needlework skills. She captures both her family life and her patriotic feelings for her country in the scene she has created.

Another sampler with a patriotic image of an eagle, done in the same time period, was created by Matilda Filbert of Berks County, Pennsylvania, in 1830.[22] Miss Filbert was twelve years old when she created this silk and silk chenille embroidery on a linen ground, which measures twenty-two and three quarters inches by seventeen inches. The figures and symbols cover almost the entire background, with a flower and vine motif along the entire edge of the linen. The Goddess of Youth is featured on the left half of the piece, standing below a willow tree near a brick building and other trees. The American eagle is shown with wings spread in the top half of the frame, with stars and hearts overhead. The sampler design was based on an engraving by Edward Savage of Philadelphia, dated June 1796.

A mourning sampler done by Barbara A. Baner of Harrisburg, Pennsylvania, in 1812 may have been a mourning piece intended to commemorate a war casualty.[23] These types of samplers became popular in the early nineteenth century. Mourning samplers typically included depictions of willow trees shading burial monuments or funeral urns, crying figures, and names of and tributes to the dead. Earlier mourning samplers honored Revolutionary War heroes or the founding fathers. Miss Baner's piece included all of the typical imagery, including a seated female figure under a willow tree holding a lidded urn. The butterfly in the sky often symbolized immortality. The design features a central square block, surrounded by smaller blocks framing the eighteen and one half inch by seventeen and three quarter inch fabric. Baner was nineteen years old at the time she created the sampler, old enough to have known a soldier, whether he was a relative or a friend.

Another example of a sampler honoring a Revolutionary War hero is found in the collection of the Peabody Essex Museum. It commemorates the death of Major Anthony Morse and is done in silk embroidery on satin. It features a central tombstone embellished with a large painted angel who points to the heavens and is inscribed with painted letters which read "Sacred to the Memory of Majr. Anthony Morse OBIT March 22D 1803 AE 49."[24] The design also includes a young woman kneeling beside an urn on the tomb, against the stitching of the willow tree in the background.

Although there were very few samplers with patriotic imagery, some contained verses which pertained to war and patriotism which were often illustrated with images. It was not uncommon to include short lines of verse on a sampler, and many verses pertained to virtues to be practiced or other religious principles to which the maker aspired. But patriotic themes began to appear around 1770.[25] Some supported the Revolutionary War, with subjects such as "Love of Liberty," and General Washington. One woman's sentiments were captured by her title "Lines on Peace by an English Lady," and another's in "On War." Later, after Washington's death in 1799, he became a popular subject for embroiderers, as can be seen in one sampler with a verse titled "On the Death of General George Washington Who Died December 14, 1799."[26] This direct documentation of their opinions left no doubt of a woman's attitude toward war. It was not left open to interpretation, but stated clearly in a lasting sampler of their own creation.

Another sampler featuring these patriotic symbols, the American eagle, George Wash-

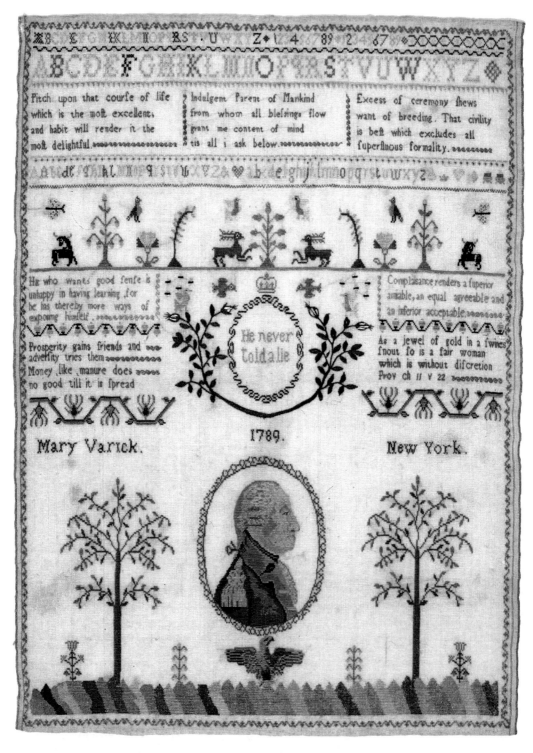

Mary Varick, George Washington Sampler, 19th century. Silk and linen (Museum of the City of New York/The Art Archive at Art Resource, New York).

ington, and verse, is in the collection of the Museum of the City of New York. Embroidered by Mary Varick of New York in 1789, an image of George Washington is featured prominently in the lower half of the piece. He is shown in profile in an oval frame, sitting atop a small figure of an eagle with wings spread. Above the image of Washington are the words "He never told a lie," also in an oval frame. Sitting atop that frame is a small crown, perhaps signifying the seamstress' opinion as to Washington's role in American government. The remainder of the sampler includes verses arranged in sections of the upper half, describing specific virtues that Miss Varick wanted to extol. She has also included the alphabet twice across the width of the sampler, a traditional exercise found on many samplers. There are small figures of animals and vegetation, expertly done with great detail throughout the sophisticated composition. Her primary focus, however, is on George Washington, an admirable man and possessor of the virtues that made him a worthy military and civilian leader.

A unique early sampler that is very rare was created by a Native American girl, Nancy Graves (Ku-TO-Yi), born in 1817, who created her sampler at the Cherokee Mission in Dwight, Arkansas, in 1828.[27] She attended the school from 1826 to 1829. The piece is fourteen inches square, done in silk thread on linen. It contains an inscription admonishing western girls to view the sampler and learn, and includes quotes from the Bible. This needlework was taught to the girls by missionary schoolmistresses in a short-lived attempt to provide an education similar to that given to wealthy young women in the East. By 1829 the schools were forced to close, and the Native Americans were forced to move to Oklahoma. But this surviving artifact from that time is a reminder of the impacts of war on the native people and the inappropriate attempts to assimilate the children into the larger culture.

Twentieth-Century Samplers

Samplers again came into fashion in the early twentieth century as part of the colonial revival movement popular during the period.[28] By World War I, their purpose had changed. They were no longer used to display a woman's needlework skills and were now used decoratively in the home. But by the First World War they were also used to promote causes, in the same way that posters of the period were. Some were displayed in public exhibitions or sold to raise money for various charities. Others were created to honor war heroes or support war related events. But in many cases they fulfilled the traditional use of expressing the maker's opinions about the war.

Lillian Gary Taylor created three commemorative samplers between 1914 and 1917 that feature lists of the nations involved in the war and of significant events that occurred during World War I.[29] She also included her own commentary on the events, and her choice of what to include is evidence of her opinions about the war. Her first sampler includes a Bible quotation at the top and down each side and features guns pointed at the list of nations affected by World War I and the word "humanity" embroidered at the bottom. Her second sampler also includes a verse from the Bible, a list of the nations involved in the conflict, and commentary concerning the outstanding events and battles of 1916. The third sampler includes images of soldiers and General John Pershing, representing the role America played in the war. It also lists the battles fought during 1917, the first year of America's involvement, and the fates of the rulers of the nations involved. In only three cloth samplers Ms. Taylor has

written her own history of the American involvement in the war, and created a permanent record of its impacts.

Mary Saltonstall Parker (1856–1920) also designed and made samplers that expressed her thoughts about World War I. As a young woman, Parker had received training in art needlework, and throughout her life she created samplers, designing and producing at least one sampler each year beginning round 1907.[30] Three of her samplers dealt with World War I and its effects on her family. Her first sampler was begun in 1914, prior to American involvement in the war, and is a synopsis of the situation around the world at that time. It includes symbols for each of the European nations involved in the conflict and a display of the instruments of war, including planes, ships and soldiers. The bottom register of the piece shows the women at home waiting for the war to end. Her second sampler records the names of her sons and her father, who served in the navy in 1842, as well as images of the war. Again it refers to the women waiting at home, obviously a subject with which she was familiar. In this sampler she also used images from the Bayeux Tapestry that recorded the Norman conquest of England, specifically the large sailing ship. Parker thus links her work and themes to the themes that have concerned women from the earliest times as they endured the impacts of war on their lives.

Quilts

Quilt making has been referred to as the "democratic art" by Robert Shaw in his comprehensive book *American Quilts: The Democratic Art, 1780–2007*.[31] Quilt making was adopted early by American women and has been a form of art-making and self-expression throughout the country's two hundred plus year history. From the earliest European settlers to indigenous Native American women and then later contemporary seamstresses of all backgrounds, women have used cloth and thread to record the events and images of their lives and times. These fabric bedcoverings and wall hangings have transitioned from family linens to works of art in modern times. But they have remained a constant means of expression for their creators, and have consistently been used to express patriotism and opinions on war and peace for women.

Prior to 1750, quilt making, like the making of clothing, was a necessity and girls were taught to sew at an early age, in their homes.[32] As previously noted, sewing was part of their education; quilt making was also part of this education in many of the American colonies. The most common type of quilt construction was the pieced quilt, which allowed the use of scraps of fabric left over from dress making or from old clothes. The motifs on these pieced quilts were done in multi-colored geometric shapes, and the variety of patterns that could be created was endless. The earliest American quilt patterns came from Europe with the colonists, but before long colonial women developed their own designs, the result of cultural contacts among immigrants and with natives and slaves.[33] And contrary to myth and popular belief, the earliest American quilts were not homespun necessities, created from frugally hoarded scraps of clothing and other salvaged fabric by hardworking settlers, but were elegant decorative bedcovers crafted by upper-class women.[34] The fabric needed for the quilts was expensive and had to be imported from England as cotton was not yet available in the colonies. Making a quilt was time consuming and only those with household help had

time for such an endeavor. Sometimes a quilt was actually made over a long period of time, and many times the quilt was only made for a special occasion, such as a wedding or anniversary. One of the iconic American images is of the quilting bee, where a group of women gathered around a quilt spread on a frame, all with needle in hand, working on finishing it. According to Shaw, relatively few quilts were actually created at bees; the vast majority of surviving pieced and appliquéd quilts were constructed and finished by an individual woman.[35] But the bees were common social activities, and provided a place for women to get together and socialize, especially in rural areas. There were occasions when women sewed quilts as a group, usually in church sewing circles, to make a quilt for a joint cause or for a local event. These were sometimes fund raising activities to support troops in wartime.

Beginning with the Revolutionary War, patriotic imagery has appeared on quilts and bed coverings created by American women. These themes appeared more often during times of conflict, especially during wartime. For example, quilts featuring the American eagle enjoyed wide popularity from the late 1780s until the 1840s and then declined, only to be revived again during the Civil War.[36] Other popular themes during these times were the American flag, and images of U.S. presidents. Sometimes patriotic slogans were included in the design.

There are several examples of patriotic American quilts in the collection of the National

Quilt: *Unequal Nine Patch*, **unknown maker, circa 1840. Roller printed cotton fabrics. Hand quilted 70 in. by 77½ in. Gift of Sina Pearson (courtesy La Conner Quilt & Textile Museum).**

Museum of American History.[37] One of the earliest in the collection, the *Brown-Francis Family's Patriotic Quilt*, 1800–1820, was owned by members of this Canterbury, Connecticut, family and had been used in the family's eighteenth century homestead. The focus of the quilt design is an adaptation of the Great Seal of the United States, placed in the center block. An appliquéd eagle holding an arrow in one claw and a leafy sprig in the other dominates the block. Behind the eagle is a shield with fifteen stars that indicate the number of states in the Union from June 1, 1792, until June 1, 1796. The central design is set in a field of four and three-quarter inch blocks, alternately plain and pieced, in a nine-patch variation. The fabrics include thirty-eight roller-printed, plain colored and white cottons. By the 1840s, pieced quilts had begun to be the primary type of quilt construction as cotton became readily available and affordable. Shaw has noted that the pieced quilt was redefined through the development of block-style organization, an American innovation that opened up vast new realms of compositional possibilities.[38] The design of this quilt is an example of both of these facets of American quilt making. The focus of the design, the American eagle, has from the eighteenth century signified patriotism and sacrifice, which was recorded by the women in their quilts.

Another example of this type of patriotic quilt is in the collection of the La Conner Quilt and Textile Museum in Washington State. The *Unequal Nine Patch* was made circa 1840 by an unknown seamstress. It is made with hand-pieced blocks measuring eight and a half by nine and a quarter inches, set on point with alternate plain blocks of similar size. It is an early quilt using roller printed fabrics from the 1830s and 1840s, and the quilt blocks have printed fabric centers and corners, with solid white alternate patches. The alternate blocks and setting triangles create an image of an American eagle surrounded by floral sprays of pink roses, cream leaves and brown florals, which are surrounded by a brown path and additional floral sprays. The eagle holds a ribbon in its beak, printed with the words *E Pluribus Unum*. Its talons hold arrows and branches, marking it as the official seal of the United States.[39]

Mary C. Nelson of Saratoga County, New York, created an appliquéd quilt with an eagle as its central focus in 1846.[40] The American eagle is shown in silhouette against a background of twenty-eight stars, representing the number of states in the Union at the time, with the inclusion of Texas in 1845. The flag's appliquéd stars and eagle are made of discharge-and-roller-printed cottons. The blue, brown and white printed cotton used for the eagle gives the bird the effect of having feathers. The quilt's eight-inch border is composed of six stripes, two each of a red ground print, a blue and white, and plain white cotton, contributing to the patriotic theme. Mary Nelson's father served in the War of 1812, twelve years before her birth, and her quilt reflects her feelings of patriotism for her country, even though she lived in a time of peace.

Less than twenty years later, the peace was shattered by the beginning of the Civil War. In 1861, Mary Rockford Teter made a quilt for her son, a Union soldier from Indiana.[41] She based her pieced and appliquéd quilt on a design published in the July 1861 issue of *Peterson's Magazine*, a popular women's periodical published in Philadelphia. She personalized it by quilting the name of her son, George Teter, and the names of Generals Scott and Taylor under whom he served. Also found in the quilting are the names "Abe" and "Abe Lincoln," "General Lyon," the word "Cat" and the year "1861." There are thirty-four stars appliquéd in the center diamond, which is white on a blue background, and the same number appliquéd on the red and white striped border of this eighty-six by eighty-seven inch quilt. The stars represent the number of states in the Union from July 4, 1861, until July 4, 1863, the Civil War years. Mrs. Teter was from a family with a long history of service to her country; her

great-grandfather was Captain John Rockhold, who served during the War for Independence; her father was a captain during the War of 1812, and her son served during the Civil War. Her quilt is a historical document, for both her family and her country.

In 1863 Susannah Pullen guided her Sunday school class in Augusta, Maine, in the making of a pieced quilt, with the hope of providing a diversion for the wounded soldiers during their long days spent recovering in hospital, but also intended to "alleviate or prevent disease and lead to happiness and Heaven." The numerous inscriptions on this quilt provide an insight into the feelings and concerns of the period, and perhaps all war eras.[42] The fourteen young women in the Sunday school class contributed more than 150 inscriptions that were penned on the quilt's fifteen separate star-patterned blocks. The construction followed the guidelines set by the U.S. Sanitary Commission for bedding to be used during the Civil War.[43] The inscriptions included patriotic messages, as well as practical medical advice. Pullen included an inscription on the back of the quilt expressing her feelings about war: "The commencement of this war took place on Apr. 12th 1861. The first gun was fired from Fort Sumter. God speed the time when we can tell when, and where, the last gun was fired; & 'we shall have war no more.'"[44]

In the 1940s, Welthea B. Thoday used the same idea of creating a collaborative quilt by sending squares of white cotton fabric to friends, family members and coworkers and asked that each make a block for a World War II quilt.[45] More than two hundred years after the earliest American quilt makers, the idea of sewing fabric blocks together to create a quilt is still a way that women chose to record their reactions to war and the impacts that occurred in their lives, as well as their feelings of patriotism, using a durable example of their skills. Many of the blocks sent to Thoday contained significant dates and slogans that were popular during the period. Others depicted the Four Freedoms, American flags, and other iconic symbols. In a small booklet, "Record of World War II Historical Quilt," she identified and sketched each of the quilt squares and its significance as part of what came to be known as the World War II Friendship Quilt. The colors red, white and blue dominate the quilt, which was completed in the 1970s. Thoday made the central panel, copying the design from a three-cent postage stamp that was introduced on July 4, 1942. It depicts an American eagle with its wings outstretched to form a large "V" for victory, surrounded by thirteen stars, with a "Win the War" banner unfurled across the bird's breast. This iconic imagery is as easily readable to a viewer today as it was in the early nineteenth century. And the information included in each of the quilt blocks provides a vivid commentary on the impacts of war on each woman contributor's life.

The effects of World War II on women were also expressed in quilts made by women who immigrated to America after the war. In 2002, Minia Moszenberg created a quilt titled *We never said goodbye, separated April 1942.* The figural quilt is embellished with ink drawings, yarn, paper and paint on a grey ground as a tribute to family members murdered at the Chelmno death camp. The nineteen inch by fourteen in quilt tells the story of the family's apprehension by the Nazis. The scene shows a family of four wearing the yellow Stars of David required of all Jews under the Nazi regime, as well as a soldier with a skull for a head who confronts another Jewish woman. A swastika-bearing skull floats in the blue sky, an ominous sign of what was to come.[46]

In April 1986, the Museum of American Folk Art in New York City sponsored the Great American Quilt Festival.[47] The event's goal was to create a piece for the centennial

anniversary of the Statue of Liberty. It presented fifty-one finalists in a nationwide competition on the theme of "Liberty, Freedom and the Heritage of America." One of the quilts entered in this competition is in the permanent collection of the La Conner Quilt and Textile Museum.[48] The quilt, *Liberty in America* (C5), was made by Ruth Carol Coombes and measures seventy-two by seventy-two inches. Coombes used hand appliqué, machine piecing and hand quilting to create her quilt. The top is composed of parts of the Statue superimposed over an outline of the United States and includes a bit of Bedloe's Island, the base on which Liberty stands. Also included is Liberty's torch and book, inscribed JULY MDCCCLXXVI. Coombes has highlighted the expression in 0Liberty's face to great effect. The hand quilting emphasizes the individual pieces and echo quilting is used around the Hawaiian Islands and the mainland. The quilt's backing is done in a small scale print in black. The quilt show was designed to encourage a spirit of patriotism in both the participants and attendees, and the images in Combes' quilt emphasize the power of American ideals.

In 2003, American women again came together to create a quilt that documented the impacts of war on their lives. The hospital ship USS *Comfort* (T-AH 20) was deployed to the Persian Gulf to provide support during the American Operation Iraqi Freedom. One of the ship's personnel, Lieutenant Paula Godes, a physical therapist and avid quilter, decided to make a quilt to document the activities on board the ship. She was joined by Lieutenant Commander Patricia McKay, an orthopedic surgeon and quilter who brought her sewing machine along on the deployment. Other crew members joined the effort and began designing the quilt, culminating in thirty four blocks arranged into a twelve foot by eleven feet, six inch quilt. Quilting clubs from throughout the United States donated fabric, needles and thread. The design includes four flags which provide medical statistics from the deployment and document the nine purple hearts awarded on board. At the center is a photograph of the ship; the center block is surrounded by fourteen stars containing quotations from staff members. The activities of each department aboard the ship are documented in a separate quilt block. The blocks were put together on board the *Comfort*, but the finishing of the quilt was done by quilters from the Falls Church Quilt Unlimited Guild of Virginia. This quilt joined the efforts of women in the service and civilian women, of women at war and at home, and was done primarily by military women in support of their own war efforts. It represents the changing role of women in the unchanging face of war, recorded in the timeless medium of thread and fabric.[49]

Early Native American Quilts

As with women in all of the cultures who made quilts, Native Americans created objects that were unique to each woman, using needle and thread to express their own ideas and opinions. Native women had a long tradition of creating textiles such as tipis, bed coverings and clothing, using animal hides, sinew, quills, shells, seeds, and eventually, beads. Several factors came together to foster changes in materials and types of textiles the women created. The herds of buffalo that were the main source of hides for Plains Indians for centuries were gradually depleted after the arrival of the Europeans. As the Euro-Americans began to move westward across the continental United States, including many missionaries, they brought new examples of linens and clothing with them, and some pioneer women, especially the wives of missionaries begin to teach the Native women western sewing skills. This practice

became widespread in the nineteenth century with the establishment of mission schools, and the establishment of trading posts across the West provided a place to buy, or trade for, new materials, such as cloth, and supplies for sewing. According to C. Kurt Dewhurst and Marsha L. MacDowell, "Natives and non–Natives—quilters and quilt collectors, writers and scholars—have found quilting to have a significant role in Native life."[50] Because of their long history of textile production and their well-honed skills with needles and sewing, Native women quickly took to quilting. They created items for their own private use, and unlike the other crafts they produced, they did not make quilts for the marketplace, or for the tourist trade. Quilts appeared in many Native American homes, used for bed coverings and wall hangings for warmth, for blankets for individual adornment, and for gifts. There were also uniquely tribal uses for quilts that became widespread.

While they may have used patterns taught to them by Euro-Americans at first, gradually Native women began to create their own unique color combinations and designs. The star pattern, however, was the most commonly used, appearing regularly in Native American quilt design. According to Beatrice Medicine, a Lakota Sioux, "Seldom is a *star* quilt used as an ordinary bed covering in reservation homes; rather, *star* quilts are used in ways that distinguish their meaning and role within Lakota Sioux life."[51] The Lakota, along with many other Native cultures, have a long tradition of giveaways, a ceremony in which an individual or family honors others or celebrates a special occasion by actually giving away large quantities of food and gifts. Quilts have become a part of these traditional ceremonies, including one ceremony common to all Native Americans: the honoring of veterans of our nation's wars. The star quilts are the traditional design of these honoring quilts.[52] The star has become one of the most popular of all symbols in Native quilts, with its combined ties to the natural world and as a symbol of patriotism. The other image frequently used on honoring quilts is the American flag, another symbol of patriotism and pride.

A quilt that records the impacts of the history of war and conflict that affected her life was a pictorial quilt made by Rebecca Blackwater, a member of the Sioux who lived in Santee, Nebraska, around 1915. Blackwater was one of six Sioux women hired to help run the residence used by reservation superintendent Charles Eberle Burton. In the morning the women did housework and in the afternoon Mrs. Burton taught them to sew and quilt.[53] The quilt was a gift to Mrs. Burton, and includes many images that tell the story of the conflict between Native people and white men. This seventy inch by seventy-eight inch quilt has a black background, with brightly colored applique figures of Native Americans, animals and birds, and tipis and campfires, also.[54] Some figures carry guns and some are shown with bows and arrows, which could signify that they were hunting, but some obviously appear in war regalia and perform war dances. There is a tomahawk above a peace pipe in the upper left corner and the peace pipe above the tomahawk in the lower right corner of the quilt, symbolic representations of war and peace. The many figures are arranged in horizontal rows over the entire surface of the quilt. This is a rare surviving early pictorial quilt, and even rarer for the story that the quilter was able to convey which provided her perspective on the story of her people.

Hawaiian Quilts

A similar process occurred in the Hawaiian Islands, after their "discovery" by Captain James Cook in 1778, and the resulting influx of Europeans and eventually Americans involved

in whaling. These first visitors were followed by missionaries in the early nineteenth century, who taught the native Hawaiians reading, writing and sewing. Schools were established across the islands by the missionaries, and many of the missionaries had brought quilts with them to their new homes. Hawaiian women were exposed to new clothing and textile examples, and gradually began to make quilts in their own unique designs which use large radially symmetric applique patterns of stylized botanical designs in bold colors on a white background. The designs are made from a single cut on folded fabric and the quilting stitches normally follow the contours of the applique design. Once cotton became available, they replaced the old technique of making bed coverings, called *kapa moe,* from a paper-like material called *tapa* with the new material. The quilts were practical, decorative bed coverings in the mild climate and the women were making a distinctive new form of appliqué quilt by the 1870s.[55] During the period between the time the United States seized control of the islands in 1893, and their annexation in 1898, the Hawaiian kingdom flag was no longer permitted to be flown. As a result, Hawaiian women, including members of the royal family, began making flag quilts as a mark of their national pride and a memory of their freedom. The flag, done in red, white and blue, had also previously been used by the kingdom, protectorate, republic, and territory of Hawaii. It is the only U.S. state flag to feature the Union Jack Flag of the United Kingdom, a remnant of the period in Hawaiian history when the islands were under the influence of the British Empire. To this day, Native Hawaiian quilters include the Hawaiian flag on their quilts as an expression of loyalty and identification with Hawaii as an independent Native nation.

Early African American Quilts

There is no "typical" or uniquely African American quilt. African American women made quilts for the same reasons women have always made quilts: for bed coverings, for door and window coverings, or for special occasions. After coming to this country as slaves, they worked in households as well as in the fields, most likely learning sewing skills along with other domestic skills. There are stories and photographs of slaves assisting in the sewing of quilts for their mistresses, since this was a time-consuming task and sewing was traditionally a part of women's work at the time. If they made quilts for their own use, there are very few that survived. Poor women of all races have long made quilts from scraps of fabric out of necessity, and the resulting quilts were not necessarily different from each other. Since the quilt makers did not usually identify themselves, there is no way to know who made a particular quilt, or what her background was. African American women in the seventeenth, eighteenth and nineteenth centuries were often not in control of their own lives since they were usually slaves living in homes that were not their own. The items they made were probably intended for immediate use and not collected or stored as keepsakes. And as with many quilt makers, they may not have signed their quilts as they weren't considered works of art but items for everyday use.

But there are quilts made by African American women dating from after the Civil War that have reflected their on-going struggle for freedom and equality that continued into modern times. These quilts have often been preserved and handed down through families. The Michigan State University Museum has collected quilts created by African Americans who immigrated to the state during the nineteenth and early twentieth centuries. By this time, the Civil War had been over for more than thirty-five years and life had changed for many

African Americans. They had been declared freed for some time, had had time to establish homes of their own, and to begin to lead lives similar to those of other Americans. Mary Williams (1893–1979) of Kerrville, Tennessee, made a quilt in 1939 that she presented to her grandson and his wife as a wedding gift in 1969.[56] The quilt is titled *Donkey Quilt*, and was made from a pattern similar to one published in the *Kansas City Star* newspaper in 1931. This pattern was published in response to requests for a pattern representative of the Democratic Party, a way to express patriotism during the upcoming 1932 presidential election. Mary Williams could have chosen any pattern for her quilt but "voted" with her needle and thread, showing her pride as an African American voter. Her quilt is divided into four equal sections by blue fabric lines, with the image of a donkey in each quadrant. The background was probably originally red, but has since faded to pink. She kept the quilt for thirty years and then gave it to a family member, treating it as a treasured memento, not an everyday item.

Later, several African American women created quilts to document events that had transpired in the 1860s and 1870s in Michigan communities. Entitled *Old Settlers' Reunion*, the embroidered pictures and words pay tribute to black families who homesteaded the area in an earlier migration from the Southern states after obtaining their freedom after the Civil War. Deonna Todd Green and Ione Todd created the seventy-seven by seventy-six inch quilt in 1990, recording the impacts of the Civil War on the lives of these early settlers. They testify to the normal lives that were created, including a baseball team, a community church and school house, after the families left captivity in the South and were able to settle as any other pioneers had throughout the country.

A quilt honoring the history of African Americans and acknowledging their struggles for freedom is *View From the Mountain Top* from 1991, made by Beverly Ann White. This quilt was created as a didactic tool for younger generations, another example of a quilt that served as a text and the power of images to influence people's lives. The quilt features appliquéd and embroidered portraits of African Americans important to the struggle for freedom and equality, including Medgar Evers, Thurgood Marshall, Martin Luther King, Jr., Harriet Tubman, Frances H. W. Harper, Sojourner Truth, Mary McLeod Bethune, Frederick Douglass, Ralph Bunche, Booker T. Washington, and W. E. B. Dubois. These bust portrait images are arranged horizontally in rows on an orange background. The quilt provides a story and a record of the African American struggle for freedom and equality during and after the Civil War, and illustrates the change in status of quilts from household linens to art objects.

Another historical quilt in the collection of the museum is *Idlewild*, from 2000, also made by Deonna Todd Green. Idlewild is a resort located in rural northwestern Michigan and was one of the few places that allowed African Americans to vacation beginning from 1912 through the mid–1960s. It is also a year-round community that is still popular with vacationers and retirees. The quilt measures seventy-seven inches by seventy-six inches and is composed of twenty-five embroidered blocks with images of historical buildings and the portraits of famous residents and visitors. When the 1964 Civil Rights Act opened up other resorts to African Americans, Idlewild's boom days came to an end, but it remains historically significant as a reminder of earlier times in the lives of its visitors, and as a part of American history.

One of the later quilts in the collection was completed in 2008, and is titled *Yes We Can*, which became the slogan for Barack Obama's campaign for President of the United States that year. The quilt, made by Denyse Schmidt of Bridgeport, Connecticut, is fifty-six

inches by fifty-four inches, and has large blue and white letters on a red background repeating the phrase "Yes we can" over and over in horizontal rows covering the quilt. The phrase "Yes We Can" reflected African American enthusiasm for the idea that a Black man could become president of the most powerful country in the world, an affirmation that the struggles for civil rights had been worth the pain and suffering that had been endured. This quilt is a replica of the one that the artist made as a fundraiser for the campaign of Obama as part of the Obama Craft Project: Crafting for Change. The quilt is many things and the embodiment of the phrase "the medium is the message." It is a quilt, an object for fundraising, a text of the candidate's campaign slogan, an historical document of a significant moment in the nation's history, and a work of art. The quilt has come quite a distance from a utilitarian object for household use.

Knitting

One of the most traditional ways that American women have supported the troops during war time is by knitting, from socks to sweaters to caps—from the Revolutionary War to the current twenty-first century wars. Women through the ages have responded to these pleas for warm knitted clothing, anxious to provide some type of support, often providing an abundance of what was requested. Knitting is a link to home and more peaceful times, as well as a rewarding activity that produces meaningful results.

During the Revolutionary War, women responded to pleas from the soldiers to send socks. While commercially produced socks were available, they were expensive and in short supply in the colonies. American soldiers were woefully ill supplied during the American Revolution and socks were very important for the men, especially during the winter months at places like Valley Forge. Soldiers frequently wrote home asking their mothers, sisters and wives to send socks. One of the ways women of this era demonstrated their patriotism was by boycotting British goods by alleging that "none but homespun" would be worn and "spinning wheels and knitting needles would doom foreign manufacturers."[57] So knitting socks for the soldiers was done not only to provide warmth and comfort, but also to allow women to take a political position. While these women supported the soldiers through many other means, such as taking care of the homestead, sacrificing by doing without imported luxuries and sometimes necessities, and living without their family members, they were proactive in their support of the war effort through their sewing and knitting. They also established a tradition of "knitting bees," working in groups to spin and weave yarn for cloth and knitting, as well as making clothing for the troops. A side benefit was that this work allowed them to stay busy and productive while their men were away at war.

Almost a hundred years later, a similar plea was sent from men at war to women at home—"Send socks." During the Civil War women on both sides stepped up to fill a similar need. The soldiers always went through socks quickly, due to being on their feet so much, the lack of time and resources to wash their clothing, and the lack of opportunity and the means to replace them. Homemade socks were considered superior to manufactured ones, in both durability and comfort. They were also symbols of home and caring, a memory of what the men were fighting for. And for both women and men, they were a link to life before the war, and a symbol of hope for what would continue once the war was over.

The tradition of knitting for soldiers continued into the twentieth century and occurred on a large scale during World War I. When America entered the war in 1917, Mabel Boardman, the Red Cross Central Commission's only woman member, concluded that there were not enough supplies of warm clothing for the troops. She urged women to knit garments, or at least buy wool for those knitters who could not afford it.[58] Women responded in great numbers, producing millions of garments; former Civil War knitters joined in, and despite their advancing years, contributed over 600,000 knitted articles.[59] Women again knitted in groups, which they continued to do throughout the war, focusing on socks when wool became scarce towards the end of the war.

During World War II women played a larger role in the war itself, as military members who freed men for combat duty or as reporters and photographers covering the war. But those at home also contributed to the war effort, again knitting for the troops, and in such numbers that the government eventually officially encouraged them to knit, which they did throughout the war, both for the troops and for European refugees displaced by the war. In subsequent wars involving the United States, women continued to knit for the soldiers, but on a much smaller scale and as an individual effort rather than one supported by the government. In 2008, Marlys Anderson, who had a grandson who was stationed in Korea, knitted a wool watch cap to send to him. Because he liked the cap so much, he asked her to knit one for each member of his army unit. As word about the caps spread, demand increased, and to date more than 11,500 caps have been sent to troops deployed in Iraq and Afghanistan.[60] Other similar groups across the country have knit caps for active military members and blankets and lap afghans for wounded warriors.

In 2009, a U.S.-based non-governmental organization grassroots peace and social justice movement dedicated to ending U.S. funded wars, called CODEPINK, asked knitters to knit pink or dark green squares to help create a quilted sign intended to be hung on the fence of the White House in Washington, D.C., on Mother's Day as a form of protest against the wars in Iraq and Afghanistan. Knitters from across the globe, including the United Kingdom, France, Turkey and the Netherlands participated in the event.[61] The slogan "We will not raise our children to kill another mother's child" was spelled out in green squares on a pink background. Unable to hang the flag on the fence, they unfurled it in a park across the street and then marched it down Pennsylvania Avenue in front of the White House.

Beginning in the last half of the twentieth century, knitting became much more than a means of creating practical garments. Contemporary knitters began to use the medium to express their opinions, on war and politics, through knitting as an art form. The same has been true for other forms of what were once considered crafts, including quilting and weaving, as women took up needle and thread as tools to communicate their ideas and opinions on modern society. Textiles became part of the language and fabric of the contemporary world.

Contemporary Textiles

Textile artists in modern times are considered artists in the same sense painters and sculptors have always been, and their work is exhibited in museums and galleries across the country. But this change came about after a series of well-known movements in Western art, craft and design. According to Mary Schoeser, Britain, with its powerful textile industry

and the world's richest consumer market in the mid-nineteenth century, provided the first of these: the Arts and Crafts movement.[62] The movement's basic principle was that the fine and applied arts were equal in status. Along with the Central School of Arts and Crafts in London, founded in 1896, it helped to establish the idea of entrepreneurial and interdisciplinary textile practice in studios, schools and workshops. Because of the wide scale production of manufactured goods, a debate began about who should be responsible for design—the industry or the artists. While the manufactured goods were "designed" by architects for mass production, a backlash arose regarding the separation of design from the making of objects and a desire for "noble simplicity" and authenticity. This idea spread, along with the idea of preserving dying crafts and finding new applications for these skills, a core aspect of the Central School's program. Artist-designed textiles began to appear, in Britain and throughout Europe, and in the United States. Tapestry weaving underwent a similar transition, as the idea of individual creativity came to be prized in a dawning age of mass production.

But this change did not occur overnight. During World War II, American women entered the work force in great numbers to take on jobs as the men were away at war. After the war most women went back into the home, returning to traditional roles as homemakers and mothers. Some still practiced the sewing and other craft skills taught by their mothers, but women were also interested in appearing modern and in emerging new technology. The country was relatively prosperous compared to pre-war times, and knitted garments and quilts were primarily made by only those who needed them. In the 1960s women began to re-enter the work force in greater numbers and the rise of feminism led to their more direct contribution to contemporary culture. Women artists began to use various traditional media to express themselves, and some began to use textiles in new ways. An interest in quilts in particular was revitalized around the time of the American Bicentennial celebration in 1976. Crafts gradually began to have a different status as mixed media installations, soft sculpture, and fiber art became part of the standard practice of many fine artists, both women and men.

Contemporary American women fiber artists express their voice through their art, allowing textiles to serve as their language. Their work is no longer simply decorative but often demands an emotional response from the viewer. These women often express strong views on society and the events of their time, and their work illustrates the impact of war and other national tragedies on their lives.

Pam DeLuco

Pam DeLuco is a textile artist who has worked in weaving, knitting and crocheting, but now focuses on paper art and book arts. This has led her to typesetting, letterpress printing and book binding. She has worked as production coordinator for the Small Plates Book editions at the San Francisco Center for the Book, where she met Drew Cameron, a combat veteran, in 2007. Cameron had just turned his military uniform into pulp which was used to make paper, and described it as a cathartic experience, on one he believed would be to do healing for other veterans.[63] In March 2008, DeLuco joined Cameron and Drew Matott at Columbia College in Chicago to learn to make paper. Then she took part, along with eleven Iraq War veterans, in the first Combat Paper West Coast tour, teaching papermaking to other veterans.

In 2009 DeLuco flew to Burlington, Vermont, to work with Nathan J. Lewis, a combat papermaker who wanted to publish his writings. Using combat paper made from his own uniforms for the covers, they produced thirty copies of his collections of poems and essays. Combat paper is always made from veterans' uniforms, plus the addition of some abaca fiber (to counteract the polyester in the uniforms and help the hydrogen bond), American flag fragments, and whatever dollar bills people want to add to the mix. Each batch also contains some "lineage fiber," fiber pulped from a previous batch of combat paper. Blue paper is made with fibers from an Iraq War veteran's dress blues. DeLuco and Lewis formed the Combat Paper Press to publish his book, and have since expanded their efforts. Their second book was a collection of poems by Irish poet Greg Delanty, which had a cover of pale grey paper made at Arizona State University when John Risseeuw hosted the veterans on their first West Coast tour. It was his work with Cambodian mine victims that inspired the Combat Paper Project. These papermaking workshops where veterans use their service worn uniforms to create works of art allow the veterans to participate in the "transformative process of papermaking to reclaim their uniforms as art and express their experiences with the military.... Through ongoing participation in the papermaking process, we are broadening the traditional narrative surrounding the military experience and warfare. The work also generates a much-needed conversation between veterans and civilians regarding our collective responsibilities and shared understanding in war."[64]

A recent book published by the Combat Paper Press in 2012, for which DeLuco created the layout, titled *Life After War* contains eight original poems created by Jan Barry. The handmade cover is made from military uniforms worn in various conflicts including Vietnam, Afghanistan and Iraq. While DeLuco continues her involvement with the Combat Paper project, in her spare time she raises and tends bees, which provide the wax for her hand spun linen thread, or harvesting mulberry leaves to feed the silkworms which provide silk which she uses to make headbands for bound books.[65] She has found a unique way to help create a commentary about the impacts of war, and to help alleviate some of those impacts at the same time on those who have served, through the creation of textiles.

Cathy Erickson

Cathy Erickson has focused the body of her work on the impacts of World War II internment on Japanese Americans. In 2002 she began collaborating with poet Margaret Chula to create a series of quilts using Japanese-style fabrics, combining their works. Erickson, who has a master's degree in chemistry, began her artistic career by working in stained glass, but made her first quilt in 1996. She began to make art quilts in 2002, meeting Chula the same year.

They call their series of quilts *What Remains: Art Quilts and Poetry on Japanese Americans in Internment Camps*. According to Erickson, what began as two people, a poet and a quilter creating a single poem and quilt for the Visual Verse project by the Contemporary Quilt Art Association, has changed and grown.[66] Her eight inch by ten inch art quilt *A Girl's Lace Blouse* features the front upper left of a blouse, its upright collar stitched in white on a black background in an intricate pattern. The accompanying poem, *Shikata ga nai,* by Chula, tells the story of the blouse, worn by the daughter of an interned Japanese family after the war for the pinning of the Distinguish Service Cross awarded to her brother. Her

brother had joined the Army from the camp, and was killed in battle as a member of the 442nd Infantry Regiment, which was composed almost entirely of Japanese Americans. The unit fought in the European theater and is the most decorated infantry unit in the history of the U.S. Army. Chula's mother stood behind her as she received the medal for her brother, but was not allowed to receive her son's medal since she was an Issei, a Japan-born Japanese American who was considered to be loyal to Japan and therefore an enemy alien.

Another quilt and poem by the pair, titled *Voices from the Shoji (with detail)*, measures thirty-four inches by sixty inches and includes photographs in its pattern. The poem which is printed on the quilt states: "Observing our golden anniversary Marike and I limp across the threshold of Barracks 31-C." The only colors used in the quilt are black to outline the cream colored blocks which feature photographs from the subjects' lives, along with paragraphs from the poem alongside each photo. On the front side of the quilt is a large photograph of the married couple. Such quilts add personal stories to the historical record of the impacts of World War II on the lives of many Americans, preserving their stories and enriching our understanding of the impact of war on people's lives.

Dale Gottlieb

Dale Gottlieb is an artist who has worked in a number of different media, from painting and drawing to illustrating children's books, but it is in her work in textiles that she has chosen to use to express her ideas regarding war and peace. She was raised in Brooklyn in the 1950s and attended Brooklyn's Ethical Culture School through the eighth grade, where she received a solid foundation in ethics, philosophy and humanitarianism. Upon her graduation from the School of Art and Design at Alfred University in western New York, she began her career as an artist. After many years as a practicing artist, in the early 1990s she began to think about expanding her art making into another medium, forging a relationship with Lobsang Tenzing, a Tibetan Buddhist who lives and works with his family in Nepal.[67] He operates a carpet business and he and Gottlieb set up a collaborative process to produce the rugs she designed. In Bellingham, Washington, Gottlieb creates a gouache painting that serves as the rug design. She mixes her paints to match the color-coded yarn Lobsang uses and indicates on a digital scan of the painting the numbers of the corresponding yarn colors. She emails this design to Lobsang and his workers create a proportional grid from which they weave the rug, which she receives three months or so later. Gottlieb has said it has changed her work since the words and images make up the weave of the carpet itself, rather than siting on the surface, as in painting.[68]

An example of Gottlieb's work is *Tuskegee Airmen*, from 1995, which is an homage to the first Black pilots who fought in World War II, and her way of paying tribute to these men. The rug shows a portrait of a uniformed airman, from the waist up, seated at the controls of his aircraft. As is her style, he is shown at the extreme foreground of the composition, looking directly at the viewer. The title of the painting is woven across the top of the rectangular piece. The warm colors of the orange gloves and yellow collar on the aviator's jacket and headphones complement the cooler colors of the plane's interior. After completing the rug, Gottlieb learned that she had a personal connection to one of the Tuskegee airmen, since one was the father of her sister-in-law.

Other subjects for her rugs have included the words of Anne Frank and the Dalai Lama.

One rug features images of the buildings and trees of a World War II German concentration camp, as seen through the eyes of a child-prisoner. All of her rugs reflect the artist's desire to express her philosophy to the viewer, especially her desire for peace and connectedness, through her use of seemingly simple imagery, infused with color and warmth.

Katherine Knauer

Katherine Knauer purposefully designs quilts to express a certain viewpoint, especially on the subject of war. She has stated that she "believes the unexpected juxtaposition of a traditional craft associated with comfort and warmth and disquieting imagery brings an extra layer of energy to my work."[69] Knauer began making quilts in 1976, and in 1984 began printing her own fabric designs with stencils in order to achieve the exact results she wanted. She updated her technique of hand printing with Photoshop in 2009 when she began using an online fabric printing service. She creates her designs based on specific topics, often taken from current news headlines. She has said she continues to produce quilts rather than working in other media because she loves being part of a craft tradition, and feels a connection to seamstresses, weavers and knitters of previous generations.

Her quilts on the topic of war include an eighty-four inch by eighty-four inch square piece titled *Conventional Forces*, from 1984. The pattern is a Log Cabin variation, a traditional pattern which she adapted to accommodate textiles she designed and printed that feature images of "conventional" (non-nuclear) war. The centerpiece of this quilt is a large image of a Vietnam-era tank; other images on the quilt include paratroopers, a concentration camp, falling bombs, jungle fighters, hand grenades, tanks, aircraft and wounded soldiers. The reverse side of the quilt is a stenciled hand-grenade design that took three days to print. The colors of the quilt are primarily warm, soft earth tones, providing another contrast to the images depicted.

Another war-themed quilt was made by Knauer in 1991 titled *Desert Stormy Weather*, which measures seventy-eight inches by seventy-nine inches. This large piece has a narrow, five-pointed star in the center that reaches from top to bottom and side to side, delineating five sections on the quilt. Each section contains small stars and text primarily of terms taken from the Periodic Table or environmentally related terms such as "black rain." One section has two quotes, one from Dwight D. Eisenhower, "Every War Will Surprise You," and one from Napoleon, "War is the business of Barbarians." This quilt combines Knauer's war themes from her previous work with her latest Elements/Environmental series.

Because she has worked as a craft artist throughout her career, Knauer has said that stitching is her "native language." She uses this language to communicate her concerns, combining modern issues with traditional techniques used by women through the ages.

Penny Mateer

Penny Mateer, a Pittsburgh artist, produces protest art, by her own definition, using fabric and other media. Her background in theater and film arts provides her with the tools and experience for some of the pieces she creates. In 2007, she was inducted into the Quilter's Hall of Fame in Marion, Indiana, as an artist who creates non-traditional art using traditional materials. Of her Protest Series she says, "I am working on a series inspired by protest songs

of the sixties using a play of words from a title or phrase from a song. The events of recent years make me question what we have learned since then as I consider our involvement in Iraq, the real estate debacle, expansion of access to medical care and immigration questions."[70]

Part of this series is *Stand! (#8 Protest Series Part 2)*, which was part of the 2012 West-moreland Museum, Greensburg, Pennsylvania, Juried Biennial. This installation consists of fifty-two Styrofoam human heads covered in commercial fabric, decoupaged and appliquéd, then mounted on approximately four-foot poles which are also covered in fabric and arranged in a series of groups, mounted on flat wooden stars, painted red or blue. According to Mateer, "I started with the idea to cover the Styrofoam heads with stars and stripes and republican and democrat fabric."[71] The piece is based on the song "Stand!" by Sly and the Family Stone. The grouped heads make a strong visual impact, all in red, white and blue, all positioned almost at eye level, the human sized heads serving as a reminder of those who opposed the Vietnam War at the time the song was popular.

Mateer has made several quilts as part of this series, all based on other music of the '60s, including one titled *All We Were Saying #1 Protest Series*, from 2005, which measures twenty-nine inches by thirty inches. This quilt is machine pieced of commercial fabric, all in red, white or blue, which is then appliquéd and quilted. There are four figures in the center, with feet touching, spread in a circle, surrounded by planets. The quilt's title is taken from a song by John Lennon, which ends with the line "is give peace a chance." Another quilt in the series is titled *What's Goin' On? #7 Protest Series*, from 2010, which measures ninety-two inches by sixty-one inches, and features red, white and blue commercial fabric. The quilt is bordered by busts of the Statue of Liberty, and the words, embroidered in black at the top and bottom panels, "Give me your tired, your poor."

This series, Penny Mateer makes clear, is about protest, linking patriotic colors, the age-old art of quilting, and music from an era known for anti-war protest, to create a strong, emotional visual impact that has signifiers that are clearly understood by many people.

Claire Renaut

Claire Renaut is of French and German heritage and currently lives in Seattle, Washington. But on September 11, 2001, she lived in New York City, within sight of the World Trade Center. She witnessed the attacks on the Twin Towers, and volunteered in the efforts to save and treat the survivors. She also kept copies of all of the newspapers printed in the week that followed, and stored them in a box for the next ten years. During that time, she has said she felt the news they contained remained too raw to allow the papers to be thrown away or recycled, but Renaut finally found a way to use the newspapers to create her own memorial to the events of September 11 by creating a work of art. By shredding the papers into strips and using the newsprint fabric to knit a tapestry which featured distinct, two-dimensional silhouette views of the Twin Towers, she was able to transform the stories and images from the newspapers into something more positive. She learned the technique used in this project on a trip to Japan in 2005. Although the paper was brittle with age and difficult to work with, Renaut has said that "once knitted, the forms it produces seem to have a life of their own." She feels that the newsprint "has been transformed into something I can live with, I can look at and not feel the pain and sorrow."

In order to fund this project, which she called *9/11 Knit,* Renaut turned to

kickstarter.com, an on-line site created to unite artists and others with projects that require funding with those willing to provide the required money. She was able to raise the funds for her project in one month, and completed several related works for a show at Seattle's Gallery 110 in November 2011, in honor of the ten year anniversary of the attack on the Towers. Renaut was born in France, lives in the United States, studied art in Japan, and used the most modern technology to gather support for her project. As a woman artist she felt compelled to respond to the defining terrorist attack in her lifetime using the techniques many women before her had, both to assimilate and express the impacts of war on herself and her society.[72]

Whatever their material, women continue to use textiles to create objects to help them comprehend and respond to war, violence and terrorism. In earlier times, women made the garments and regalia that men wore into battle, showing their love and support for these warriors. They showed their own patriotism and loyalty to their cause through the flags they made for public display and the samplers and quilts they made for their homes, often using the same symbols on both. When their men went off to war, they quickly made an abundance of clothing items to keep these soldiers warm and comfortable, and to remind them of what they were fighting for. Working with textiles has long been a way for women to respond to events that impact their lives, resulting in objects that are often both useful and beautiful, reflecting the practicality that often must come first for themselves and their families. Women in the twenty-first century are able to create textiles that are at the same time art and historical records, grounded in a shared history of using their hands to express the impact of war on their lives and the history of their country.

THREE

Canada

As part of the North American continent, Canada has a rich history of explorers and settlers coming to its shores from the European continent. Beginning with the Norse about 1000 CE, followed by the Portuguese and the Spanish, then the French and the English, European colonization was a continuous process in the sixteenth century. But before the arrival of these Europeans, the approximately 300,000 aboriginal people who were living in this part of the North American continent for at least ten thousand years had rich cultural traditions and well-established patterns of subsistence and trade.[1] The early European settlers were interested in fishing and in the fur trade. At first conflicts with the Aboriginal people were minimal, but as white trappers and Native people competed for fur and game resources, hostilities between the two grew. The resulting conflicts were fought on Canadian soil until the establishment of the Canadian Confederation in 1867 which created the provinces of Ontario, Quebec, New Brunswick and Nova Scotia in the Dominion of Canada and, in some cases, beyond. The fur trade itself disrupted the Native world by fostering conflicts between those who wanted to control the supply of furs to the Europeans and trading routes to the interior, by spreading epidemic diseases, and by stimulating the migration of whole populations.[2]

Textile production in Canada began with the Aboriginal, or First Nation, women during pre-historic times. The impact and importance of the earliest wars are reflected in the textiles created by the Aboriginal women before and after European contact, primarily in the clothing they made for the warriors who fought these battles and continued in the textiles made by the immigrant women who settled in the region.

Those Europeans who came to colonize and settle in eastern Canada during the 18th and 19th centuries included women who created homes for their families. They furnished them with textiles they made, sometimes incorporating patriotic symbols to show their commitment to their new country. As women came from throughout Europe, they brought their traditional textile skills with them, and used them as they adapted to their new homeland. According to the 1870–1871 Canadian census, the population of the nation was composed primary of people of British (2.1 million) and French origin (1 million). In addition to the German-speaking immigrants (203,000) and to the Aboriginals (136,000 in 1851), there were small groups of people who had arrived from several other countries.[3]

Canada remained a British colony after Confederation united the region and Canadian soldiers supported British troops during the Second Boer War, and World Wars I and II. Canadians fought overseas in World War II. During both world wars, thousands of Aborig-

inal men and women voluntarily enlisted in Canada's armed forces, serving with other Canadians in every theater in which Canadian forces participated. More than 500 Aboriginal servicemen lost their lives on foreign soil during the wars.[4] As the men fought, the women at home knitted and sewed for the soldiers. They also sought to offer comfort to fellow British subjects who felt the direct impact of the war by making quilts to send to the families displaced by war.

Since the Second World War, Canada has remained committed to multilateralism, and Canadian soldiers have been part of the United Nations peacekeeping operation to provide support during the Korean War, the Gulf War, the war in Kosovo and the wars in Iraq and Afghanistan. Canadian women have always been impacted by war as their fathers, husbands and brothers left home to join the war effort, leaving the women to "keep the home fires burning." Contemporary women textile artists have used traditional materials or new media to express their own ideas on the impact of these events. Because of their country's widespread involvement in conflicts worldwide, Canadian women are intensely aware of the effects of war on a society and on families in every culture.

First Nation Historic Textiles

The Aboriginal peoples of Canada are divided into 12 linguistic groups: the Inuit living in the Far North; the Beothuks in Newfoundland; the Algonquians, in the central region (Prairies, Ontario, Quebec and the Maritimes); the Iroquoians in the St. Lawrence lowlands and Great Lakes region; and the Huron and Sioux in Manitoba near Lake Winnipeg, and on the West Coast several different groups live along the Pacific Ocean.[5] The earliest women who inhabited the region created garments worn by their husbands, sons and brothers in battle. As in a number of cultures in other parts of the world, it was the women of First Nation groups who did the sewing and some garments they made were specifically designed to be worn during warfare. According to Arthur Ray, "[t]he women also fashioned the clothing, from hides and pelts, and decorated it with porcupine quills, moose hair, and perhaps painting."[6]

The women Ray referred to are identified as Northern Forest people, who spoke dialects of either the Athapaskan or the Algonquian language.[7] The women of all of the Plains peoples were skilled at dressing and painting buffalo hides; their more sedentary Mandan neighbors to the south (the Upper Missouri River valley), who farmed, also excelled in these arts and were renowned for their feathercraft and hair work.[8] The Inuit women of the Arctic had special tools to use as scrapers for working hides and sewing kits that included bone needles and thimbles.[9] West Coast villagers were the only Canadian Indians to develop the art of weaving.[10] The women had been utilizing these skills for centuries before their contact with Europeans, establishing textile traditions specific to their region and tribe. Many of the tribes were nomadic, following the seasons, or the herds of animals they needed to survive, and their earliest textiles did not survive to present day due to their fragile nature, the harsh climate and because they were objects made to be used on a regular basis. The peoples of the tribes themselves were non-literate, relying on their strong oral tradition to pass down their histories through the generations, so there is no written record of their textile traditions.

But post-contact textile artifacts are well documented and many examples have been collected and preserved in museum and private collections throughout the world. The

accounts of explorers, traders, missionaries, and artists, recorded beginning in the seventeenth century, have survived, providing a wealth of information about native textile traditions. Geographer and surveyor David Thompson (1770–1857), on a trip to the Far Northwest in 1787, commented on native textile traditions, when he wrote, "See the wife of an Indian sewing their leather clothing with a pointed brittle bone or sharp thorn and the time and trouble it takes."[11] And numerous examples of the type of garments that would have been worn by warriors and created by the women of their tribes have survived in numerous collections. Some of the materials used by the women changed after contact with Europeans. The Mi'kmaq, for example, were originally noted for their moosehair embroidery and porcupine quillwork on birch bark and basketry containers, hide and textile clothing. Glass beads introduced by European traders were welcomed early by Mi'kmaq and other aboriginal women artists as substitutes for the more difficult to work quills and moosehair.[12]

Between 1800 and 1830, the Mandan women from the Upper Missouri River area made garments known as "war shirts" of deerskin decorated with porcupine quills, human hair, horsehair, beads, sinew and pigment. The deerskin, or buckskin, garment was decorated with bands of elaborate quill and/or bead work across the shoulders and down the sleeves. Scalp locks were interspersed among the long cut feather fringe that ran the length of the sleeves.[13]

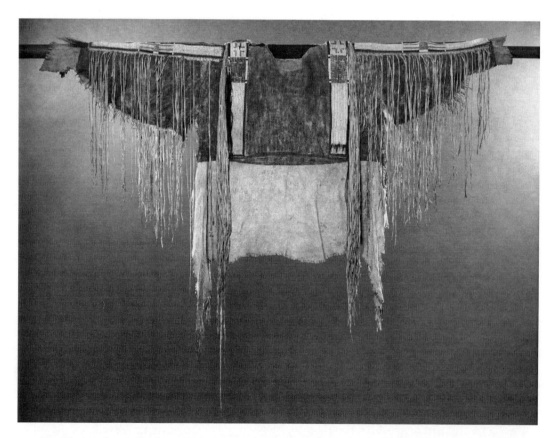

War Shirt, unknown maker, North Dakota, circa 1800–1830. Deerskin, porcupine quill, human hair, horsehair, beads, sinew and pigment. Purchased from Thomas B. Donaldson; funds from John Wanamaker (courtesy Penn Museum, image # 152330).

Certain Blackfoot warriors were the owners of special costumes that included a shirt and leggings which were carried, bundled, into battle, and worn only when the warriors came home so that they might enter their camp in glory. These outfits, called scalplock suits, had fringe made from scalp hair, augmented by painted stripes, sewn onto the sleeves and leggings. Large discs were sewn onto the front and back of the shirt. A scalplock suit in the Canada Museum of Civilization was made circa 1840, of tanned deerskin, with porcupine quills, hair, glass beads, woolen cloth and paint. It is unique in combining the distinctive insignia of three tribal patrons—the sun, the weasel and the bear, which were thought to transmit their powers to the wearer. A considerable amount of skill and expense were required for the creation of a scalplock suit, making them treasured warrior possessions.[14]

Man's Coat, unknown maker, Mi'kmaq people, Eastern Woodlands, North America, 1865–1900. Stroud, silk, silk ribbon, grosgrain, metallic ribbon, cotton thread, glass beads. 27 in. by 43 in. Gift of Mr. David Ross McCord (McCord Museum, accession no. M956.1).

European fur traders introduced glass beads to Canadian First Nation peoples in the seventeenth century as trade goods. On their 1804 expedition to the Canadian Northwest, Lewis and Clark brought beads to trade with First Nation peoples; unfortunately they guessed incorrectly about the kinds of beads the natives would prefer, which was the blue and white variety. Instead, Lewis and Clark brought primarily red beads and mock garnets.[15] Beads were used by First Nation women on a number of war-related textiles such as the "pipe bag" made in the late ninth century by a woman of the Woodland Cree people. Before entering into battle, Woodland Cree warriors put pipes and tobacco into deerskin bags such as this one, and attached them to their belts. To preserve the leather, the bag was tanned using cow brains, and then smoked to make it water-repellent. The glass beads are sewn onto the panels on the bag's front and back. Each panel contains a different floral pattern, imagery

which appeared after contact. The bag was created prior to 1880 because the silver cut-metal beads were not used for embellishment after that date.[16] The beauty and the familiarity of such an object would have provided comfort as well as a reminder of the maker to the warrior as he entered into battle.

The military garments worn by the Europeans also influenced the peoples that they conquered. The coats worn by European military personnel during the eighteenth century were often later acquired by the Mi'kmaq through trade or as gifts. The women soon began making similar coats for the men in the tribe. Throughout Canada, native women frequently made copies of an object they liked, adapting it to their own tastes. One example of a native-made European style military coat, in the collection of the McCord Museum, was made between 1865 and 1900, using stroud, silk, silk ribbon, grosgrain, metallic ribbon, cotton thread, and glass beads. The style is reminiscent of a military officer's coat without being an exact copy. The use and placement of the silk ribbon and glass beads is uniquely the result of the seamstress' personal taste and choices.

In the nineteenth century gloves were worn by military officers, including members of the United States Cavalry, who rode on horseback. These gloves were unique in style, with extra-long and wide cuffs, which covered the arms almost to the elbow and usually included fringe. First Nation women made similar gloves for their warriors to wear but with a difference—the addition of beadwork patterns. A pair of such gloves in the McCord Museum provides a typical but still unique example. They were made between 1875 and 1925 by a woman of either the Assiniboine or Nakoda peoples. They are made of tanned and smoked hide, with a cotton cloth lining, and decorated with glass and metal beads, cotton thread and sinew. The design begins on the back of the hands and continues up the cuffs. A red flower with four pale blue leaves is the dominant design feature, surrounded by additional smaller flowers in white beads with green trim. The beautiful, colorful design, primarily done in soft colors, seems unusual for gloves worn by a man for such a purpose, but is consistent with the aesthetic preferences of the woman who made them and her people.

Another military-influenced object in the collection is an epaulet, one part of several pairs in the museum collection. An epaulet, an ornamental shoulder-piece on an officer's uniform that identifies the wearer's rank, is a European item that was adapted by the maker, in this case a member of the Huron-Wendat people. It was made between 1800 and 1830 by a woman of this tribe of the Eastern Woodlands, who would have encountered both French and English soldiers in her daily life. The epaulet is made of blackened deer hide, moose hair and possibly horsehair, sheet metal cones, glass beads, silk ribbon and cotton thread. The softly colored flower design stands out against the black background, especially since the square shape of the deer hide piece is outlined in white thread about one half inch from the edge. Along the bottom is a fringe of dyed animal hair pulled through the metal cones with white beads sewn along the top. The epaulet was likely intended to be worn on the shirt or jacket of a male member of the tribe, creating another unique garment that shows assimilation and adaption of the European military uniform articles by native women for use by members of their tribe.

All of these examples are evidence of the impact of the European colonizers on aboriginal society. Although the textiles created by these women did not depict war imagery per se, they reflected a process of assimilation, absorption and adaption of the invading nations' military power and its reality for their lives. They provide documentation of the changes

occurring for their society, and an attempt to possess the images of the outsiders and make them their own, perhaps absorbing some of their power in the process.

An example of the assimilation of the outsider's culture is the appearance of floral imagery in the objects created by the Aboriginal women. Over a period of about forty years, between the end of the War of 1812 and midcentury, floral iconography came to predominate not only in art commodities but also in a wide range of objects made for internal use, displacing earlier indigenous traditions that had featured geometric motifs and depictions of the *manitos*, or spirits, who bless human beings with power.[17] As noted by Ruth Phillips, this adaptation of floral iconography was one of the most rapid and dramatic changes in the history of Native North American art.[18] One source of this influence was the Ursuline nuns in Quebec who in the sixteenth century had started mission schools in which they instructed Aboriginal girls in the art of embroidery. While the floral patterns were beautiful, according to Phillips by adopting floral designs Aboriginal people used the conventions of the dominant culture to express in a "muted" way their dissenting point of view.[19] They created a new iconography, using old and new techniques and materials in varying degrees to create their traditional and newly adopted art forms.

Souvenir Art

The impact of the Europeans on the North American continent occurred over nearly three centuries, beginning in the middle of the sixteenth century and continuing to the middle of the nineteenth century. It began with trade between indigenous people and the French, English, Spanish, Russian and American visitors. Eventually trade routes were established into the Canadian interior and across the northern part of the continent, followed by the establishment of trading posts which brought European settlements. Missionaries and missions quickly followed, their role becoming stronger in the early nineteenth century as their membership grew due to the conversion of the native population. This increased European presence led to the development of new native art forms intended for the European market.

Souvenir art is defined as the large body of objects made for trade by Aboriginal peoples.[20] This art reflects the impacts of conquest on the indigenous peoples as demonstrated in the objects they created, including clothing, blankets, baskets and other textiles. These products date primarily from the mid-nineteenth century as the interest in and demand for certain handmade objects grew among the European traders. The women artists gradually began to make objects specifically designed for the traders, changing traditional objects so that they appealed to their buyers' tastes. These included beaded pouches, moccasins, pin cushions, and other Victorian-style "whimsies" made by Iroquoian and Algonquian peoples, and later for sale at agricultural fairs and at Niagara Falls, Ontario.[21]

A pincushion in the collection of the American Museum of Bath, England was made by an Iroquois woman in the late nineteenth century.[22] The star shaped pincushion is made of cloth, glass beads, sequins and stuffing material. It includes an image of the American flag; Ruth Phillips has noted that these Native-made souvenirs of the Victorian era often displayed patriotic symbols which were intended to appeal to the tourists at such sites as Saratoga Springs, New York. They also served as a sign of assimilation of at least some aspects of the dominant culture by the maker.

An example of an object that represented a unique, creative idea of its maker is the "Tree of Peace," made entirely of beadwork by Sophronia Thompson, probably a member of the Tuscarora tribe.[23] She used the Victorian genre of a table ornament to express an Iroquoian concept of the great tree of peace, including a wigwam, a native home, at the base of this tree. The thirteen and a half inch tall object includes a light green trunk with a golden bird perched atop the tree's spiraling branches, set on a dark green base. The tree is a treasured object in the collection of the Niagara County Historical Society in Lockport, New York.

Haida women, from what is now British Columbia, excelled in basketry. Their handmade woven hats are frequently shown in early engravings by Russian artists at the period of first contact. The traditional painted, woven hats became a popular tourist item late in the nineteenth century. Metis women, descended from marriages between French and Indian forebears in western Canada, made Octopus pouches, so called for the double tabs at the bottom, that were used by warriors for carrying pipe, tobacco and flint and steel. These were typically decorated with floral designs done in silk ribbon and glass beads. These floral designs made by the peoples of the northern forests were once thought to be traditional native motifs, yet such patterns are seldom seen on items made and used before 1800, and were never present in prehistoric native art expressions. Instead the designs on these mid-nineteenth century Metis pouches clearly represent European flowers in compositions that are reminiscent of colonial folk art. This floral art originated with Metis women living at missions and fur trade posts when they began integrating these designs into their work.[24]

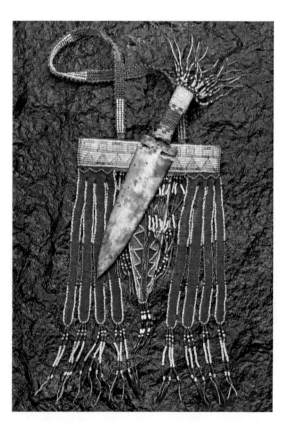

Knife and Sheath, unknown maker, Eastern Wood Cree (Swampy Cree), circa 1750. Knife: iron, wood, porcupine quills, skin thong, glass beads, woolen yarn, 11⁶⁄₁₀ in. long. Sheath: wood, tanned skin, porcupine quills, woolen cloth, glass beads, 9½ in. long (courtesy Canadian Museum of Civilization, III-D-568, S89–1834).

Among the much coveted native trade items was an iron knife and its embellished leather sheath. Ojibwa women embellished these knife sheaths with their traditional bead and quillwork, which showed the technical skills of the women who made them. The presence of imported materials in the sheaths, such as iron, trade cloth and glass beads, on otherwise traditional items suggests that these pieces were made soon after contact with Europeans beginning in the mid-eighteenth century. A knife in the collection of the Canadian Museum of Civilization is an example of a rich and complex aboriginal culture, as it was encased in an elaborately decorated sheath, and serves as an example of early artistic traditions and technical skill.[25]

Other factors that played a role in the creation of art for tourists included the pressure on Aboriginal peoples to assimilate, which meant giving up their traditional way of living. This change led to increased pressure on the native peoples to support their families as their lifestyles changed and they were no longer able to participate in native traditional activities. Many of the women tried to provide a source of income, and many were able to do so through their crafts. Cowichan women had woven blankets of mountain goat wool prior to the arrival of Europeans. When British settlers arrived on Vancouver Island they introduced sheep, and also taught the indigenous women to knit. These women then began making sweaters and other items of sheep wool that provided some or all of their family's income. By the end of the nineteenth century the distinctive designs and knitting techniques of the Cowichan women were established and they are still known today by that name. This distinctive style of sweater is knitted in one piece, with no sewn seams.

Some women did not earn money only for themselves and their families; in some cases they also made money for the furtherance of the goals of their colonizers. To raise funds, missionaries during the nineteenth century frequently staged exhibitions of arts and crafts made by their converts.[26] Missions had begun to spread west after the War of 1812, and shows were held in such areas as the Great Lakes region, Nova Scotia and Ontario. The items the indigenous women of this area made were popular, and for the buyers, they were examples of the learning ability of these women and of how assimilated they had become. Because they actually had no other real options to earn income, the women attempted to adapt to their circumstances in order to survive. Their negative feelings toward their conquest could not be freely expressed in their art, but the objects they created and the ways in which they were decorated is a record of their reaction and their adjustment to the newly dominant culture. By the first quarter of the nineteenth century, the majority of the native people of Canada had been impacted by the European immigrants as these newcomers built their settlements, established missions and created an economy based on trade and agriculture. The Aboriginal people went from being independent within this territory to having to adapt to this new way of life and to gradually become dependent on the Europeans who established the dominant culture. One of the few options left to these indigenous people was to create objects to sell to this new market. Many native women were able to do so, using traditional techniques and adapting their designs to appeal to buyers, enabling them to provide income for their families.

Hooked Rugs

The process of colonization of the continent continued for several centuries, and eventually involved warfare between France and Great Britain. In the seventeenth century, the Frenchman Samuel de Champlain transformed transient contact into a permanent European presence in Canada.[27] He did this by establishing the New France colony in Eastern Canada, which was a settlement, not just a trading post, and thus changed the level and style of European involvement in this new world. By 1681 there were ten thousand French settlers in Canada, which included a strong female presence, something which had not previously been true in earlier settlements. When the British took political control in 1763 after decades of conflict with the French, the New France colony had 70,000 inhabitants, significantly more

than British citizens in the region.[28] The number of English speaking settlers in Canada increased rapidly after the American Revolution, due to the arrival of the Loyalists from the American colonies to the south as well as because of the increase in immigration from Europe, largely Great Britain.[29] By the census of 1870, the population of the nation was almost three and a half million, mostly British in origin, then French, a small number of German immigrants, and only 136,000 aboriginals, whose numbers had been decimated by disease. Additionally several waves of immigrants had arrived, including Irish, Italians, Russians, Dutch, Jews from Eastern Europe, and Japanese.

The construction of the Canadian Pacific Railway in the early 1880s increased the pace of immigration and opened up the Canadian West. Additionally, there was population fluctuation between the United States and Canada as people moved back and forth across the border to find employment and farmland. At the end of the nineteenth century, the Canadian government began promoting immigration to the West by offering low-cost land to homesteaders, and the populations of the western provinces gradually increased as more immigrants arrived.[30]

As women moved to a new country and new homes with their families they continued their traditional role in setting up households and creating a comfortable home for the family. Textile production was part of this role as they made quilts, knitted, sewed and supplied their households with items that provided warmth, comfort and beauty. Most families could not afford to spend much money on furnishing a home, and even scraps of material and worn items were used and re-used to avoid waste. Since floor covering was a luxury, women began to make hooked rugs. A hooked rug is made by pulling loops of yarn or rag strips through a loosely woven foundation cloth, usually burlap, using a tool like a crochet hook. The strips were made from worn out clothing, curtains, bedcoverings and any other scrap fabric that was available. It is probable that rug hooking developed independently and simultaneously in several centers including Quebec, the Maritimes and New England. Hooked rugs were made in much greater numbers in the eastern half of the continent than in the western half since, by the time the Canadian West was settled, store-bought rugs had become widely available.[31]

The rugs the women made served a practical purpose, but they also offered an opportunity to add a personal touch to their homes. And since they could be a means of expressing an opinion or an idea on the part of the maker, women often expressed their patriotism in the rugs they made. Because they were made to be used rather than simply for decoration, not many rugs survive, especially the earliest rugs. The New Brunswick Museum owns the oldest known hooked rug made in Canada, in 1860, by Abigail Smith of New Maryland, New Brunswick.[32] The Canadian Museum of Civilization owns a collection of nearly 400 hooked rugs, mostly made in Eastern Canada.

Two Eastern Canadian communities are well known for their rugs. The first are the rugs from the Grenfell missions in Newfoundland and Labrador. Dr. Wilfred Grenfell industrialized local rug, or mat, making in 1913 and standardized the patterns used in local production. Local women made the rugs, which were sold to raise money for medical missions. There was no opportunity for the women to create their own patterns or have any input into what the rugs looked like, but they were able to earn money by making the rugs.

The idea of providing a way for local women to earn an income was also the basis for the establishment of another rug industry. The Cheticamp rug industry was established by

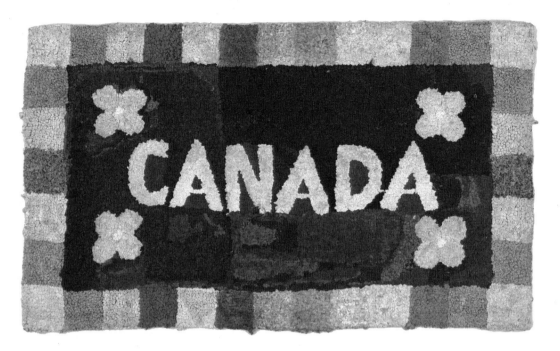

Hooked Rug, unknown maker, Canada, early 20th century. Burlap, wool, synthetic, silk. 19 in. long by 33½ in. wide. Gift of Simon Waegemaekers (courtesy Textile Museum of Canada).

two American women, Lillian Burke, a New York artist, and Mrs. Alexander Graham Bell in the 1920s. Cheticamp, Nova Scotia, is an Acadian fishing village which has become known for unique, high quality rugs that are still made and sold today. The wool for the rugs is dyed locally.

The best known Cheticamp rug maker was Elizabeth Lefort-Hanford (1914–2005), who initially created landscape or scenic images on her rugs. But she had a talent for creating rugs with patriotic themes and is best known for her rugs that focus on those. In 1959 she created *United States Presidential History*, a rug that depicts thirty-four United States presidents and their seals. The rug took six months to make and features busts of each president, arranged on four groupings in the four corners of the rectangular rug. Another large rug, made in 1967, is titled *Canadian Centennial Hooked Rug*. The sixty-eight foot square rug includes images of Canadian leaders past and present, as well as scenes of Canadian accomplishments from across the country. Elizabeth Lefort, as she was professionally known, also made rugs with the image of Queen Elizabeth and Pierre Trudeau, the former prime minister of Canada. She was awarded many honors for her work and was acknowledged for having turned the local rug hooking industry into an art.

Lefort is one of the few rug makers who was known as a named artist. Many women made rugs, but for the practical need of keeping their homes warm rather than as art objects. But many were able to express their opinions on political and social issues through their art as well demonstrating as their skill as rug makers. One rug in the collection of the Textile Museum of Canada that demonstrates use of a patriotic theme is a forty-eight cm. by eighty-five cm. rectangle which prominently features the word "Canada" at its center. This rug, made between 1905 and 1915, consists of wool and silk fabric hooked on a burlap ground.

The single word is worked in large white letters on a black rectangle which is surrounded by multi-colored squares. Patriotism was a popular theme for hooked rugs of this time period, especially since Canadians fought in World War I. Other rug makers expressed their patriotism, but for the Mother country, Great Britain. Three rugs in the collection, each made circa 1930, feature the British flag, and one includes the sentiments "There will always be an England," along with Canadian maple leaves in each corner. Another of the three simply features an image of the British flag, red lines on a dark background. A rug, made circa 1940, features maple leaves and beavers, both decorative and patriotic imagery for its Canadian maker, while a 1947 rug features maple leaves along the edges of a rectangular tan colored background. The prolific use of patriotic symbols in hooked rugs occurred just prior to and during World War II, as these women reacted to the impact of their men fighting overseas and expressed their patriotic feelings for the cause.

Another well known rug maker was Emily Carr (1871–1945), one of Canada's foremost women artists. Between 1914 and 1927, when she struggled to make a living as a landlady, she supplemented her meager rental income by making hooked rugs, many of which included patriotic images.[33] Carr was a painter, and she ultimately had a successful artistic career, but rug making provided a fall back when she needed it to support herself, as it had for many other women.

Rugs provided women comfort for their homes, and sometimes even a means of income. But they were also a blank canvas, creating an opportunity for individual expression and creativity. Many women used this canvas to express their patriotism and their loyalty to their new, adopted country, especially during wartime. This was part of the process of assimilation for some and a means to express a desire for unity, as members of various ethnic groups came together as Canadians.

Quilts

Quilts provided another opportunity for a woman to use her sewing skills to express her ideas, and to demonstrate her skill with a needle and thread. They could be used as bed coverings, wall hangings or window coverings to decorate a home. But quilts could also be made to bring comfort to others, a labor-intensive gift serving as a strong expression of the feelings of its creator.

Making quilts during wartime has been a continuous theme for Canadian women since the early days of the European conquest. The members of the Women's Institute of Prince Edward Island have made quilts to donate to fire and flood victims, to orphanages, to hospitals, to the needy, among other causes for more than a century. During the First World War, the Ray of Hope (Murray River) branch made two quilts, one for France in 1916 and one for a Canadian-run hospital in England in 1917.[34] The quilters also were part of the massive quilting effort of Canadian women during World War II.

Thousands of quilts were sent by the Canadian Red Cross Society to Britain from 1939 to 1945 as part of the World War II war relief program. These quilts were given to British families that had been bombed out of their homes, as well as to members of the armed forces, hospitals and hostels. Each quilt had a small label which read "Gift of the Canadian Red Cross Society." The quilting program was set up so that quilt tops were made by individuals or by

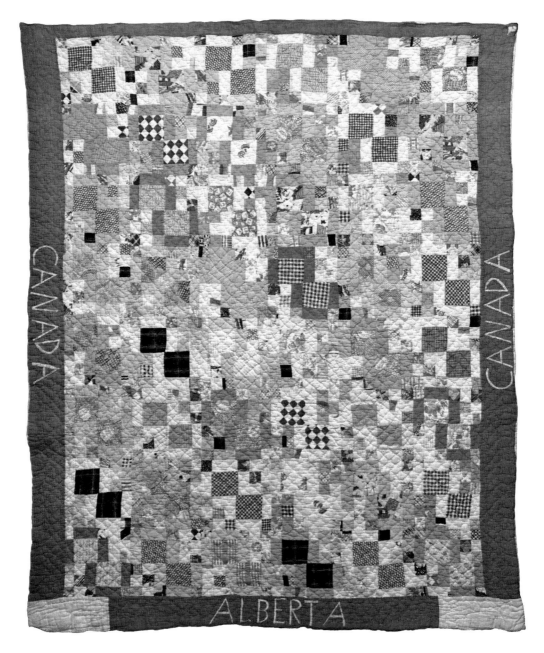

Red Cross Quilt, unknown makers, Alberta, Canada, 1939–1945. Various fabrics with pink and grey flannelette backing. Accession no. H04.57.1 (photograph courtesy Lucie Heins, Western Canadian History, Royal Alberta Museum).

groups. The backing and batting were provided by the Red Cross to its community work groups, and the quilts were assembled in quilting bees. Such groups met monthly at different homes and members also worked at home, each keeping track of the number of quilts that it turned over to the Red Cross.[35] Many families in Britain kept the quilts they received during the war in their families as a memory of a kindness extended during a difficult time.

The York, England, Quilt Museum and Gallery has one of the Red Cross quilts in its collection, titled *Suit Wools Canadian Red Cross Quilt*. This quilt, which still has the Red Cross label on back, is made from squares of suiting wool in plain, check or striped design, with no pieces being exactly the same. The quilt is tied with pink and blue wool to keep the three layers together, a technique that made it quicker to produce to meet the high demand.[36]

The Quilt Association in Llanidloes, Wales, has a quilt which was given to Doris Evelyn Jones from Kent during the war. Jones, who died in 2007, and her son were sleeping in an air raid shelter during a bombing raid when their home was destroyed. They eventually evacuated to Halifax, Nova Scotia. Their quilt is a nine patch piece, with thirty blocks made of various cotton fabrics; the reverse is done in a blue striped flannelette sheet, with a Canadian Red Cross patch in the bottom corner. The colorful quilt demonstrates the anonymous quilters' penchant for using every scrap of material to create something new and useful.[37]

The Western Development Museum in Saskatchewan has a Red Cross quilt that includes information on the recipient. The quilt was made by the Moose Jaw quilters and was given to a family in the Netherlands. The original recipient gave the quilt to the wife of her surviving son years after the war ended, and it was treasured as a family heirloom. When the son and his wife moved to the United States in 1994, the wife contacted the Moose Jaw Chamber of Commerce looking for a suitable home for the quilt. Fifty years after it was made, it was returned to the town where it was created.

Another quilt that returned to its birthplace was created to honor veterans of both World War I and World War II. The quilt was made in 1952–53 by the Ladies Auxiliary, General Lipsett Branch of the Royal Canadian Legion in Emo, Ontario. The quilt squares contain the name and dog tag number of men and women who had served in the Canadian armed forces during both world wars. On the center square, which is nine times larger than the other squares, are the words British Empire Service, which is now known as the Royal Canadian Legion. The border and center square are arrayed with maple leafs, which at the time of the quilt's creation were the Canadian national emblem. The quilt was discovered by the relative of one of the men whose information is included on the quilt. After advertising in the local paper for information about it, one of the original makers came forward and provided detailed information about its creation.[38]

The Western Canadian History Program's textile collection includes nearly one hundred quilts and pieced and quilted cloths. Some of these quilts have been made by women who live in Alberta and some were brought there by immigrant families. Among the collection is a Red Cross quilt, one of thirty-two hundred made in the Edmonton district during World War II. The quilt is made of forty eight sections in which nine-patches are balanced by squares bordered on three sides. The quilt is backed with pink and grey striped flannelette, thought to be a Red Cross supplied fabric.[39] The maker is unknown. In the Red Cross quilt process, quilt tops were made by individuals, and the backing and batting were provided by the Red Cross to its community work groups, which assembled the quilts in a bee. Groups met monthly at different homes and members also worked at home. More than 3,200 Red Cross quilts made in the Edmonton district were distributed in 1942.

The idea of making quilts to honor those who serve in wartime continues into contemporary times. In 2006, Jane Guthrie of Brockville, Ontario, founded the Canadian Comfort and Remembrance Project (CCRP) after hearing of the death of Canadian diplomat Glyn Berry who was killed January 17, 2006. Their goal is to bring comfort to the families of fallen

Canadian soldiers by providing them with quilts. The quilt blocks used include a maple leaf, called 'The Maple Heart' block, with each maker stitching her name, home town and words of comfort in the center of her block. The Canadian military adopted the CCRP and serves as an intermediary, offering the quilts to the families of fallen soldiers. By November 2006, twenty-two quilts had been delivered to recipients, and the project continued until 2012, by which time the withdrawal of Canadian Forces from Afghanistan meant there were no longer as many casualties, which their backlog of quilts could accommodate if needed.[40]

Although the Royal Canadian Mounted Police are not usually thought of as soldiers, they are a Canadian institution that has an image that encompasses cowboys, protectors and soldiers. It is a national, federal, provincial and municipal policing body. There are Mountie detachments in small villages in the far north of Canada, in remote First Nation reserves, and in rural towns as well as larger cities. Members of the force served in both World War I and World War II. In 1975 Beth Craig made a quilt to honor those who serve in this police force, and to illustrate the qualities the Mounties embody. Using primarily red and white, the quilt features maple leaves in each corner and scattered among the fifteen squares that make up the center of the quilt. The other seven squares depict Mounties performing various duties. The reverse contains white maple leaves on a red background. The quilt is in the collection of the Museum of Civilization, and expresses patriotism while honoring the contributions of this famed institution.

Knitting

While members of the First Nation stuffed their boots with naturally shed wool from musk oxen and the Salish people blended dog hair, duck down and vegetal fibers into the yarn used to weave blankets, knitting was not a textile technique used in the region prior to the arrival of European settlers.[41] In addition to embroidery, missionaries taught knitting to native women and girls as a way of discouraging idleness.

By the early twentieth century, the Canadian Handicrafts Guild was founded in Montreal to encourage arts and crafts production among middle and upper class Canadian women. The group promoted crafts including textile production as art forms, organizing exhibitions of such "women's" work across the country and the ability to provide knitted clothing for their families was seen as a status symbol for many women.

With the advent of World War I, knitting took on an aura of "craftivism" as women and children from across Canada knit mufflers, socks, sweaters, balaclavas and afghans for soldiers fighting in Europe. The knitted goods provided by Canadian women were essential to the war effort and their contribution was recognized in a government leaflet which noted that

> the work done by Canadian women in order that this war may come to a successful ending— peace with victory—is nothing short of amazing.... Socks by the millions of pairs ... comforts without stint makes a record of devotion and faithfulness never before equaled ... for four years the work has gone on and somehow the hands have not lost their cunning nor the hearts their love for freedom and right and the flag.[42]

The Canadian Red Cross sent knitting patterns to women across the country, resulting in thousands of Canadian women knitting for the cause.

During both World Wars I and II, Canadian Girl Guides (Guides du Canada) made significant contributions to the war effort by making surgical dressings and bandages, working in factories that made military uniforms, and organizing knitting groups to provide socks for the troops. During World War II, they created a two year long National War Service Project, known as The Guide Overseas Gift Project, which began in November 1940. The Guides knitted and sewed more than 29,665 articles of clothing, such as afghans, sweaters and booties, for British children displaced by the war.[43]

As in Great Britain and the United States, Canadian women again knitted for their soldiers during World War II. In one year, one group of women used one and one-half tons of wool to create sweaters, socks and other objects for civilian refugees and service members. Once again the Canadian Red Cross Society provided patterns for women to use. One such booklet, provided by the Canadian telephone company's yellow pages, included patterns for knitted goods needed by members of the army, navy and air force. Knitters were advised to follow the patterns carefully to insure that "the garments will be well shaped." Women were also cautioned to watch their needle size and tension because "wool is too precious to waste."[44] The thirty-two page booklet contains more than thirty patterns for a variety of types of clothing including socks, rifle mitts, sleeveless sweaters, helmet caps, convalescent jackets and amputation covers, as well as an indication of the difficulty of each pattern. The booklet's small size—it measures three and a half inches by six and seven-eighth inches—made it easy for the knitter to carry with her.

The exhibit "The Forgotten War Effort: Knitting," held at the Bala Museum in Bala, Muskoka, Ontario, in 2007, revealed the ways in which the practice of knitting in Canada changed overnight as the result of war. What had been a technique used by women to help clothe their families became a full-scale war support effort by women were encouraged to produce service wear and hospital garments for the troops serving abroad. Examples of knitted garments made by patriotic women during World War II were recreated by visual artist Nancy M. Green of Dunrobin, Ontario using a 1940s knitting pattern book of her mother's titled "Service Woolies by Beehive." Linda Jackson-Hutton, curator of the Bala Museum, grouped Nancy's knitting into two groups: Convalescent and Field Knitting. Examples of the field knitting include a knitted helmet cap that provided warmth under a soldier's metal helmet, and "rifle mittens" that exposed the trigger finger, while afghans and amputation covers were among the items in the convalescent category. The museum is located in the former home of Lucy Maud Montgomery, the Canadian novelist who wrote the *Anne of Green Gables* series of novels. *Rilla of Ingleside*, the eighth of nine novels in the *Green Gables* series, documents the way in which knitting became an important task for many Canadian women on the home front during World War I.[45]

Knitting during wartime was also the focus of a special exhibition in 2013 at the Canadian War Museum titled "New Brunswickers in Wartime, 1914–1946," which included photographs of boys and girls who formed knitting clubs at school and home to support the war effort. The children joined women knitters across the country to make warm woolen socks and other knitted comforts to include in care packages for the soldiers on the front lines.

Activist knitting did not stop with the end of World War II. During the Vietnam War, the group Voice of Women knitted thousands of camouflage baby clothes "to be shipped to Vietnam so as to protect children and their families from the U.S. air strikes."[46] A number

of Canadian groups continue to use knitting as a form of social protest against the war in Iraq and Afghanistan.

Canadian women also continue to use knitting to support political causes, including supporting the troops fighting in Iraq and Afghanistan. Founded in 2009, Operation Toasty Toes—Canada allows knitters to show their appreciation to the troops by knitting or crocheting slippers, hats or other comfort items.[47] Janice Hickman, owner of Janice h. knits in Perth, Ontario, heads a drive to provide one thousand knitted helmet liners for Canadian soldiers serving overseas. The balaclava style cap provides warmth in the extreme nighttime cold in Afghanistan as well as giving a touch of home to the soldiers.[48]

The Boomer Cap Project began in 2013 as a way to honor a Canadian soldier named Andrew who was killed in action in Afghanistan and to help make a difference for the Afghan children who have been subjected to the horrors of war. Word of the project was spread through Soroptimist International Clubs, of which Andrew's mother is a member. The group has shipped more than 300,000 knitted caps to Afghanistan, Romania, Guatemala and other locations that have experienced the disruptions that result from war. The Canadian Navy is including the caps in the humanitarian aid packages they provide to refugees rescued at sea, making the caps ambassadors of hope and love throughout the world.[49]

Contemporary Textiles

Many of the contemporary textiles created by women artists express strong feelings about war. Canadian textile artists have become politicized by the wars in Iraq and Afghanistan, where Canadian soldiers have fought in both wars. In the past, the country has also provided air support to American and British troops in Serbia, joined the North American Treaty Organization's (NATO) peace keeping activities in Kosovo, and sent an infantry company to assist Australian security forces in East Timor during their war for independence. Many of these artists create works that challenge the viewer as they demand an emotional response to the images of war. The softness of the materials sometimes used in textile art in no way indicates a softness of subject matter or of opinion by the artist indicating the impact of conflict on a community, and on women specifically, when fathers, husbands, sons and brothers go off to war.

Contemporary works by Native artists, in contrast to the art of the past, give free rein to the artist to express her own ideas through a wide range of media now available to her, and to receive recognition as an individual artist in her own right. Since the Second World War there has been a growing international recognition of Canadian Native art.[50] Tourist art has continued to be produced and to be widely sold in special shops, at airports and on reserve lands by the Native residents, and is also available on line. The objects produced are similar in style to the traditional objects that began to be made in the nineteenth century, such as rugs, baskets and pottery. Other objects are created by artists for their own people's use that are based on traditional techniques and imagery. While many of these artists express their own ideas and creativity, as contemporary artists do elsewhere, they are still influenced by traditional values they share with other members of their community.

Social criticism and sociopolitical activism can be found in the works of many contemporary artists, whose works question both the past and present difficult relations between

Native and EuroCanadian society.[51] The media they use includes installation art and video art as well as textile art, connecting the present to the past.

Nadia Myre

Nadia Myre is a visual artist and an Algonquin member of the Kitigan Zibi Anishinabeg who lives in Montreal, Quebec. Her multi-disciplinary textile practice has been inspired by participant involvement as well as recurring themes of identity, language, longing and loss. Her work was selected for the 2011 Montreal Biennale and the 2012 Sydney Biennale, and was part of an exhibit, "Vantage Point: The Contemporary Native Art Collection," at the National Museum of the American Indian in Washington, D. C. Her works are also found in the collection of the Montreal Museum of Fine Arts and The Canadian Museum of Civilization.[52]

Indian Act is a work she completed in 2002. For this piece, Myre took the printed pages of the Canadian law which lays down the legal framework within which Canada's native peoples live. She and 200 friends then covered those fifty-six pages with tiny glass beads in red and white, the colors of the Canadian flag as well as the color of the beads which Lewis and Clark brought to trade with the Natives they encountered. Myre covered some pages of the act entirely with the beading, some part way, while the rest of the text is left visible for reading. As has been previously noted, the Aboriginal people did not use beads until the Europeans brought them, and they did not need an Indian Act until the Europeans came, but somehow the beads are closely associated with Indian art. All of the components of the piece, including the red and white beads that reflect the colors of the Canadian flag, are of Euro-North American origin, brought into the Native world by outsiders, but Myre takes these components and creates her own narrative about the conquest of First Nation people, signifying her possession, incorporation and transcendence of these symbols.

An ongoing canvas and thread project, begun in 2005, is *The Scar* project, which is a communal work in which she invites others to share their "scars" by cutting and then suturing raw canvas. Myre herself created a personal scar piece composed of six horizontal canvases, each depicting a long scar made by a slit in the canvas "healed" by irregular stitching. This work is called *Landscape of Sorrow*. She continues this theme in *Scarscapes*, which features several small rectangles made from glass beads and cotton thread, each with a central image of a black scar against a white background. This work again uses traditional Aboriginal materials, beads, to comment on the scars inflicted on Native peoples as the result of European colonization. Using these materials, the artist speaks both to Native people and to the general public, who both understand the iconography and the message of her work, which addresses the scars individuals may have suffered, because of the actions and policies of the European settlers, war and other significant experiences.

Ruth Cuthand

Ruth Cuthand was born in Prince Albert, Saskatchewan, in 1954 and grew up near the Blood Reserve in Alberta. A Plains Cree and Scots/Irish artist, she earned Bachelor and Master of Fine Arts degrees from the University of Saskatchewan and has taught young artists at First Nations University of Canada in Saskatoon for twenty-five years. Her own

work as an artist was shown in a retrospective held at the Mendel Art Gallery in Saskatoon titled "Ruth Cuthand: Back Talk (Works 1983–2009)" which travelled to venues across Canada in 2012 and 2013.

Included in the exhibit is the complete installation of her twelve piece *Trading* series. In these mixed-media works, viruses, as seen in microscopic scans, are rendered in beads while the name of the corresponding disease is painted, stencil-like, in white acrylic paint beneath the beaded image on a black suede surface. Cuthand's work comments on the exchange in which Aboriginal people received beads along with the epidemics of disease such as smallpox and the measles that ravished their communities after European contact. This work is consistent with the artist's other works which comment on the relationships between Native peoples and early settlers, white attitudes toward Aboriginal women, and Mormon-Native relations in Cardston, Alberta, her childhood home.

The piece for which Cuthand is best known may be *Treaty Dress*, done in 1986. In this work, she takes sections of the American and British flags, rearranges them and sews them together. They are seemingly haphazardly arranged to creates the shape of a vee-necked, three quarter sleeved short dress. One half is the red and white stripes of the American flag with a star-covered navy sleeve, and the other is a large section of the British flag. Created by a Native woman, the dress can be seen as a commentary on the patched together nature of the colonized country as well as a portrait of Canada. Since it is a woman's garment, there is also an element of commentary on the country's treatment of Native women, who must abandon their traditions and wear the "garments" of their conquerors. Cuthand has commented: "I have been working on a series of shirt/dress images since 1983. The shirts/dresses have their historical roots in the Ghost Dance Religion of the late 1800s, which arose in reaction to the Indians being forced to submit to government authority and reservation life. It focused on a Messiah to come and liberate them. Over the years the images have evolved into clothing of the soul.... In 1985 while studying in Montana, I began working with sewn canvases. The sewn edge and the movement of the loose canvas reinforce the dress imagery."[53] The dresses serve as a potent reminder of the impact of war on native peoples in the Americas.

Frances Dorsey

Frances Dorsey teaches at the Nova Scotia College of Art and Design in Halifax. The impacts of war have long been part of her life because her father served in World War II and she was aware of his writings on war and its casualties, of which she has said, "These fragments were so poignant, ... as a second-hand witness I felt splashed by the flames yet protected from the burn marks.... My brother and I, initially helpless witnesses to the histories of our parents, became accomplices and curators (as do all children). In this way, I suppose, generations pass on to one another the impulse to wage war, or peace, or something in between."[54] The other strong influence on her work is the time she spent in Ho Chi Minh City (Saigon), Vietnam as a child, before the American war. She has said it had a strong influence on her work as she wrestled with what was real and what was imagined in this patchwork city, and she addresses the same issues in her work.

Her artistic medium is cloth, although she began her artistic career by studying painting. She founded she did not like paints, but preferred the canvas. When she moved to a very rural farm in Canada with a group of friends as a protest to the war in Vietnam, she began

to teach herself how to weave, to try to understand how cloth was created. Dorsey then decided she needed additional education and returned to school to get a degree in textiles and a Master of Fine Arts degree. She has continued to work in the medium of textiles, moving from material she has woven herself to used table linens in recent years. While cloth has its own meaning, she has said, the used and discarded table linens carry their own histories, and allow her to reuse material that otherwise has no value.[55] For more than twenty years, she has used cloth to create works that commemorate the sacrifices made by those who fight and those left behind.

In her piece *Spill, the Mothers* (C6), from 2010, Dorsey uses used linen tablecloths, with natural dyes and extracts, and stitching, for the three hanging cloths in the installation, which measures eight feet by four feet by one foot. The warm-toned damask cloths are beige, gold and rose colored, produced through the use of natural dues and earth oxides to lessen the damage to the environment. They are hung on the wall, draped from a peak point and fall to the floor, evoking images of home and family, the three linens standing as silent witnesses to absences caused by war. The haunting forms of this commemoration piece have the appearance of shrouds, ghostly apparitions or mourning veils, reminding the viewer of the sorrow a mother feels upon learning of the death of her son, his blood spilled in battle.

War has been a major theme in Dorsey's work since the mid–1990s. Her series *Soldiers—Weaving,* from 1999, features a number of variations on the same theme. *Gun* features a black bazooka and images of red soldiers that have been silk screened onto a forty inch square cotton and linen jacquard twill weave printed with newspaper articles about war. *Ghosts* features the same black bazooka printed over ghostly images of soldiers against a dark grey sky. *Black Gun* features the black bazooka printed on a grey, green and beige camouflage background. *Soldiers/Gun* features a red bazooka printed over the figures of a number of soldiers in the mid-ground. The features of the soldier on the far left are clearly distinguishable, becoming less distinct as the figures fade into the grey background. *4 Squares* is a series of just that—four squares printed with the images used in *Soldiers/Guns* and smaller red figures of soldiers printed over a background of newspaper articles. Her *Tea Towels* series features the same bazooka image in multiples printed on a series of 20 inch squares that change from green to yellow to gold.

In addition to her printed textile series, Dorsey has created a number of installations that address the topic of war. *Bodies,* from 1996, features twenty-one figures made from military uniforms stuffed with straw, arranged in groups across the gallery floor. *12 Flags for a War,* from 1999, features the flags of the United States, Great Britain, Australia and other coalition forces involved in the Gulf War.

All of Dorsey's war works can be seen as commemoration pieces which evoke a profound sense of sadness and loss. Their meticulous craftsmanship and soft texture can initially obscure their true message. Dorsey has said that she wants the viewer to have "a delight in something beautiful and then growing disquiet as the content sinks in."[56]

Barbara Heller

Barbara Heller is a tapestry artist with a studio in Vancouver, British Columbia. She has created and exhibited her work for the past thirty years, teaching and promoting this traditional art through articles, symposia and other media. Through her work she has demonstrated that this medium is as modern and relevant as any other, and can be very effective in

allowing an artist to create a record of her world and her response to it. She has said that "medieval tapestries were political or religious parables clothed in classical allusions," but "the familiarity and non-threatening nature of textiles allows me to seduce the viewer into taking a closer look at preconceived assumptions, and perhaps, to make changes."[57] Heller has also stated that she uses her own photographs and her Jewish heritage as influences in her work, which reflects her concerns about events in the larger world, including those of 9/11, the destruction caused by landmines and the impact of senseless wars on civilian populations.

Originally a printmaker, she developed chemical pneumonia from the fumes. As a result, she needed to find a new medium for self-expression. In explaining why she was drawn to working in tapestry, Heller explained that she saw a traveling show of tapestries from Poland in 1974, and recognized that there are more possibilities for tapestry than just those depictions found in medieval and Renaissance Europe. She realized that tapestry can be used to provide commentary on political and social issues such as war and its impacts. She also chose tapestry because it is possible to work for a period of time and then leave the work when necessary without negatively impacting the piece, especially important because she has children, and the medium is non-toxic. Her work reflects her talent as a figurative artist, which when coupled with her expressive use of color, allows her to create woven works that resemble a painted canvas. Heller's commentary against war has been a thread that has run throughout her career.

In a recent series of tapestries that deals with "current threats: nuclear war, environmental degradation, the implications of 9/11, the legacy of landmines ... she incorporated dead birds in many of her tapestries, a personal icon representing the senseless killing of war."[58] Her large tapestry, *Still Life ... With Bird* (C11), which was made in 2003, measures five feet by five feet square. It features handspun cotton and wool weft on a linen warp. A large bird-like creature, fashioned from actual bones, hovers over the skeletons of tall buildings set against an orange background that resembles fire. The piece could be interpreted as representing New York City in the aftermath of 9/11, or any modern city after it had been devastated by war. Two smaller twelve and a half inch by twenty-four inch horizontal tapestries, titled *War Zones: Bosnia*, and *War Zones: Rwanda* feature dead birds, laying on their backs. A vertical piece of the same size, titled *War Zones: Somalia*, also features a dead bird, and as with the other two, the figure of a human has been superimposed on the dead bird.

In her *Cover Up Series—Afghan Woman* from 2001, which measures thirty-five inches by twenty-five inches and is composed of a wool weft on a linen warp, an Afghan woman entirely enrobed in a bright orange burqa stands in front of a grey stone wall. The image reminds the viewer of the repression women in that region faced under the Taliban regime, which ruled Afghanistan after the Soviet withdrawal in 1989. In another work from the series, titled *Eritrean Refugees*, two women in red robes walk together across a desert landscape that features tents in the background. Of both these works Heller has said she is "illustrating how we "cover up" our identities by covering ourselves, whether we choose to wear the costume or whether it is imposed upon us."[59] Other figures in this series include images of French Foreign Legionnaires and Canadian Klansmen.

Barbara Hunt

Barbara Hunt, originally from Winnipeg, currently lives and works in Newfoundland where she is a professor at the Grenfell campus of Memorial University in Corner Brook. She

works primarily in textiles and her current work provides a commentary on the devastation of war by knitting antipersonnel land mines in pink wool. She began her *antipersonnel* series (C1) in 1998 and has continued it into the twenty-first century; to date she has created approximately fifty knitted landmine sculptures. Hunt takes the traditional feminine, soft craft of knitting and creates a commentary on the hard weapons of destruction, making the viewer sees them in a new light without diminishing their destructive power. The artist saw a demonstration of the impact of these weapons on a civilian population long after the war in which they were used ended, and was aware of the worldwide attempts to locate and destroy them. Her knitted landmines serve as a reminder of the many and varied types that remain and the importance of the removal programs. She uses irony and ritual, through the medium of a nurturing skill, to comment on a deadly weapon that results in loss and grief.

Knitting is not Hunt's only tool for social protest. Her other works which comment on the impacts of war are made from worn camouflage army fatigues. In a piece called *Fodder* from 2003/04, she hangs military jackets alongside each other on a wall. The piece was part of an exhibition titled *Dark Cloth* held at the Textile Museum of Canada in 2004. The focus of the exhibition was cloth and its capacity to express powerful ideas about conditions in contemporary life. Its goal was to show that the usual ideas associated with the domestic arts—quilts, wallpaper and hand weaving—can be subverted to express ideas about violence and cruelty. Hunt has said: "as a descendant of Irish/English pioneers I was taught some of the textile skills expected of women, living in Newfoundland with its rich tradition of textile processes.... The repetitive nature of textile works seems to be a common way of coping with grief and loss."[60]

Michele Karch-Ackerman

Michele Karch-Ackerman is an installation artist who works with knitting, sewing and quilting, techniques which she calls "domestic acts of love." An installation is a work that takes over or transforms a space, indoors or outdoors, and that usually gives the viewer a sense of being not only a spectator but also a participant in the work.[61] Her installations serve as a commentary on events in Canadian history that involve loss, especially in women's lives. Originally trained as a painter, Karch-Ackerman switched disciplines after the birth of her children. She felt knitting and sewing fit more easily into her new life than painting did, and as such opened up a whole new world of artistic possibilities.[62]

The Sweaters is a nationally touring installation created by Karch-Ackermen which memorializes the loss of young lives during the First World War, in particular members of the Newfoundland regiment who fought in the Battle of Beaumont Hamel, France. The unsuccessful attack occurred on 1 July 1916 during the first day of the Battle of the Somme on the war's western front. The Battle of the Somme was the regiment's first major engagement, and during an assault that lasted approximately thirty minutes the regiment was all but wiped out. The installation features hundreds of tiny woolen sweaters hung en masse on a wall, commemorating the many lives lost. The tiny garments, knitted by the artist and several volunteers, reflect the youth of the regiment's members, and remind the viewer of the mothers, wives and sisters at home and the magnitude of their loss. Karch-Ackerman sees the young men who died as the "Lost Boys" from *Peter Pan*, who deserve love and honor for their sacrifice.[63]

Rochelle Rubenstein

Rochelle Rubenstein is a Toronto-based printmaker, painter, fabric and book artist. Her textile work is based on block printing, painting and embroidering silk from which she then creates wall hangings, bed quilts, standing columns and wrapped 'houses.' One of these works is *Fabric Auschwitz* from 2011, a softoleum printed, painted and embroidered silk work that measures seventy-two inches by forty-two inches in size. The fabric piece is a vertical rectangle composed of alternating blocks of horizontal or vertical stripes, dark grey and black in color, reminiscent of the clothing worn by prisoners of war during World War II. Rubenstein has said one of the influences on her work is her Jewish Hungarian relatives who were confined in an Italian refugee camp in 1946. Commenting on her textile technique, Rubenstein has said that she "loved the process of woodblock printing on silk. As the silk never stays put the prints are always a bit of a surprise."[64]

Another of her war-related pieces, *Sept. 11, 2001*, a woodblock printed, painted and embroidered silk measuring sixty-four inches by fifty-five inches, is striking in its depiction of fallen and broken tall buildings atop layers of ground and other buildings. The colors used in the piece are soft browns and light teal, and the beauty of the piece and the fabrics used stands in stark contrast with the destruction depicted.

Rubenstein's mother was a dressmaker, and as a result she learned to design her own clothes and choose fabrics when she was a child. She also incorporates the influence of her mother and her three-dimensional world of dressmaking into her own creation of three-dimensional works of art. Painting and woodblock printing on silk came naturally to her. One of her ongoing projects, *Marginalia*, which combines wood and fabric, is her artistic critique of the religious fundamentalism that led to the events of 9/11. Based on Aztec codices and the drawings found in the margins of sketch books and newspapers, it contains images of dressmaker dummies, gas masks, her Jewish Hungarian relatives in an Italian refugee camp, Aztec figures working and fighting, September 11 scenes, emergency room stretchers and other unrelated images. She typically repeats and re-works some of these images until they become abstract. As a child, Rubenstein loved to draw on both paper and fabric, and combines these two in her current work.

Vita Plume

Vita Plume became a textile artist as a result of her cultural heritage—she grew up in a community that had an active history of textile traditions. Her parents emigrated from Latvia to Canada as a result of World War II. Since they expected to return to Latvia some day, Plume received a Latvian education along with a Canadian one. She started weaving as a teenager at Latvian summer camp and found the process exciting and rewarding. Once she learned to weave, she never stopped, especially intrigued by the language of textiles, the meaning of cloth and what the patterns convey.[65] In her earliest works she addressed her Latvian ancestry through the patterns she used in her weavings. She recognized that by using Latvian patterns she could address the history and culture of this small country and her experiences growing up in Canada as the child of Latvian émigrés who fled the destruction of World War II and the oppression of the Soviets.

Plume moved to the United States to accept a teaching position at the College of Design,

Vita Plume, *Fallen Soldiers*, 2011. Linen, cotton, polyester. 220 panels, each approx. 12 in. by 8 in. (photograph courtesy of Vita Plume).

North Carolina State University in 2001, where she began exploring the relationships of faces to cultural identity. This experience led to her *Fallen Soldiers* project, which began in 2011. This work in progress is composed of panels, approximately nine inches by eleven inches in size, each showing the eyes and initials of one fallen United States or Canadian soldier, casualties of Operation Iraqi Freedom and Operation Enduring Freedom (Afghanistan). The project includes all 159 Canadians who have died in the wars since the invasion of Iraq and 180 (approximately two percent) of the American casualties. The artist provides a key to the exhibition, which gives each soldier's full name, rank, place of birth and date of death. The individually woven panels are arranged on opposing walls in an orderly grid five rows deep, reminiscent of the layout of a cemetery. These portraits are in muted tones of brown and grey, and are abstracted from official military portraits available on the internet. The soldiers' military uniforms are not visible; the images only focus on their eyes, which appear to be smiling in these formal, pre-deployment portraits. Looking into these eyes, the viewer becomes aware that the soldiers are no longer able to look back at anyone.

Plume has said that her work deals with trying to gain some understanding of the war that changed her family's fortunes forever and that *Fallen Soldiers* commemorates the thousands of soldiers who have died in Iraq and Afghanistan, and to all of those who have been

killed or injured by war. For Plume, it is a statement of commemoration and protest about the true cost of war and in honor of all the lives that were and could have been.[66]

Barbara Todd

Barbara Todd is an interdisciplinary artist, working in photography, drawing and cut-out silhouettes, but is best known for her quilted textiles works. Canadian by birth, she divides her time between Montreal and Troy, New York. Her quilts reflect her experience with cut-out silhouettes, since some include black cut-out figures appliqued onto a deep blue background. Her imagery frequently includes rockets and guns. In her work throughout the 1990s, she used the hand quilted bedcover to create works that presented links between the human body, domesticity and warfare. One quilt was part of an exhibit of Todd's work at the Textile Museum of Canada in 1998. By using child-like cutouts of weaponry, she emphasizes the loss of innocence that occurs in warfare, which is stark opposition to the usual idea of quilts being part of the comfortable furnishings found in a home. As with many of her textile artist sisters, she uses a craft usually associated with domesticity and nurturing to emphasize the disharmony of life on the home front that occurs with war, and the inescapable truth that war touches everyone. Todd has commented, "I try with each new work to mingle the pleasures and anxieties of mundane dailyiness with larger themes."[67]

Todd's work combines links between domesticity and warfare, contrasting security and mortal danger, creating an unsettling tension for her viewers. She uses her sewing skills to explore these tensions, creating items that are equated with human comfort, such as quilts, and protection with an acknowledgment of the dangers in our world through the images she includes. Fabric is her canvas, and needle and thread are her instruments of commentary and communication on the realities of war and its impacts.

Helene Vosters

Helene Vosters is a performer, scholar and activist whose work focuses on the role of public mourning practices in the construction of narratives on death related to war and militarism. The Toronto native's intention for her anti-war performance *Unravel* is to focus attention and intention around the loss and fragmentation that results from the violence of war and to investigate the relationship between "gestures of care and the potential for empathetic connection within the context of anti-militarist struggle."[68] During the performance she deconstructs a military uniform seam by seam and thread by thread, an activity she sees as "part mourning ritual and part meditation on the warp and weft of militarism's fabric."[69] She seeks to discover the ways in which the military-industrial complex is connect to general society and determine how to disentangle these connections. *Unravel* has been performed in numerous venues in Canada and the United States and Vosters invites non-artists to participate in the uniform unraveling. She hopes that the communal art making resulting from an unraveling will lead to a broader conversation about the role of war in contemporary society.

At dawn (7 a.m.) on Remembrance Day, November 13, 2013, Vosters staged her performance *Shot at Dawn,* in Veterans' Memorial in Queen's Park, Toronto. For the performance, twenty-five participants, each wearing a blindfold embroidered with the phrase "Shot

at Dawn" and the name and date of the execution of one of the twenty-five Canadian soldiers who were killed by Canadian firing squads during World War I, stood before the Veterans' Memorial as if facing a military firing squad. *Shot at Dawn* is the first in her series titled *Embroidery for the Forgotten Dead of History*, which uses embroidered textiles to call attention to and "disrupt narratives produced through the nationalist and militarist commemorative practices which act as frames that inscribe certain events and losses into social memory, while casting "others" (events and populations) beyond the realm of our (dominant) collective memory."[70]

From the earliest times in Canada, women assumed the role of seamstress and creator of textiles for both comfort and protection. But they were not content with just creating functional objects, they also used their skills to add beauty as well as utility to the objects they created. Native men went into battle wearing clothing provided by the women, When it became necessary, Aboriginal women used their sewing skills to provide an income for their families, their art Post-contact reflecting the women's creativity and individuality in creating objects that were also pleasing to their conquerors. These First Nation women have been able to use their art in modern times to express their own ideas and commentary on contemporary life for themselves and their people, as well as to comment on what happened to their country.

As other women came to Canada to settle and make homes, they created textiles that enhanced their environments and provided comfort and beauty in their surroundings. These items also often expressed their patriotism and assimilation into their adopted country. In modern times, women in Canada, as in other parts of the world, have used their artistic skills to express their own ideas and political opinions, allowing their textiles to move from items of utility to works of art. Contemporary women artists continue these early roles, but their art is created as art, not only for utilitarian purposes. They have formalized their commentary on war and created a vocabulary based on traditional materials and techniques. But their contribution to the dialogue between artists and their society is as strong and clear as their art.

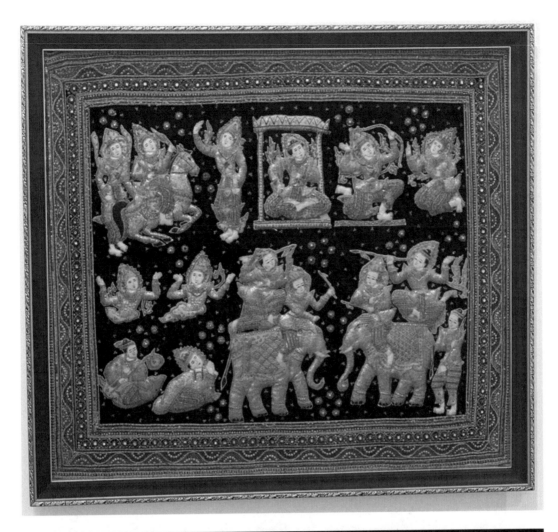

Top: Shwe chi doe (Kalaga), Burma, early twentieth century (courtesy Denison University Museum Collection). *Bottom:* Barb Hunt, *antipersonnel*, 1998-ongoing. Hand-knitted yarn. Dimensions variable (photograph by Art Gallery of Ontario, courtesy Barb Hunt).

Azra Aksamija, *Monument in Waiting*, 2008. Hand-woven wool kilim, prayer beads. 70¾ in. by 130 in. (photograph courtesy Azra Aksamija).

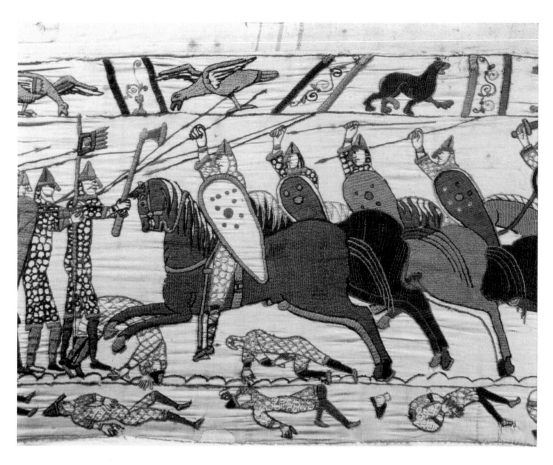

Top: The Bayeux Tapestry (detail): Saxon cavalry under Harold II, 1020–66, King of England at the Battle of Hastings, England, eleventh century. Musée de la Tapisserie Bayeux (photograph by Gianni Dagli Orti/The Art Archive at Art Resource, New York). *Bottom: Gauntlets,* unknown Plateau artist, North America, circa 1880. Faceted glass beads on brain tanned hide with cotton lining. The Elizabeth Cole Butler Collection. 2012.126.73a,b (courtesy Portland Art Museum).

C3

Left: Overlord Tapestry: The Blitz detail, 1968–1972. Appliqué embroidery, cloth on linen. Whitbread's Brewery (The Art Archive at Art Resource, New York). *Above:* Mary Tuma, *Twisted Rope*, 2011. Fabric (courtesy Mary Tuma).

Ruth Carol Coombes, *Liberty in America*, 1986. Hand appliqué, machine piecing, hand quilting. 72 in. by 72 in. (courtesy La Conner Quilt & Textile Museum).

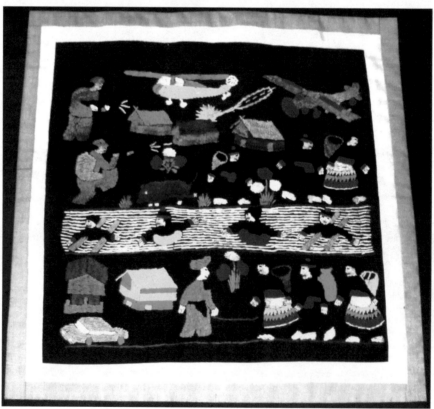

Top: Frances Dorsey, *Spill, The Mothers*, 2010. Used linen tablecloths; natural dyes and extracts, stitching (photograph by Steven Farmer, courtesy Frances Dorsey). *Bottom:* Hmong storycloth pillow cover, Thailand, late twentieth century. Cotton and embroidery floss. 17¼ in. by 17 in. (collection of Deborah Deacon).

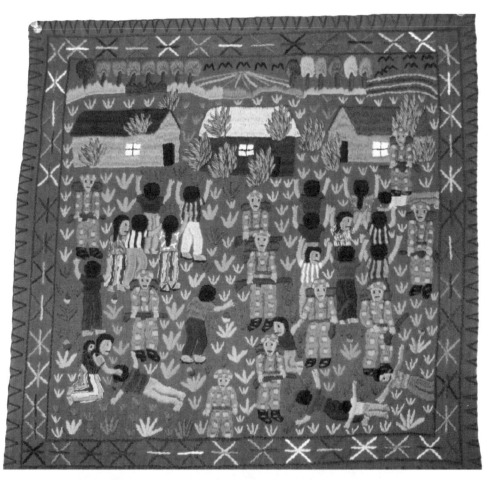

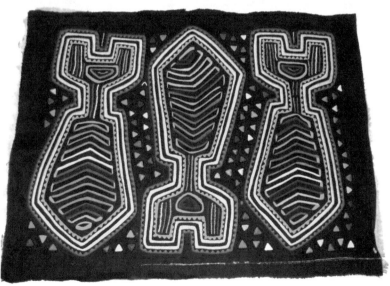

Top: Embroidery, Guatemala, early twenty-first century. Yarn on cotton fabric. 18½ in. by 18 in. *Bottom: Bombs* mola, Panama, twentieth century. Cotton and embroidery floss. 12¾ in. by 17⅛ in. (both collection of Deborah Deacon).

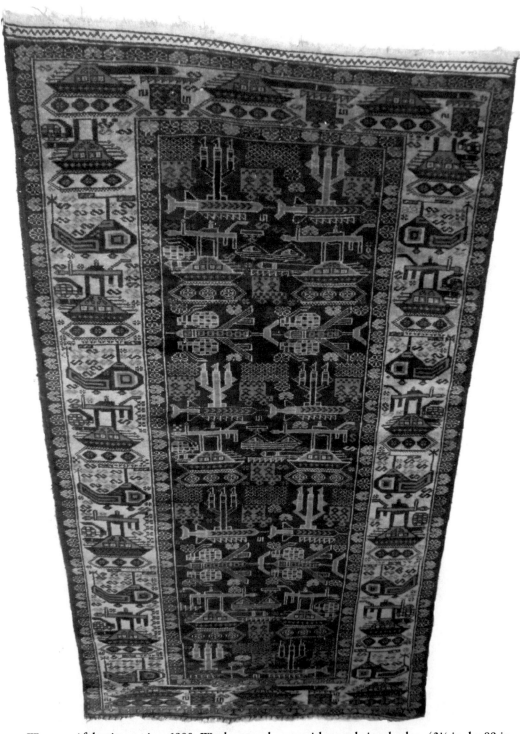

War rug, Afghanistan, circa 1980. Wool on wool warp with goat hair selvedge. 43½ in. by 89 in. (collection of Deborah Deacon).

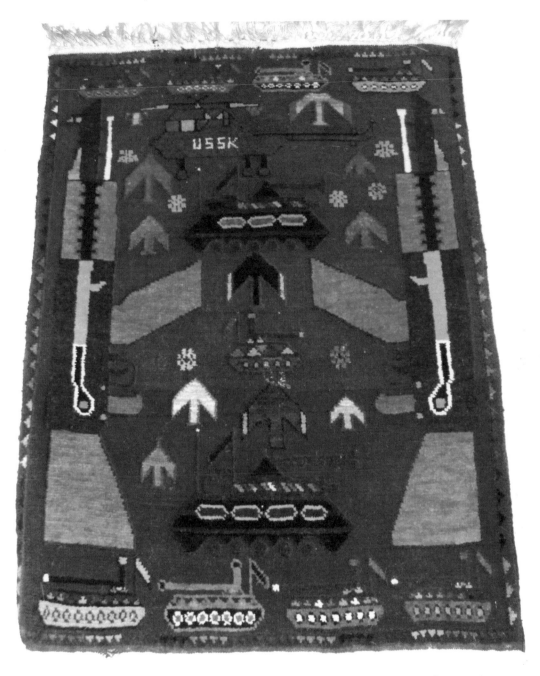

War rug, Afghanistan, circa 2010. Wool on cotton warp (collection of Deborah Deacon).

Sara Rahbar, *Barriers of Separation and Distance (Flag #29)*, Iranian-American, twenty-first century. Textiles and mixed media. 79 in. by 47 in. (courtesy Sara Rahbar).

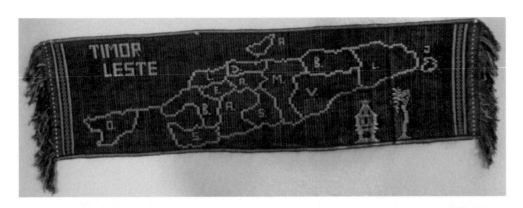

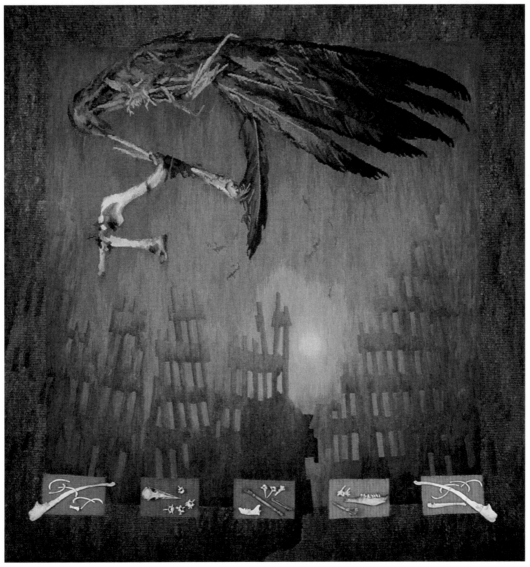

Top: Timor-Leste, wall hanging, East Timor, circa twentieth century. Cotton and synthetic yarn (courtesy Chris Lundry). *Bottom:* Barbara Heller, *Still Life ... With Bird*, 2003. Handwoven tapestry. 62 in. by 60 in. (courtesy Barbara Heller).

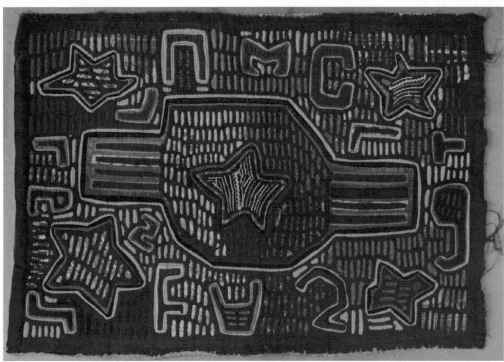

Top: Zapatista dolls, Mexico, late twentieth century. Cotton wool, yarn and embroidery floss (collection of Deborah Deacon). *Bottom: Stripes* mola, Panama, twentieth century. Cotton and embroidery floss. Kuna Indian mola from the Elizabeth Hans Collection. Copyright Diana Marks (courtesy Diana Marks).

FOUR

Latin America

The countries which comprise modern Latin America extend from Mexico south through Guatemala, Panama, Colombia and Peru to the southern tip of Chile and Argentina. United by the Spanish language, they share many common cultural traditions. Some of these traditions—the Roman Catholic religion, their alpha-numeric writing system and literature—were brought to the region by the Spanish conquistadors. Others, such as stone carving, textile production and pyramid building, are native to the cultures that originated in the region. In most of these cultures, during pre-industrial times, women wove the cloth that was worn by both the aristocracy and commoners, was used as tribute payments, and was worn by warriors into battle. This cloth was often embellished with brightly colored feathers or elaborately woven or embroidered geometric and figural images, which often included depictions of warriors carrying weapons and the heads of their defeated enemies. These same images were seen on steles and in paintings and carvings found on important buildings and ceramics. In these early cultures where warfare was an integral part of society, women, specifically the cloth they wove, played a key role even though the weavers did not directly participate on the battlefield.

The arrival of the Spanish brought changes to traditional cultures in the region. The Spanish introduced the concept of weaving workshops where men often became the primary weavers. Traditional imagery was replaced with European and Christian symbolism, although in some instances they were combined to create a new iconography for local elites. Women continued to weave in their homes, creating linens and clothing used in everyday life. These textiles also made use of the new iconography.

As Latin American countries gained their independence in the nineteenth century, they struggled to determine the type of government they would adopt. By the third quarter of the twentieth century, many of these countries plunged into civil war, which resulted in the disappearance, torture, and murder of thousands of citizens. Throughout the chaos, women continued to produce textiles for household and personal use. They also created textiles that commented on the violence that surrounded them, documenting the terror and giving a voice to the powerless.

Mesoamerica

While the exact date of the arrival of humans in the Americas is unknown, contemporary scientific evidence indicates that people had arrived in the region approximately thirteen

thousand years ago.[1] The evidence of earliest human habitation does not include actual textiles; however, there is evidence that textile production, and the use of the backstrap loom, began in Mesoamerica in ancient times. The earliest Mesoamerican weaving dates to between 3000 BCE and 1500 BCE, known from plain-weave impressed pottery shards found in Ecuador.[2] Loom weaving in the Americas is believed to have actually begun in South America after 1800 BCE and moved north into Mexico shortly thereafter. In addition to decorative images woven into Mesoamerican textiles, embroidered and painted images were commonly used as decorative elements on textiles throughout the region.

The importance of weaving in Mesoamerican cultures was documented by the Spanish conquistadors who arrived in the Americas in the sixteenth century. Weaving was the domain of women and the life of a Mesoamerican woman centered around textile production. Female babies were presented with the equipment used in textile production—spinning whorls, battens, a reed basket, skeins of yarn, a shuttle and a spinning bowl—at birth. At a woman's death, the equipment was burned with her body.[3] During her lifetime, a woman produced all of the utilitarian textiles required for her family's needs, as well as the cloth used for tribute payments. In many cases, women produced the luxury textiles worn by the elites and used in religious ceremonies. They also produced the clothing worn by warriors into battle. Many of these textiles featured abstract geometric designs; others contained representations of flora, fauna and human figures.

Because Mesoamerican cultures used pictorial systems as their written language, much of the imagery depicted on their textiles can be seen as a non-verbal system of visual communication, conveying information about the wearer's social status, occupation, and age as well as their cultural beliefs and history.[4] Imagery also denoted military rank and solicited the help of the gods for successful hunts and military campaigns.

The Aztecs

The Aztec Empire (13th–16th centuries CE) encompassed 80,000 square miles in central and southern Mexico, spanning from the Pacific Ocean to the Gulf Coast and south into modern day Guatemala. At the height of its power, the multi-ethnic population exceeded fifteen million people.[5] Aztec culture was based on warfare. From a young age, boys were schooled in the arts of war, expected to prove themselves as courageous warriors on the field of battle as adults. While they did not fight the enemy on the field of battle, Aztec girls were not exempted from the warrior culture. Childbirth was metaphorically seen as a battle and girls were told from a young age that they could one day achieve victory on the battlefield by giving birth. Bernardino Sahagun, a Franciscan friar who studied Aztec culture for more than fifty years early in the Spanish colonial period, noted that a woman in labor had "become as an eagle warrior ... as an ocelot warrior [who] returned exhausted from battle."[6] At the birth of a child, the midwife shouted war cries, an indication that the new mother had "fought a good battle, had become a brave warrior, had taken a captive, had captured a baby."[7] Women who died in childbirth were honored as fallen warriors, believed to become goddesses who accompanied the sun on its track across the sky from noon to sunset throughout eternity.

The Aztec woman's world was also closely tied to the production of textiles. Two Aztec goddesses were associated with fertility, sexual power, and women's work. Xochiquetzal was

the goddess associated with beauty, sexual power, pregnancy, childbirth and women's crafts such as weaving and embroidery.[8] In her role as the patroness of weaving, she is depicted as a beautiful, youthful woman and with looms, spindles and weavings. As the goddess of motherhood, fertility, and midwives, she is portrayed as an old woman with a skull face, carrying the spear and shield of a warrior. The fertility goddess Tlazolteotl was associated with licentiousness and childbirth, and also served as a patroness of weavers. She is depicted with spindles and threads "stuck in the unspun fillet of cotton that encircles her head."[9]

In addition to producing textiles for family use, Aztec women were responsible for making the luxury feather cloaks and garments worn by rulers, deity impersonators during religious ceremonies, nobles, and warriors. Featherwork was a complex, time consuming process in which feathers from macaws, parrots, flamingos and other birds were attached to a plain weave textile, beginning at the bottom edge of the fabric. The feather was applied to the surface by bending the quill, then stitching it to the fabric. New rows were added above the previous ones, typically varying the colors to create geometric patterns of squares, rectangles and checkerboards. A tunic can contain five thousand feathers and could take months to complete, making featherwork the most highly prized textiles in Aztec society.[10] So important to the proper conduct of warfare were these feather textiles that no great warrior could go into battle without one. Non-feather decorated woven cotton textiles tended toward abstract representations whose stepping, zigzag and rectangular designs, related to the local landscape and architecture, were created primarily in white and indigo blue or brown and white. While the textiles Aztec women wove did not depict warriors or actual images of war, they played an integral role in the Aztec warrior culture, as did the women who created them.

Peru

Textiles also served as an important symbol in several Peruvian cultures, including the Inca Empire. Established in the mid-fifteenth century, the Inca Empire encompassed the area from modern day Ecuador south to central Chile. But weavings by a variety of cultures in the Andes Mountains predate the Inca Empire, originating in the first millennium BCE. Much of what is known about Andean textiles comes from mummy burial bundles which have survived in the dry Andean climate.[11] These textiles show that fibers were worked earlier in this region than other materials, such as clay. Basketry is known to have been made as early as 8600–8000 BCE and the impression of plain weave fabric has been seen in accidentally heated clay dating to approximately 3000 BCE. Cotton cultivation, important for fishing nets, carrying cloths, and clothing, was developed along the Pacific coastline while camelid fibers were used in the mountain regions.

Among the textiles known from the mummy burial bundles that date from the Early Horizon–Early Intermediate Period (300 BCE–200 CE) are embroidered Paracas vicuña wool mantles, shawls and loincloths that feature borders of a light colored cotton plain weave background with the images embroidered in warm colors. Paracas textile production was highly developed and the textiles served as symbols of wealth and prestige. They were used as bartering items for diplomatic and military negotiations, as well as offerings in religious ceremonies.[12] Upon an individual's death, the body was wrapped with a cord to hold it in the fetal position, then in several layers of textiles and either placed in a necropolis that con-

tained several large subterranean burial chambers able to hold up to forty mummies or buried in single graves. It is believed that each burial chamber was owned by a specific family or clan and was used over the course of many generations, while the bodies buried in single graves do not necessarily appear to have been related to those buried around them.

Mantles, which also served as coverlets, hangings, or mummy wrappings, feature an embroidered border on all four edges, while loincloths typically have narrow embroidered borders on three edges. The mantles were heavily embroidered, and the most elaborate were reserved for the most important people in the society, who deserved the hours of work required to make the mantles for their glorification and protection in death. The embroidery, which was done using cactus quills for needles, has two distinct styles: geometric, which features abstract birds, serpents and pumas, and curvilinear, where the figures bend and twist, and include dancers, warriors, composite beings, animals, birds, and fish. Figures are first created with dark outline stitches, then the area is filled in using running and stem stitches. Couching is also used. Figures are depicted with the head in a frontal position and the body in profile.[13] The masked warriors depicted in a Paracas loincloth in the collection of the Museum of Fine Arts Boston are embroidered with black, camel and olive green bodies wearing tunics with embroidered borders, on an olive ground. The figures each carry a knife and hold a severed head in their right hand.

The Late Intermediate Period (1000–1476 CE) on the north coast of Peru was a time of disunity where a variety of cultures in the region interacted in peaceful trade and warfare. Like other Andean cultures, women of the Lambayeque culture produced high status textiles for the elite as well as fabrics for everyday use. They wove long narrow bands of tapestry weave which were decorated with complex imagery featuring human figures, animals, flora, geometric patterns and images of the gods, done in a subdued color palette of white, olive green, gold and brown. The bands were cut to a needed length and then sewn onto garments. One sleeve fragment from the period, in the collection of the Museum of Fine Arts Boston, shows three large figures wearing crescent headdresses, flanked by smaller figures, a traditional Andean power relationship depiction of a captor who holds the hair of the smaller captives. Two of the figures wear tunics covered with gold-colored squares, representations of tunics with appliqued beaten gold plaques. The third figure wears a tunic with a traditional zigzag pattern.[14]

Textiles also played a prominent role in Inca court life and diplomacy, as they were used to differentiate the elite from commoners, who were forbidden to wear brightly dyed textiles by strict sumptuary laws. Textiles were the Incas' most prized possessions, serving as a form of artistic expression and communication and identifying an individual's sex, social rank, region of origin, and culture.[15] They also served as indications of power. Inca rulership of a conquered region was demonstrated through textiles, the geometric symbols an indication of the diversity of the people and places under the ruler's control. Inca rulers rewarded military heroes with specially decorated woven tapestry coca bags, which were worn with pride by the recipients. Prisoners of war were stripped of their clothing and forced to wear a special tunic to mark their humiliation as captives. Processed and unprocessed textile materials such as woven cloth and spun fibers served as currency and tax revenue.[16] Textiles provided information about the nature and order of the Inca universe. In some cases, weavings served as a metaphor for farming as geometric patterns mimicked the local landscape; their creators were seen as "weaving the land."[17] Textiles were also associated with local plants and animals,

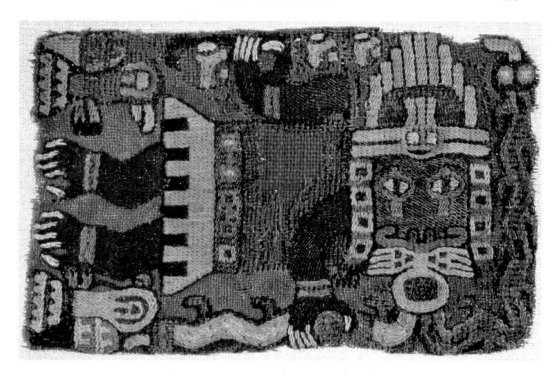

Paracas Embroidery, Paracas, Peru, 600–200 BCE. Alpaca wool (Werner Forman/Art Resource, New York).

which were transformed by weavers into decorations on ritual and utilitarian cloth. Women were the primary weavers in most regions in the Inca Empire, although men did weave secondary textiles. The women who produced high status textiles, those intended for the sun and rulers, also held high status in Inca society. The sun was considered the greatest of the celestial powers, and those textiles intended for use during religious ceremonies were considered to possess cosmological power and importance. The women, known as Aclla, lived privileged lives in walled, single access textile workshops. Their work was documented by the Peruvian chronicler Guaman Poma, who included an illustration of women spinning under the direction of a woman overseer in his works.

The aesthetic appearance of a textile was key for an Inca weaver. The value and hue of the colors used were important to the artistic effect of a piece of cloth. Abstract, repetitive patterns were most prevalent in pre-conquest Inca textiles, which were woven in cotton or camelid hair. The predominant color palette included red, yellow, ochre, brown and black, with some green, white, blue and purple, much of it coming from the natural color of the fibers used in weaving.[18] Native cotton grows in a variety of natural colors, ranging from white to soft pink, brown and grey. Camelid hair, which ranges from white through pale brown to black, with camel being the most popular color, came from the undomesticated guanaco and vicuña and the domesticated llama and alpaca.[19] Natural dyes from minerals and plan fibers were also used. Vicuña hair was particularly valued for luxurious tapestries for rulers and as gifts from rulers to conquered provincial leaders. Few of these luxury textiles have survived, victims of ritual burnings as sacrifices to Inti, the sun, the greatest celestial power, and the Spanish Conquest.

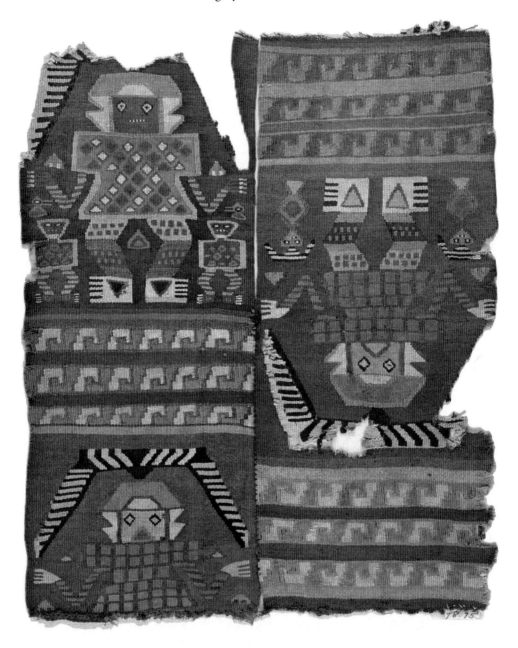

Fragment of a Sleeve, Peruvian (Lambayeque), Late Intermediate, AD 1000–1476. Cotton and wool slit tapestry. 13¾ in. by 11⁵⁄₁₆ in. Museum of Fine Arts, Boston. Gift of Edward W. Hooper, 78.75 (photograph copyright 2014, Museum of Fine Arts, Boston).

In the pre-conquest period, Inca men wore an *uncu*, or tunic, over their cotton loincloth. Military *uncu* featured a black and white checkerboard pattern on the tunic's body, with an inverted step-triangle in red running from the shoulders to the middle of the tunic. As warriors stood shoulder to shoulder, the tunics formed a visual representation of the Inca cosmos, the rhomboid depicting the upper and lower worlds, while the red represented the human

world.[20] The Inca key, repetitive geometrics composed of two squares, separated by a wide slash, placed in two corners of a larger square or rectangle, was another pattern associated with Inca warrior attire.

With the arrival of the Spanish in South America in the early sixteenth century, Inca textile iconography began to change, the result of conquistadors marrying into Inca society. The Inca elite continued to proclaim their noble status through their clothing, although by the end of the sixteenth century, adult males from the Inca nobility wore Spanish dress, reserving their *uncu*, worn over breeches, for special occasions.[21] Military-type tunics disappeared with the Spanish conquest and high status *uncu,* done in double-faced tapestry weave, began to feature Western imagery including European heraldic symbols, the Hapsburg double-headed eagle, and Christian symbols. The color palette and garment sizes also changed, the result of the relocation of textile production from the home to *obrajes* (workshops) and intermarriage between the small framed Incas and larger Spaniards, as well as the introduction of wool from imported sheep, metallic wrapped yarns, and silk. Colonial period textiles typically feature depictions in blue, red, pink and purple on a white background.

The *uncu,* which was used to clothe religious statues in Peruvian churches until the late eighteenth century, served as a useful tool for Spanish officials who saw its use as a way to maintain social distinctions within the population and the pre-conquest social infrastructure, providing an easier transition to Spanish rule, turning them into a tool of conquest.[22] Church officials saw *unca* that featured Christian religious imagery as didactic tools, a way to teach Christianity to an illiterate population. Clothing a statue of a male saint in an *uncu* helped new converts more readily accept the new religion. An *uncu* in the collection of the American Museum of Natural History is an interesting adaptation made during the colonial period. The brown and tan top portion of this *uncu* indicates the high status of the Inca wearer, while the border contains Spanish influences, referencing the garment's two intended audiences. The *uncu*'s border features several groupings of paired figures wearing traditional Inca military and civilian *uncus.* The figures carry shields, axe-sceptors and staves, weapons associated with warriors. The border also features European heraldic and religious imagery—a lion, the Augustinian heart pierced by an arrow—as well as abstract geometric forms, combining visual elements from two disparate cultures into a new cultural iconography, one that serves as a reminder of the proud Inca past while acknowledging the new reality of their lives, making this *uncu* and similar textiles subtle sites of resistance and commemoration of a culture now lost. By the beginning of the nineteenth century, traditional Inca dress had virtually disappeared from the region, the victim of conquest, modernization and westernization.

The Maya

At its height, the Maya culture of Guatemala stretched from southern Mexico in the north to modern day Nicaragua and El Salvador in the south, and from the Caribbean in the east to the Pacific Ocean in the south and west. Like many other Mesoamerican cultures, textiles played a key role in Maya society, although most of the surviving Maya textiles date from the twentieth century, due in large part to the rain forest climate throughout the region which causes the rapid deterioration of cloth. Much of what is known about pre-conquest

Maya textiles comes from wall paintings and carvings. Traditional textile patterns included stripes, geometric designs, animals, maize plants, birds, flowers and trees, an encoding of the Maya vision of the world.[23] With the arrival of the Spanish under Pedro de Alvarado in 1523 and the fall of the Quiché and Cakchiquel kingdoms in 1543, some western images were reinterpreted by Maya weavers to give them a Maya context.

In the pre-conquest period, weaving was considered to be women's work, done on a backstrap loom, typically using a brocade technique which produces an identical image on both sides of the textile. In Maya mythology, the goddess Ixchel taught the first woman to weave, and the Maya consider cloth to be born on the loom.[24] Women were seen as guardians of Maya culture and values and the *Popol Vuh*, the native text of Maya myth and history which was translated into Latin and Spanish by the Spanish invaders, warned against abandoning Maya beliefs and traditions, which would be seen as a betrayal of the ancestors. This warning would have applied to weaving due to the social and religious significance of textiles in Maya culture. As a result, Maya mothers have continued to teach their daughters to weave to this day. As in other Mesoamerican cultures, cloth was used for tribute payments and as currency in pre-conquest times. At her birth, a Maya girl was given weaving instruments by the midwife; at her death, a Maya woman was buried with her weaving instruments.

Maya women initially wove in cotton, but with the arrival of Spanish sheep, wool was used in mountain regions. Natural dyes provided a wide range of colors for their work. Traditional dress for men was composed of a loincloth and sleeveless shirt of white or a solid color. Women wore a *huipil*, a long blouse over an ankle-length wrap skirt, held up by a woven sash belt. The *huipil* is made from a rectangular panel, intended for everyday wear. On special occasions, larger, more luxurious *huipil* are worn. Maya textiles are village specific in terms of the weave, color and motifs used, although each weaver develops her own personal designs within the larger village identity, so village members can easily be identified by their clothing.[25] Traditional patterns contain naturalistic representations of fruit, flowers, birds and animals which carry hidden meanings. The bat, for example, is linked to the moon goddess and is often worn by a midwife. Human figures are not traditionally included as part of the traditional iconography. Motifs can cover the entire surface of a garment, be scattered throughout the garment, or appear on isolated bands at the neck, hem or arms of the *huipil*. With the arrival of the Spanish, men often wore trousers made from four lengths of cotton or wool instead of their loincloths. Women added a full skirt with a drawstring waist to their wardrobe, the result of European influence.[26] Unlike in Peru, the traditional motifs were not modified as the result of contact with the Spanish. City dwellers adopted Spanish style clothing, but ethnic Mayans continued to wear traditional clothing.

Traditional dress served as a marker of Maya ethnic identity in rural areas of Guatemala well into the twentieth century. The custom lost popularity during the Guatemalan Civil War (1978–86), an ethnic cleansing designed to eliminate the Maya culture, which was centered in the highlands. During the war, between 100,000 and 200,000 civilians were killed by military death squads and four hundred Maya villages were destroyed, displacing one million people. Ethnic Mayas were subjected to gunfire, abductions and violent death.[27] The destruction of many Maya towns severely impacted Maya weavers' ability to support their families. As a result of the violence and death, many women had become the primary income earners in their families, and in the face of wrenching poverty many continued to try to weave, despite the physical ailments they had suffered during the violence

which were often aggravated by weaving.[28] During the war, many Maya women in the countryside stopped weaving and wearing traditional clothing to avoid being identified as ethnic Maya.

The overthrow of democratically elected President Jacobo Arbenz by the military began a period of ethnic cleansing of the Maya in the region, many of whom were accused of being communists. A number of guerrilla groups formed in the highlands to counter the army's death squads. In 1981, the army created civilian self-defense patrols, known as PACs, to fight the guerrillas. The PACs practiced a scorched earth policy which included mass torture, rapes and murders. The Communities of the Population in Resistance (CPR), which formed in the early 1980s as one of the guerrilla groups, was composed of more than 30,000 displaced Maya from Sierra, Ixcan, and the Peten.[29]

After the war ended, in a continuing effort to escape the stigma of being Maya and to blend into their surroundings, some Maya moved to the cities; these women also stopped weaving.[30] It took many years before those who remained in their villages began to again wear traditional dress as a symbol of ethnic pride, solidarity and survival, and to weave to help support their families. These women returned the use of traditional imagery, reviving the patterns and colors specific to their particular village. Many joined weaving cooperatives which today sell *huipils* and other woven goods to tourists. While Maya women are again teaching their daughters to weave, they are often joined by men who weave on treadle looms, which were initially introduced by the Spanish, to supplement their income.[31] But the *huipil* remains the primary symbol of Maya-ness. The contemporary Maya weaver creating a *huipil* "is not simply [making] a garment to cover her up, but a statement about herself, her community, her culture, and her history."[32] It is a passive form of resistance, an indication of ethnic pride that shows the strength of the Maya woman to persevere in the face of any adversity.

In addition to wearing *huipils* as a showing of Maya pride, women in the CPR (Communities of the Population in Resistance)-Sierra village of Santa Clara in the El Quiché highlands in Guatemala have created striking embroideries that document the horrors they experienced during the thirty year civil war. Quiché is the fourth largest department in Guatemala, with a population of 740,000, eighty-five percent of whom are poor, illiterate Maya. During the civil war, the people in the region were subjected to unspeakable horrors; 327 massacres are documented in the region, with 200,000 killed and a million people displaced, eighty-five percent of whom were Maya.[33]

In 1988, American Ramelle Gonzales visited the CPR-Sierra where she saw firsthand the result of the thirty year long civil war—poverty, fear, disrupted lives. A few years later, after relocating to Guatemala, she established the Foundation for Education, Inc., a nonprofit organization aimed at improving education in Guatemala by providing educational scholarships and establishing boarding schools which emphasize and teach Maya youth about their heritage with the hope of instilling pride in the children.

In addition to working to provide educational opportunities for Maya children, Ramelle worked with a number of Maya women living in Ixil whose lives had been impacted by the violence of the civil war. She suggested that the women participate in an embroidery project to help supplement their income and preserve their history. Guatemalan women have no native embroidery tradition. Most of the women were weavers, but they enthusiastically learned to embroider, taught over a period of three months by a student from Ramelle's

school.[34] She provided the women with the plain cotton cloth and floss used in the project. She noted:

> The original idea was to have the women make embroideries that reflected their daily lives— fetching firewood, bringing water from the river, caring for children, and perhaps making tortillas. While I expected to see their first batch of embroideries depict ordinary daily activities, what I received instead were scenes of bombs falling from helicopters and soldiers killing people.[35]

She was overwhelmed by the emotion the works evoked, as they expressed the women's personal experiences and feelings, reflecting their personal suffering and resilience.

The embroideries are approximately nineteen inches wide and eighteen and a half inches

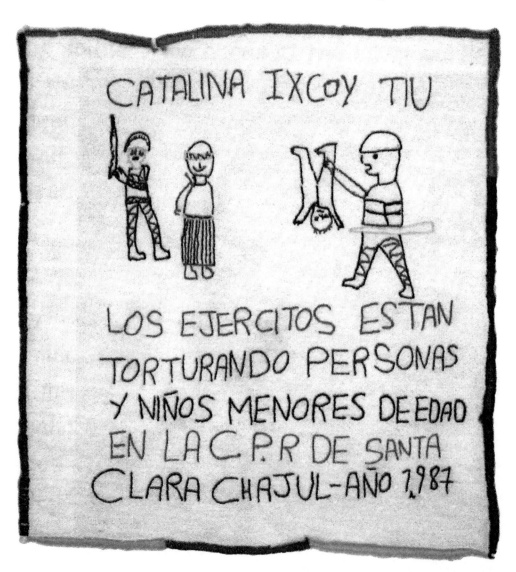

Embroidery, Guatemala, 20th century. Embroidery floss on cotton fabric. 19 in. by 18½ in. (courtesy Ramelle Gonzales).

long. Images of helicopters, people, houses, and landscape are embroidered onto the black or white backgrounds using brightly colored floss. The fabric edges are finished using a blanket stitch. Most of the pieces contained an embroidered narrative describing the scene depicted. A few include appliqué images as well. The embroidered images, done in a naïve style using primarily chain and satin stitches, can be difficult to look at. Some show helicopters shooting at houses in a village; others show mass graves or people being rounded up by the PAC. This embroidery shows a soldier holding an infant upside down by the ankle as another soldier guards a prisoner whose arms are tied behind his back. All of these initial embroideries tell the story of the hunger, fear and death the women witnessed. Manual Antonio Pacheco Caba, a student of the Foundation, commented, "The people dramatize the story of what happened during the war every year so that the children will know what the parents suffered and that no one will forget."[36] By 2000, the women stopped creating the embroideries and returned to weaving, believing that they have told their tale and that their experiences will not be forgotten.

During the early twenty-first century, Ramelle Gonzales began working with women from San Andres Semetabaj, a municipality in the Solola department of Guatemala, as she expanded her educational program in the region; once again her students taught the local women embroidery techniques. The embroideries produced by these women have a much different appearance and feel from the ones produced at Ixil. Rather than depicting simple scenes of violence against individuals or small numbers of people, these embroideries capture the destruction of entire villages and the murder of large numbers of individuals in graphic detail. In the scene shown here (C7), a group of ten men in green camouflage uniforms hold a group of villages at gunpoint. Many of the women are dressed in traditional attire. One soldier restrains a boy who is trying to run to his mother, as she kneels over the bloody body of a man. Three other figures lie prone at the feet of two soldiers. Most stand with their backs to the violence, gazing in horror at the burning buildings in the background, yellow-orange flames blazing from the roofs and surrounding ground. These new pieces, done on backgrounds of royal blue, red or black, exhibit a horror vacui, with green grasses, symbolic of the lush grasslands that surround the village, interspersed among the figures and buildings. Trees and farmland are shown at the top of the embroidery, which is framed by a row of butterflies, symbols of rebirth and love.

Today Maya women are safe from the violence they experienced during the civil war, but they are still poor, dealing with hunger, a lack of clean water, and a lack of education. The sale of their embroideries brings them much needed money and provides them with an opportunity to tell their tale of persecution and death to the outside world.

Chile

After winning their independence from Spain in the nineteenth century, most of the countries in South America were not invaded by foreign powers in the twentieth century.[37] Many of them, however, experienced internal strife and civil wars which took a tremendous toll on their populations.[38] In Chile, under the regime of General Augusto Pinochet, the people were subjected to the traumas of war and the possibility of becoming a "disappeared," a person abruptly abducted by the government, never to be seen again.

Beginning in the early 1970s, the U.S. Central Intelligence Agency began to foster insta-

bility in Chile, trying to disrupt the Popular Unity government of Marxist president Salvador Allende. The CIA's attempts were largely unsuccessful; however, Allende's utopian dreams were derailed by economic troubles in 1972 and 1973, which resulted in a bloody coup by the Chilean military on September 11, 1973, leading to the elevation of General Pinochet as the Chilean leader.[39] Pinochet and his enforcer, Colonel Manuel Contreras, head of the Directorate of National Intelligence, established a network of spies and terrorists whose tactics included kidnappings, torture camps and murder, designed to instill fear throughout Chilean society. In the first three weeks of Pinochet's regime, fifteen hundred people were killed or disappeared. In the seventeen years of Pinochet's regime, more than 280,000 people were tortured or imprisoned.[40]

Most of the *deseparecidos,* or "disappeareds," were men and students who actively opposed the right-wing dictator, leaving wives and mothers to cope with the uncertainty of their fate. The women also had to cope with economic and emotional uncertainty. In Chile, women have historically been seen as a major social force, governing home and family. Their role in public life revolves around feminine concerns such as schools, day care, the income and family.[41] In school, girls were educated in "feminine subjects" such as needlework, music, art, and household operations, skills required to be considered a good wife. These skills helped Chilean women to survive during the adversity they faced during the war.

In the mid–1970s, a group of women formed the Association of Families of the Detained-Disappeared under the protection of Cardinal Raul Silva Henriquez in Santiago. The Cardinal's organization, the Vicariate of Solidarity, worked to help the poor living in shantytowns around Santiago, who were subjected to raids by the military, water and electricity cuts, and the round up of family members. The Vicariate staff was composed of middle class professionals who had lost their jobs in the Allende government or in local universities as the result of the coup.[42] The Vicariate established secret workshops in churches throughout the city, bringing together women to share their experiences and find ways to support themselves. This support came from the creation of *arpilleras,* small fabric wall hangings with burlap backings that used embroidery, applique and occasionally three dimensional figures superimposed on cloth to create scenes of their daily lives, including the arrest and disappearance of loved ones, scenes of prison camps, and police brutality. Typically the groups were composed of approximately twenty women. There was no formal hierarchy among the women and decisions about themes for their work were made by the group. Each group had an official treasurer who distributed sales income to the participants and reviewers who finished the work and insured that each one represented a significant theme and realistic situation. A member of the Vicariate staff picked up the *arpilleras* from the workshops and took them to distribution sites once a month. Since there were few buyers of *arpilleras* in Chile except for the occasional tourist who visited the Vicariate, the *arpilleras* were exported by non-governmental agencies, expatriates and church charities to Europe, Australia, and North America, who smuggled them through customs as sympathetic agents looked the other way, in order to raise money for the women who made them.[43] Sales revenues were returned to the women who used the money to support their families.

The *arpillera* tradition is not native to the Santiago area, but is an ancient folk textile tradition of the Isla Negra region of Chile. Those produced in Isla Negra before 1973 used embroidery and applique on burlap to depict animals and daily life in the countryside. People were rarely included in the scenes.[44] The subject matter of *arpilleras* evolved in large

part due to the efforts of Chilean artist/singer/songwriter/folklorist Violeta del Carmen Parra Sandoval (1917–1967), whose own *arpilleras* were influenced by the Chilean mural movement from the early 1970s which featured political statements representing the voice of the poor. Parra, who taught the art of *arpillera* making to early arpilleraistas in Santiago, often commented that "[a]rpilleras are like painted songs."[45]

Arpilleras are stage-like scenes that tell stories through their flat appliquéd scenes and figures. They are sketches done with fabric and embroidery that resemble a naïve painting, using no sense of perspective or proportion to depict people, buildings and vehicles. At first glance, an *arpillera* appears to be an innocent depiction; however, upon further inspection, its child-like images actually reveal scenes of repression, loss and violence. A form of folk art, *arpilleras* tell a personal story as well as serving as a "tale of the tribe." They are described by the phrase "*sacando sus trapitos al sol*," meaning "to get to the bottom of something."[46] They tell a simple narrative story, complete with heroes and villains, trials and tribulations, and courage and struggle. *Arpilleras* were originally created for private purposes, to express what was in each woman's heart and soul, the sorrow that was too painful to say aloud. They speak, revealing absences, losses and silences and their creation helped the women who created them stay whole and human. Many *arpilleras* were considered to be dialogues with the missing, a means to keep their memories alive, giving the women an opportunity to talk about the events surrounding the disappearance of their loved ones, a way of sharing the preoccupations and worries of their everyday lives. The making of *arpilleras* became both an occupation and a preoccupation, a private art form that became public art as their creators told their stories, letting the world know what was happening in Chile.

Designed to help gain sympathy for their plight, the use of human hair, clothing scraps, skewed perspective, misspellings and child-like lettering showed the women's lack of education and sophistication—and sincerity about their cause.[47] Despite their naïve appearance, however, the designs were carefully carried out and executed. While there were many common themes among the works, each bears the personal, individual style of its creator and each *arpillera* recognizes and memorializes a life. Created in marginalized spaces by anonymous women, *arpilleras* gave a voice to women who had no power, making them forceful, effective expressions of resistance and their creators active participants in the struggle for freedom.[48] As Graciela, a Vicariate employee commented:

> The *arpillera* became a symbol of quite a large group of people who were at that time working, eh, socially, against the dictatorship. You understand? That was sort of the crucial thing.[49]

As word of the *arpilleras* spread, they become a way for women to raise extra money to support themselves and their families. They can also be seen as a "feminine form of political action where personal power is not the goal, but collective power is sought because it is perceived as the only instrument of change."[50] They provided such an accurate picture of the political climate that they were banned for sale in Chile.

Arpilleras and their creators became part of a larger resistance movement in Chile, a movement for memory and justice, joining writers, guerrilla groups, labor unions, artists, exiles and church leaders. While they were nearly invisible in Chile, the *arpilleras* were officially banned by the Chilean government which questioned their creators' designation as artists, considered as "tapestries of defamation" and "anti-Chilean." Early in the arpillerista movement, they were the subject of an exhibition in a Santiago art gallery; a month later,

on January 13, 1977, the gallery was bombed.[51] *Arpilleras* were known outside of Chile and served as vehicles to raise support for the Chilean resistance. In the United States, the academic Chilean expatriate Marjorie Agosin published numerous articles and books about the *arpillera* movement while Professor Eliana Moya-Raggio from the University of Michigan curated exhibitions of *arpilleras* in Ohio and Michigan to raise funds for the arpilleristas. In Washington, D.C., Isabel Letelier, whose husband Orlando was killed by the Chilean military, exhibited *arpilleras* in the Washington area.[52]

Gender played an important role in the success of *arpilleras* worldwide. Sewing and embroidery are considered to be feminine arts and the depictions of children and domestic scenes using bits of cloth and yarn brought the domestic arena into the public sphere, a feminist act that privileged female folk art that helped change history, ultimately contributing to the downfall of the Pinochet dictatorship. As Marjorie Agosin noted:

> The harsh military dictatorship that stressed domesticity and passivity was disarmed, muzzled by the *arpilleristas,* who through a very ancient feminine art exposed with cloth and thread the brutal experience of fascism.[53]

The *arpillera* tradition was not restricted to Chile. In the 1980s, the tradition was exported to Peru where it was used as a form of protest against the atrocities committed by the military government and members of the *Sendero Luminoso,* the Shining Path, the Communist Party of Peru.[54] The Peruvian military overthrew the legally elected government of President Fernando Belaúnde Terry in 1968; in 1980 the military again allowed free elections, which the *Sendero Luminoso* opposed. They instituted a program of violence that was carried out against the peasants, trade union members, and elected officials. Like their sisters in arms in Chile, the poor Peruvian women living in shantytowns around Lima were soon organized into workshops, supported by the Episcopal Diocese of Peru, where they began to create *cuadros* that portrayed the violence, trauma and repression to which they were subjected.[55] The tradition was introduced to Peru in 1979 by German expatriate art teacher Roswitha Lopez who is credited with introducing the *arpillera* tradition in the shantytown Pamplona Alta. She had purchased three *arpilleras* on a visit to Chile and thought that Peruvian women could also benefit from making similar products.[56] In creating the small wall-hangings the women were able to express difficult feelings that cannot be expressed in words. The *cuadros* also served as a means of economic support for their families. The Peruvian *cuadros* differ from the *arpilleras* produced in Chile. While *arpilleras* tended to be flat, somber works with some slight padding and few three dimensional pieces, the images on *cuadros* are rendered in bright colors, with three dimensional objects attached to the surface. Small pieces of wood and faux leather were often used for guns and boots while small dolls were used to depict people. The imagery itself also differed; *cuadros* tended to depict more explicit violence, often showing massacres and the round up of individuals.

As the violence subsided in Peru with the arrest of its leader, Abimael Guzman, in 1992, the women in the workshops continued to produce *cuadros*. The post-war *cuadros* depict happy images of local life—weddings, the marketplace, workers in the field.[57] In one of these *cuadros*, a woman tends the plants in her cabbage patch, as a camelid and sheep look on. Behind her, the sun shines brightly on the hills, two white houses with bright red roofs, and local flora that includes fruit trees and prickly pear cactus. The square, brightly colored three

dimensional quilts, which come in a variety of sizes, are sold in markets, airports, hotels and on the internet, providing much needed income for families living in abject poverty.

At the same time that General Pinochet's troops and the Shining Path were perpetrating violence against the citizens of Chile and Peru, civil war raged in El Salvador. With the assassination of Archbishop Oscar Romero in 1980, peaceful demonstrations against the right wing military government turned violent as it repressed the dissent. Leftist guerrillas organized as the *Farabundo Marti* National Liberation Front (FMLN) in opposition of the government. Seventy thousand people died in the raids that both sides mounted against the civilian population. The FMLN was ultimately unsuccessful in their attempt to overthrow the government, in part due to the assistance given to the Salvadoran government by the United States; however, they maintained military strongholds in the countryside for several years. In 1989, six Jesuit priests, their housekeeper and her daughter were murdered by members of U.S. backed government troops, ultimately bringing the violence to international attention. The United Nations brokered peace talks and a peace accord was signed in January 1992, effectively ending the conflict.

As in Chile and Peru, *arpillera* workshops were set up in San Salvador, sponsored by the United Methodist Church.[58] Women created *arpilleras* that depicted the violence they encountered, often in graphic terms similar to those found on Peruvian *cuadros*. The large *arpillera* shown here is typical of those created during the period. It features a helicopter bombing a home, as green-uniformed government troops watch. A dead body lies on the path that runs to the bottom of the piece. At the left, a white clad friar in front of a church protects a boy and girl. At the bottom of the piece stand four gun wielding guerrillas dressed in black. The site of this particular event, Communidad de Carasque, is embroidered behind one of the government soldiers, marking it as a depiction of an actual event; trees, buildings, the injured man and the smiling sun which shines brightly on the scene are all identified with embroidered labels. On the back of the *arpillera*, a small piece of off-white cloth contains the first names of the women who made the *arpillera*.[59]

No matter where they were created, *arpilleras* have served a number of roles for the creators and those who have experienced them. They commemorate the dead, document historical events, provide economic assistance to those who make them, give a voice to the invisible, and teach us that it is often difficult to live with our memories. As Marjorie Agosin has stated:

> The *arpillera* is an amalgamation of voices and histories appearing in a humble fabric made by the hands of mothers, daughters, sisters, and wives—the living relatives of loved ones who have disappeared.[60]

Arpilleras were not the only form of textiles that allowed Chilean women to express their feelings about the chaos their country experienced during the 1970s. When women in the small town of Ninhue were introduced to the western embroidery style known as crewelwork, they created tapestries that illustrated events from their daily lives. These tapestries, which quickly became popular pieces of folk art, allowed the women to express themselves creatively and provided additional income for their struggling families.

In 1971, Chilean expatriate Carmen Benavente returned to her family's *finca* in the Itata region to visit her ailing father, only to discover that most of the family's farmland, and that of the other wealthy landowners in the region, had been appropriated by their former tenant

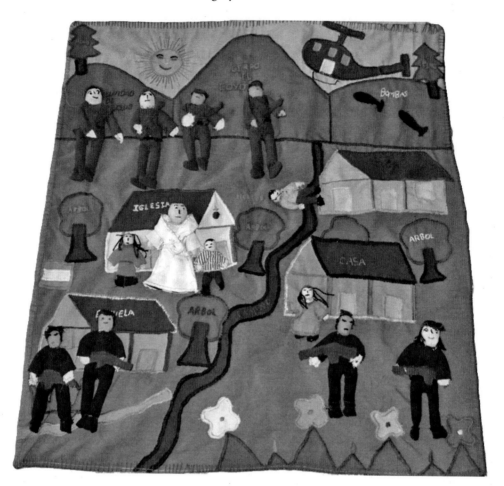

Arpillera, El Salvador, late twentieth century. Cotton, wool and embroidery floss. 27½ in. by 25¼ in. (collection of Deborah Deacon).

farmers who resented the agricultural reforms her family had attempted to introduce. The land redistribution was codified by the *Diario Oficial* which published the appropriation decree of Coroney and Collipeumo in January 1971.[61] As a child, Benavente had spent her summers on the family *finca* and loved the rhythms of country life and the interdependence of the lives of the people who lived there permanently.

As she viewed the unrest, poverty, and violence in the region, she longed to help bring peace and prosperity to the people, and ultimately devised a plan—to bring the women of one small town, Ninhue, together in an embroidery workshop the output of which she believed would help the women financially and emotionally. In addition to the personal connection she had with the women in Ninhue, Benavente believed that the town's isolation and traditional values made it the ideal location for her project. In her vision of the project, she would teach the women crewel embroidery and help them find a market for their works, and the women would be responsible for designing and creating the textiles to be sold. While her idea was met with skepticism from her family members, she actually received help from the local parish priest, who urged community members to work with church-sponsored

groups in a variety of activities including sewing, knitting and cooking. She returned to Santiago to procure the yarn, fabric and other accessories associated with crewel embroidery required for the workshop in Ninhue as well as for those she planned to establish in Santiago. She charged the women in Santiago a modest fee for their embroidery lessons and used that money to purchase additional supplies for the women in Ninhue.

The initial Ninhue group of forty-three women met in an old adobe house owned by the church. There had been a long-standing rich textile tradition in the region, but the younger generation of girls no longer wove, seeing the process as old fashioned and too time-consuming. Embroidery was still used to decorate household linens and occasionally clothing; however, wool embroidery, or crewel, was unknown in the region.

Crewel work, sometimes called Jacobean embroidery, has its origins in seventeenth century England. Known for its graceful designs, beautiful colors and interesting stitches, the embroidery designs typically reflect influences from China, Persia and India, and incorporate fruits, flowers, vines, and leaves in flowing sinuous designs.[62] Typically done on a linen backing, crewel embroiderers use wool yarn to create a number of stitches including chair, chevron, satin and stem.

Benavente's enthusiasm and skillful instruction helped the women overcome their initial apprehension, and before long they were creating tapestries that contained images of their lives—houses and town buildings, landscape, animals, trees and people—all rendered in bright colors according to the creator's own imagination. Colorful images of the *copihue* or Chilean bellflower, the Chilean national flower, and the San Agustin national shrine reflect the women's love of their country, while depictions of daily activities such as watching television, children going to school and farming scenes give viewers a glimpse into their lives. Over time, the tapestries developed a characteristic "Ninhue" look, the result of a similarity of themes, motifs, stitch and color choices, and the mood of the works. Despite a certain commonality, like the *arpilleras* created in Santiago, each woman's voice is apparent in the embroideries.

While the majority of the Ninhue tapestries did not contain politically charged imagery, the result of the town's distance from the violence in Santiago and the local villagers' lack of strong political feelings, several women did create tapestries that addressed war and politics. Fifteen year old Patricia Medena's patriotic tapestry *Naval Battle* depicts Agustin Arturo Prat Chacon, Ninhue's war hero, who commanded an attack against the Peruvian armored ship *Huascar* after it had rammed his ship, the *Esmeralda,* during the 1879 Battle of Iquique. Prat was killed during battle and his name quickly became a rallying cry for Chilean forces. He has been memorialized as a great hero throughout the country, including by Ninhue's bust memorial which Medena depicted in the upper right hand corner of her piece. Medena used French knots in the same color as the background of many of her designs to add texture to her compositions, including this piece. The tapestry shows Prat's twin masted ship, a Chilean flag atop each mast, and Pratt standing on the choppy turquoise waves, surrounded by black whales.

Adela Parra's tapestry *Police Station* can be seen as a protest of the terror inflicted by members of the Pinochet government. A Chilean flag flies outside a generic police station, one that does not resemble the Ninhue police station. Despite the cheerful flowers in the building's garden, the subdued colors of the building and the uniformed policeman and his large police dog give the piece a somber, almost menacing, feeling. Adela has embroidered

her name, the town's name and the numerals 197 in red across the top of the tapestry. The numeral three which completes the date is embroidered in black, a possible reference to the year of Pinochet's coup. Missing from this composition is her trademark dove, a symbol of good luck she originally traced from a cement bag.[63] Parra is a woman of many talents. In addition to being the mother of eight, she raises produce on a large piece of land as well as knitting, sewing, painting fabric and making ceramics.

Benavente kept her promise to market the women's tapestries to help them raise money for their families. Their first exhibition was held at Hernán Edward's folk art gallery, *El Callejón de las Artesanias* in Santiago, receiving significant publicity in the local press and selling all of the tapestries on display. Benavente subsequently took tapestries to the United States, hoping to find additional markets for the works. The tapestries were popular there, selling in museum stores and galleries in several states. Benavente initially exhibited the tapestries at Indiana University and at the Inter-American Culture Center in New York, followed by a major exhibition at the International Folk Art Museum in Santa Fe, New Mexico. Over time, additional opportunities for sales in Chile also opened up, providing the women with additional funds and avenues for creative expression. However, competition from *arpilleras* and shifting artistic tastes in the 1980s, led the women to modify their tapestries to include the addition of three dimensional stuffed animals, people and vegetation. By the turn of the twenty-first century, a number of the women changed their focus, producing cross stitched pictorial rugs, made by a group of women working together on each rug.

Argentina

As with much of the rest of Latin America, Argentina experienced civil war in the 1970s and 1980s, as leftist guerrillas battled a right wing government, a conflict that can trace its roots to the political unrest of the 1950s. During much of this time, Juan Dominguez Perón was an important military officer and politician, serving in several key positions in a number of administrations including three terms as president. His last term began in 1973 and lasted for just nine months, until his death in 1974, when he was succeeded by Maria Estella Martinez, the vice president of the Republic and Perón's third wife.[64] Her government was overthrown in March 1976 by a military junta, beginning the *Guerra Sucia,* or Dirty War, during which thousands of Argentinian citizens were subjected to large scale torture and rape designed to maintain social order and eradicate political subversives. In 1976, Amnesty International revealed the human rights violations in Argentina to the world, including illegal detentions, executions, torture and the disappearance of its citizens which had been occurring for several years. By the time the war ended, thirty thousand people, thirty percent of whom were women, had "disappeared," most likely into one of the three hundred forty torture camps.

As occurred in Chile, Peru and El Salvador, Argentinian women mobilized, seeking answers to the disappearance of their children. They did not, however, create *arpilleras* to tell their stories; rather they used another form of women's work to bring attention to the violence. In 1977, fourteen mothers began walking around the Plaza de Mayo in Buenos Aires daily, wearing white head scarves embroidered with the words *"Aparicion con vida"* (Return Our Children Alive), or the names of the disappeared.[65] Known as the Mothers of the Plaza de Mayo (*Madres de la Plaza de Mayo*), eventually up to one thousand women

joined the daily march in the plaza, creating a social movement for human rights and democracy. The Madres walked because the police would not let them sit, and used their identities as mothers as both a symbolic form of protest and a practical basis to contest oppression. Their own physical weakness was their greatest strength. All Argentinians knew that the military was using force against Argentinian citizens, but given the macho nature of the culture, the military would have been emasculated had they been seen beating up grandmothers in public. As a result, the women were able to hold their protest marches without significant harassment, allowing their protests to come to the attention of the international community, even as the torture and murder continued. Their actions awakened Argentinians to the possibilities engendered by women's resistance. The Argentinian military government finally fell in 1983, following Argentina's loss to the British in the Malvinas/Falklands War—to a country led by two women: Queen Elizabeth II and Prime Minister Margaret Thatcher.

Mexico

On January 1, 1994, masked indigenous guerrillas captured a Mexican Army base and five cities in Chiapas, Mexico. The Mexican government recaptured the area four days later, but the violence continued in the region for several years as the guerrillas fought for better living conditions in the region. Chiapas was both the poorest Mexican state and the richest, populated by poor indigenous Maya farmers and wealthy companies drilling for oil and providing hydroelectric power to other regions of Mexico, displacing the indigenous population from their traditional lands.[66] Two guerrilla groups, the *Ejército Zapatista de Liberación Nacional* (EZLN) (Zapatista Army of National Liberation) and the *Frente Zapatista de Liberación Nacional* (FZLN) (Zapatista Front of National Liberation) claimed to represent the indigenous population, demanding reinstatement of their native lands. The guerrillas were accused of torturing and killing non-indigenous people in the region and quickly became local folk heroes.

At the turn of the twenty-first century, small dolls dressed in black, many masked and carrying guns, began appearing in the region (C12). Initially it was believed that these representations of the Zapatista guerrillas were made by women in Chiapas, despite the fact that they did not have a native doll-making tradition. It was ultimately discovered that the dolls actually were made by Chamula craftswomen from the nearby municipality of San Cristobal de las Casas, allegedly at the recommendation of "an Italian woman" visiting the region in 1994.[67] In addition to a rich textile tradition that includes felting, dyeing and sewing, the Chamula have a doll-making tradition which they adapted to the recent events in the region. While they were impacted by the Zapatista movement, the Chamula were not necessarily sympathetic to it. Rather, they saw the Zapatista dolls as a market product, a way to increase their personal finances in a region of overwhelming poverty. In addition to individual black masked dolls, some wear brightly colored shirts popular with the indigenous population and female figures frequently carry children in their arms. Some figures ride on burros, such as the one seen here, which are used to indicate the indigenous poverty of the region. The dolls, which are three to six inches tall, are made from fabric scraps, twigs and yarn.

The Zapatista dolls gained notoriety as the result of the influx of journalists and human rights workers into Chiapas. In 2006 the Mexican government decided that the Zapatistas were good for tourism and gave their official approval to the sale of the dolls. The dolls

joined the Zapatista T shirts, bumper stickers and coffee mugs for sale in airports and tourist shops, turning guerrilla warfare and revolution into a tourist attraction. The creation and sale of the Zapatista dolls, which can be read as a symbol of the global commodification of both war and native cultures, can also be seen as an indication of the adaptability of an indigenous community to a changing global market.

Panama and Northern Colombia

Molas are probably the most famous type of art produced in Panama and parts of northern Colombia. The brightly colored reverse appliqué textiles have been made by generations of Kuna women who inhabit the San Blas islands on the Atlantic coast. At the time of the arrival of Vasco Nuñez de Balboa in 1510, the Kuna occupied the area around the Gulf of Uraba, and were of great interest to the Spanish conquistadors who attempted to convert them to Catholicism. With the murder of Balboa in 1519, the Spanish shifted their attention from the native population to the search for gold and silver, although Catholic missionaries still worked at converting the population, an unsuccessful endeavor that marked the beginning of the Kuna's resistance to conquest. The Spanish conquistadors left the region in 1611, but were followed by French Huguenot missionaries who lived and intermarried with the Kuna for a century. In 1726, the Kuna expelled the Huguenots from their lands, once again asserting their independence.[68] By the early nineteenth century, the Kuna had migrated to the Darien region of Panama where the women cultivated cacao while the men engaged in hunting and fishing. By the 1850s, they moved into the San Blas islands, although the women continued to farm in the delta region. At the turn of the twentieth century, they planted coconuts on the islands and outlying areas, selling them to trade ships which stopped in the islands.[69] The Kuna continued to maintain their autonomy, resisting efforts by the Panamanian government to bring them under Panamanian control. In 1925, the Kuna again expelled whites from their land, declaring their independence. After a number of skirmishes with Panamanian police forces, the Kuna signed *La Comarca de San Blas,* which allowed them to retain autonomy while their affairs are overseen by a Panamanian governor.[70]

As part of the Kuna need for autonomy, they place great emphasis on their outward appearance as a marker of Kuna identity. Initially this was accomplished through the application of body paint in colored pigments by both men and women. Men traditionally wore loincloths and women wore short skirts made from cloth woven from locally grown cotton, leaving their breasts bare. When the Huguenots began to proselytize among the Kuna, they introduced commercial cloth and sewing implements to the Kuna, encouraging the women to cover their breasts. When he visited Panama in the 1860s searching for a practicable location for a canal to connect the two oceans, Lucien de Pyudt reported that Kuna women wore blouses that went to their knees, edged with yellow and red designs. By 1927, these shirts had evolved to resemble the modern mola blouse, worn over a wrap-around skirt.[71]

The origin of mola making has its roots in mythology, as does the origin of the Kuna themselves. The Kuna believe they were created when life began, but were hidden in the underworld, unseen until Nakekiriai, a god-like woman, discovered them. Eight hundred years ago, Dios-Papa and his wife Nana punished the world three times by fire, darkness and flood. Dios-Papa sent Iborkun, the bringer of moral and ethical teachings, to show the people how to live, including identifying proper social roles for both men and women, such as

a woman's responsibility for making clothing.[72] While the weaving of cloth is a tradition within Kuna culture, the mola blouse is not an indigenous tradition, but rather the result of contact with the west. The mola blouse does, however, serve to identify who is Kuna and who is not.

The modern Kuna blouse is composed of a yoke which extends over the shoulders in front and back, short sleeves, and a front and back mola panel with complementary colored and themed imagery extending from the yoke to the hem. The complementary imagery is linked to the Kuna belief that all beings have a double, an invisible soul. The double molas are not identical, but share similar designs with subtle variations in size, shape and color. The blouse seams are usually embellished with decorative bands at the yoke. The blouse shape probably was taken from Huguenot clothing and the earliest molas were made from tradecloth.

Mola making is a social activity. A Kuna woman sews blouses for the women in her family; she must be satisfied with the final outcome of her design and often seeks approval from her peers. Designs and techniques are passed down from mother to daughter, although there are common themes that cross family boundaries. Molas are not signed, but the best patterns are regularly copied, the name of the designer passed along with the design but forgotten when the design falls out of fashion. Women with "good hands," those with excellent technique, are not always the ones who design the best molas. Rather, the best mola maker is the woman who reinterprets old designs in a unique manner or invents new ones. Kuna women typically own dozens of mola blouses, replacing them as they wear out or fade.

Mola making is a complex process and it can take weeks, even months, to complete a panel, which is done using hand-stitched appliqué, reverse appliqué and embroidery on multiple layers of brightly colored fabric. The intricate design is cut through the top layers of fabric to expose the colors beneath. The raw edges of the fabric are turned under using small stitches to produce a finished edge.[73] The predominant colors used are red, blue, yellow-orange and white. Over time, other colors were added, including greens and neon colors. Additional colors are added to the piece by inserting small pieces of fabric to the exposed layer, visible through lateral slits in the top fabric layer. Embroidery is used to enhance the design, frequently to indicate animal eyes, feathers and flower pistils and stamens. Teena Jennings-Rentenaar has identified five categories of designs used in molas.[74] The labyrinthine style uses complex designs done in either a naturalistic style with rounded curves, or a more angular geometric style. It is likely that the original inspiration for the naturalistic labyrinthine style comes from the Kuna body painting tradition. The virtuoso patterning of zigzag and labyrinth patterns requires tremendous talent, cutting the intricately connected patterns without lifting the small pointed scissors used to make the intricate cut until it is completed. In the central motif style, the primary image is usually centrally located and depicted larger than the surrounding motifs. Motifs can include local flora and fauna or objects found in everyday life. Imagery for molas made in the historic style include Kuna independence day depictions or specific events that happened in a particular village, such as a memorable hunting or fishing trip. Narrative style molas include depictions of village life, mythology and religious imagery. The final style, called outstanding, typically features a combination of elements from several categories or contemporary popular culture.[75]

Sources for designs are taken from the creator's imagination, nature, cultural or religious

traditions, and the outside world and many designs are tinged with elements of humor and irony. The multiple layers that make up a mola are believed to be related to the Kuna belief that the world is composed of eight layers. The density of the design, especially in the labyrinthine designs, could be related to the density of inhabitants in Kuna villages, or it could be indicative of a *horror vacui,* related to the fact that silence is an uncommon occurrence in a Kuna village. The actual subject matter of molas is often open to interpretation, as the imagery is not always clear and precise. As Michel Perrin has noted, "Everyone uses the name she wants according to what she sees."[76]

The most common imagery found on molas includes local flora and fauna and religious and mythological symbols. Changes to the imagery depicted on panels, as well as the format and sizes of the mola panels and their separation from the blouse, began in the mid-twentieth century, the result, according to some scholars, of a Peace Corps initiative that allegedly brought ideas of modernity to the area, urging the women to create new products incorporating mola imagery for western consumption.[77] Items such as vests, purses, wallets, pillows, and wall hangings became available in airports, hotel gift shops and in post exchanges in the U.S. controlled Canal Zone. Many of these objects were embellished with traditional Kuna imagery; however, images of western popular culture figures, such as Tony the Tiger and the RCA Victor dog, and objects like electric fans, caduceus and comic book characters were also seen, as women adapted images from magazines and the news media into their pieces. Alphabet letters and numerals were frequently added decorative motifs.

The change in imagery cannot totally be blamed on, or credited to, the Peace Corps program. From the beginning of the mola tradition, Kuna women have demonstrated a sense of experimentation and a willingness to try new things. This experimentation with imagery from outside the Kuna universe began during World War II, when women made molas for sale to U.S. servicemen stationed in the Canal Zone and those passing through the Canal on Navy and merchant vessels.[78] Many of these molas featured images copied from items such as matchboxes, cigarette packages, and food labels, as well as sports heroes and other popular culture figures, brought to the islands from the Canal Zone. Many featured American patriotic imagery such as military insignia, American flags, airplanes and warships. One early mola, in a private collection, depicts a World War II American radar station logo. Later representations of U.S. military imagery include a copy of a 1955 U.S. Army reenlistment poster featuring a tiger seated on a chair, an Army cover (dress hat) perched on his head, staff sergeant (E-6) stripes on his right arm, lighting a cigar with his left paw. The words "Win Your Stripes" appears at the top of the mola and "Re-up Army" at the bottom of the mola. The bright red mola image is a mirror image of the original reenlistment poster and includes a band containing the words "Win Your Stripes" along the right and left edge, which are not present in the original poster. The mola maker has also added the image of a parrot to fill the void above the tiger's knees, as well as colored slashes in the remaining voids. The tiger's stripes are indicated by vertical red stripes. Military recruiting posters were prominently displayed throughout the Canal Zone and often found their way to the islands.[79] Another military related mola (C12), done in the central motif style using a red top layer of fabric, shows a U.S. Air Force Senior Airman (E-4) rank insignia surrounded by four five pointed stars. Because it dates to the 1960s, the numbers two and nine on the mola could possibly refer to the 29th Weapons Squadron which was stationed in Panama from March 1965 to January 1966.[80] The letters "NMC" could stand for "Not Mission Capable," an indication

that an aircraft was not available for duty. In all likelihood it was made to be sold at the post exchange (PX) at Howard Air Force Base.

While molas containing U.S. military imagery were created as a means of raising money for the families of Kuna women, they are also war images, a reminder of the fact that portions of Panama were occupied by a foreign power—the United States—for almost a century. The American occupation allowed for the smooth, safe operation of the passage between the Atlantic and Pacific Oceans, but provided Panamanians with little additional security or economic support, although the local military bases did sell some local Panamanian crafts, such as molas and baskets, in the base exchanges. By the 1980s, mola sales, primarily to Americans, provided the major source of cash for the Kunas. The American withdrawal from the Canal Zone in 1999 resulted in a significant decrease in that income, but an expansion of imagery and sales venues has allowed them to rebuild their sales.

At the beginning of the twenty-first century, new mola imagery included references to the war in Iraq. The mola (C7), which dates to 2003, shows three bombs, gaily depicted in bright pinks, turquoises, oranges and yellows on a burgundy background that measures sixteen inches by twelve inches. The tips of two bombs point upward, while the central bomb points down, their bodies filled with a series of large appliqued chevrons and the tails embroidered with tiny "x's" done in brightly colored thread. The areas between the bombs are filled with small appliques of brightly colored triangles. Another similarly themed and colored mola in a private collection features two bombs.

Molas are textiles, initially created for practical purposes that, contrary to Erwin Panofsky's distinction between practical objects and objects that are intended to be experienced aesthetically, also strive to be beautiful.[81] Throughout the years, Kuna women have converted western materials and imagery to fit their design aesthetics and parameters, allowing them to better understand the world around them. Molas serve as the basis of social exchange and shared work as Kuna women invent new iconography while continuing to respect their traditional visual culture.

Molas are not the only form of textile that comments on violence in the region. In the fall of 2002, an unusual basket was found among a group of baskets imported from the Darien region of Panama, for sale in the gift shop of the Heard Museum in Phoenix, Arizona. The other twenty or so baskets were decorated with abstract geometric images or flora and fauna common to the Darien region, while this basket contains images of trees, a raptor, toucans and a cluster of houses common to the Darien. What makes the basket most unusual, however, are the two depictions of paired figures, each accompanied by a dog. In the smaller pair, both of whom wear a loincloth, the lead figure carries a rifle pointed directly ahead, ready for an encounter. The second figure uses a walking stick, their dog carried on his back. In the second pairing, the lead figure carries what appears to be a rocket propelled grenade launcher; three grenades are worn on a belt at the waist of his loincloth. The second figure, which appears to be a woman, wears a skirt and carries a basket on her back. She holds what appears to be a grenade in her left hand. The depiction of human figures on baskets from the region is extremely unusual, especially on baskets created for export. The depiction of armed figures is most probably a reflection of the increasing violence in the Darien region, the result of drug trafficking across the border in Colombia. Some of the indigenous population has been forcibly recruited by illegal armed groups, while others have been displaced by the violence, forced to relocate to the cities and abandon their traditional ways.[82]

In the tropical lowland forests of the Darien/Choco region of southern Panama and northern Colombia, women of the Wounaan and Embera tribes have woven water tight baskets for personal use for generations. Basket weaving is so important to tribal life that a girl's ability to weave is one of the most important traits required to make a good marriage. Basket weaving reinforces ethnic identity and femininity and serves as a vehicle for a woman to show her artistry. The Wounaan and Embera are separate tribes who speak unrelated languages, although they share a similar mythology, culture beliefs and material culture. The Embera moved into the Darien in the seventeenth century, while the Wounaan did not arrive in the region until the mid-twentieth century. Members of both groups come into contact with each other regularly and do intermarry.[83]

Water tight vase-shaped coiled baskets, known as *hösig di*, are traditional Wounaan utilitarian objects, although the Embera have a similar basketry tradition. The Wounaan are considered to be better artisans because their baskets typically have a tighter weave and more intricate designs, but it can be difficult to determine which group made individual baskets. The baskets are made from chunga, or black palm, and nahuala, the Panama hat palm, fronds.[84] Chunga plays an important role in both Wounaan and Embera culture, its trunk and fronds used for houses, to decorate flutes used in ceremonies, for bows and arrows and blow guns, and to immobilize evil spirits. The chunga is a solitary, sub-canopy palm with sharp black spines up to eight inches in length on its trunk. The fronds can reach twelve feet in length, although only fibers from a newly emerging frond are flexible enough to use in basketry. Four chunga fronds are required to make a large basket twenty-five centimeters tall. Men harvest the palm for the women at the waning moon to ensure the strength of the fibers.[85] Deforestation, overharvesting and violence from the drug trade have made chunga procurement more difficult, as men must travel further into the forest to find usable palms, and in the twenty first century about twenty percent of weavers purchase chunga so they do not have to travel to find it.

Women process the chunga fiber, folding it at the mid-rib, then peeling away the outer skin on both sides of the frond. The fiber is then soaked overnight in soapy water to lighten its color; it is then dried in the sun to bleach it further. The fibers are divided into thin weaving strips which are twisted to hide frays and to make them even thinner for weaving. The baskets are sewn using chunga fibers threaded into a needle, then wrapped around a small bundle of fronds. The basket maker begins with a foundation of nahuala fibers which gives stability and shape to the basket. Coils of chunga are stitched over the foundation to form the basket. The more narrow the fibers used, the finer the basket. Two types of stitches are used: *diente peenado*, done on top of the coils to give a smooth surface, and *escalara,* which produces the corrugated surface that defines the coils.[86]

Decorative elements are worked into the basket using naturally dyed fibers. The dye plants are boiled, the pieces removed and fibers placed into the dye solutions. Black comes from cocobolo wood; after dying, the fibers are buried in mud from mangrove swamps to darken the color. Yuquilla root yields yellow and gold, while pucham leaf results in violet and pink, and rust when combined with ash. The solemon plant produces blue, green, grey and purple, and teak gives rust and purple-brown. The jugua tree fruit produces blue black and jobo bark provides tan.[87] Each basket is one of a kind, a repository of cultural information. The imagery used on the baskets incorporates religious symbolism, the environment, and the Wounaan and Embera cultures. Traditional Wounaan baskets originally had little

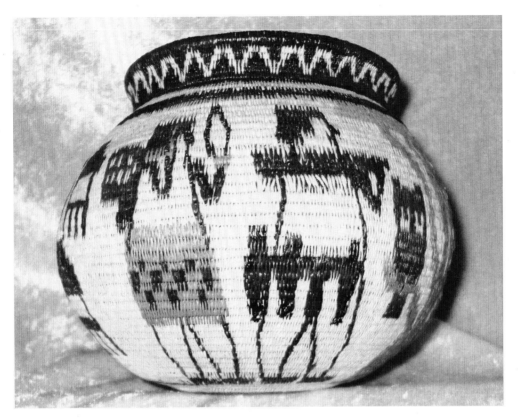

Wounaan-Embera basket, Panama, late twentieth century. Palm fiber and natural dyes. 5¼ in. by 5¼ in. (collection of Deborah Deacon).

decoration, the geometric patterns derived from body painting designs or decorative elements used on boats to help fishermen communicate with the spirits. In 1982, Rob Binder of the Summer Institute of Linguistics encouraged Wounaan women to incorporate colorful designs into their baskets, something the Embera women were already doing, in order to make them more appealing to potential buyers.[88] He believed that by developing a market for the baskets, the women could join Panama's cash economy and improve their lives. In the 1980s and 1990s the baskets were sold at fairs in the Canal Zone in Panama. In that same period, several galleries began selling the baskets as works of art.[89] The Panamanian market for the baskets decreased with the withdrawal of U.S. military personnel from the Canal Zone in 1999, but the Panamanian government, recognizing the importance of the baskets to its economy, developed a tourism campaign centered on the baskets to increase interest in them internationally. The basket weavers were encouraged to modify the images on the baskets to include animals, plants, birds, and butterflies to appeal to a broader clientele.[90] The baskets are now available for sale in art galleries worldwide and on the internet.

Contemporary Textiles

Because much of the chaos of the civil wars in Latin America has ended, only a few contemporary Latina artists, such as painter Damary Burgos and sculptor Marta Palau have cre-

ated art that addresses war.[91] While Latina textile artists like Olga de Amaral and Ana Maz-
zone are aware of warfare occurring in other parts of the world, the majority do not appear
to be interested in addressing the topic in their art, preferring instead to look to their cultural
heritage by using traditional geometric imagery or to nature and the local environment,
revealed through the use of vivid colors and abstract patterning.[92] A few textiles artists, how-
ever, do choose to comment on contemporary warfare as well as past violence, continuing
the tradition begun by their ancestors.

Josefina Fontecilla was born in Santiago, Chile, in 1962. Her installation work typically
examines ideas of decay and the passage of time, often evoking feelings of melancholy. Her
1998 work *Delirios* consists of five large panels of red brocade, taken from an old family
home, that feature the ghost-like forms of the physical objects that formerly hung on the
home's walls, the result of fading over the years. In addition to the sense of melancholy and
the passage of time, the size and feeling of the piece allude to the scale of torture, disappear-
ance and loss Chileans experienced under Pinochet, reminding viewers that those who dis-
appeared are no longer at home.[93]

Creole artist and poet Nydia Taylor Auchter became interested in the arpillerista move-
ment when she was a senior in International and Intercultural Studies, Latin American Stud-
ies, Women's Studies and Peace Studies at Goucher College. During her studies in Nicaragua,
she researched the garment industry, which reinforced her theory that sewing and textile
production can be exploitative, expressive and subversive.[94] Although she was not a sewer
or quilter herself, she decided she wanted to tell the story of her Afro-descendant community
of Bluefields, Nicaragua using a combination of quilting and the *arpillera* tradition, drawing
her inspiration from the women who used their sewing to provide visual messages of the
horrors they experienced under the Pinochet regime.

The quilt, which took five months to assemble, ultimately measures sixty-five inches
square. Each of the forty-nine blocks, which measure eight inches square, is made from fabric
scraps, in part to follow the example of the arpilleristas and in part because she was working
on a student's budget. In addition to using old clothing gathered from family and friends,
she bought the purple fabric used between the individual blocks in Nicaragua, and purchased
the batting, thread and backing in the United States.

The quilt contains three categories of blocks: ones she made about Latin American
women; blocks her friends made about Latin American women; and blocks made by women
who personally inspired her, including her mother, her university advisor and a singer/song-
writer.[95] She helped some of her friends decide what to depict on their blocks, asking many
to create blocks about their lives and experiences, while she created blocks about the Chilean
arpilleristas. Nydia situated her personal block at the quilt's center because she saw herself
as the glue for the project. Her family's patches radiate out from hers, leading to patches
about Argentina, Brazil and Chile. The Chilean patches concentrate on the torture, impris-
onment and resistance originally voiced by the arpilleristas, while the blocks about Bluefields
address issues of race and identity. The completed quilt depicts the history of the creativity,
strength and determination of twentieth century Latin American women who have faced
great trials and tribulations, using stories taken from her research and the personal experience
of her family members.

In the summer of 2012, while walking in the Coyoacan neighborhood of Mexico City,
Liliana Sanchez discovered a display of hand embroidered handkerchiefs hung in a public

park. They bore the phrases "Embroidering for peace. A handkerchief per victim." The handkerchiefs were embroidered by members of Red Fountains, a group whose goal is to embroider handkerchiefs with the names of the fifty million individuals who have died as the result of drug violence throughout Mexico. The women who create these memorials are the mothers, sisters and relatives of some of those who have died or disappeared and they are embroidering "hope and memory" as they share their thoughts and experiences with the violence associated with the drug wars.[96] While the idea began in Mexico City, it has spread to Guadalajara and Monterrey, two areas filled with drug violence, where the members of LUPA (Fight for Love, Truth and Justice, Nuevo Lion) meet every Thursday at ten o'clock a.m. at the kiosk Lucila Sabella at the Macroplaza.

Sanchez sees this embroidery as therapeutic, "cultural manifestations ... where people meet face to face with others who carry the same discomfort, the same uncertainty. Shouting in unison, laughing or mourning, without shame or restraint because the person next to them is capable of understanding, it becomes a treatment that is very necessary."[97] When asked, the women say they are embroidering for peace.

The tradition of Latin American women commenting on war began with the textiles women produced for the warfare-centered cultures of the Aztecs and Incas. Women participated in these warrior cultures by producing both high status textiles that depicted images of warriors as well as the geometric and feathered garments worn by those warriors as they went into battle. During the Spanish conquest, textile imagery incorporated the new iconography of the conquerors but also became a site of resistance as women continued to include traditional warrior figures in their textiles. During the social upheaval that occurred throughout the region during the twentieth century, Maya women who survived the attempted ethnic cleansing in Guatemala used their traditional *huipils* as symbols of pride and resistance while women in Chile, Peru and El Salvador used richly colored and embroidered appliquéd *arpilleras* to tell the world of the torture, kidnappings and murders of thousands who opposed the right-wing dictatorships in their countries and to support their families in times of social and economic upheaval. Many women in the region, such as the Kuna and Wounaan and Embera in Panama, have adapted their textile traditions to help support their families while providing commentary on social and political events. Contemporary Latin American textile artists, whether working with a European sense of aesthetics, reviving their pre–Hispanic roots or inventing a new artistic language, continue to provide commentary on their lives and the world at large. Their art serves as a bridge between their traditional culture and the global culture, allowing the women to express their feelings about their personal experience with war, violence, and terror, as well as their hope for the future.

FIVE

Asia and the Pacific Rim

Textile production began very early in Asia. Pottery produced by the Neolithic Jomon culture in Japan (10,500–300 BCE), in Neolithic Korea (circa 3000 BCE), and in Shang Dynasty China (6000–1045 BCE) contain surface decorations made by impressing woven fibers into the wet clay surface prior to firing.[1] Remnants of woven textiles have been found in excavated Indus Valley settlements (2500–1500 BCE) in western Pakistan.[2] Throughout the region from the earliest times, clothing served as a mark of civilization. The making of cloth was associated with life and fertility, and the making and wearing of cloth served as a mark of status and a means of gender differentiation. As Song Yingxing (1587–1666) noted in the *Tiangong kaiwu* (*Exploration of the works of nature*) in 1637, "The noble wears sweeping robes, resplendent as mountain dragons they rule the empire; the humble wear coarse wool or hemp garments, in winter to protect them from the cold, in summer to shield their bodies."[3] In most Asian countries, cloth production and decoration were considered women's work and many countries in the region developed pictorial traditions in their textiles in addition to using a variety of plant and animal fibers to create cloths of solid colors and geometric patterns. In many areas, women created the textiles worn by armies, making the women vital participants in the war effort. In some locations, they produced textiles that contained images of war, either from real or imagined conflicts. Over time, in both China and Japan, textiles were produced by both women and men, both of whom were depicted at work spinning, weaving, dyeing, embroidering, and sewing fabric in paintings and prints. In other locations, women remain the primary creators of textiles in the region into the twenty-first century.

China

Not much scholarly work has been done on women's roles or work in imperial China, primarily because household work has not been seen as an important historical process by scholars. Much of what is known on the subject comes from anecdotal evidence found in literature and art. This lack of information, coupled with western misinterpretations of Chinese culture, has led to the western perception of Chinese women as helpless victims of patriarchy, illiterate and kept imprisoned in their homes, unable to work because of their bound feet, cut off from the world of politics and economics. In fact, throughout history Chinese women have a "long tradition of integration into the world of economics and politics through

their work."[4] This work centered on textile production—spinning, weaving, sewing and embroidery.

In Chinese culture, differences between men and women's roles in society were determined by the spaces they occupied and the work they performed. An ancient Chinese proverb noted, "Men till, women weave."[5] Textile production held equal economic value with agricultural products, providing the family with objects of barter and a means of economic survival. Cloth was made in the home, but the production of cloth tied women to the state by the fifth century BCE since cloth could be used to pay taxes. In fact, women who did not produce their own cloth had to buy it in order to pay their taxes, providing the women who wove with income to support their household.

Spinning, weaving and embroidery were considered to be divinely inspired arts to be practiced in the home for the benefit of the family and culture. As early as the Han Dynasty (206 BCE–220 CE), stone carvings show women spinning and weaving. As the Han Dynasty literary figure Ban Zhao (45–116 CE) noted in her work, *Nu jie* (*Instruction for Women*), womanly work was tied to womanly virtue, proper womanly speech and properly womanly conduct, as prescribed by the tenants of Confucianism, making textile production an important aspect of a woman's life.[6] The acquisition of textile skills taught female values of diligence, frugality, order and self-discipline. The technical and management skills required to produce textiles were firmly fixed in the female domain, leading to the identification of woman as weaver and weaver as woman. Beginning at the age of eight, Chinese girls learned how to cultivate and harvest cotton, hemp and ramie as well as all aspects of silk production—how to hatch silkworm eggs, unwind the silk from the cocoons, spin the fibers, weave the cloth and make clothing. In the 1290s CE, a woman named Huang Daopo invented a cotton gin to remove the seeds from cotton bolls, developed a technique to untangle cotton fibers for spinning, and designed a multiple-spindle treadle-operated wheel which allowed a woman to spin several threads simultaneously.[7] These inventions vastly improved the quality of textile production in China.

In Chinese society, textiles forged social bonds and served as gifts for ceremonial occasions such as weddings. Undyed cloth was used for burials and mourning clothing. It served as a medium of exchange and currency. Basic textiles such as ramie, hemp and cotton were used to clothe the Army as well as for peasant clothing. Silk textiles were used at court to pay bureaucrats and military officers for their work, to reward individuals for loyal service, buy off nomadic enemies, and impress tribute monarchs in Southeast Asia, as well as for daily wear by members of the imperial household and bureaucrats. In later imperial China, silk yarn spun by peasants was used in imperial manufactures. Prior to the late Ming Dynasty (1368–1644 CE), bolts of cloth used for tax payments were given directly to government representatives. By the early seventeenth century, middlemen performed this service, demanding cloth from the weavers themselves as payment for their services and then turned it over to the government.

From the Southern Zhou (474–221 BCE) through the Han Dynasty (206 BCE–220 CE), women produced a number of types of textiles, including plain cloth, which the peasants used to pay their taxes and the government used to clothe the army; utilitarian objects like shoes and cordage; and luxury textiles such as elaborate embroideries, painted and loom-patterned silks, and gauzes.[8] By the Song Dynasty (960–1279 CE), while plain weave cloth such as twills and tabbies were produced by women in individual peasant households, in

larger elite households, the mistress of the house organized textile production, assigning tasks to female family members, servants, and hired help. In these wealthy households, complex silk weaves were produced on draw looms.[9] Images of women participating in all stages of cloth production were popular representations for Chinese artists, including the Emperor Huizong of the Northern Song Dynasty (reign 1101–1126 CE) whose painting *Ladies Preparing Newly Woven Silk* is believed to be a copy of a lost work by Zhang Xuan (active 713–741 CE).

The Song Dynasty (960–1279 CE) brought changing roles for women in terms of property and inheritance laws and ritual performance, diminishing women's authority and increasing their subordination to men. Motherhood and marital fidelity were now the priority, although women still continued to weave cloth, especially in rural areas. Societal changes impacted men as well as women. Prior to the Song Dynasty, male and female elites favored rich brocades and embroideries done in rich colors as status symbols. During the Song Dynasty, the literati established new fashions at court, featuring subdued refinement in gauze and raw silk which resulted in changes in textile demands.[10] The most valuable textiles were soon produced in state manufactures and private urban workshops which employed men and women. In these large operations, a separate group of workers was responsible for each part of the production process, such as dyeing, weaving, reeling, and spinning, so one woman was no longer responsible for all aspects of a textile's production, making fabric production more efficient and consistent. Professional designers developed patterns for the weavers to follow. Early in the Song Dynasty, rural women produced raw silk and tabby weaves, but by the dynasty's end they concentrated on silk sericulture and the production of raw silk and yarns, for which there was an increased demand.

Eventually some of the silk cloth production moved to state run manufacturing operations that used conscripted male and female workers, and by the late Ming Dynasty large urban workshops, also manned by both male and female workers, created most of the silk cloth made in China. Both state manufacturers and urban workshops used complex looms to produce fancy weaves such as damasks, brocades, gauzes and satins.

Even after the introduction of western style factories in the late nineteenth century, home textile production remained important in China, especially in rural areas, providing crucial economic support for the family. While women no longer produced the cloth used to clothe soldiers, they continued to spin and weave cotton and hemp, and produce textiles for their dowries. In the early twentieth century, "women working at classically female tasks could earn enough not only to support themselves but also to buy foodstuffs for a whole family, and, of course, to clothe them."[11]

The period between 1000 and 1800 CE saw considerable changes in China in terms of economic expansion, urbanization, commercial growth, new divisions of labor and in visual depictions, including in textiles. One popular form of depiction was the *kesi*, or silk tapestry with cut designs. The technique had been invented in Central Asia, eventually making its way to China by the eleventh century.[12] Initially produced by women during the Tang Dynasty, *kesi* featured woven figural and landscape designs as well as Buddhist imagery. Tapestry weaving is done in a flat weave using partial wefts on full warp threads to form the design, making the textile double sided. For *kesi*, raw silk was used for the warp, while numerous shuttles of different colored boiled silk were used for the weft; the vertical gaps between the adjacent areas of color that result from changing colored threads are visible when the

tapestry is held up to the light.[13] *Kesi* reached the height of its popularity during the Song Dynasty and featured an emphasis on classical coloring, refined depictions and realistic designs. A woman from this period, Chou K'o-ju, is considered one of the greatest *kesi* weavers of the Song Dynasty. The form was revived during the Ming Dynasty (1368–1644 CE), when *kesi* featured painted embellishments and a wide range of subjects including landscapes, Buddhist imagery, historical and mythological stories, and copies of famous paintings. Many *kesi* were influenced by prints and paintings.[14] During the Ming and Qing Dynasties, kesi were made by both male and female weavers. In addition to tapestries, the technique was used to create robes for the imperial family and high ranking court officials.

A series of eight banners with flowers and narrative scenes, produced in the late 17th or early eighteenth century (Qing Dynasty) and now in a private collection, contains painted images on the obverse and *kesi* tapestry on the reverse. Each is done in the shape of a traditional Chinese vase with a different flower on a banner above the vase and four streamers beneath the vase. Four of the banners feature gold vases with black tassels, and the other four feature white vases with light blue tassels. The belly of each vase features a scene from the Yuan drama *Xi xiang ji* (*Romance of the Western Chamber*), a prose romance based on the *Story of Yingying* by Yuan Shen of the Tang Dynasty (618–907 CE). The story is a tragedy about the love, union and separation of two young lovers in the first year of the Zhenyuan reign in the Tang Dynasty, and was a popular subject for artists from the time of its publication. The scenes depicted on the banners tell the story of the rebel general Sun Biao, known as the Flying Tiger, who is ultimately defeated by the hero General Du. Sun Biao is shown attacking the Pujiu Temple and in his campaign tent while General Du is shown on his white horse as he routs the rebel troops.[15] While the actual weaver of the banners is unknown, it is likely that similar depictions from this story were woven by women in earlier times.

The *kesi*, woven during the Qing Dynasty, was inspired by the historical novel *Romance of the Three Kingdoms*, one of the great classic novels of Chinese literature. The novel, written in the fourteenth century, depicts the period following the fall of the Han Dynasty (206 BCE–220 CE) when various areas of China were controlled by feudal lords who battled for control of the region. The four foot by six foot textile, which features weapons-wielding soldiers on horseback and others who appear to engage in hand to hand combat training while their superiors watch from horseback, is highlighted by metallic threads and is completely reversible, as are all *kesi*. Much of the color on this piece comes from ink washes and colored pigment, including the grey of the horses, red saddlebags, and brown of the rocks. The use of color and metallic line gives the piece its sense of motion and emotion.[16] Works like this, possibly completed as a special gift for a wealthy individual, remained popular through the waning days of the Qing Dynasty.

During the Ming and Qing dynasties, court officials and members of the military wore embroidered or woven badges on their robes, indicating their civil or military rank. Initially the wearing of rank badges was optional, but in 1652 CE, the Qing emperor Shunzhi decreed that all civil and military officials must wear rank badges on the front and back of their dark surcoat, or *bifu*, which was worn over their court robe.

Rank badges measure eleven or twelve inches square. While they were made in imperially sanctioned workshops, the fact that women embroidered rank badges is documented in a nineteenth century Qing dynasty ink and color painting included in the Pacific Asia Museum's on-line exhibition *Rank and Style: Power Dressing in Imperial China.*"[17] The paint-

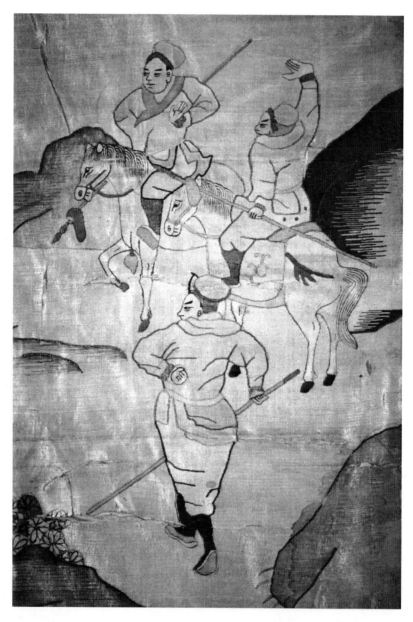

Kesi (detail showing vignettes of ancient warriors), China, late Qing Dynasty. Paint on silk (courtesy Laurie Petrie Rogers).

ing shows three women, two of whom are embroidering rank badges while the third watches them. Embroidered badges feature satin stitch; Peking knots, also known as "forbidden stitch" due to the mistaken belief by westerners that its extremely small size weakened the eye sight of the women who used it; couching; flame stitch, known as gauze stabbing; and petit point which was done on gauze. Badges for court officials featured a different bird for each rank, while military rank badges featured animals.[18] Women wore the same rank badges as their husbands, with the images reversed. A man's badge features the appropriate bird or

animal at the center of the badge, facing the sun, which is located in the upper left hand corner of the badge while the woman's bird or animal, also centered, faces the sun which is located in the badge's upper right hand corner.

The majority of badges in western collections are those of court officials and their wives, collected by Christian missionaries in the late 19th and early twentieth centuries. They were popular souvenirs because of their colorful motifs and small size, and were readily available for sale as traditional court attire was forbidden by the Republican government. Military badges are found much less frequently than those of court officials, the result of their destruction by their owners seeking to avoid persecution during the Republican revolution.

Japan

As was the case in China, textile production in Japan was considered to be the realm of women. The earliest weavings, known from impressions found on Bronze Age pottery, were made from hemp, reeds, and other coarse plant fibers. By the time the Japanese emperor Seimu received a gift of silkworm eggs from the Chinese emperor in 188 CE, the Japanese were already weaving three grades of silk, two grades of hemp, and ramie.[19] Members of the nobility and upper class wore silk in pre-industrialized Japan, while commoners wore home-spun hemp, which was locally grown. Weaving was done by women in the home and girls learned to weave at a young age, producing clothing, bedding and other household good as well as items for their dowries and trousseaux. Beginning in the Heian era (794–1185 CE), women were shown weaving, dyeing fibers, drying fabric, cutting and sewing in paintings, books and prints.

Embroidery was an early form of women's work in Japan as well, a natural progression resulting from the repair and reinforcement of garments and household objects, tasks performed by women. Over time, the aesthetics of pattern, color and stitch selection became more important than the practicality of the textile itself. The oldest existing Japanese embroidery, a Buddhist textile known as the *Tenjukoku mandala shūchō*, was created in 622 CE by court embroiderers to honor Prince Shotoku, who popularized Buddhism in Japan.[20] The embroidery shows the prince in the Western Paradise of the Pure Land sect of Buddhism. Other early embroideries were didactic pieces, designed to teach Buddhist precepts to the faithful. By the Heian era, embroidery patterns and color usage for clothing were based on social rank. Motifs used in clothing embroidery expanded beyond Buddhist symbols to include Chinese motifs such as the phoenix and dragon, and birds and flowers, all of which were steeped in symbolism. The tortoise, depicted as a hexagon, and crane symbolized longevity, while the plum, pine and bamboo when grouped together were known as the three friends of winter, symbolizing ideals of pure spirit (plum), longevity (pine) and flexibility (bamboo); they were often embroidered on clothing worn in winter.[21] Samurai saw the popular wave pattern as a symbol of the offensive and defensive maneuvers of warfare, while the general population saw it as representing a bountiful harvest of fish and sea plants. Cherry blossoms, or *sakura*, can be seen as being feminine, but also served as a metaphor for sacrifice and duty to country during times of conflict.[22] *Sakura* have been part of the *kamon*, or family crest, for a number of Japanese clans, including the Oda, Omura, Arema, Ikeda, Onodera, Takigawa, Takahashi, Wada, Naito and Mikumo clans. It was also worn by the Heian era

General Minamoto Yoshitsune, one of the greatest and most popular samurai in history. The *kamon* is a roundel encircling a figure of a plant, animal, man-made, natural or celestial object. While *kamon* are usually printed in several places on a kimono, they were often embroidered on less formal items to identify the owner. During the Edo period (1603–1868 CE), sumptuary laws banned luxury fabrics and gold thread embroidery for the wealthy, and embroidery in general for the lower classes. As a result, Japanese men and women often hid extravagant textiles beneath their outer garments, a tradition that continued after the restrictions were eased.[23]

By this time, commercial weaving was being done by men working in shops, much like the artists who were creating paintings and sculpture in workshops supervised by a master (male) artist. Women still wove in the home, especially those living in rural areas.[24] Women living in urban areas purchased lengths of cloth to make clothing from shops that sold fabric and also made kimono to order. Images of samurai and kabuki scenes were popular depictions frequently found on the lining of men's *haori*, the lightweight coat worn over a kimono. During the Meiji Restoration (1868–1889), despite the modernization that was occurring in other areas of Japanese society, there was little mass production of textiles; most textiles were produced in the home or as part of a cottage industry of small workshops. The fabrics produced included silk, flax, ramie and cotton, which was introduced into Japan from China after the sixteenth century.[25] The Japanese began importing raw cotton and finished cotton goods from China in the fifteenth century and later they also imported cotton from India. In the sixteenth century, the Japanese adopted Chinese cotton cultivation techniques, producing domestic cotton in warmer areas of the island nation. The spinning of cotton became a cottage industry and cotton quickly replaced hemp for peasant clothing. Rural women spun and wove cotton for personal consumption and additional income.[26] By the end of the nineteenth century in the West, textile manufacturing produced a wide range of types and quality of fabrics, while textile production in Japan remained labor intensive, resulting in short runs of individual fabrics and patterns.

At the turn of the twentieth century, the industrialization of textile production in Japan had begun. Modern cotton milling equipment was imported into Japan from the West at the end of the Meiji era, resulting in the manufacture of expensive industrially produced textiles. The introduction of spinning machines and mechanized looms led to an increase in the availability of less expensive mass produced textiles. Mechanized printing with rollers resulted in the introduction of complex, colorful designs with modern images, many done on muslin, which took western dyes well and was used for children's kimono and as linings for *haori*.

The modernization of Japan brought changes to Japanese society and fashion, despite the empress' encouragement of a "patriotic revival of interest in the arts of the past."[27] Young Japanese women began working in textile mills in the late nineteenth century, where they produced western style clothing as well as traditional kimono fabric. By the 1880s, some men began wearing western-style clothing for work, but continued to wear kimono in the home.[28] Modern young women also wore western-style clothing, while more traditional women continued to wear kimono, although modern decoration was frequently added to the traditional attire. The traditional kimono was still worn extensively throughout the first quarter of the twentieth century, primarily by older people. By 1925, only one-third of men wore traditional garments to work. In contrast, only thirteen per cent of Tokyo women wore western dress.

By the 1920s men and women were working as weavers in small factories. As Japan geared up for war, the number of women working in commercial weaving factories increased significantly as men were drafted into military service. These factories produced textiles vital to the war effort. During this period, women were encouraged to wear modern clothing rather than the traditional kimono, which required a significant amount of fabric to make, fabric that was needed for the war effort. During World War II, the Japanese government enacted clothing restrictions designed to reduce a woman's wardrobe. Most women adopted a "uniform" of sorts—a dress with shorter sleeves, made of somber, inexpensive fabric.[29] Women in the cities who wore kimono were seen as extravagant and lacking in support for the war. Because of fabric shortages during the war years, women recycled fabrics, redesigning their clothing into patchwork styles. The Pacific War Collection of the Lafayette College East Asia Image Collection includes a postcard titled "Just cut any type of cloth into the same size square and…" which features a young woman in a patchwork kimono, proudly showing off her new design. Even though she wears a kimono, she would have been seen as being patriotic since her attire was made from recycled fabric.[30] In the Kanazawa area, garments known as *hyakutoku* were made from remnants of clothing that, when sewn together

"Just cut any time of cloth into the same size square and…," Postcard, Japan, mid-twentieth century. Ink on paper (courtesy East Asia Image Collection, Pacific War Postcard Collection, Lafayette College, www.lafayette.edu).

into a new garment, were presented to soldiers as they went to war, thought to be a talisman that would protect the man against enemy bullets.[31]

Wives, sisters and mothers created a number of textile talismans intended to protect their loved ones during their wartime service. Long narrow cloths, known as *ten ugui,* frequently painted or embroidered with an image of the "Rising Sun" flag, were used as headbands by soldiers.[32] Small flags bearing the red sun on a white background, known as *hinomaru,* were embellished with the names of family members and close friends, best wishes, inspirational sayings, and imagery intended to protect the soldier on the front.

Possibly the best known talisman intended to protect the soldier from harm was the *senninbari,* or thousand stitch sash. The sashes, intended to be worn under a soldier's uniform, got their name literally from the one thousand stitches embroidered onto the cotton fabric—one stitch from each of one thousand different women.[33] In order to obtain the stitches, a woman would stand in a public place like a train station or street corner and ask women who passed by to sew a stitch for her loved one. The stitches on some *senninbari* are arranged in orderly rows, while others are arranged to form images like butterflies and cherry blossoms. Some *senninbari* feature painted images of a tiger, a symbol of invincibility, ferocity, and power, whose image was intended to ward off evil and protect the soldier while he was on the front line.

Senninbari, Japan, mid-twentieth century. Floss, pigment and ink on cotton. 13 in. by 62 in. (collection of Deborah Deacon).

In addition to creating talismans to protect soldiers in battle, like their female counterparts in the west, Japanese women on the home front knitted sweaters, vests, socks and scarves for those far from home, often including them in care packages. The Japanese government supported such efforts, which were pictured on postcards, posters, and in other government propaganda. One postcard shows two young women, one wearing a traditional school girl sailor uniform and the other in a traditional kimono, doing their part for the war effort. The school girl is shown filling a bag with "goodies" while the kimono-clad girl is shown knitting a vest. Knitting became a popular past time for women in Japan during the modernization period, and women created sweaters and shawls for themselves and sweaters for their children. Its popularity continued during the war years, one of the ways in which women supported the war effort.

South Asia

As was the case with East Asia, textile production in South Asia (India, Pakistan, Sri Lanka) began very early, as evidenced by the clothing depicted in sculpture and actual textile fragments from the Indus Valley civilization in modern day Pakistan. Textiles have played an important role in social, cultural and economic life throughout South Asia for centuries. Much of the textile production originally centered around cotton, which is native to the region, although silk was introduced as part of the trade along the land and sea trade routes that ranged from China to Africa and the Mediterranean, along with Buddhism, Hinduism and Islam.[34] Indian merchants traded printed and woven cloth in specific colors and patterns throughout island Southeast Asia, each individual pattern made for a specific location in the region. This trade cloth served as a means of regional identification and a form of wealth throughout the region for centuries.

In India, most weaving and woodblock printing of textiles intended for commercial trade has always been done by men, while women participate in related processes like spinning, winding yarn and threading the loom. In some areas, women have historically embroidered and woven household textiles, as well as sometimes participating in commercial textile production in limited ways. When Vasco da Gama landed in Calicut (Calcutta) in 1498, he began a new era of trade and conquest in the region. Admiral Alfonso de Albuquerque's defeat of the Byapur sultans led to the establishment of permanent Portuguese settlements on the Indian subcontinent. The Portuguese quickly recognized the importance of the textile production in Gujarat, Rajasthan and the western Malabar Coast, as well as in Bengal, Bihar, Orissa, and the Coromandel Coast in the east. Duarte Barbosa, the Portuguese author and Portuguese India Officer credited with writing one of the earliest examples of Portuguese travel literature, noted in 1518:

> In this city (Cambay) [Khambhat] they make very delicate cushions, and pretty ceilings (or canopies) of bedsteads, of delicate workmanship and paintings, and quilted clothes for wearing. There are many Moorish women who produce very delicate needlework.[35]

Early in the Portuguese conquest, Catholic nuns arrived in India, bringing with them European embroidery traditions which they used to create church vestments and other textiles. The nuns taught these embroidery techniques to female converts, resulting in a "bilateral

慰問袋に真心こめて

びつゝ、姉妹が真心こめて作つた慰間袋、あたゝかい

少女の心を、そのまゝ現したやうな毛糸のチョツキも、

もうすぐ出來上ります。

雪の荒野に立つ勇士の上を思

"The military care package is loaded with your sincerity," Japan, mid-twentieth century. Ink on paper (courtesy East Asia Image Collection, Pacific War Postcard Collection, Lafayette College, www.lafayette.edu).

cultural exchange of quilting concepts, designs and techniques."[36] By the sixteenth century, Indian women were creating distinctive embroidered quilts for the Portuguese market, quilts that provided a harmonious blending of two disparate cultural textile images to form a new textile tradition. These Indo-Portuguese quilts, which were also given as gifts to important individuals in India, were not produced in great numbers. The quilts were made from silk imported from China and featured a large center rectangular panel surrounded by numerous decorative bands, known as *padrâo de faixas* or pattern of bands. Botanicals, birds and imaginary creatures filled the bands. By the beginning of the seventeenth century, western motifs began to be included in the embroidery, including Old Testament stories, figures from Greco-Roman mythology, and images of contemporary events.[37] A number of the quilts featured images of Portuguese soldiers and galleons, reflections of the region's colonial status. One quilt, in a private collection, features western warships among its red-embroidered floral motifs, while another features galleons and soldiers on horseback subtly embroidered against a salmon and pale pink background. The military figures are obviously foreign—they wear western military uniforms rather than the traditional clothing of the region and carry rifles rather than swords and daggers. By including the presence of these foreign military personnel, the women were creating an historical record of a specific point in time, a time of upheaval when their region was subjected to colonial rule. They serve as a reflection of the environment in which they lived, and a way for them to address the emotions that they experienced. In addition to quilts, the embroidery and quilting techniques were used to create bedspreads,

window banners used for festival occasions, and curtains for windows and beds. The tradition remained popular until 1637, when the Portuguese were expelled from the region.[38]

When the British arrived in India, they found a thriving textile industry that included chain stitch embroideries done by men in Gujarat, which quickly became popular imports in Britain. British women brought their needlework traditions with them to the new colony, traditions that were quickly adopted by elite Bengali women and that eventually were adopted by poorer native women for their own use. In Bengal, an important textile center for centuries that decreased in importance with the importing of European and American machine produced textiles into the region, men did the weaving, while women carded and spun thread at home, which the male weavers used to make cloth.[39] The women also produced embellished textiles as part of their dowries, important to the establishment of their new household. These included door hangings, quilts and quilt covers, and decorative squares as well as the bride's wedding clothes; their creation was a family affair, with mothers, sisters and nieces contributing to the dowry textiles. In Muslim areas, rural women also embroidered their headscarves and the bodices of their *kameez*, the long, loose shirt worn over the *shalwar*, loose pajama-like trousers worn by men and women.[40]

One of the most important textiles produced in Bengal is the kantha, a quilt made from layers of recycled white saris and dhotis, the rectangular cloth worn by men. A dhoti, which measures about fifteen feet long, is wrapped around the waist and legs, and knotted at the waist. Saris typically measure up to nine feet in length and are two to four feet wide. Kanthas are embroidered through the numerous layers, typically using running and back stitches. Red and blue threads predominate, with accents of black, greens, yellow-orange, and occasionally purple and hot pink. The earliest kanthas date to the first part of the nineteenth century; most date between then and the mid-twentieth century. The embroidery has its roots in alpana, the rice paste and color finger-painted designs done on the ground or floor for festivals and major life events.[41] The most basic alpana motif is the single lotus flower, also a popular depiction on kanthas. In Buddhism and Hinduism, the lotus represents beauty and non-attachment because it is rooted in the mud but floats on the water without becoming wet or muddy. The plant symbolizes the way one should live in the world in order to gain release from rebirth—without attachment to one's surroundings. Other popular designs include Buddhist images such as the wheel and footprints of the goddess Lakshmi, the tree of life, local flora and fauna, such as elephants and peacocks, and characters from literature, leading scholars to conclude that kantha imagery was shared with literature and the visual arts. Many kanthas contains images of village life—festivals, scenes from daily life, weddings—allowing women to record the events and people which impact their lives. Another popular motif replicates sari border patterns which typically include kalkas, or paisleys. While most kanthas are unsigned and undated, Muslim women typically produced non-figural images in their work, making regional identification possible in some instances.

A kantha in the collection of the Philadelphia Museum of Art, which dates to the second half of the nineteenth century, depicts two men on horses, brandishing swords as they prepare to do battle. The central roundel features a large lotus, while the border features alternating kalkas (paisleys) and tulip trees. Each corner features a large kalka with elephants, fish, peacocks and florals filling each quadrant, all done in deep indigo, blue-grey, red and camel on a cotton plain weave ground. Given that the figures are dressed in native attire and brandish swords, this is most likely a representation either of a local historical

battle or an imagined war from a literary work. Another piece in the collection, which dates
to the same time period, includes depictions of two processional chariots containing a Shiva
linga, each pulled by a single horse in the bottom portion of the square kantha, an indication
that this is part of a religious ceremony. A fashionably attired Calcuttta couple can be seen
in the far right frame while a single man wearing a conical hat can be seen in the top frame.
A man dressed in a military uniform and boots is also depicted in the bottom portion of the
piece. The piece offers the viewer an expression of the rich and varied life in urban Bengal
during the nineteenth century, which included the presence of British military personnel,
part of the British colonial bureaucracy that ruled the region.

Throughout the height of their popularity, the motifs found on kanthas remained con-
sistent, leading Stella Kramrisch, curator at the Philadelphia Museum of Art and an early
proponent of Indian art, to remark:

> Time has nothing to do with the symbolism of kanthas nor with their making. The symbols
> stored in the kanthas belong to the primeval images in which man beholds the universe. Their
> meaning is present in their shape and the position and relation which these shapes within the
> whole; symbol and composition are inseparable in kanthas.[42]

No matter the maker, kanthas share a commonality in composition. They include a
central roundel, a form of sacred space that mimics the composition of the cosmos, which
contains the primary image. The other motifs are oriented around this central roundel. Kan-
thas also have motifs in each corner which help to subdivide the quilt into quadrants, allowing
for discrete groupings of images in each section. The design on a kantha begins with a running
stitch, which is used to outline and fill individual images, and for textured backgrounds, giv-
ing texture to both sides of the fabric, even though the embroidery is done on the right side
of the fabric. Darning stitches, several rows of running stitches done close together, give the
fabric ridges. Chain stitches are used occasionally for a bolder effect. By the early twentieth
century, backstitches, buttonhole, satin, cross stitch and seed stitches were also used. Vari-
ations in the length of the stitches and thickness of the floss used are integral part of the
over-all visual composition.[43] Originally the threads used to embroider kanthas were obtained
by unraveling old saris, then twisting them together to make a thicker floss. Eventually indus-
trially produced embroidery floss replaced the handmade floss.

Kanthas were created as gifts for family members to mark life cycle occasions such as
marriages and births. Highly prized by the recipients and the women who created them,
they are handed down through the generations, giving the recipient his/her familial, social
and religious identity.[44] Larger rectangular kanthas serve as blankets and wraps for warmth,
floor cloths, shrouds, and palanquin seats while smaller ones serve as baby quilts, prayer
mats, and decorative and ritual objects. Worshippers sit on smaller square kanthas during
prayers or for ritual meals. As kanthas wear out, they are either patched or cut down to make
smaller textiles. In modern times, these smaller kanthas are used as book covers, table drapery
and wrapping cloths. The creation of these heirlooms from old garments worn by family
members evokes memories of the past, providing comfort and a sense of belonging to the
recipient.

While most kanthas contained traditional flora and fauna, religious imagery or scenes
from daily life, kanthas made between 1850 and 1950 often contained images of moder-
nity—trains, ships, British soldiers and weaponry[45]—as women embroidered a record of the

impact of the British colonial regime on their lives, making them witnesses to the changes occurring in the world around them. They also served as a form of social protest. When the women felt threatened by tigers—or British soldiers—they were able to overcome these perils through their needlework.

Beginning in the early twentieth century, during India's quest for independence, the kantha transformed from women's craft into a symbol of tradition and the Indian nation. Mohandas Gandhi encouraged Indians to return to the use of indigenous cloth and clothing as a sign of patriotism and a means of breaking Indian dependency on western imports.[46] When the subcontinent gained its independence in 1947, Bengal was torn apart. The western portion, with its Hindu majority, became part of India, while the eastern portion became part of the new Muslim nation of Pakistan. This fragmentation, along with the later independence of Bangladesh in 1971, created a complex tangle of politics, personal remembrances, national lies and collective amnesia that contradicted the mythology of the existence of a united subcontinent prior to the arrival of the British. This mythology can be debunked by listening to the stories of the survivors of the violence that rocked the region as the various factions vied for supremacy and by examining the embroidery of the women of the region.[47] During this time, it was not only the men who fought who suffered the horrors of war; the elderly, women and children were subjected to violence at the hand of the various military factions fighting for control of the region.

As Indians and Pakistanis struggled to define themselves and their nations, traditional textiles moved from the domestic sphere to the public sphere to become symbols of national identity. Women in Bengal saw their traditional dress turned into a battleground in the years prior to the 1971 Bangladesh war, as traditional Bengal dress became symbols of national identity for the new country.

> After 1947, *phulkaris,* the floss-silk embroidered head coverings of the Punjab, were promoted as symbolic of unified Pakistan. In the eyes of East Pakistan, however, the government's focus on this product as representative of the nation as a whole echoed and emphasized the imposition of Punjabi culture on Bengal. Among the ways that East Pakistan manifested resistance was through the symbolism implicit in women's dress and accoutrements, including the right to wear a forehead mark and ornament the hair with flowers.[48]

The Bangladesh War of 1971 disrupted domestic life for women, resulting in a diminishment in the making of alpanas and the production of kanthas in the region as women struggled to rebuild their shattered lives. By the late 1970s, a revival of the kantha tradition was supported by non-governmental agencies operating in the region which saw their production as a way for women to earn money and boost national pride. The kanthas made during this revival had a different intention, authorship, tools and techniques than the originals. Kanthas became part of the public sphere, a commercial enterprise rather than a product with personal meaning. Women no longer had control of kantha production. Men now designed much of the imagery which is pre-printed onto the quilt.[49] Embroiderers use a hoop when creating their designs, resulting in greater uniformity in the stitching, making modern kanthas mere shadows of their creative former selves.

Not all modern kanthas are mass produced, however. Textile artist Surayia Rahman has revived kantha production as an art form in Bangladesh, a way for women to earn income in the poverty ridden region. As a young child, she dreamed of being an artist, sketching images of the places and things around her.[50] Accepted into the Calcutta School of Art, she

never attended classes due to the 1947 partitioning of the subcontinent. She married at seventeen, raising three children. In 1958 her artistic talents were recognized by the Women's Voluntary Association, which sold her paintings and embroideries in their shop. She soon turned her attention to making kanthas, and then to creating tapestries of rayon thread on silk, a technique she termed *nakski kantha*. *Nakski kantha* are art tapestries based on the kantha tradition, meant to be displayed on the wall rather than used in daily life. Her tapestries originally depicted stories based on the British colonial period, rural life, and Bengali poetry.[51]

Her piece, *Georgian Times,* now in the collection of the Textile Museum of Canada, is a memory of her early youth in Calcutta. The piece features a central rectangle divided into nine different scenes. At the center, a cartouche shows a group of British military personnel interviewing a dhoti-clad native. On either side of the cartouche are scenes of British soldiers interacting with a variety of local people, including a Hindu woman wearing a sari and a man wearing a dhoti, with a temple in the background on one side and a Muslim in front of a mosque on the other side. Beneath them are images of local scenery. A bell-shaped cartouche above the central cartouche contains images of a group of men in native and western attire. In the bottom register is a scene of a social event, where local men and British soldiers dance with women in western attire as musicians play in the background. The left and right borders of the piece contain floral motifs while the top and bottom borders contain stylized lotus flowers flanked by scenes of rural life—a horse drawn carriage, forests and farmland. The tapestry provides a glimpse of the past, a time when South Asia was an occupied region under the control of a foreign power, in some ways an idyllic time before the chaos brought on by independence and religious warfare.

While warfare in the region has subsided, the threat of war, in the form of a nuclear holocaust, still hangs over the region as both India and Pakistan build a nuclear arsenal. In 2000, textile artist Archana Kumari protested the nuclear arms testing, expressing her fear over the possibility of nuclear war and her hopes for peace in the region in her *sujuni* titled "Bomb Blast." A *sujuni* is an applique textile made in rural areas, typically in collectives which provide the women with the opportunity to earn additional income.[52] The crafting of each piece is a group effort. Typically one woman, the storyteller, draws the design on the fabric, another woman adds the applique pieces, and a third does the stitching using chain, stem and backstitches. The women who do the last two steps have a great deal of flexibility in the selection of colors and stitch styles used in the depiction.

The story told in Kumari's piece resulted from an encounter she had with some craftspeople in Delhi in 1998 who told her about India's atomic bomb tests in the Thar Desert in Rajasthan. In keeping with the *sujuni* tradition, she drew the design, then hired several women to do the applique and stitching. Her *sujuni* is brightly colored, cheerful even. The piece is divided into three registers, surrounded by a border of individual male and female figures lying on stretchers, representing potential casualties of a nuclear war. They are not dead, however; their eyes are open, an expression of the artist's optimism that war will not come. The top register contains depictions of natives of the Thar Desert whose lives have been disrupted by the nuclear testing, the groups of Hindu and Muslim women talking and crying, an expression of Kumari's desire for peace. Beneath them is a desert scene, including several camels and palm trees. The central register contains two rows of bombs, one labeled India and the other Pakistan. On the right side of the bottom register stand three skyscrapers

Surayia Rahman, *Georgian Times*, India, late twentieth century. Cotton plain weave with cotton embroidery (courtesy Suraiya Rahman and the Textile Museum of Canada).

Archana Kumari, Bomb Blast, India, twentieth century. Cotton embroidery on cotton cloth. 85 in. by 56 in. (courtesy Textile Museum of Canada).

representing the United States, Japan and Russia, modern industrialized nations Pakistan was emulating in its development of modern technology. In the center of the register, a speaker addresses the Indian parliament; to the left, two people hold hands in a gesture of friendship. The wall hanging is finely done, using two hundred twenty stitches per inch on plain weave cotton. It is a form of protest art, serving as a warning about the dangers of war that we all face in the twenty-first century.

Southeast Asia

Textiles have played an important role in Southeast Asia for millennia. They serve a multitude of functions in the region, as ritual gifts, currency and forms of wealth, clothing for the living and the dead, baby carriers, household goods, and religious purposes. As in much of the world, weaving patterns from mats and baskets were transferred to textiles made from abaca (banana plant), ramie, hemp, silk and cotton, plants locally cultivated. Textile production throughout the region, including the growing of plants, dyeing of fibers, weaving, and distribution of the final product, is considered to be women's work, and weaving is seen as an expression of womanhood.[53] Girls learn to weave at an early age, joining their mothers in weaving textiles for the home and for their dowries, including gifts for their family and in-laws as part of the wedding ceremony.

The earliest plain weavings were done on backstrap looms. In time, continuous warp patterns and finally weft patterns, ikat and tapestry weaves developed, along with more sophisticated looms. Typically plain cloth woven in subdued colors is worn for everyday events, while cloth with bright, intricate patterns is used for ceremonial wear. Certain colors and patterns are reserved for chieftains or special occasions. As with Mayan *huipil* designs, color, design and style of textiles are part of group identity in much of Southeast Asia. Women take great pride in creating unique and elaborate textile patterns. These elaborate patterns are handed down through the generations. The patterns are buried with the last weaver in a line so they do not fall into a rival's hands, although clever women may try to copy a pattern they like, leading to changes in pattern and color usage in a particular area over time. Many of these patterns are geometric in nature, while others include representations of birds, plants, figures, and actual or mythological animals.

A shoulder cloth (hinggi) from East Sumba, in the collection of the Mingei Museum, done in cotton weft ikat, features alternating red and black bands of two different types of birds, diamonds, and armed soldiers on horseback, all portrayed in beige with touches of red and black. The soldiers are grouped in twos and wear western style uniforms while a native holds the reigns of both horses, making this a reflection of the occupation by the Dutch conquerors whose presence changed the region forever.

Java

One of the most important textile traditions on the Indonesian island of Java is batik. Originally developed for women's private use, batik's importance widened by the end of the eighteenth century, the result of the demise of imported fabrics from India.[54] Initially,

Javanese men began to wear batik fabrics, but eventually women made fabric for trade, as Dutch merchants increased their demand for ikat and batik fabrics for their home market. Ikat is a woven technique where the warp (and sometimes weft) threads are resist-dyed using a technique similar to tie-dye so that the undyed (or different colored areas) form a design when woven. Batik also is a resist technique; the technique refers to both the process of wax resist as well as to the fabric produced by the process. In batik, a wax is applied to areas of a woven textile to prevent the absorption of dye. Designs are either produced from a stamp or drawn freehand using a stylus that dispenses the wax. Once the fabric is dyed, the wax is removed. Multiple applications of the resist are required for multicolored fabrics. Originally natural dyes, including indigo, were used in batik. Synthetic dyes were imported into the region beginning in 1890, allowing for more vivid and a wider range of colors.

Textile production is a female task in Java. The wearing of batik was a form of communication. The colors and designs' symbolic content was understood by members of the community but not by outsiders. The making of batik serves as a metaphor for the spiritual maturation of a woman. The growing of the fibers for weaving is likened to childhood, the spinning of fibers to adolescence, the weaving to adulthood and the preparation of dyes to old age.

The period between 1890 and 1910 is considered to be the golden age of batik. The opening of the Suez Canal and invention of the steamship brought an increased number of western women to the East Indies (Indonesia) in the late nineteenth century. These new arrivals embraced the elaborate patterns and beautiful colors of batik fabric, resulting in an increased demand for the fabrics.[55] This increased demand changed a formerly seasonal occupation, done by the women after they completed their domestic chores and crop care, into a full time occupation. Traditional batik motifs include stars, animals, abstract geometrics and the tree of life.

Early in the twentieth century the export trade and the increased contact with westerners as the result of increased Dutch colonial expansion led to changes in batik patterns, which soon included images of modernity including steamships, trains, airplanes and depictions of contemporary events. Batiks with imagery of western ships, aircraft and soldiers were usually created for the tourist market, but they also served as a way for women to contextualize their status as a conquered people.

A pair of batik trousers in the collection of the Los Angeles County Museum of Art contains images of Dutch soldiers, done in rich shades of red, green and brown against a cream ground. The officers are mounted on horseback, while a bugler leads a single column of infantrymen. Another infantryman lights a cannon, while still others carry a palanquin filled with supplies. Interspersed among the figures are campaign tents and clumps of grass indicating a path. The figures are depicted with black and brown faces, indicating that the Dutch army included local Indonesians in its enlisted ranks. The pants depict the 1894 Dutch conquest of the island of Lombok by an army composed of Dutch and allied natives. The same event, done in shades of red, black, brown and blue, is depicted on a woman's hip wrapper, or *sarung perang,* made between 1920 and 1930, also in the Los Angeles County Museum of Art collection. The wrapper also features top and bottom stamped borders done in a floral motif, as well as a panel of flowers and greenery in the center of the wrapper.

As Indonesia struggled to build its national identity after achieving independence in

Detail of Woman's Hip Wrapper (Sarung Perang Lombok, Kain Kompeni), Java, Pekalongan, circa 1920–1930. Hand drawn and stamped wax resist on machine-woven cotton, synthetic dyes. 40¾ in. by 7⅝ in. Inger McCabe Elliott Collection (M.91.184.380) (Digital Image Copyright 2014 Museum Associates/LACMA. Licensed by Art Resource, New York).

1949, both Presidents Sukarno and Suharto appropriated Javanese batik textiles as symbols of "Indonesian-ness," despite the fact that they were native to just one island of the new nation. The textiles quickly became an important part of the Indonesian culture. By the 1970s, men's European-style batik shirts in short and long sleeves were deemed suitable for work and official events.[56]

Bali

In 1994, professor Joseph Fischer discovered a "five-foot-high stack of wonderfully embroidered Balinese cloth in an antique shop in Sanur, Bali," uncovering an almost extinct textile tradition that dates to the early twentieth century.[57] The embroideries, done in vibrant colors on primarily white cotton cloth and augmented with sequins, beads, mirror glass and gold threads, featured depictions of gods, goddesses, kings, demons, warriors and sages from the classic Hindu epics the *Ramayana* and *Mahabharata,* making them depictions of imaginary wars.

Throughout its history, the Indonesian island of Bali experienced waves of friendly and unfriendly invasions, which brought with it Buddhism and Hinduism from India, Javanese culture during the Majapahit Empire (1293–1500), contact with the Portuguese and Dutch beginning in the sixteenth century, and finally conquest by the Dutch in the nineteenth century. While the Balinese rebelled against the Dutch colonial administration, unlike in Java, women did not depict images of warfare in their traditional textiles during this time. Instead, they chose to depict images from the traditional Hindu epics that were popular forms of entertainment through *wayang kulit*, or shadow puppet theater.

In 1995, Fischer traced the embroideries to a village in Negara in western Bali, where he met forty women, all of whom were more than sixty years old, who had done the pieces. Only twenty were still occasionally embroidering. The embroideries, known as *sulaman*, were used as offerings and for ceremonies like weddings and cremations. The oldest dated to the 1920s, and most had been created in the 1940s and 1950s. Fischer talked to the women about reviving the unique tradition, but they were not interested, believing they could make more money by weaving.

Hinduism is the dominant religion in Bali and the embroideries can be seen as the embodiment of Hinduism. The myths they illustrate are important to daily life, depicting beliefs and customs including virtuous behavior and proper conduct. They served a similar function as paintings, palm leaf manuscripts, sculpture and dance—the transmission and preservation of Balinese culture.

There were six types of *sulaman*, made in two locations on the island—Jembrana in the west and Buleleng in the north.[58] They were made in the same six sizes as traditional paintings from Bali and served similar purposes. *Ider-ider* are long, narrow horizontal hangings displayed from the eaves of temples. Often fringed, they typically measure eleven inches tall and 100 inches wide. The most common form of *sulaman,* they typically have a painterly look to the illustrations and are narrative in nature, telling a story through multiple depictions of characters on one *ider-ider. Tabings* are square or rectangular temple hangings, thirty inches wide and sixty inches long. They are the most spectacular of all of the cloths, featuring a complete composition within the textile, like a stage scene that features all of the characters from a particular epic. The women often selected their favorite scenes from the *Ramayana* or *Mahabharata* to depict on the *tabing. Leluwour* are square ceiling canopies found in houses and ritual structures. The forty-four inch to forty-seven inch textiles feature floral and geometric designs, often with applique leaves. They are usually signed, dated and annotated with information describing the occasion of their creation. *Lamak* are small vertical hangings made for the home and outdoor family shrines. The twenty inch by thirty inch hangings usually feature one key figure from one of the epics. *Langse* are curtains or room

dividers. They are only made in Singaraja in the north and feature a few figures on undecorated cloth. *Umbul-umbul* are triangular pennants displayed on tall bamboo poles at the entrance to a village or temple celebration. They are usually made from white or yellow plain cloth and sometimes feature a *naga,* or snake.

Most of the embroideries are done on white cloth, although some have red or yellow backgrounds. The *sulaman* are not usually backed, giving a viewer the opportunity to clearly see the embroidery process. They often are edged with fringe and feature continuous borders of diamonds or triangles, flowers, vine tendrils or wavy lines. A variety of stitches is used to create the figures, including stem stitch on trees and plants, satin stitch for flower outlines, figures, clothing, and to fill in areas with color. Chain and cross stitch add to the dramatic appearance of the scenes. The figures depicted were modeled on shadow puppets and frequently appear in pairs, particularly snakes and clowns, which are often included on *ider-iders.* Characters are identified, usually in Indonesian script, although early *salaman* often featured Balinese script. The names or initials of the makers are often signed in ink or pencil on the textile's reverse.[59]

The women who created the *sulaman* were intimately familiar with the great Hindu epics, a requirement if they were to tell the story properly since the epics contain complex storylines in which the numerous characters assume disguises as they interact with people, animals and mythical figures. Several of the key figures depicted are warriors, known for their skill in warfare. Durga, the goddess of battle, is the popular fierce form of the Hindu Goddess Devi and she is featured prominently on a number of the embroideries. She is depicted with multiple arms, carrying various weapons and riding a ferocious lion or tiger and is often pictured as battling or slaying demons, particularly Mahishasura, the buffalo demon.

The imagery featured on one *ider-ider* in the collection of the Johnson Museum of Art at Cornell University portrays the epic battle between the family of the victorious Pandavas and defeated Kauravas at Kurukshetra (India) in the war known in Bali as Berato Judo (Baratayuda). The war is the climax of the Mahabharata, which documents the dynastic succession struggle between two groups of cousins from an Indo-Aryan kingdom called Kuru. According to the epic poem, the war lasted only eighteen days, during which vast armies from across India fought on one side or the other. Despite its short duration, the description of the war accounts for more than a quarter of the epic as it describes individual battles, the deaths of several prominent heroes, military formations, meetings among the military leaders and the weapons used by both sides.[60] At the center of this detail, two brown skinned opponents, one balding and bearded, the other with flowing black locks, brandish swords while standing over the body of a fallen comrade who lies face down between them. Another fallen comrade, this one with black skin, flowing black hair and a moustache, lies on his back, mortally wounded. The ground is depicted by rounded humps and two plants done in shades of beige, yellow and black, frame the central figures. The bottom border contains a series of alternating black, yellow and white triangles, while the top border is done in brown diamonds. At the top center, the words "BeRATO JuDO" are framed in yellow, identifying the scene depicted.

A rectangular *tabing* from Negara, also in the collection of the Johnson Museum of Art, shows a scene from the *Ramayana,* the Hindu epic poem that tells the story of Rama, an avatar of the Hindu Supreme God, Vishnu, whose wife Sita is abducted by the demon

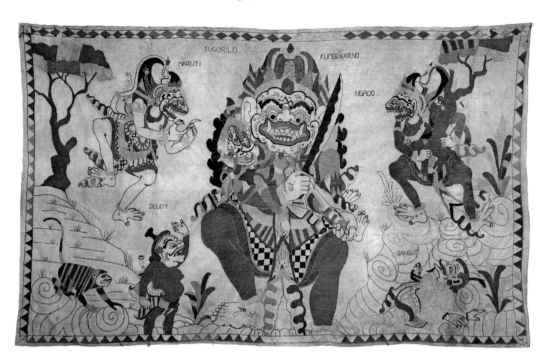

Tabing, with scene of Kumbakarna fighting Sugriva, Hanuman and Anggada, from the Ramayana, Bali, twentieth century. Embroidery and color on plain weave cotton acquired through the George and Mary Rockwell Fund (Herbert F. Johnson Museum of Art, Cornell University).

king of Sri Lanka, Rawana. The epic's sixth book features the battle in Sri Lanka between the monkey and demon armies of Rama and Rawana, respectively. At the center of this *tabing* is a colorful depiction of Kumbakarna, the ogre brother of King Rawana, who is shown grasping the monkey general Sugriwa in his arms while brandishing his kris. At the top of the scene, the monkey-warriors Hanuman and Ngado attack the ogre in an attempt to rescue Sugriwa, while the clowns Delem and Sangut frolic as usual in the lower register. The rocky landscape is depicted using back stitches, while the vegetation is depicted in shades of brown, yellow, green and orange using satin stitches. In this composition, it is likely that the artist was not depicting a specific scene from the epic, but rather assembled the characters she liked best to make this scene, a common occurrence in the creation of these embroideries.[61]

Other popular war images from these epics include Widur Budi, a demon warrior; Rama, the hero of the *Ramayana;* the monkey god Hanuman killing an enemy, also a scene from the *Ramayana;* and images of monkey officers from Rama's army. These depictions of imaginary warfare from these Hindu epics are clear evidence of the importance of the works in the daily lives of the Balinese people, an importance that continues to today in painting, palm leaf manuscript illustration, and sculpture.

Democratic Republic of Timor-Leste (East Timor)

In 1975, Indonesia invaded the eastern portion of the small island of Timor, intent on uniting the entire island and the two nearby islands of Atauro and Jaco under its authority.

The Portuguese had begun trading with the natives of East Timor in the early sixteenth century and had colonized the island by mid-century. After numerous skirmishes with the Dutch, the Portuguese ceded control of their portion of the island in 1859, reassuming control of the area after the Japanese defeat in World War II. East Timor declared its independence from Portugal on November 28, 1975, but was invaded and occupied by Indonesia nine days later. During the next twenty years, Indonesia conducted a bloody campaign of pacification as the Catholic residents of East Timor were subjected to rape, imprisonment and torture at the hands of the Muslim occupiers. The Indonesian invasion ruptured East Timorese society, resulting in the destruction of families and deaths of innocents. As a result of the chaos, women were forced to assume responsibility for the running of the household, providing food, shelter and education for their families.[62] The women also participated in active forms of resistance such as protesting in the streets, activities for which they were arrested, beaten and imprisoned. Many joined the *Falintel,* the resistance movement, carrying arms and fighting against the Indonesian invaders.

Another form of resistance that was employed by East Timorese women came in the form of weaving. Weaving is women's work in the region, and the influence of textiles on women's lives is noted in the local expression "bringing a thread and bobbin" which refers to a newborn child.[63] Many of their weavings include Catholic imagery, taken from western art traditions. While the native language of East Timor is Tetum, the women began adding slogans of resistance to their *tais* weavings—written in Portuguese, the language of their former colonial masters, rather than in Indonesian, the official language of Indonesia. These included phrases such as *Viva Timor-Leste, Timor-Leste* (C11), and *Viva President Xanana,* a reference to East Timor's first president, Xanana Gusmão.[64] Many included images of the East Timorese flag. The piece here was purchased in the traditional market in Dili, Timor Leste, in 2000, just after independence. As Chris Lundry, a member of the United Nations observer team noted, "While the market was definitely a tourist destination, and many textiles were sold to tourists, the Timorese bought and traded these textiles, especially in the euphoria following independence."[65]

Tais weavings are used for ritual purposes, for clothing and for home décor. Clothing *tais* are gender specific. Men traditionally wear a *tais mane* (man's cloth), a large wrap that fastens at the waist, usually finished with tassels. Women's *tais feto* (women's cloth) is in the form of a strapless tube dress. The *selendang* is a slender scarf worn at the neck. *Tais* are woven primarily in cotton; however, in recent years synthetic fibers have been imported into the area and incorporated into the weavings. Dyes used to color the cotton come from native plants including mango skins, turmeric and potato leaves. Red, the primary color in the nation's flag, is a dominant color used in textiles. *Tai* are typically woven on a backstrap loom during the dry season and can take between a few weeks and several months to make, depending on the intricacy of the pattern.

Traditional images include the crocodile, an important native animal prominently featured in the region's mythology, pig, lizard and geometric patterns. Other images included on shoulder cloths and tais included warships, bombs and aircraft—weapons of war the women encountered during their ordeals. These depictions strengthened their resolve in their quest for independence and helped them come to terms with the horrors they encountered during the Indonesian occupation. During the U.N. supervised elections of 2001, women wove shoulder scarves and decorative wall hangings in U.N. blue and white as a show

of appreciation for the safety the U.N. observers brought to the elections. Since winning their independence, the women have returned to using traditional imagery in their weavings.

Vietnam

Like their counterparts in insular Southeast Asia, women on mainland Southeast Asia were also responsible for textile production, which includes weaving, appliqué and embroidery. Textiles serve as a form of communication, identifying the village, clan or ethnic identity of the wearer. In most areas, back-tension looms with circular warps are used to create textiles, including resist tie-dye ikat. Also popular are designs using supplementary warps or wefts, tapestry weaves, embroidery and applique.

During the American Vietnam War, a group of peoples in the central highlands of South Vietnam, called Montagnards by the French, were allies of the Americans. The Degar, as they prefer to be called, were comprised of thirty-six tribes totaling approximately one million people from two different linguistic groups, each with distinct customs, mores and religious beliefs.[66] The groups lived in isolation and were not greatly influenced by foreign traditions from China, India or the West until the War. The weaving of cloth was an important aspect of village life and short-staple cotton is one of the primary fibers used in cloth production. Cotton was planted in rice fields during the rainy season of July and August and harvested during the dry season. The cotton was processed using a wooden cotton gin, then spun into yarn. Indigo blue and red were the principal colors used for textiles, with some white and yellow also included, and stripes as the primary decoration. Weaving was done on a body-tension loom using a continuous warp. The principle clothing for men included a loincloth worn with or without a jacket; women wore a sarong and blouse. Blankets and baby carriers were also important textiles. Loincloths typically measured eight inches to ten inches wide by 118 to 276 inches long. The length of a man's loincloth depended upon his tribe and the social status of the wearer—the longer the cloth, the higher the wearer's status. A woman's sarong was made from a piece of rectangular fabric, knee length for daily wear, ankle length for ceremonial occasions. Blankets, made from two to four lengths of fabric sewn together, could reach seventy-eight inches in length. They served as hammocks, shrouds, and baby carriers and frequently featured geometric designs in supplementary weft. These designs resemble Dongson-style Neolithic geometric patterns such as triangles, lozenges, zigzags, and key and hook designs, each with a name taken from nature, such as cucumber seeds, palm leaves and toucan's beak.[67] As the war came closer to their traditional homeland, they began to produce blankets with military iconography, including helicopters, jets, bombs, guns and soldiers with dogs, images of war which they had seen first hand during the confrontations between Viet Cong and American troops that occurred in the region. These blankets were made for their own use, although some were also acquired by American military personnel.

The Degar were driven from their traditional homeland by the North Vietnamese in 1972 as the result of their support of the South Vietnamese cause, fleeing to refugee camps in the Vietnamese lowlands.[68] In the refugee camps they continued to occasionally produce blankets with military iconography, some of which were made for personal use and others

for sale to visitors to the camps. An indigo blanket in the collection of the Phoenix Art Museum contains two narrow bands of alternating red images on a white ground at each edge. An examination of the figural rows revealed that some of the figures were missing legs or heads, an unusual but obviously intentional omission. The other rows of images were initially identified as shrimp, but a closer examination revealed that the shrimp were actually bombs, making this a textile of war. Another blanket, in the private collection of an American military advisor assigned in the region, features alternating rows of helicopters and bombs at each edge. This piece was procured in the village where it was made in the mid–1960s, an indication that these war textiles were produced for almost a decade before the Degar left their homeland and actually used in the village context. While they were not produced in great numbers either within the villages or refugee camps, they made interesting souvenirs for the military men fighting in the region.

Montagnard baby carrier, unknown, Vietnamese textile, twentieth century. Cotton and synthetic dyes. Collection of Phoenix Art Museum, gift of Amy Clague, 1996.33 (photograph by Ken Howie, courtesy Phoenix Art Museum).

The Hmong were another ethnic group displaced by the American Vietnam War. Prior to the war, the Hmong, or "Free Men" peoples of the mountain region of North Vietnam, Laos and Southern China, who dressed in elaborately embroidered clothing, were separated from the majority population of the region due to religious and cultural differences exacerbated by one hundred years of colonial rule. There are several Hmong groups, including the White, Blue, Green and Striped Hmong, each living in different areas of the region, identified by different textile traditions. As a result of their persecution at the hand of the victorious majority governments in Vietnam, Laos and Cambodia because of their support of American efforts, many Hmong fled across the Mekong River into Thailand, temporarily settling in refugee camps while awaiting permanent settlements in the west.

Textiles are valued family treasures, serving as badges of individual, clan and ethnic identity. As part of a patrilineal clan system, Hmong women are responsible for maintaining the home, including the production of textiles for clothing and other household needs. The Hmong have no temples and build strictly utilitarian homes, so clothing decorations were the only ornamentation they used in their native lands. This decoration included embroidery

and applique designs on the clothing of adults and children, believed to enhance "the life of the soul."[69] A Hmong woman's needlework determined her eligibility as a wife as well as her place in society, so women were said to embroider their hopes and dreams into their work. Although they are believed to have power, textile patterns were not uniform among the different Hmong groups, each subjected to regional, tribal and external economic and cultural influences.

Hmong women had a wide range of needlework skills, including applique, reverse applique, tuck and fold applique, couching, cross-stitch and satin stitch.[70] Mastery of these needlework skills requires years of practice and girls begin to learn these techniques at an early age. These techniques are used to form abstract patterns called *paj ntaub*, or flower cloths, used as signs of kin affiliations, wealth and marital status in both everyday life and for ceremonial events such as New Year's celebrations and rites of passages such as dowry pieces and bride payments. The traditional shape used for *paj ntaub* is a square. The majority of the patterns are non-representational, for allusions to the natural world are considered dangerous, thought to bring unwanted attention from evil spirits. In Hmong society, only those women with the hereditary right to use wax (to make batik cloth) were permitted to do pictorial representations since the Hmong believe images of objects could become hiding places for evil spirits. The Hmong have a strong oral tradition of sacred poems, myths and magical chants that give these multiple layered abstract textile patterns multiple layers of meaning. The *paj ntaubs* record symbolic messages intended to be preserved and sent to family members in the spirit world, a means of requesting help from the spirits and of remembering the ancestors.

Hmong clothing is made from homespun of cotton or hemp that is sometimes dyed indigo (by postmenopausal women), red, green or orange.[71] The patterns are used on belts, baby carriers, hats, tunics, shirts, sashes, jackets, leggings, and story cloths made in a traditional color palette where the colors have specific meanings. Embroidery patterns are done in complementary colors. Red is an important color, thought to repel evil spirits. Baby carriers are usually embellished with bright embroidery done in red, yellow and pink to protect a baby from evil spirits while small children wear ornately colored hats designed to make evil spirits believe they are flowers.[72] The complex patterns are influenced by the world around them, named for the objects with which they are associated. The spiral figure is associated with water and the toad-rhinoceros spirit, while stair-step triangles reference crocodile teeth.[73] While many traditional patterns have been used for generations, patterns have changed over time as the result of contact with French, Chinese and lowland Lao peoples during the late nineteenth and twentieth centuries.

Representational embroidery, known in the west as story cloths, began to appear after the Hmong came into contact with outsiders in the Thai refugee camps to which they fled after 1975. Seen as an extension of traditional needlework, they combine the Hmong oral tradition with their sparse visual artistic tradition. Scholars theorize that the story cloths, which illustrate the Hmong way of life in their Southeast Asian homeland, the impact of the war, their escape to Thailand, and traditional myths, developed in the United Nations refugee camp Ban Vinai in northern Thailand after the fall of Saigon in 1975, spreading to other camps in the region as women were encouraged to make objects for sale to western tourists.[74] Some scholars maintain that story cloths were made spontaneously by Hmong women in Ban Nam Yao refugee camp in 1977, while others say the source was a Flower Mai

Hmong in Thailand in approximately 1980. Still others believe that western refugee workers suggested that the women use a pictorial style for their work.[75] Story cloths are seen as self-conscious statements about Hmong ethnicity which evolved as the Hmong developed a written version of their oral language in Ban Vinai camp.[76] Some story cloths are linked to images seen by shaman, who are women, during trances.

The new artistic format, known as *paj ntaub dab neeg* (flower cloth of people and customs), is embroidered on a grey, blue, green, black or beige background. The cloths do not always follow the color dichotomy or symmetry of traditional Hmong embroidery. The designs fill the picture plane, with no clear distinction between positive and negative space, but the images do follow a narrative order, reading from upper left to right in each register, then continuing across to the next row, reading like a western book. Story cloths became a "visual version of an emerging contemporary legend—a personal or communal narrative about an event based on written fact and personal or communal experience and mixed with traditional materials and belief."[77] The Hmong adoption of picture writing can be seen as coming from a change in their thinking from a non-literal to a literal sense of reality, since the scenes depicted help systematize and organize events in recent Hmong history, making them controllable, much like words on a page. Hmong women select which events and people to depict on their story cloths, providing a carefully constructed scene for the viewer. The term story cloth was believed to have been coined by a group of Hmong women living in Montana in the late 1970s to describe this new artistic format. Some anthropologists have suggested that the images on story cloths closely parallel the simple, comic book style books used in the camps to teach the Hmong to read.[78]

The story cloths are done in a square or rectangular format and range in size from three inches square to king-size bed pieces. They serve as pedagogical tools, telling stories of the Hmong to other Hmong and to outsiders. The earliest pictorial cloths contained images of single, large animals arranged without any apparent relationship to each other, similar to illustrations in a child's alphabet book, done in bright colors. Eventually the imagery evolved to include human figures and illustrated stories. Many depicted the flora and fauna of their homeland, as well as mythological animals taken from their traditional stories. Some depict Biblical stories, images from western children's books and textbooks. The embroidery is done in chain, satin, straight, and cross stitch using brightly colored floss to depict their ethnic clothing. Animals and plants are realistically colored and depicted.

The most compelling story cloths are those that tell the story of the Hmong flight into the refugee camps (C6). Typically they show the Hmong in their villages and working in the fields, where they are confronted by green uniformed Pathet Lao soldiers who menace them with rifles and destroy their village. Figures are usually shown in profile; only a few plants are used to indicate fields of crops and a few huts indicate a village. Helicopters are often depicted in the act of destroying the village. Central registers often show the traditionally clad Hmong fleeing from their village, while lower registers show them crossing the Mekong River, often floating in inner tubes, on rafts, or swimming, a dangerous undertaking since most Hmong are not strong swimmers. In the final register, the Hmong enter the refugee camp, often escorted to safety by Thai soldiers.

Initially Hmong women made the story cloths to help them remember the old ways and to document the story of their flight from their homeland. Despite their bright colors, these embroideries are not gentle, happy textiles. They are instead strong statements docu-

menting the hardships they had endured for years. While some see story cloths as strictly tourist art, made to earn income while the women awaited resettlement and for non–Hmong by Hmong women resettled in the West, they also serve as advocacy art, pleading the Hmong case for refugee status in the court of public opinion. This refugee status is what enabled the Hmong to relocate to Australia, New Zealand, America and other western countries.

Over time, the textiles changed to meet a new social context and customer. In some cases, they have become a family industry, with men drawing patterns from books and women doing the embroidery. Color palettes have changed with the introduction of commercial dyes and changing consumer tastes. By the early 1990s, Hmong women had ceased to embroidery war story cloths, citing a lack of interest in events of the past by both young Hmong and westerners and their own desire to move past the horrors of war. Today, textiles made for the tourist market include traditional applique imagery as well as illustrations of Hmong myths, western stories and flora and fauna from both the Hmong homeland and their adopted countries, and are done in a variety of formats including pillow cases, bedspreads, wall hangings, and Christmas ornaments. Story cloths, especially those that document the Hmong war experience, are more than just tourist art. A form of documentation of the Hmong search for recognition as a displaced people, they were "directed at a buying public whom the Hmong hope[d] to convince of their plight and legitimacy as refugees from communism."[79] Like the works of other women who have created textiles of war, Hmong story cloths can be considered to be a form of advocacy art as well as a means of recording and preserving a lifestyle changed forever by modernity.

Cambodia

In April 1994, Bud Gibbons, a former American soldier who served during the American War in Vietnam, arrived in Phnom Penh to become part of Veterans International, a subsidiary of Vietnam Veterans of America. The following year he became the manager of a rehabilitation project in the remote northern province of Preah Vihear, which was the first organization outside Phnom Penh to provide prosthetics to victims of land mines and wheelchairs to other handicapped individuals, which included women who had lost limbs to land mines left over from the American war and the decades of civil war that followed. As Project Manager of the Preah Vihear Income-Generating Project in Cambodia, Bud instituted and oversees a training program for the disabled, with an emphasis on disabled women. As part of this training program, Gibbon had the idea to reinstitute silk weaving, a traditional Khmer art in pre-war Cambodia, believing that the production of scarves and wraps for foreign tourists would provide an income for the disabled women in the region. In 1997, using grant money from the Vietnam Veterans of America, he brought in artisans to build wooden looms and sent six women to Siem Reap in western Cambodia to learn how to weave. He also imported silkworms and mulberry trees in an attempt to produce local silk, but it quickly became obvious that it was more cost effective to import silk from China and Vietnam for his weavers than to produce it himself. He also realized that he needed the help of a professional weaver to train the weavers and give him advice on the project. He contacted Carol Cassidy, an American weaver who operated a weaving studio in Laos.

In 1989, American textile artist Carol Cassidy arrived in Laos on a contract from the

United Nations International Labor Organization to serve as an advisor to the weavers at Lao Cotton.[80] A skilled weaver, she had previously worked on United Nations weaving projects in Africa and the Caribbean. At Lao Cotton, she taught Lao weavers to use Swedish looms and monitored the quality of the textiles woven by the 210 weavers in the project. As part of the project she also designed fabrics for commercial sales, many based on traditional textile designs which were produced by local craftswomen. She eventually opened her own workshop in Vientiane which produces silk textiles based on traditional designs, but using innovative colors and designs. Her staff of fifty workers is involved in all aspects of textile production, including dyeing, winding of threads, weaving, and finishing, and they receive a fair wage for their work. The designs feature animal and mythical-creatures, including the Naga or river serpent, a mythological water serpent with unparalleled benevolent powers, as well as abstract geometric prints and stripes.

In 1998, she joined Gibbon's weaving project in Preah Vihear as an advisor, working with five women who had been wounded by the thousands of land mines left over from the Vietnam War and Cambodia's decades-long civil war. Today the project employs more than eighty farmers, spinners, dyers, weavers, and finishers, and the project contributes sustainable income for the artisans and their community, resulting in a village with electricity, clean water and children who attend school on a regular basis. Many of the women weavers are amputees who have been unable to find work, discriminated against due to their disability, who have now secured long-term employment with the Weaves of Cambodia project.

By 2002, the Vietnam Veterans of America organization decided it could no longer support the weaving studio, so in 2003, Gibbons asked Cassidy to take over the project, telling her, "It's that or closure."[81] Cassidy reluctantly agreed, despite her heavy workload at her Lao studio. Her enthusiasm about product design and the response of the women to her advice and instructions convinced her to assume a greater role with the project. For the past ten years she has alternated her time between her studio in Vientiane and those in Siem Reap and Preah Vihear.

The textiles, which are currently woven in silk on thirty-eight looms and include scarves, shawls, sarongs and other accessories done in traditionally inspired Cambodian patterns, are produced in vibrant, contemporary colors and are finished by hand.[82] The textiles are popular worldwide, available for sale at a number of high end retailers in the United States and Europe and have been exhibited at numerous museums in the United States. Cassidy believes that the Weaves of Cambodia project proves that successful development ventures do not require million dollar investments to succeed. Rather, she has proven that with careful thought, enthusiasm, patience and a clear plan, people living in rural areas impacted by war can successfully participate in the global economy.

Australia

Because it was settled by European immigrants after the Industrial Revolution, Australia has no real tradition of hand crafted textiles.[83] The aboriginal people of Australia wore little clothing in the warmer regions, covering themselves with animal skins as warmth was needed. As members of the British Empire, Australian had ready access to imported manufactured textiles from England, as well as from India and Southeast Asia. In the early twentieth

century, immigrants from the Middle East, Europe and Asia brought their own textile traditions to the continent, sparking local interest in hand-crafted textiles. In 1922, the Handspinners and Weavers Guild was founded in part to promote the thriving wool industry. After World War II, interest in other textile crafts boomed, leading to the creation of the Crafts Council of Australia.

Knitting and filet crocheting were very popular during the first half of the twentieth century. Women made both decorative and functional domestic objects, including tea cozies, tablecloths, pillow covers, and lace cuffs and collars using both published crochet patterns and their own imaginations. During World War I, women embellished their creations with war-related images, including ships, soldiers, flags and patriotic slogans such as "Success to the Allies" and "God bless our brave boys," based on patterns published in ladies' magazines. In many cases, crochet items were personalized with the name of a specific serviceman. Some works were sold as part of fundraising efforts in support of the war effort. Mary Card, a well known Australian designer, sold her crochet doily patterns to the public, donating the proceeds to war charities.[84] Her most well-known pattern, designed in 1916, featured the images of an Australian soldier in commemoration of the ANZAC landing on April 25, 1915. She designed a matching sailor two years later. These crochet objects allowed women on the home front, far removed from the fighting, to show their patriotism and support for the war effort.

Another way in which women showed their support for the war effort during World War I was by knitting socks for the troops. The seamless grey socks, made from eight-ply wool yarn, were vital for the troops, whose regulation socks often rotted in the wet, muddy trenches in Europe. Dry socks helped prevent trench foot, the bane of many a soldier's existence.[85] The tradition was revived during World War II, as Australian women again manned their knitting needles to create socks for the troops. After hearing Mark Donaldson, a winner of the Victoria Cross, speaking about his experiences in Afghanistan in 2011, the Country Women's Association in Werribee began a campaign to knit caps and gloves for the Australian troops stationed overseas.[86] CWA Radio published the patterns for a man's skull cap, intended to be worn beneath a helmet, and open finger gloves, which keep the hands warm while allowing for the operation of sensitive equipment.

Among the textiles included in the collection of the Australian Museum of Clothing and Textiles, is a pair of men's underpants made from a roll of tram destination material during World War II by Mary Ridley, using a World War I pattern that includes French seams which discouraged lice.[87] The tram destination material, which is made from a heavy cotton canvas, contains the names of the various stops along a tram route. It was purchased without the use of a wartime ration card since they were made in the early days of the deprivation of World War II, and is an excellent example of the creative reuse of textiles that were no longer needed for their primary use.

As the conflicts in Iraq and Afghanistan have continued, many Australian women have used their sewing skills to support the troops. In 2011, members of the Gumnut Quilters in New South Wales began a project to create colorful laundry bags for Aussies serving in the war zone. They titled their project (and blog) Aussie Hero Quilts (and laundry bags), and their project is dedicated "to encouraging people to make quilts and laundry bags to send to Aussie service men and women currently serving overseas—to express our gratitude for their service.... Our quilts are not works of art, but works of the heart."[88]

Because military issue laundry bags are white, blue or olive green, it is difficult to distinguish one person's laundry from another when retrieving clean clothing. The bags are typically requested by family members, allowing the maker to personalize a bag even more with an individual's initials and a special print fabric. The bags are made of a heavy exterior fabric like canvas, with a bright calico lining, and closed with a sturdy rope.[89]

After making several dozen laundry bags, the women quickly added quilts to their repertoire. The quilts, which measure forty-two to forty-four inches wide and seventy to seventy-five inches long, are made from colorful cotton or wool/polyester blends in any pattern the quilter wishes to use. The blog features a fairly easy "Block of the Month" for novice quilters to use if they so desire. Each Aussie Hero piece includes a label that notes:

This is an
Aussie Hero Quilt
made for an
Aussie Hero
serving overseas
with gratitude for your service
2013
aussieheroquilts.blogspot.com.au
friends of AHC@gmail.com

As the result of numerous requests, sewers are provided with a list of goodies they can include with their piece, if they would like.[90] By late September 2013, a total of 2093 quilts and 3369 laundry bags had been sent to the troops. Additionally, several quilts had been sent to a hospital in Kandahar to be used for wounded soldiers being transported to Germany for additional care.

Award winning quilter Lucy Carroll's quilt *Soldier On* won first place honors and the Viewer's Choice Award in the Pictorial Quilts section at the Sydney Quilt Show in 2013. The quilt was made to publicize the work being done by the organization of the same name which works to "enhance recovery, inspire communities and empower Australia's wounded, giving those who have served our country the dignity they deserve and the chance to do and be whatever they choose."[91] Soldier On was founded in 2012 by two former soldiers who saw first hand the physical and psychological effects of war on those who served in Iraq and Afghanistan. At the time of its founding, there was no charitable organization in Australia dedicated to supporting wounded soldiers, and Soldier On has filled that void.

Carroll, who is a graduate of the Australian Defense Force Academy and is married to a naval officer, wanted to do something to help wounded service members when they return home.[92] A self-confessed textile obsessive, she turned to quilting as her way of helping. After exhibiting the Soldier On quilt in as many venues as possible, she plans to sell the quilt and donate the proceeds to Soldier On.

Soldier On features an interesting perspective—the most important action of the quilt occurs at a vanishing point that gives the appearance of great distance from the viewer, who looks down a long hallway to a door frame in the distance. To the left, a wall filled with columns of three dimensional bright red poppies with black stamen and pistils embellished with black seed beads on a black ground. To the right is a row of white windows atop a charcoal grey partial wall. A grey tile floor leads the eye to the end of the hallway, where the

image of two soldiers can be seen from behind, the one on the right supporting his wounded comrade, two-thirds of the Soldier On logo. Carroll over-dyed the fabric to get the exact colors she envisioned for the quilt.[93] She chose to include the poppies because they are symbols of remembrance of the sacrifices made by service men and women for generations. The scarlet corn poppy grows in disturbed ground in western Europe. The destruction resulting from the Napoleonic Wars led to acres of red poppies, which grew around the bodies of fallen soldiers. In late 1914, poppies again populated the fields of Northern France and Flanders, leading Canadian surgeon John McCrae to pen the poem "In Flanders Field."[94] The poppy has been associated with the sacrifices of war ever since.

New Zealand

Knitting was brought to New Zealand by missionary women in the nineteenth century. Some women brought spinning wheels with them, while others procured them upon their arrival. The spinning wheel allowed the women to make their own wool yarn for knitting and weaving. Commercial knitting patterns were available for outer garments by 1895; patterns for children's garments and adult vests and sweaters were available earlier.[95]

During World War I, women were encouraged to knit socks, gloves and balaclavas for the troops. *Her Excellency's Knitting Book,* which contained officially sanctioned patterns, was published in 1915 under the guidance of Lady Liverpool, wife of the governor, as a fund raiser. New Zealand's women responded to the call to action, producing 130,047 items in August 1916 alone. Children were also encouraged to do their part for the war effort. Numerous photographs of the period show children making clothing for the British and Belgian Relief Fund and New Zealand troops. In addition to knitting socks and scarves, they wrote letters and sent care packages to the men serving overseas.

Knitting retained its popularity during the years between the wars, and played a valuable role during the depression of the 1930s. During World War II, yarn was distributed to knitters by the National Patriotic Fund Board as women were again encouraged to knit for the troops. "Knit for Victory" became a large campaign throughout New Zealand, and women were expected to contribute by knitting or taking apart old clothing for re-purposing. More than one million items were ultimately made for the troops.

During World War I, more than 250 women's patriotic organizations were founded in New Zealand, each providing items for the war effort. The St. Clair Ladies' Club, which was established in December 1914, partnered with the Red Cross to send hand made objects to the troops fighting overseas. Included in these objects were quilts that helped raise funds by having people purchase and sign squares that were then embroidered and sewn into quilts, intended for hospitals treating the wounded. In addition to the names and patriotic slogans included on these quilts, patriotic images such as the flags of the Allies, were often added by the quilters.[96]

Patriotic New Zealand women also wove cloth and sewed clothing for people in Britain, in a show of solidarity with the motherland during World War II. They created quilts to raffle for the war effort, especially in support of the Red Cross. In 1943, women from the small town of Moneymore created a quilt for the Red Cross to use in a hospital treating wounded in Europe. The quilt features a large central red cross on a white background com-

posed of small squares. Each square, which was sold to women to embellish as a fundraiser, was embroidered with patriotic imagery and slogans, as well as the names of family members and friends serving in the war, and those who did the red floss embroidery. The squares were assembled into a quilt by several women. The quilters lost track of the quilt once it was given to the Red Cross, but it resurfaced in 1981 when it was discovered in a California flea market by a Canadian woman who returned it to Moneymore in August 2010 to great fanfare.[97]

The tradition of quilting for the troops has continued into the twenty-first century in New Zealand as women have created patriotic quilts for their loved ones serving far from home. Several groups are selling quilts that feature large yellow ribbons appliqued atop a backing made from patriotic military printed fabric, with the proceeds going to organizations that support the returning troops.

Women across Asia and the Pacific Rim have used their textiles to explore their reactions to war for centuries. While some of these wars are based in traditional mythology and stories and as such can be considered as depictions of imaginary warfare, they have played critical roles in religious practices and society in the regions in which they were created. Other textiles which depict images of war have played a crucial role in either the war effort, as in the creation of senninbari by Japanese women in the first half of the twentieth century, or in helping women come to terms with the warfare that raged around them. In all cases, these textiles served as a bridge between the women and the horrors they experienced, allowing them to put the violence into context and deal with the emotions they experienced. Some of the textiles served as a form of protest against violence, while others serve as symbols of hope for peace and prosperity.

Six

The Middle East and Central Asia

Textile production developed as women's work very early among the nomadic groups throughout most of the regions known today as the Middle East and Central Asia. Women use a wide variety of textile traditions to create objects for domestic use, trade, and sale in the region's bazaars, allowing them to contribute to the economic welfare of their families. Girls in the region learn to embroider in childhood, producing personal and household items for their dowries. Each group of women uses favorite stitches, color palettes, and motifs in their textiles. Satin stitch is almost universally found in embroidery throughout the regions, while cross stitch is widely used in Uzbek and Hazara embroidery. Kohistan embroidery features white thread and beads.[1]

Throughout Central Asia, domestic weaving was not widespread; felt production and embroidery were particularly important since felt was widely used for tent coverings and furnishings, hats, clothing and boots. Felting is an ancient textile technique and was widespread throughout the region by the fifth millennium BCE.[2] Camel hair, goat hair, sheep wool, and horse hair were initially spun into the thread used in textile production. By the fourteenth century, cotton and silk were also used. Red, from the root of the madder plant, and black, from a mixture of pomegranate peel and iron, were prominent colors used in textile production. Early decorative elements added through embroidery or applique, and featured abstract geometrics, florals, the sun disc, and real and mythical beasts, served as totems for tribal groups.[3]

While felting was prevalent in Central Asia, across the Middle East woven textiles have been important, used by nomadic groups for portable furnishings and for cotton clothing and silk by nomads and urban dwellers alike. In Islamic areas today, men weave since it is not considered appropriate for women to work in public. Many Islamic women do still weave in the home, producing fabric for domestic use.

In the Middle East, men were not always the weavers, however. Spinning and weaving were originally considered to be household tasks, performed by women as far back in time as ancient Egypt, as evidenced by paintings and manquettes found in tombs of pharaohs and aristocrats. By the time of Ptolemaic rule, large scale household production resulted in popular, high quality commercial textiles. Both male and female weavers produced commercial textiles in workshops known as corporations; the President, or master of the looms, worked with the government which set production levels.[4] During this Roman period, textile production was a hereditary trade, passed down through familial lines. Roman era frescoes in catacombs and villas show people attired in the traditional clothing of the time—neutral

colored plain weave linen that features decorative borders and bands in a variety of colors and patterns. Many of these textiles were produced by women across the far reaches of the Roman Empire and from regions outside of Roman control, traveling across the famed Silk Road.

From the dawn of history, Syria has served as a trading center for goods traveling between Asia and the Mediterranean. The city that grew up around the oasis at Tadma, better known as Palmyra, quickly became a center for textile production as well as the seat of power for the warrior queen, Zenobia (240–circa 275 CE). At the death of her husband, Septimus Odaenathus, in 267 CE, she vowed to expand the Palmyrene Empire for her young son, conquering Egypt and extending her reach north into modern day Turkey. Famous for her beauty, intellect and bravery in battle, she was a true warrior, hunting, riding and drinking with her military officers. Zenobia was eventually defeated by the Roman Emperor Aurelian, captured on the banks of the Euphrates River, and taken to Rome in chains. During her reign she was depicted in profile on coins, wearing a diadem; the coins' reverse featured the Roman goddess Juno wearing the goatskin cloak associated with warfare.[5] Palmyra was a matriarchal, clan-based society where women owned property and had political and economic freedom not found elsewhere at the time; however, most women were not warriors.[6] They did, however, weave, both as an economic necessity and for religious reasons. The importance of weaving was deeply embedded in Palmyrene society. The great female deity of Syria, who was depicted holding a distaff in sculpture, was said to have the power to weave cosmic destiny and control fate. In funeral portraiture dating between the second century BCE and the third century CE, Palmyrene women were frequently depicted holding a distaff and spindle. Women were also buried with a distaff to commemorate their life's work and as an association with the goddesses of resurrection and renewal.

Palmyrene women wore headdresses which were used as signs of their status, identifying their clan and cultic affiliations through the headscarf's iconography.[7] While the style of headdress changed over time, several styles were popular for extended periods of time. Before 95 CE, an undecorated headscarf was worn atop a turban roll or cap and beneath a veil. Between 90 and 220 CE the headscarf was decorated with carved or incised lines called striates, while between 50 and 250 CE, scarves with painted striates were also popular. Between 110 and 272 CE, popular vegetal designs included fig leaves, palm fronds, olive branches, flowers and acanthus fronts. The fig, palm and acanthus were all associated with the rejuvenating and sexual powers of the goddesses. These designs were embroidered either along the edges of or throughout the entire headscarf using silk thread. Cross stitch and cross hatch stitches were also used in popular embroidery patterns.

Textiles found in tombs in Palmyra provide evidence of the city's wealth and women's abilities. Fabrics of animal wools from sheep, goats and camels, flax, cotton and wild silk (tussah) were prevalent. Chinese silk, while expensive, was actually more common than wild silk due to the large scale silkworm production throughout the country, and was often used as decorative strips on linen and woolen garments. The most common silk textiles in Palmyra were plain canvas weaves and Han Dynasty damasks. Despite the existence of a warrior queen and their matriarchal society, war was not a subject of depiction for Palmyrene textiles. Rather textile designs emphasized curvilinear geometric, vegetal and floral motifs.

Coptic and Byzantine Textiles

Coptic textiles, whose production began in the third and fourth centuries CE in Egypt, were hand woven with unbleached linen warps and dyed wool wefts and frequently featured woolen tapestry decoration. Men's garments were done in sedate colors with monochrome interlace motifs while women favored floral and figural decorations. During the Early Coptic period (3rd–4th centuries CE), the primary decorative themes were taken from nature and mythology. By the middle period (5th–7th centuries CE), depictions included abstract natural elements and Christian symbolism. During the Late Coptic period (7th–12th centuries CE), as Islam became the predominant religion in the area, geometric patterns and calligraphy were used as decorative elements in textiles.[8]

Coptic women spun flax and wool into yarn in their homes, selling the yarn to merchants who sold it to weaving workshops and private weavers. Itinerant weavers, slaves and freedmen, both men and women, wove as individuals and in organized weaving workshops. An individual could apprentice with a master weaver, although weaving was primarily a family enterprise. Weaving was also a popular activity for both nuns and monks, who considered it to be a humble, meditative occupation.

Many Coptic weavings from the early and middle periods feature human and animal figures as well as scenes from the Old and New Testaments. Images from classical western mythology, such as depictions of Amazons and Greek key geometrics, were also popular. Nude warriors, often depicted holding a shield and paired with a lion, were common textile motifs, reflections of contact with the classical world. In one sixth century CE depiction in a private collection, a nude warrior, woven in reddish brown wool on a tan linen ground, is shown running, shield tightly held against his body. As with other similar depictions, this is not necessarily a war image, despite the presence of a weapon-wielding warrior. Rather, it is a spiritual representation common to the time period. The figure's nudity was symbolic of spiritual purity. An accompanying lion represented man's bestial nature, a common theme in Christian textiles, rather than strength or courage which it symbolized in pre–Christian times. The combination of both figures represented the battle of the spirit against man's natural animal inclinations, which at the time was viewed as a war-like activity.[9] Although it is not possible to determine whether a particular warrior image was woven by a woman, that very easily could have been the case since both men and women worked in commercial weaving workshops.

Coptic tapestries, as well as pile carpets from Central Asia and Byzantine silks, were popular throughout Europe and the Mediterranean from the 5th to the 13th centuries. Byzantine silk fabrics and tapestries were famous for their brilliant colors, gold thread, and intricate designs. So important was textile production to the Byzantine Empire that dyers, weavers, gold embroiderers, and tailors were mentioned in the Edict of Diocletian and in the Theodosian Code.[10] Byzantine silk production began during the reign of the emperor Justinian (483–565 CE) when two Christian monks smuggled silkworm eggs out of China. The silkworms thrived on Syrian mulberry plants, thus beginning a profitable sericulture industry in the West.

There were several levels of textile production in Byzantium prior to 1200 CE: imperial workshops which were under royal patronage; public guild workshops; private workshops run by wealthy Christian citizens and modest homes of Islamic male craftsmen; and private

looms for women's domestic weaving. As early as the fourth century CE, female Christian weavers worked in imperial silk weaving workshops alongside male weavers. As in many other societies, weavers were members of a hereditary cast, and weaving was considered low status work.[11]

Prior to the thirteenth century, the Church was the largest consumer of Byzantine silks, which included church hangings and furnishings, manuscript bindings, relic and funeral wrappings, and vestments.[12] Among the most prevalent patterns found in Byzantine textiles were birds and florals, geometric patterns, hearts, palmetto and lotus, and animal and human figural scenes, often contained as pairs within roundels or medallions. Other popular depictions were trees of life, winged horses, and other mythological animals, as well as figurative scenes, often hunting scenes or stories taken from the Bible.

Several Byzantine textile fragments in museum collections feature military figures. An eighth century roundel in the collection of the *Musée National du Moyen Age* (National Museum of the Middle Ages), Cluny, Paris, features a golden four-horse chariot driven by an armor-clad horseman set against a dark background. Found at the tomb of Charlemagne in Aachen, it may be a depiction of the first king of France, a mighty warrior who united a group of disparate petty rulers into a cohesive nation. A tenth century fragment in the collection of the Royal Museum of Art and History in Brussels features three medallions containing warrior driven chariots done in shades of brown, black and tan. As with Coptic textiles, it is impossible to know whether these depictions of warriors were created by a male or a female weaver, but such images certainly reflect a pride in military heroes from the past.

As Islam spread across the Middle East and North Africa, the imagery found on textiles made within the region changed to accommodate new, very different religious values. Rather than figural depictions and mythological creatures, many Islamic textiles featured geometric patterns, florals, fruits and vegetables, and calligraphic ornamentation, often embellished with gold thread. As in China, textiles were used as tax payments, sent from the provinces to the ruler. Clothing was also used by Arab nobles as an annual gift to servants in lieu of, or as part of, their wages.[13]

Islamic embroidery, known as *tirāz*, rose to prominence by the sixth century. Over time, the meaning of *tirāz*, an Arabicized Persian word, changed to refer to a robe with decorative embroidered bands of calligraphy, worn by a ruler or high ranking official. It can also refer to the workshop where the robes are made and to strips of writing done either in woven or embroidered fabric, mosaic, stone or wood, as well as a tapestry with a woven inscription.[14] There were two types of *tirāz* produced—*khassa*, which was made exclusively for court use, and *amna,* which was available for purchase in the bazaars. The creation and giving of *tirāz* was seen as a sign of patronage, a contract between the caliph and the people. *Tirāz* was often presented to the caliph in lieu of tax payments and as tribute. It was also given to temples, mosques, monasteries and churches throughout the Mediterranean.

Despite the common misperception in the west that Islam prohibits figural depiction in art, there is a rich tradition of figured representation in Islamic textiles. In the famous *One Thousand and One Nights,* or *Arabian Nights*, story, which is set in the Sassanid Persian Empire, there is mention of a young woman who embroiders a border of birds, wild animals and hunters using gold, silver and brightly colored thread.[15] The Italian explorer Marco Polo

commented on the rich variety of gold and silk textiles, many adorned with images of birds, animals and human figures, found in the bazaars along his travels. In speaking of Kerman, Polo noted:

> The ladies of that country and their daughters also produce exquisite needlework in the embroidery of silk stuffs in different colors, with figures of beasts and birds, trees and flowers, and a variety of other patterns.[16]

The factory system of textile production began in Persia and spread throughout the Islamic world by the tenth or eleventh century. Both Baghdad and Samarra were important centers of palace supported textile production. Other important weaving centers were located in Alexandria, Yemen and Armenia. Both slaves and harem girls worked in weaving factories, and women initially worked in commercial textile workshops throughout the Muslim world. Among the carpet weavers of the Basinna group in Khuzistan both men and women wove, and in Nisa (Turkmenistan) women were the weavers. Marco Polo also noted that in Gilan, the Caspian area of Armenia, women raised silk worms and wove silk (which he called Ghelli), creating waist cloths that were exported around the Arabic world.[17]

Over time, as Islam became more conservative, in many areas of the Islamic world women's roles in society became more restricted as the Koran's teachings were reinterpreted. As the result of these new restrictions, women were no longer permitted to work in public, and men assumed all aspects of commercial textile production. In many cases, women continued to produce textiles for domestic and personal use within the household. At various times, typically during times of war or conflict, these skills would serve the women well, allowing them to express their feelings about the conflict and to support their families by selling the textiles they produced, important for women who lost their husbands during a conflict.

Russo-Turkish War of 1877–1878

The Russo-Turkish wars were a series of conflicts fought between Russia and the Ottoman Empire between the seventeenth and nineteenth centuries as Russia sought to expand her territory in order to secure a warm water port.[18] The Russo-Turkish War of 1877–1878 was the final war between these powers, fought in the Balkans and Caucasus, the result of Russia's claiming of Kars and Batum, and the desire of Romania, Serbia and Montenegro for independence from the Ottoman Empire. The war resulted in thousands of Muslim civilian casualties and more than 130,000 (primarily Turkish) Muslim refugees, many of whom ended up in refugee camps in Eastern Europe. The war was the impetus for the creation of the Red Crescent relief agency which, along with western relief agencies, established a variety of craft projects to enable the refugees to support themselves in the camps.[19] Women were encouraged to create embroideries using colored silk and metallic threads in new and different ways. Their traditional geometric and floral patterns were embroidered on purses, trinket boxes, household items, greeting cards and scarves for sale to aid workers, tourists and for export to the West, allowing the displaced women to earn money for food and other necessities for themselves and their families.

The Armenian Genocide

One side effect of the Russo-Turkish War of 1877–1878 was the internationalization of the Armenian question. Armenia was an ancient civilization, the first nation to officially embrace Christianity as its national religion in 300 CE. Modern Armenia is situated in the Southern Caucasus, bounded by Georgia in the north, Azerbaijan on the east, Iran on the south and Turkey on the west. Over the centuries, its empire had extended across Central Asia and the eastern Mediterranean. From the sixteenth century through World War I, it was controlled by the Ottoman Turks, who subjected Armenians to discrimination, religious persecution, heavy taxation and physical violence. During the Russo-Turkish War of 1877–1878, the Armenians saw the Russians as their saviors against the Turks and Kurds due to their common Eastern Orthodox religious beliefs, siding with the Russians against their Turkish oppressors. The British and Prussians feared continued Russian expansionism after the war ended and insisted on the return of Armenia to the Turks as part of the armistice. A rising sense of Turkish nationalism after the Russo-Turkish War of 1877–1878 resulted in the massacre of thousands of Armenians by Turkish troops in 1894 and 1896. What today is known as the Armenian Massacre began on April 24, 1915, with the arrest of 250 Armenian intellectuals in Constantinople.[20] This led to the Ottoman government's systematic extermination of Armenians; ultimately between 600,000 and 1.5 million were killed and thousands of women, children and elderly Armenians were deported to the Syrian and Iraqi deserts. Still more fled to refugee camps in Eastern Europe or Aleppo, Syria, to escape persecution. At the end of World War I, Armenia became an independent republic; two years later, however, the region was annexed by the Soviet army and incorporated into the Soviet Union.

Armenian women are famous for their elaborate embroidery work, which features florals, abstract geometrics, and mythological and real animals. Domestic embroidery is used on household goods such as tablecloths, table runners, book covers, pillows and clothing. One important form of Armenian embroidery is known as *marash*. Typically worked on dark velvet, the light colored interlaced cross stitches, clusters of crosses, circles and squares have a raised appearance that resembles wood and stone carving.[21] In exile, Armenian women used their needlework skills to create textiles and domestic household objects for sale in bazaars in the cities in which they had settled and for export to the West. While these objects did not contain war images, their sale allowed the women to support their families in the face of the upheaval they experienced as the result of war.

Refugee Aid Projects

In the 1930s, a refugee aid project known as Near East Industries was founded in Athens by the Near East Foundation. Initially intended to help Christian war refugees in the Balkans, it also supported other refugees in the Eastern Mediterranean.[22] Among the projects that allowed women to use their needlework skills to support their families was the creation of handmade dolls wearing the costumes of various people from across the Middle East, such as the male doll wearing traditional Palestinian dress from the early twentieth century. The eight and one half inch tall doll has a stuffed cotton body over a wire armature and an expressively painted face that features brown eyes and a jaunty black moustache. He wears a striped caftan over

his white *thob*, a loose fitting white robe with sleeves, white linen belt tied at the waist. His red skull cap is covered with a white winding cloth, an indication, along with his low cut shoes with upturned toes, that he is an urban dweller. His turban covers his black wool hair. His white *thob* carries a tag noting the doll was made by Near East Industries in Athens, Greece, although it does not identify the actual doll maker, who most likely was a woman.

The label on a pair of soft bodied female dolls, also with painted faces, identified their maker as a Miss A. G. Malaby at the Arab Refugee Handworks Center in Jerusalem, Jordan.[23] The bodies of these dolls are made of satin over a padded wire armature. Their faces are expressively painted on a gouache base and they have black wool hair beneath their veils and headrolls. The women's clothing, which is representative of Ramallah circa 1940, is hand embroidered using a traditional color palette and cross-stitched pattern depicting a variety of vines and flowers. One figure wears a dark blue winter dress with insets of red at the sides over a white underdress. A red embroidered rectangle is appliqued on the chest and additional embroidery extends across the shoulders and down the sleeves. The edge of her red veil is trimmed with colorful embroidery. The second figure wears an elaborately embroidered white summer dress, a striped sash at her waist. Her long red veil, edged with sequins to mimic the traditional coins used in full-sized clothing, trails down her back to the floor.

Doll in Palestinian garb, Greece, twentieth century. Cotton, wool and pigments. 8½ in. tall (ccollection of Deborah Deacon).

Handmade cloth dolls such as these were initially imported into the United States by Kimport Dolls, a doll and toy company founded in 1933 in Independence, Missouri by Ruby McKim (1891–1976). McKim, a graduate of the Parsons School of Design, spent many years as an art supervisor for the Kansas City Public Schools, but dolls were her first love and her company is credited with popularizing the trend of collecting dolls from around the world. Many of the dolls sold through the Kimport Dolls catalogues were made by women in refugee camps, displaced by war and political upheaval in their homelands. The sale of these dolls allowed the women to support their families in difficult economic times and allowed American girls to become familiar with costumes and people from around the world.

Central Asian Skullcaps

The wearing of skullcaps by both men and women throughout Central Asia is an ancient tradition, visible in sculpture, murals, and terra cotta images, as well as in Penjikent paintings from the sixth to eighth centuries and miniatures from the fifteenth and sixteenth centuries.[24] Worn by Volga Tartars, Uzbeks and Bashkers in Central Asia, as well as in Iran, Turkey, Afghanistan and China's Xinjiang province, skullcaps are made of brocade, velvet and cotton and take many forms including the peaked felt *kolpaks* from Uzbekistan, circular banded caps, and tall quilted hats topped with a pompom, all worn by men. Women's caps also vary in size and style. Some Uzbek caps tend to be small, quilted and embroidered circular caps with black velvet bands while others are stiff with a flat top, decorated with jewels. In seventeenth century Bukhara, women wore small peaked or domed caps decorated with embroidery and jewels.

In Uzbekistan, the skullcap, or *chuplashka*, is an artistic and aesthetic object, a reflection of spiritual wealth and the aesthetic ideals of the period. Prior to the twentieth century, the colors and patterns were specific to individual ethnic groups and regions, and often identified the status of the wearer. The wearing and style of skullcaps changed over time throughout the region, the result of changing technology, the regions incorporation into the Soviet

Skullcap, Uzbekistan, circa 1920s. Silk embroidery on cotton (courtesy Irina Bogoslovskaya and Adam Smith Albion).

Union, and increased contact with outside influences. For instance, in several areas during the nineteenth century, half of a man's caps was often hidden beneath a turban.

Skullcaps were initially considered to be domestic goods, produced by women in the home for family use. From the nineteenth to the mid-twentieth century, skullcaps were mass produced by women who were considered professional craftsmen. By the 1880s, imported Russian velvet, flannel and sateen were used for skullcaps, resulting in the development of new color palettes and embroidery designs. During this period, men wore black caps while women's caps were more colorful. By the twentieth century, skullcap designs changed, the result of Russian influence and the introduction of chemical dyes and commercial thread. Both men's and women's skullcaps were now covered with ornate embroidery. Different stitch types and designs were found in the region. Uzbek and Hazara women used cross stitch to create geometric designs, while Tadjek women favored flower motifs created in satin stitch.[25]

Uzbekistan has a tradition of decorative and applied art, seen in elaborate, colorful wood carvings, ceramics, jewelry, weaving, printing and embroidery. A woman's creativity and imagination play important roles in creating a skullcap. The basic elements of the designs are first drawn on the fabric in ink with a sharp reed. The designs are created using a variety of stitches, including *bosma* (couching), *ilmoq* (buttonhole), straight, *yorma* (chain) and *iroqi* (cross) stitch.[26] Black, white, dark blue, violet, green, yellow and red are favored colors and these colors frequently carried symbolic meaning. White is a sacred color, symbolizing happiness and success; light blue also symbolizes happiness, and dark blue symbolizes the heavens and the male principle.

Vegetal motifs, featuring lilies, tulips, grapes, pomegranates, cherries, leaves and climbing vines, are popular depictions. Numerology also plays a role in popular motifs. Four flowers embroidered on the top of a cap are intended to protect a man's health; sixteen flowers along a cap's edge indicate a desire for a large family. A circle symbolizes the sun as well as the seasonal cycle. Colorful stylized birds such as pheasants, roosters and nightingales are symbols of happiness as well as of the soul since the birds are seen as bridges between the real and mythic worlds.[27] A ram's horn, represented by a spiral, symbolizes the universe while snakes embody ideas of good and evil. Symmetrical geometric patterns and good wishes written in decorative Arabic script are also featured as ornamental elements.

As Uzbekistan was incorporated into the Soviet Union, modifications were made to both the patterns found on skullcaps and the ways in which they were worn. In the early twentieth century, skullcaps fell out of favor, seen as old fashioned (and negatively viewed by the Soviets as symbols of ethnic pride), and many Uzbekis adopted western styles of dress. Clothing in the Soviet Union served as a form of propaganda during this time and Uzbek women were expected to shun traditional Muslim clothing in favor of Western styles as part of the Soviet attempt to pacify the region. In April 1918, Vladimir Lenin ordered the use of art for propaganda purposes throughout the Soviet Union. Speaking specifically about Central Asia, he commented, "...we must create an exemplary, cultural socialist state, which must show the repressed nations the difference between Tsarist and Soviet power" and noted that industrial production in all forms was a means of achieving this end.[28] This decree included all forms of textile production and soon depictions of important Soviet leaders were seen on posters, carpets, fabrics, and paintings. Textiles were seen as reflections of the modern economic achievements of the state and made excellent vehicles for propaganda. Printed

woven fabrics and commercially produced carpets soon bore images of tractors, factories, power plants and modes of modern transportation. In 1920s printed textiles, images of the Soviet hammer and sickle frequently replaced florals and in Turkestan, images of the hammer and sickle were found in traditional ikat weavings, as was the Kremlin tower and other revolutionary images.[29] Slogans such as "Long live the party of Comrades Lenin and Stalin" were also included in commercially produced textiles of the period.

By the late 1920s, men and women in Uzbekistan and other Central Asian regions within the USSR began to again wear traditional clothing, including skullcaps which girls and women wore with or without a covering kerchief. These skullcaps were produced by craftswomen working as members of embroidery cooperatives which produced round, square and conical caps. By the 1940s, skullcap production was big business in the region and several new motifs were introduced. After World War II, skullcaps were more colorful and highly decorated with beads, metallic threads, spangles, and relief decorations. One of the new motifs found on skullcaps like the one featured here, from the mid-twentieth century, was the Soviet red star. As noted by art historian Irina Bogoslovskasya, while it was originally intended as a form of propaganda, when included as an element within the Uzbek floral tradition, the star loses its original symbolism, becoming a reflection of everyday life under Soviet occupation.[30] In addition to the red star, Tajek and Turkmen women included the phrase "CCCP" (the Cyrillic abbreviation for the Soviet Union) and the hammer and sickle in their skullcap embroideries, developing a new aesthetic tradition. Turkmen women began including the Soviet red star into their floral traditions in the 1960s and 1970s. The inclusion of Soviet imagery in objects of everyday use by the colonized people of Central Asia shows a willingness to conform to the demands of their colonizer. With the breakup of the Soviet Union in the late twentieth century, however, women stopped including Soviet references in their embroidery, returning to more traditional decorative motifs.

Turkmen Weavings

There are five tribes of Turkmen which historically inhabited northern Afghanistan and the Central Asian region known as Turkmenistan. Each of the tribes is known for its carpet making tradition, and each has its own traditional designs, typically done against a dark red or beige background. The carpets are made for tent use, as door hangings, and carrying bags, as well as for export to the west. The largest group, the Teke, inhabit the area around Ashgabate in Turkmenistan. The majority of Turkmen rugs on the market today are Teke in origin. The typical Teke central design is framed by a five section border—a central wide band surrounded by two thin bands on each side. Traditional Turkmen carpet patterns include geometric designs such as the Bukhara design, also known as elephant's foot design, and the *gul*, or lozenge, done in sheep wool. Prior to the 1910s, natural dyes were used; after that date, synthetic dyes became available, changing the color palette somewhat. Turkmen carpets first were discovered in the markets of Bukhara in the 1880s, and the pattern name "Bukhara" is still applied to that first discovered pattern. A figural tradition was begun under Soviet rule, and continues today.

Despite its Islamic roots, in Turkmenistan, women weave while men make their loom frames. Men do participate in processes related to rug production, including wool dyeing,

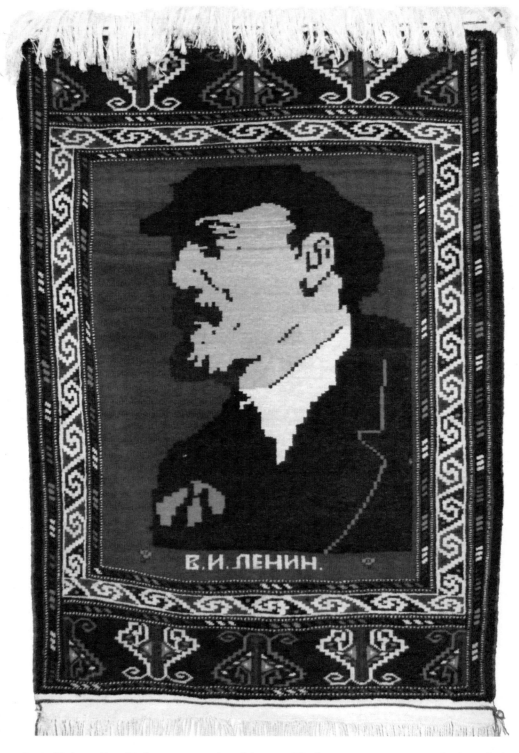

Lenin Turkman Rug, Turkmenistan, twentieth century. Wool on cotton warp. 29¾ in. by 48 in. (collection of Deborah Deacon).

rug shaving, washing and stretching.[31] Among the important domestic products created by women are carpets, a tradition that continues today despite the state encouragement of the mass production of carpets which began in the 1980s. While Turkmenistan's isolation limits the markets for its products, ethnic Turkmen weavers in other countries such as Pakistan and Afghanistan are better situated to sell their home produced textiles and carpets to a global market.

Turkmen carpets are not woven, rather they are made from knots tied onto warp and weft threads on an upright loom. While rugs were initially made in the home, today many are made in carpet factories, which are not automated. Instead, they feature groupings of women and their looms, sitting side by side on the floor, often working on the same large loom to complete a large, complex patterned carpet. The rugs are made of wool, typically on cotton warps and wefts. The women use three tools to create their carpets: a knife, to cut the yarn after tying the knot; a comb, to pound the knot to increase the pile density; and scissors, to even the depth of the nap. The finest Turkmen rugs contain between 200 and 400 knots per square inch. A skilled woman can tie up to 10,000 knots per day, resulting in only twenty-five square inches of the finest carpet.

In the rug shown here, the largest band, which contains stylized florals in dark green, rust, red and white, is surrounded by a narrow band of green, rust, and white diagonals in groups of three. Above these bands is a band of navy, white and red in a geometric wave pattern, topped by another band of diagonals. The central image features a profile depiction of Vladimir Lenin done in shades of brown, beige, red, black and navy. Lenin's name, framed by two small flowers, is written in Cyrillic letters beneath the image. The rug is done in wool on a cotton warp and weft and dates to the 1960s, a time when weavers were encouraged to feature Soviet heroes and other patriotic Soviet imagery on their rugs. While the women are still making some figural rugs today, since the break up of the Soviet Union they have stopped making rugs with Soviet imagery, choosing instead to return to traditional patterns.

Kyrgystan (Kyrgyz Republic)

The Kyrgyz Republic, formerly known as Kyrgystan, gained its independence from the Soviet Union in 1991. Since attaining independence, the region has experienced significant civil unrest, the result of border dispute with neighboring Kazakhstan, Tajikistan and Uzbekistan as well as clan violence between the Kyrgyz majority and Uzbek minority in the south and the illicit cultivation of marijuana and opium poppies. Additionally, a high unemployment rate has contributed to civil unrest in the region.[32] The majority of the population is Muslim, although there is a significant Christian minority in the region.

Textile production is considered to be woman's work in the region, and Kyrgyz women produce a wide range of textiles made primarily of felt, made from sheep wool. Most homes and the yurts of the nomads contain handmade felt carpets, called *shirdaks*, as well as elaborately embroidered felt wall hangings known as *kyiz*, which are made by a mother to commemorate her child's marriage. To create a *shirdak,* a large piece of wool is felted, then pattern pieces are cut out and appliqued to another piece of felt. The remaining pieces of felt are then appliqued to a different piece of felt, resulting in the production of mirror images. The colors and patterns used in traditional Kyrgyz textiles are based on traditional rural life and

represent plants, flowers, animals and other emblems of daily life and are typically used as applique patterns. The textiles exhibit a balance of positive and negative images, and are a display of a young woman's skills suitability for marriage.

During the Soviet occupation, garment factories, staffed by women workers, produced men's suits for sale in Eastern Europe. With independence, however, a fledgling commercial fashion industry began, one that uses traditional Kyrgyz felt decorative imagery. The new designers, many of whom are young female fashion students, have been holding a fashion week annually each spring and fall since 2006, introducing colorful clothing lines for men, women and children in a variety of fabrics including wool, silk and cotton. Many collections feature modest fashions appropriate for a conservative Muslim woman, and many make reference to traditional imagery and motifs. One 2011 collection featured a "Secret Police" collection of political textiles, a commentary on the corruption and violent policies of the State Committee for National Security (GKNB), the local successor to the Soviet-era KGB. The GKNB is accused of using torture and murder against citizens who oppose a variety of government policies.[33]

Palestine

The term Palestine originally referred to the area that lies between the Syrian interior and the southern coastal area of the eastern Mediterranean Sea. The term is a derivation of the word *Plesheth*, which means migratory, a term translated in the Old and New Testaments as "Philistine." The region was also known as Canaan during Biblical times. It was an important trading crossroads and the original population of Palestine was a mixture of ancient Greeks, Egyptians, Babylonians, and Romans. The arrival of Arabs in the region began with the nomadic Bedouins in the century following the death of the prophet Mohammed, and the Islamic Empire was established in the region following the Battle of Yarmouh in 636 CE with the conquest of Syria. For centuries Christians, Jews and Muslims have lived in the region with varying degrees of war and peace, as subjects of the Ottoman Empire in the eighteenth and nineteenth centuries and the British Empire in the twentieth century.

As with most of the people in the region, textile production was considered women's work and girls learned to sew and weave at a young age. The majority of the Islamic population was nomadic and women produced clothing and domestic goods in animal wool and plant fibers. This tradition of women weaving continued in the rural areas well into the twentieth century, although in urban areas men became the commercial weavers in keeping with Islamic tradition.

By the nineteenth century, embroidered decorations appeared on Palestinian clothing, the result of the diverse influences from Syria, Turkey and Europe. Embroidery quickly became a form of women's art, passed down through the generations. Like other textile traditions, girls learned needlework skills at a young age, learning a variety of stitches and elaborate patterns which varied from group to group. While motifs might be specific to a particular group, designs did change over time, going in and out of style. Stitches and motifs were often named after objects in the local environment, such as ears of corn, palm trees, etc. In many cases, certain stitches and motifs were specific to different parts of a piece of clothing. Typically embroidery is found on sleeves, chest panels and side panels of shirts and

dresses. The embroidery is done on the cloth before the garment is assembled, requiring a great degree of skill to create the patterns so they align when the garment is complete.

Palestinian girls make their trousseaus, which include simple dresses and veils for daily wear and richly embroidered dresses for celebrations such as weddings, circumcisions, festivals and pilgrimages. Many of the celebratory dresses and veils are adorned with silver coins provided by a girl's father as part of her dowry. The groom's contribution to the bride's trousseau includes luxury textiles made by professional male weavers. After their marriage, women continue to sew and embroider, replacing worn out clothing and household goods.

A Palestinian woman's dress reflects her age and marital status. Red embroidery is associated with the blood of virginity and menstruation, a reflection of a woman of prime child-bearing age. The embroidery on a menopausal woman's clothing is darker and more restrained. During periods of mourning, clothing with brightly colored embroidery is turned inside out or dyed blue as an indication of grief.

Embroidery is an expensive investment in terms of the time and labor required to create the elaborate patterns that adorn a woman's clothing, making these patterns a conspicuous display of wealth and pride. A strict set of technical and aesthetic standards for embroidery developed, and women were criticized for sloppy work, poor color usage and skimpy embellishments.[34] Fashion leaders skillfully incorporate new ideas into their work, gaining prestige through their innovation. A village woman's dress constitutes a woman's language while preserving her modesty and providing her with a social identity and status. The patterns and colors a woman uses in her embroidery identify her village group, marking her as a peasant or townswoman, a woman of means and experience.

In the 1930s, the introduction of commercially produced mercerized cotton thread from Dolfus Mieg et Cie (DMC), as well as floss silks and waste embroidery canvas, velvets, rayons and synthetic fabrics, made it easier for women to create their elaborate

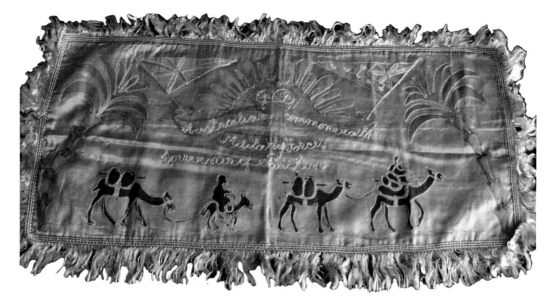

Banner, Palestine, 1940s. Paint and embroidery floss on silk with fringe. 17 in. by 19 in. (collection of Deborah Deacon).

embroideries. The arrival of Christian missionaries from Germany, England and the United States brought new patterns and special commissions to the women, providing them with a new source of income and inspiration and resulting in modifications to traditional patterns.[35]

In addition to pattern and color variations based on age, regional differences can be identified between embroidery done in the northern Galilee hills and southern Palestine. In the Galilee region, satin, hem, running and cross stitches are used to make geometric motifs of diamonds, triangles, and rectangles. Some floral patterns are also seen. Couching, a reflection of the influence of Ottoman uniforms and Christian church vestments, is seen in clothing made in Bethlehem. Women embroider on short sleeved, calf-length cotton coats, which are worn over a white tunic and trousers, as well as the girdles worn at the waist and on veils and scarves. In southern Palestine, cross stitch across two warp and two weft threads is the primary embroidery stitch, used to decorate long sleeved ankle length dresses, colorful sashes and the white veils worn over women's bonnets. Herringbone and satin stitches are also used on the symmetrical embroidery panels which are found on the garments' chest, sleeves, sides and lower back, along with running stitches on the hems and seams. Traditional patterns include triangles, chevrons, rosettes, feathers, birds and flowers.

During World War II, Palestinian women used their needlework skills to earn extra income by creating souvenirs for the Allied troops stationed in the region to send home to their loved ones. Among these souvenirs were flags made of cotton sateen with cotton embroidery such as the one shown here. While more elaborate pieces were machine embroidered, this one was done by hand. Such pieces, sold in small villages throughout the region, were often supplemented with painted details and personalized for the individuals who purchased them.[36] In this case, the flag was made for an unidentified member of the Australian Commonwealth Military Force, which is embroidered on a scroll in chain stitch across a central emblem containing a large sun. The central emblem is flanked by two embroidered flags. A caravan of painted camels and palm trees, outlined in satin stitches, crosses the bottom of the white fringed gold sateen flag.

A more elaborate souvenir of Palestine was created for Corporal A.C. Carter of the 2/3 Australian Field Workshop. The magenta rectangular fabric tablecloth features a white cotton backing and dark blue tassel fringe. The cloth features an embroidered central motif of the Australian coat of arms atop a rising sun, done in shades of green, orange, white and yellow and features the same "Australian Commonwealth Military Force" phrase as the smaller flag, as well as the phrase "Souvenir of Palestine 1941." A camel caravan, framed by embroidered palm trees, and a depiction of the Church of the Holy Sepulcher and David's Tower complete the scene. The entire scene is augmented with blue, brown and green paint.

Aubrey Cecil Carter was born in Bathurst, New South Wales, Australia, on February 16, 1910. He enlisted in the Australian army as a private in Sydney on August 5, 1940 and was assigned to the 2/3 Australian Field Workshop. He arrived in Kantara, Egypt on February 3, 1941, and served in the Middle East until early 1942. Carter was promoted to sergeant, staff sergeant and finally warrant officer by May 1943. He was discharged as medically unfit in August 1944 and returned to Australia.[37]

After the initial establishment of Israel in 1948, many Palestinians left their villages, settling in refugee camps in neighboring Lebanon or Syria. A second wave of refugees fled to the camps after the 1967 Six Day War. Additional migrations have occurred over the past

forty years as the result of conflict in the region, making Palestinians the largest refugee group in the world, numbering approximately eight million people.[38]

Textiles have continued to play an important role in Palestinian identity, with the embroidery patterns taking on national significance of the Palestinian desire for an identity and a homeland, worn by members of national dance groups and during political protests, making them a repository of cultural memory. In 1950, the United Nations Relief and Works Agency was founded to help with the Palestinian refugee crisis, providing services to refugee camps in the West Bank and Gaza Strip. The Palestinian Red Crescent Society was founded in 1960, providing health care and establishing sewing, machine knitting and embroidery workshops in the refugee camps. Such organizations were founded with the humanitarian objective of providing educational, social, economic and political assistance to the refugees.

Beginning in the 1950s, embroidered textiles became an important way for Palestinian women to earn income to support their families in the refugee camps as well as a way to maintain and promote traditional crafts through projects like the Sulafa Embroidery project, which was established in nine refugee camps. Sulafa's goal was to provide economic opportunity to Palestinian women while helping to maintain the traditional geometric and abstract patterns found in Sinai Bedouin embroidery.[39] Foreign aid workers in several refugee camps encouraged women to create products such as small square pillows and larger floor cushions decorated with tradi-

Jordan bag, Jordan, twentieth century. Fabric, wool, embroidery (courtesy Iris Cashdan-Fishman).

tional Palestinian embroidery designs, as well as oven mitts, hand towels, table runners and other household products for sale to tourists and for export. By the 1980s, the women had added clothing and bags with elaborate embroidered patterns to their repertoire, as well as eye glass holders, wallets, and dolls.[40] By the 1980s, these refugee camp projects were also promoting Palestinian heritage while encouraging women in the Occupied Territories to re-adopt their traditional embroidered dress for daily wear, as a nationalistic statement and as a form of protest against the Israeli occupation. During this time, traditional *thobs* were also adapted for the western market, their traditional embroidery relocated to non-traditional areas. During the 1990s, the women also began to embroider shawls for the western market, as well as quilts and wall hangings. At the turn of the twenty-first century, items made of Damascus atlas silk and Egyptian watered taffetas began to be sold, embellished with couch-

ing and applique in addition to the traditional cross-stitch. All of these items allow the women to provide economic support to their families while keeping the Palestinian struggle in the public eye.

At the time of the intifada in the late 1980s, Carol Morton established *Sunbula,* a crafts outlet for products from women's groups in the refugee camps. The term *sunbula* means wheat, which is considered a symbol of life in the region. Morton was the wife of the pastor of St. Andrew's Scots Memorial Church in Jerusalem and *Sunbula's* original focus was on Christian themed products such as nativity scenes, olive wood ornaments, and embroideries with Christian motifs. Later textiles with traditional Palestinian motifs done in cross stitch and couching were included in the inventory.[41] Embroidered *Sunbula* products are created in soft pastel colors as well as the traditional red and black cross stitch. The program offers training to the women whose work is sold in its shop, and shares the profits with these women.

In neighboring Jordan, the Family Care Society was established in 1969 to help dislocated Palestinians by selling refugee embroidery pieces. Among the textiles offered was an intifada dress, which featured a checked *keffiya* belt and *keffiya* fabric appliqued on the skirt. The Palestinian *keffiya,* the traditional Arab square cotton headscarf worn by Palestinian men for decades as a symbol of Palestinian resistance, has a black net pattern on a white background. The dress served as a symbol of Palestinian resistance and a reminder of the conditions under which the Palestinians were living. In 1990, the Noor Al Hussein Foundation founded the Jordan Design and Trade Center in Amman with the goal of creating employment for refugee women. The organization sells home furnishings, woven floor and wall coverings, jewelry and basketry as well as textiles and is supported by Jordan's Queen.

In Syria, the ANAT Workshop was established in 1988 in the Palestinian refugee camp of Yarmouk in Damascus. The workshop provides employment to Palestinian refugee women and Syrian women, preserving both group's textile traditions and adapting them to modern life. Their goal is to defend the women's national identities and "win friends for the Arab people." Anat was the Canaanite goddess of fertility, a fitting symbol for the women. The Workshop employs approximately 300 women, who are provided with education on sewing, macramé, tassel-making and embroidery techniques. The Workshop's founders note that "For thousands of years the Arab woman has expressed herself and her emotional requirements in her embroidery. Her dress was a piece of art and at the same time an amulet written in the poetic language of patterns and colors."[42] By providing the women with economic independence they also provide them with a sense of security and personal pride.

In 1969, the Association for the Development of Palestinian Camps in Beirut, Lebanon, established the Chatila Workshop in an effort to promote traditional needlework skills and insure the continuation of traditional patterns such as "pasha's tent," "old man's tents," and "the kohl pot."[43] As with other such groups, the workshop provides the women with much needed income and a means of expressing the impact of the chaos of war.

Among Palestinians, the revival of traditional embroidery and dress has served as a vital form of communication, acting as a vehicle for protest and national identity and serving a didactic role, teaching young Palestinian women about their culture. During the first intifada, Palestinian women in the West Bank did not feature images of weaponry on their textiles as a means of protest. Rather they incorporated the green, black, white and red of the banned

Palestinian flag into their embroidery and wore dresses embroidered with these colors as a way of protesting their treatment by the Israelis. They also created sequined pictures of Jerusalem which proudly displayed the banned flag, sold to tourists and exported abroad to support their cause. This altering of the Palestinian textile tradition is the direct result of a woman responding to her circumstances, which, Allenby noted, results in "transposing decorative techniques traditional to her culture with visual codes derived from folklore and poetry, ancient landscapes and modern warfare, and visually realized via powerful and unique symbolic iconographies, and investing her textile creations with new meaning specific to national discourse."[44]

In recent years, two exhibitions of Palestinian textiles have reflected this change that has come as the result of warfare in the region. *Portraits Without Names*, a traveling exhibition of one hundred textiles spanning two hundred years of Palestinian design, was conceived in 1995. The exhibition's title was taken from the writings of the Palestinian philosopher Edward Said, who, in 1986 noted: "to write of Palestine is to write of exile, and exile is a series of portraits without names, without context."[45] The exhibition, which featured a number of pieces created in refugee camps, was dedicated to the unknown Palestinian women who designed, embroidered and wore the clothing on display. These women were proud of their identity of Palestinians and their ability to survive despite the war and chaos that surrounded them for generations. During the exhibition, many Palestinian women who lived in Australia actually sat in the gallery, working on their own embroidery, helping with public inquiries and because they liked the ambiance of being surrounded by Palestinian textiles, something they had not experienced since leaving their homeland.

The other exhibition, *Symbolic Defiance: Palestinian Costume and Embroidery Since 1948*, a traveling exhibition by the Palestine Costume Archive in Melbourne, Australia, examined refugee camp embroidery projects and their effect on Palestinian textile traditions, as well as the use of these textiles as symbols of Palestinian national pride. Among the textiles exhibited in the exhibition were political embroideries including the flag dress of the Al Aqsa intifada or Second intifada, which featured embroidered images of the Dome of the Rock and the banned Palestinian flag.[46] Other clothing included in the exhibition featured traditional embroidery patterns done in green, red, black and white. These embroideries served as symbols of national pride for the women who created them, providing them with the opportunity to express their feelings about their personal situation and that of the Palestinian culture in a time of war.

Mary Tuma (b. 1961) is a Palestinian-American textile artist whose interest in art was evident at a young age, though she did not pursue art as a profession until she was in college after she apprenticed to a tapestry weaver in Egypt. After earning a Bachelor of Arts in Costume and Textile design from the University of California, Davis, she moved to New York and studied at the Fashion Institute of Technology before earning a Master of Fine Arts degree in fibers at the University of Arizona. According to Tuma, "textiles represent a second skin, a remaking of the identity, just by changing clothes.... Textiles have a power that is irrefutable."[47] A feminist, Tuma's work addresses several topics, including society's evaluation of women's bodies, notions of textiles as a container, and the state of events in Palestine.

In 1999, Tuma spent a summer in Jerusalem, traveling in the area to assess the environment for Palestinians. Her father is a Palestinian from a Greek Catholic family in Galilee and she has spent a considerable amount of time in the region. While the conflicts between

Israel and Palestine are of importance to her, her greatest interest is in the impact of war on the women of the region, who are typically not included in the governmental decision-making process. She has seen the negative impact that conflict has had on the human spirit first hand.

A number of Tuma's works address the oppression she has seen. Her piece *Resurfacing Palestine* is "a stitched map that serves as an abstraction of 'place' and ... a bed of stones ... wrapped in a tangle of threads that extend down from the map, connecting the physical stones with the abstract surface of the map. The stones, found in Jerusalem, refer to the first intifada (uprising), but they are softened with the threads—a sort of laying down of "arms" that can instead be used to build."[48] *The West Bank and The Gaza Map* features multicolored fabric formed into the shape of the areas in which Palestinians live within the state of Israel, with a wide swath of empty space between the two territories. The installation *Homes for the Disembodied* was originally created in 2000 and remade in 2003. It features fifty meters of continuous black gauze fabric made into a series of five long-sleeved dresses hung from the gallery ceiling. The pieces, which are connected at the hem, puddle on the floor, evoking a feeling of loss or a dim memory of the past. The ethereal pieces seem like shadows or ghosts, something not quite real but still of great importance. In the case of Palestinians, they are memories of lives and traditions lost.

Her work *Twisted Rope* (C4), seen here, is intended to "serve as a bridge allowing two people, one on each side of the wall, to climb up and meet on the top." It refers to the wall that divides a town in half, with members of the same family living on both sides of the wall, "no longer [able to spend] time together without going far out of their way and being subjected to the humiliation of an Israeli checkpoint."[49] She was inspired by the resilience of the Palestinians, who adapt to their circumstances in order to survive the occupation of their territory. Among the fabrics braided together to form the long strands in the piece, are keffiyas, symbolic of Yasser Arafat and the Palestinian Liberation Organization (PLO), and scraps from traditional women's embroidered dresses.

Tuma views her work as serious but beautiful and hopes that it will influence people's political views. She hopes that Palestinians encountering her work feel a pride in their heritage. She sees war as an event that ravages culture, causing it to disintegrate, but that it also serves as a catalyst to fiercely protect and promote culture.

The Sinai desert is the traditional homeland for the nomadic Bedouin people. Textiles play an important role in Bedouin culture, serving as an indication of marital status, tribal origins and wealth. Created by women, the textiles produced by northern groups are richly embroidered while those produced in the south feature embroidery and beadwork. Among the beaded pieces, produced for personal use and for sale to tourists, are padded, tasseled and fringed triangular *hijab* amulets which often include the use of the *khamsa,* or hand. The *khamsa* is a powerful talisman, used by men, women and children for protection. It is painted on walls, attached to clothing, included in jewelry, and hung from car mirrors. During the 1970s Israeli occupation of the Sinai peninsula, women, believing they needed extra protection against the violence, began including religious sayings such as the name of God and the phrase *Allahu Akbar* (God is Great) in Arabic calligraphy as well as images of Israeli weapons in their beaded *khamsa* talismans.[50] The talismans remain popular in the early twenty-first century, although they no longer contain images of Israeli weapons.

Israel

The modern state of Israel did not come into existence until 1948, although Jews had lived in the area for millennia. The history of the importance of textiles to Jewish culture and religious practices is well documented in sacred texts. From the earliest times, women produced the textiles used both for domestic and ceremonial purposes. The *Mishnah*, an early Jewish legal work, noted that women had an obligation to do a number of domestic tasks for their husbands, including "the grinding, baking, washing, cooking, nursing her children, making the bed and spinning wool."[51] If a woman had one or more maidservants, she could pass many of these tasks to the servant(s), but not her spinning, for spinning, weaving and embroidery were seen as vital tasks. Throughout the Bible, significant mention is made of weaving and embroidery as the booty of warfare as well as for Temple and home use. So important was textile production that it became a part of colloquial Jewish speech and history. For instance, from Job 7:6 comes the comment, "My days are swifter than a weaver's shuttle."[52]

From the time of *Exodus,* both men and women worked as embroiderers and weavers, producing the Tent of Meeting in the wilderness. The tent was composed of ten curtains of fine linen woven of goat hair, in purple, blue, linen (beige) and scarlet, colors which remain sacred today. As noted in Exodus 35:35, "And every skillful woman spun with her hands, and they all brought what they had spun in blue and purple and scarlet yarn and fine twined linen." At the direction of God, embroiderers produced an elaborate coat for Aaron as well. "You shall weave the coat in checker work of fine linen, and you shall make a turban of fine linen, and you shall make a sash embroidered with needlework."[53]

As the Jews dispersed across the Mediterranean and into Europe, men and women continued to work as professional weavers and embroiderers, producing elaborate Torah curtains, Torah covers and other religious objects in the style of the region in which they lived. While Jews were excluded from craft guilds in much of Europe during medieval times, they did establish embroidery guilds in medieval Bavaria and Bohemia, creating goods for themselves and non–Jews alike. The earliest extant examples of Jewish embroidery date to the sixteenth century. Many of these works survive in museum and private collections because they were confiscated by the Nazis between 1939 and 1945, stored in warehouses that were liberated after the war.[54]

Most Jewish embroideries were created anonymously, although some works are signed. The first known woman embroiderer created and donated a Torah curtain in Ancona in central Italy in 1630. Of her creation, she commented, "If, in after times, it be enquired, 'whose handiwork is this?'—say that it is of her of the house of Montefioro, Rachel, the wife of Jehuda, in the year (that it hath thus been worked) 5390 [1630]."[55]

While there is not one specific style of Jewish embroidery, owing to the dispersal of the Jewish diaspora, there are a number of common elements found on embroidered religious textiles. These include florals and vines, urns, classical columns, menorahs, tables, trees of life, *Ner Tomid* (Eternal Light) and other Jewish symbols. Biblical passages, written in Hebrew, also appear frequently. Despite the ban on graven images, birds, animals and human figures also appear. A nineteenth century hand towel used during Purim, the holy day that celebrates the Jews' release from the tyranny of Haman, for instance, features the embroidered figure of the hero Mordecai on a horse.[56] The symbols used in Jewish embroidery are intended

to inspire the worshippers who see them. While war images did not appear in traditional ceremonial embroideries, the dove, the symbol of peace, is frequently featured on challah covers and Torah wrappers. Challah covers are used on Friday evenings, especially at Rosh Hashanah and Yom Kippur. Challah, a braided bread eaten on Sabbath and holidays, symbolizes hope for life, good health and good fortune.

Until the early twentieth century, there was no fine arts tradition in Israel. The artists who created Judaica objects were considered craftsmen and the women who created textiles were considered to be craftsmen as well. By the second half of the century, however, with the fine arts firmly established in the country, textile art was elevated to the status of fine art, as it is around the globe. Among the topics explored by women textile artists in their works are religion, sexuality and war. Like Palestinian women, Israeli women have also been impacted by the years of war in the Middle East. And like their Palestinian counterparts, they have expressed the impact of war on their lives in their textiles. In 1973, with the onset of the Yom Kippur War, famed Israeli modern dance choreographer and visual artist Noa Eshkol (1924–2007) began piecing scraps of fabric from kibbutzim and sewing workshops onto military blankets, bedspreads and bomb targets to make wall hangings that addressed the impact of war. She did not cut the scraps, instead pinning the unmodified pieces to make elaborate assemblages of forms and colors. Members of the Chamber Dance Group, which she founded in 1954, would stitch the pieces in place during rehearsal breaks. The textiles were inspired by the abrupt departure of Smulik Zaidel, her only male dancer, who was called to war. In 2012, the Los Angeles County Museum of Art featured the exhibition *Sharon Lockhart | Noa Eshkol* which presented Los Angeles multi-media artist Lockhart's film installation and still photographs of Eshkol's original students and younger dancers performing Eshkol's choreography together with a number of carpets, musical scores and drawings.[57]

Numerous Israeli women show their patriotism by crocheting olive green yarmulkes for their husbands, boyfriends and sons to wear as they perform their obligatory military service. Orthodox Jewish tradition requires men to cover their heads at all times and the yarmulkes are worn by military men while performing their military duties indoors.

In addition to crocheting yarmulkes for soldiers, many Jewish women from around the world knit wool watch caps for Israeli soldiers to wear while on duty in colder climates. A knitting program known as "Hats for Israeli Soldiers" was organized by an Israeli blogger named Channoh Koppel and her knitting group "Chicks with Sticks." The grass roots movement, intended to send a soldier physical and emotional warmth, has furnished thousands of soldiers with these small tokens of appreciation for their service. Koppel has posted her pattern, which can be made on either straight or circular needles, on the internet so knitters around the world can create hats, which are sent to Koppel for further distribution.[58]

In 1998, Israeli textile artist Toni Friedman lost her son Magen in the Lebanon War. She created a textile exhibition in Jerusalem, titled *Shields for Magen*, to honor his service. Each participating textile artist created a shield in Magen's honor, emphasizing a shield's dual role as an object intended to protect the body and as a symbol of a family name of trade. Friedman's piece, *From Magen to Magen*, was a black shield with five stripes from Magen's uniform appliqued to the surface. Friedman then added all of his military badges and emblems to the stripes. Another woman's work featured a dove holding an olive branch appliqued to a black and red striped a quilted shield, while that of a third was done in the shape of an apron, a woman's shield against domestic chaos encountered during times of war.[59]

Israeli textile artist Maly Cohen is known for her silk painting. She creates banners for Davidic dancing, purses, scarves, ties, women's prayer shawls (*Tallitot*), and other articles of clothing, many adorned with the dove of peace, which holds an olive branch in his beak. Cohen's works look to a time when the region is no longer a place of warfare and violence.[60]

Andi Arnovitz is a textile artist who lives and works in Jerusalem, although she was born and raised in the United States. As a child, she was fascinated with fabric, a fascination that is reflected in her work. She uses a variety of forms of printmaking as well as fabric to create large scale paper garments that reflect her ideas on religion, gender and politics. Several of her exhibitions have addressed the conflicts between Palestinians and Israelis. Her installation *Garments of Reconciliation* is composed of a series of blouses whose central embroidered square reflects the influence of traditional Palestinian dress embroideries, while the knotted fringes that hang from the hem are taken from Jewish men's prayer shawls, resulting in a unique hybrid textile. Despite each piece's small size, Arnovitz sees them as a didactic platform for reconciliation, believing that the foundations of peace begin through the education of the young.[61] She hopes that this piece will allow people to put themselves in each other's shoes and eventually lead to peace.

Textile artist Maya Chaimovich spent most of her life on Kibbutz Zikim, in southern Israel before moving to Ramat Gan. The mother of three and grandmother of ten started traditional quilting in 1997 and has studied at the Shenkar College of Art Design. She quickly became attracted to the abstract style of quilting, noting, "The quilt became a language for me, to tell about exciting moments, family events, traveling and nature."[62] Her quilts use a free motion technique on a sewing machine, which gives a sense of motion to the colorful, diverse designs. She collects fabric scraps at the flea market in Jaffa, taking pleasure in recycling fragments of lace, velvet, silk, cotton and synthetic fabrics. From a distance, the fifty inch square quilts almost look like paintings; when viewed close-up, the individual fabrics tell their stories through their textures, colors and shapes.

Chaimovich gives her quilts a sense of meaning and purpose by naming them after important events in her own life or in that of Israel. Her quilt, *Rusty Forever,* reflects her memories of the Israeli War for Independence in 1948. She was born in 1945 in Kibbutz Yad-Mordechai and has few memories of the period. Those that remain, however, are very meaningful for her. She notes, "The water tower, which was bombed during the battles in the kibbutz, is still standing there up on the hill for the memory and evidence of those days and for the strength of building the future."[63] That war shaped her life, that of her family, and the lives of everyone in Israel and her work honors their lives.

Afghanistan

The nation of Afghanistan has been an area of turmoil for centuries, the result of tribal warfare and western interference. Dari speaking Tadjiks in the north and west comprise approximately twenty-three per cent of the population. Turkmen and Uzbeks, driven out of Tadjikistan in the 1920s and 1930s, form a significant portion of the population in the north, while the nomadic Baluchis in southwestern Afghanistan number less than 800,000. While the diverse tribal groups in the region have different political views, they are unified by their Islamic religion. On occasion, those religious beliefs allow for unity and peace, while at other

times the turmoil comes from conflicts between Sunni and Shia sects. The various tribes of the region were first unified in 1747 by King Ahmed Durrani Shah, who believed in political decentralization which allowed for regional tribal autonomy. Afghanistan has been subjected to numerous attempts at conquest by Western powers. The British won the first Afghan War (1839–1842), but at great cost—their garrison in Kabul was destroyed. During the late nineteenth century, Persia had an interest in the region, as did Russia and Great Britain who engaged in the "Great Game," where both sides attempted to gain influence throughout the region. In 1878, the British intervened in local Afghan politics to prevent the installation of a pro–Russian government.[64] The Bolshevik Revolution caused turbulence in the Great Game, as the Russians turned their attention inward, allowing for increased British efforts in the region, resulting ultimately in the Third Afghan War (1907), which ended in a British military victory but also led to the end of British influence in the region. This allowed the Soviets to increase their influence in Afghanistan, influence that continued throughout the mid-twentieth century as Afghanistan moved from absolute monarchy to a constitutional monarchy in the 1950s and into the 1970s. The Soviets saw Afghanistan as a key piece of their efforts to consolidate their hold on Central Asia, since northern Afghanistan sat along the southern border of the USSR.

In 1973, a coup overthrew the monarchy, but the new government remained firmly in the Soviet sphere of influence. By 1978, the country's Islamists began to see communism as anti–Islam, eventually creating a nationwide resistance movement led by the *mujahideen,* or fighters for the faith. The Afghan government appealed to the Soviets for assistance against the insurgency and the Soviets responded by sending hardware and advisors to support the unpopular government. This escalation led to massacres of the civilian population and large scale fighting between government forces and the *mujahideen.* In 1979, American President Jimmy Carter approved a CIA covert propaganda operation which provided advisors and hardware to the rebels. At the time, the Soviets had 180,000 Spetsnaz (Special Forces) soldiers, 1,800 T62 tanks, and 2,000 additional vehicles in the country. In December, the Soviets grew nervous over the rise of Islamic fundamentalism, and deployed the 40th Army to Afghanistan to support the Marxist government of Nur Muhammad Taraki and the People's Democratic Party of Afghanistan, in accordance with the Soviet-Afghan Friendship Treaty of 1978, plunging the highly westernized Islamic nation into decades of warfare and strife.[65] During their ten year occupation, the Soviets encountered numerous difficulties deploying their weaponry, which frequently resulted in civilian casualties and chaos throughout the entire country.

During the Soviet occupation, many women in the countryside carried weapons for their own protection, while others were members of armed resistance groups. Afghan women were subjected to long-term bombardments, mine fields, and rocket attacks resulting in injuries, fatigue, loss of their homes, family members, livelihood and independence, and in post traumatic stress, resulting in a steady stream of refugees fleeing Afghanistan. Three million Afghans, primarily Pathans, fled to nearby Pakistan where they settled into refugee camps, and one million to Iran where they were more integrated into Iranian society. Another two million were displaced internally. Many of the refugees were members of the semi-literature Beluch nomadic tribes whose women have a reputation for producing high quality knotted rugs, valued for their simplicity and the freshness of their colors and design.[66] Kurdish and Turkmen women also created rugs, based on their own traditions. The women in

Iran supported their families through their rug production, while initially those in the refugee camps in Pakistan wove for their own use. Eventually their rugs were also used to provide economic support to their families.

The Baluchs are a nomadic people whose roots originated in Assyria. They are first noted in history in 664 CE as residing in the region of Kirman, and were driven from the region by Seljuk expansion in the tenth century. Baluchi women have a long, rich tradition of textile production that varies by geographic location, the result of interaction with other groups in Central Asia. In Baluchistan, the women have no pile rug tradition. Instead, they create woven fabrics for floor coverings, saddlebags and storage bags which are adorned with rich embroidery.[67] Historical evidence shows that the knotted pile rug tradition used by Baluchi women began around 1900 with the adoption of the horizontal collapsible wooden loom. Iranian made rugs feature an asymmetrical knot open to the right, tied on a depressed warp, while Afghan made rugs feature an asymmetrical knot open to the left. They make limited use of a depressed warp.[68] In a depressed warp, each knot is tied around two warp threads, forming two nodes when viewed from the rug's reverse. The two warp threads often sit in a variety of angles relative to one another.

The rugs are made of sheep wool, which acquires a sheen over time, tied onto a natural or brown wool warp and weft. Rugs produced by Baluch women in northeast Iran are usually small, finely knotted, and use a color palette primarily of dark blue, brown, red and white, often on a cotton warp. Baluch rugs from the Herat region are tied on wool warps and wefts and feature a dark color palette of navy, black, red and rust. Rugs made for urban dwellings feature wool selvedges while those used by nomads have black goat hair on the selvedge, intended to help repel snakes.[69] Until the 1950s, only natural dyes such as madder for red backgrounds were used; by the end of the twentieth century, aniline dyes were widely used.

Rugs play an important role in nomadic life. They are not typically used during the day, but are spread over goat hair mats when entertaining visitors and for sleeping. While prayer rugs have a somewhat standard size of three feet by five feet or four foot by six foot with sixty-four to one hundred twenty knots per square inch, the rug size for sleeping rugs and those used for entertaining is determined by the size of the tent in which it will be used.

Rug weaving is an important skill for a young woman to learn, for she will be expected to produce rugs for her family. Girls learn to weave at home at a young age. In the refugee camps weaving is a community activity, typically overseen by the oldest women in the group.[70] In the camps, women weave for up to eighteen hours a day on looms set up in dark, dusty rooms. The imagery on Baluch rugs "was an ancient representational form of language, of religious significance," and the rugs historically have depicted significant events in tribal life through the use of easily-recognized motifs derived from a common culture.[71] Often figurative, they incorporated flowers, trees, landscapes, animals, and people as well as geometric forms into bold, semi-abstract traditional motifs that reflected the harsh existence of their nomadic life.[72] The tree of life and birds in profile are also common. Many of the geometric forms have symbolic meanings—lozenges and triangles are symbols of female fertility, while fish symbolize male fertility.

Baluch women have a long tradition of making pictorial rugs and often have adapted quickly by developing new color usage and designs to meet new market demands.[73] Such adaptations have been a way for them to show their modernity. For instance, during the

period of the "Great Game," Turkmen women included symbols modeled on western heraldic devices on their rugs.

By the early 1980s, rugs with unusual motifs began appearing in the markets in Peshawar, Pakistan, eventually making their way to the west. These early rugs contained patterns arranged in a conventional manner, with flower and leaf borders. However, the motifs were neither conventional nor traditional, for these rugs reflected the conflict surrounding the refugees through their depiction of military motifs, such as AK-47 Kalashnikov assault rifles, grenades and military vehicles, leading to their designation as Afghan War Rugs, or *aksi*.

Four distinct stages in the evolution of Afghan War rugs have been identified:

1. Traditional motifs dominate the rug and the war iconography is secondary. These are often called "hidden" war rugs. The war images are small and are usually disbursed within the rugs borders.
2. In transitional rugs there is a balance between traditional and war motifs. These rugs typically have traditional flower and leaf borders.
3. War rugs where the war iconography is dominant. These rugs also typically have traditional flower and leaf borders as well (C8).
4. Commercial mat sized rugs which measure approximately two feet by three feet, with a two to three inch border. A large AK-47 Kalashnikov assault rifle dominates the field and is surrounded by the haphazard placement of a variety of weaponry.[74] These rugs were made by women in the refugee camps specifically to be sold in order to provide economic support for the women and their families.

The hidden war rugs were the first produced, initially used by the women who knotted them. Ultimately many were sold to raise money for the family, creating a market for the unique imagery. As they became more accepted, the war imagery became more prevalent, eventually becoming larger and more dramatic.

The rugs feature a considerable amount of detail; for instance, the women differentiated between a Hind M-24 attack helicopter and a HIP-8 troop carrier, and a variety of wheeled vehicles, leading scholars to conclude that the women weavers saw the weaponry first hand.[75] While each rug is unique, common themes can be discerned. Three of the four types include map rugs, which came in many sizes but always feature a map of Afghanistan and show a convoy of Soviet tanks going through the Salang Pass in the north. Throughout the Soviet occupation, these convoys, which often also included six-wheeled BTR-60 PB Armored Personnel Carrier, did a lot of damage to the Afghan countryside, wreaking havoc for local Afghanis. The map rug shown here is also known as a mujahedeen rug because it shows the military hardware used by the Afghan resistance.[76] In addition to the tank convoy, the two foot by three foot wool on cotton warp rug features a 12.7 mm M-1938 DShiKA (Dashika) heavy machine gun, a 14.15 mm ZGU-1 anti-air craft gun, and faux Cyrillic writing.

City rugs, which also are made in several sizes, feature images of city streets, including mosques, homes, trees, mountains and civilian and military vehicles. Many include images of Soviet military aircraft such as helicopters, fighter jets and bombers. Depictions of rural villages frequently include sheep, deer and native birds.

Rugs that only depict weaponry are by far the most prevalent. They were made in a variety of sizes, ranging from prayer rugs to runners to room sized carpets. These larger rugs

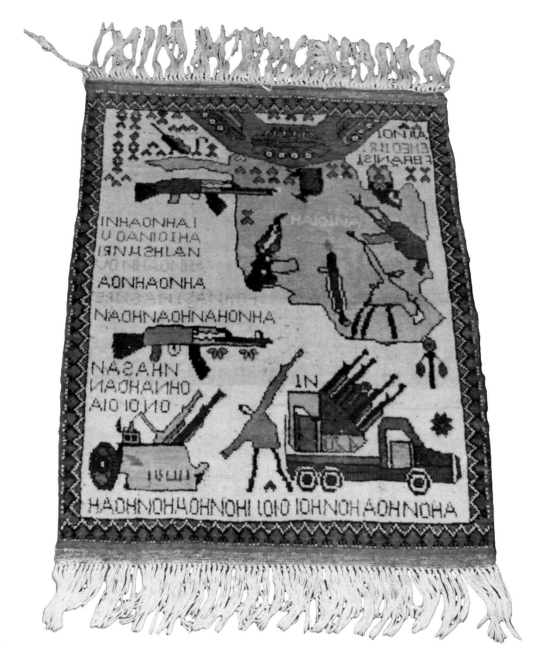

Map rug, Afghanistan, circa 1980. Wool on cotton warp. 30 in. by 24½ in., excluding fringe (collection of Deborah Deacon).

usually feature alternating rows of military vehicles and aircraft and smaller weapons such as grenades, mines and bombs. Among the aircraft depicted were the MI-8 (Hip) helicopter which features twin engine rotors, the ferret nosed MI-24 Hind attack helicopter, the BDU—22 bomber, SU-25 Frogfoot fighter bomber, the double rotor Yak 24 Yakovlev (Horse) helicopter, IL-86 personnel transport plane, and the MIG-25 Foxbat fighter jet.[77]

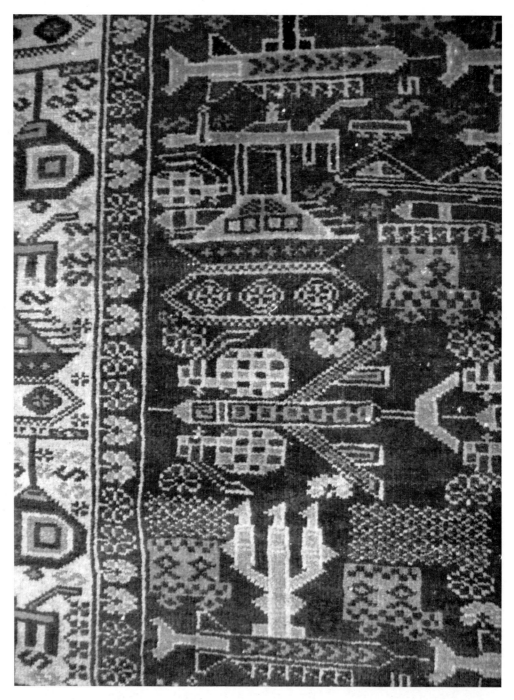

War rug (detail), Afghanistan, circa 1980. Wool on wool warp (collection of Deborah Deacon).

Military vehicles depicted on the rugs include T-62 tanks, six-wheel tracked BMP-1 personnel carriers, eight-wheeled BTR armored personnel carriers, supply trucks and staff cars. Smaller weaponry includes PMK-40 "toe poppers," small mines with wings, so named because after being dropped from an airplane, they wiggled under the soil, and when stepped on detonated, injuring a person's foot.[78] A variety of hand grenades, side arms and land mines

are also frequently depicted. Many of the prayer rug sized rugs feature a *mihrab*, in the design, indicating that they were intended for use in religious worship.

As previously noted, the small commercial mat rugs feature a single large AK-47 Kalashnikov rifle set to one side of the rug, on either a white or red background. The AK-47, with its forward angled ammunition clip, was the standard Soviet combat weapon at the time. By the end of the war, the AK-47 was replaced by the more sophisticated AK-74 both among the Soviet troops and on the rugs. The AK-74 featured a short rear handle, snub back, and orange-red banana shaped ammunition clip.[79] Depictions of other weapons, including smoke and fragmentation grenades, bombs, vehicles, and side arms filled the space opposite the rifle.

While it is difficult to date the rugs within the ten year period of their production, the region of production can often be determined by an examination of the type of wool, colors, knotting technique, warp type, pile density and fringe type, and length. Rug iconography can also be region specific; for instance, Soviet D-30 howitzers are only depicted on rugs from Uzbek, the only region in which they were used.[80] Pictorial rugs such as map rugs often feature multiple perspectives and mixed elevations and plans in their depictions. Many rugs contain indecipherable writing in Arabic, Cyrillic or Roman letters, often in combination.

All of the weaponry depicted on war rugs is of Soviet manufacture, interesting because most of the rug makers in Pakistan were for the most part removed from warfare. The tremendous amount of detail in the rugs has led to speculation that the weavers had direct access to the actual weapons, despite assertions that "throughout the war the guerrillas have seen the Soviets mainly in helicopters or aircraft."[81] Initial speculation was that Afghani women would have been familiar with Soviet weaponry as the result of seeing captured weapons and various vehicles as they moved through the countryside. Despite American support of the *mujahideen*, no American weaponry was ever depicted. It was not until 2010 that President Jimmy Carter revealed in an interview that the CIA supplied Soviet weaponry, purchased on the black market, to the guerrillas in an effort to mask American involvement in the war.

Peshawar, Pakistan, served as a base for the Afghan resistance throughout the war, a place where American military advisors, arms merchants, journalists and aid workers came together in the markets. Many of them bought war rugs as souvenirs. Initially the war rugs were made in Afghanistan and carried to Peshawar or Kabul, but eventually most of the rugs were made in Pakistan by refugees, including young men and boys.

By the time of the Soviet withdrawal in 1989, war rug production had wound down. In 1990, war rugs experienced a short popularity, seen as chic decorating items in popular magazines and featured in several exhibitions in Europe and the United States. By the mid–1990s, interest in the rugs had waned in the United States, Pakistan and Peshawar.[82]

Dealers and cultural anthropologists have speculated on the purposes for the changes in the rug iconography. Some theorize on the basis of weapon and vehicle types that they were originally made in response to a new consumer group, the occupying Soviet troops. Tatiana Owens has noted that the rugs were too expensive for the Soviet conscripts stationed in the region to purchase, leaving Soviet officers as the primary market. Ron O'Callaghan has theorized that the Soviet rug market is small and few soldiers would have wanted a souvenir of the Soviet failure.[83] In June 1980, an American diplomat brought a rug back to Washington, D.C., creating a new market for the unique creations. Although the war rugs

made up only a small percentage of the total Afghan rug production, war rugs were sent by rug agents to Frankfurt, Hamburg, London, and Zurich accidently, where they came to the attention of collectors. By 1983, war rugs were available in the markets in Peshawar, becoming a way for the weavers to supplement their almost non-existent income in the camps. By the mid–1980s, war rugs became family affairs, with even young girls weaving simple, small scale designs for sale.[84] Many rug merchants saw them as a negative aberration, a memory of an unpleasant time in history. A number of collectors saw war rugs simply as commercial products, failing to recognize that most traditionally patterned Afghan rugs are also intended for sale outside of the country.

Many scholars find the war rugs to be a subtle but powerful means of bringing the plight of the Afghan people to the west, where the Soviet invasion was largely ignored.[85] Rug weaving is a feminine craft and rugs are seen as objects of sensual pleasure. The motifs of modern warfare bring them into the male universe, undermining the intimacy and domesticity of women's work. The representation of instruments of war gave a universal meaning to the rugs and provided the weaver with a sense of control over her chaotic world. War reorganizes society as it spreads to every aspect of life. Through this process of representation, the horror is tamed, possessed and owned. Textile historian Jasleen Dhamija has noted:

> Women have always believed that by weaving the feared form they could capture it and take away the powerful evil.... It is as though the women have taken on the battle in their own way. Their sheep provide the wool, their hands clean and spin it. Nature provides the dyes and their skill, their burning desire to protect their people, their humanscape, drives them to weave these magical totemic rugs, which would defeat the apparently invincible army. Their fears are controlled, their creativity gathers the uncertainty, the impenetrable to conjure the strength for a battle with the enemy. Thus the simple rug is transformed into an expression of faith in their ability to hone from irrational, petrified anachronistic images a world of their own.[86]

The rugs reflected the essence of the Afghan world—the clash between the technology and violence of war and the reassurance brought through the creation of a domestic object like a rug. They allow the weavers to record events occurring around them, providing a sense of control and optimism for the future.

While women stopped producing war rugs at the end of the Soviet occupation in 1989, rugs with war related themes reappeared in the markets of Peshawar in 2002, following the American invasions of Iraq and Afghanistan in the aftermath of the events of September 11, 2001. Some of these small commercial rugs show support for America following the events of 9/11, depicting airliners flying into the flaming World Trade Towers in the top portion of the rug and an aircraft carrier at the bottom, separated by the American and Afghan flags which are united by a dove. These rugs, which are done on a white cotton warp, use imagery taken from propaganda leaflets dropped by coalition forces at the beginning of the newest war in the region. Other rugs depict new imagery—American planes, M-16s, and Abrams tanks, aimed at an American audience that includes soldiers and aid workers in the region. The single rifle commercial rug from the Soviet-Afghan War has changed to include two or four M-16s, primarily on a red background (C9). Runners and prayer rug sized carpets are also being produced with the new iconography. Aniline dyes in shades of pink, green and yellow have joined the traditional color palette of red, white, navy, black and brown. These newer rugs are often of poor quality in terms of materials and the sophistication of the imagery and design, and are often produced by men as well as young male and female children.

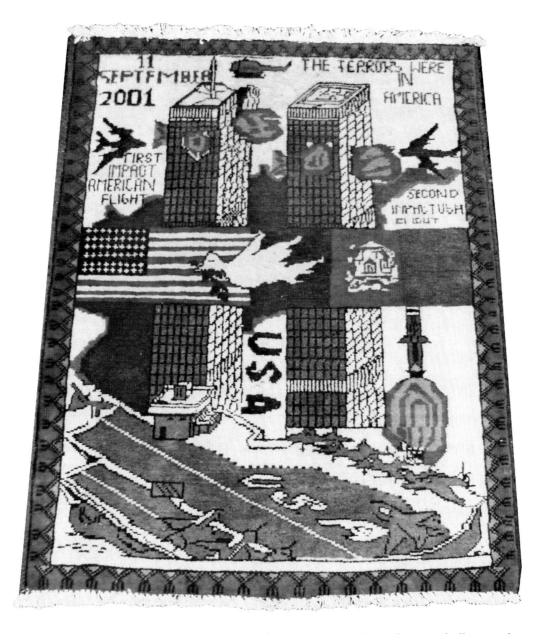

Afghan peace rug, Afghanistan, circa 2003. Wool on cotton warp. 24¾ in. by 32 in. (collection of Deborah Deacon).

With the Soviet withdrawal from Afghanistan, the Taliban, formed by members of the *mujahedeen,* took over the country's government, plunging the population into years of hardship, terror, and deprivation. Women found themselves almost totally confined to their homes, required to have permission from their husbands or fathers to leave the house. Under the American occupation, women did regain some freedoms, with many returning to work as teachers and secretaries, as well as to school. The women still live in a poverty-stricken conservative Muslim society, unable to choose their own spouses or even date. In the rural

villages, which remain very traditional despite the presence of the American military, all contact with men is forbidden once a girl reaches puberty.[87]

Afghan war rugs have been seen as inauthentic, decontextualized by their removal from maker and point of origin. They have also been seen as innovative, their use of traditional color schemes and balanced designs conveying a sense of stoicism and vitality to changing conditions in their lives. Joyce C. Ware has noted their unique place in textile production, stating that "the war rugs ... excited my interest ... because there are so few tribal rugs being woven today that reflect contemporary experience."[88] Final judgment as to their place in the history of women's craft and Asian carpets will most likely not come for decades, as time and perspective allow for more objective critique.

War rugs were not the only Afghani textiles to address the chaos brought to the region by war. In 2003, Melanie Gadener, the Executive Director of the Foundation for Self-Reliance, proposed a joint project with the Afghan Women's Association International (AWAI) to help raise money for Afghan refugees in the United States, Afghanistan, and Pakistan. The Afghan Women's Association was composed of Afghan refugees living in Fremont, California who wished to form closer ties with those left behind in Afghanistan, where they were experiencing the hardships of war first hand. The group particularly is interested in providing aid to war widows struggling to provide for their children.[89] The project proposed by Gadener, the Afghan Freedom Quilt, was intended to help heal the wounds of war by allowing the women to express their feelings about the war through their sewing.

In order to create the quilt, AWAI co-founder Shahla Arsala traveled to Kabul with instructions for the creation of a quilt square to be made by the women there. The squares would be sewn together into a quilt by the Afghani women in Fremont. In all, Arsala returned to California with one hundred and fifty quilt pieces, as well as biographies and photographs of the women who created them. The quilt pieces actually were not uniform squares; rather, the included a variety of sizes, shapes, and fabrics, including pieces of carpets, burka fragments, dresses and knitted baby booties. Each of the pieces was sewn onto a black fabric square, which were then sewn together to make the quilt. Embroidered into the four quilt borders are the names of the women who created the squares as well as those who donated money to the project (embroidered in pink), and those who did the quilting. In all, the project took three years to complete from its inception in 2003 to its completion on April 29, 2006. According to Gadener, the completed quilt succeeded in its goal of allowing the women's voices to be heard, and serves as "a remarkable symbol of stoicism, strength, the iron will to survive, and a refusal to surrender."[90]

Contemporary Textiles

In the closing decades of the twentieth century, the Middle East and Central Asia continued to experience the chaos that results from war, and women continued to express their patriotism and distress at their experiences with warfare in their textiles. During the Iraqi occupation of Kuwait that led to the First Gulf War in 1990, Kuwaiti children wore garments in the shape and red, white, green and black colors of the Kuwaiti flag, and Syrian weavers included images of the Kuwaiti flag in their traditional textiles to show their support for the Kuwaitis.

Lebanese textile artist Samia Zaru (b. 1938) was educated at the American University of Beirut, the Corcoran College of Art and Design, and American University in 1961. She taught art for the *United Nations Relief and Works Agency* for Palestine Refugees in the Near East in Palestine before she fled Ramallah after the Israeli occupation made it difficult for her family. She is best known for her use of bold colors and strong lines which communicate the tension in her multi-media installations. Zaru works in oils, acrylics, water colors, wooden blocks, metals and embroidered textiles. In 2000, she was honored as Woman of the Year by the American Geographical Institute for her body of work. The torn, gauzy fabric hung from the ceiling of her series *The Endless Cause* serves as an anti-war protest, a commentary on the horrors of war. The information that accompanied the piece noted, "Inhuman deeds, war, destruction, aggression ... unhappy people, this is what fills up our time ... human suffering is universal. We must stop and think before we start again."[91]

Beirut based Hoda Baroudi and Maria Hibri make up the design team known as "Bokja." The women's love of antiques, vintage furniture and textiles led to the establishment of their business in 2000. They endorse the sustainable use of materials in their creations, which they consider to have a spiritual content. Their *Migration Series*, shown during Design Week in Milan between April 9 and 14, 2013, featured sofas, rugs, chairs and wallpaper that "references stories of movement and change which come from all over the world, reflecting the impact of war, taxes, instability, the economy or even love."[92]

Their series *And Then There Were None* features a collection of satirical textile spheres, approximately three feet in diameter, embellished with embroidery and screen printed historical figures from across the centuries who have fallen from grace. The series, whose title is based on the 1868 nursery rhyme *Ten Little Indians,* uses dark humor to warn of the timelessness and dangers of dictatorship and question whether there will ever be a time without dictators.[93]

Each of the spheres features one historical dictatorial figure. *Going, going ...*contains a series of three images of Muammar Gaddafi within a white fabric rectangle. In the first image, he is shown in three-quarters view, saluting in his military uniform. In the second image, he is shown from waist height, tilted to the left. In the final image, only the top of his hat is visible. The sphere is made of camouflage material in shades of olive green, brown and cream and has military medals appliqued to the left of the central square. Floral embroidery is scattered across the top of the sphere in shades of pink, yellow, turquoise and green.

The sphere *Yemen* features three white rectangles on a red background. The top rectangle features a black burka-clad figure wearing a white cap, her hands painted in the colors of the Yemeni flag. In the central panel, three women, again wearing burkas, are seen, however, the only portion of their faces that is visible is their eyes. One woman has her eyes closed, the second looks to her left and the third, in the middle, stares straight ahead, wide-eyed with surprise. In the bottom panel, a crowd is featured in silhouette, fists raised. Three Yemini flags are seen in full color. The rectangles are embroidered onto the brown and black sphere with a green herringbone stitch.

The burlap *Palestine* sphere features a white dove wearing a flack jacket and body armor, a gun sight painted on its chest, amid the several strands of beige and brown barbed wire embroidered across its surface. Nearby, a child is pulled aloft by eight brightly colored balloons, a commentary on the realities of living in a war-zone and the desire for a lasting peace.

The sphere titled *Saddam Hussein* features a *Time Magazine* Man of the Year cover of

Hussein's portrait, edged in bright red, a red "X" across his face, embroidered onto the brown and black plaid wool fabric using red floss. It serves as a poignant commentary of how far the dictator had come, and in the end how far he fell.

The American invasions of Iraq and Afghanistan in 2003 brought chaos to the region as well as hope for a better life for the regions' inhabitants. In the southern Afghanistan province of Kandahar, the war has led to a lack of sustainable economic opportunities for men, leaving women to bear the burden of war, including thousands of young widows who must find ways of supporting themselves and their children. In 2003, Rangina Hamidi, an Afghani expatriate who had left Afghanistan at age three, returned to Kandahar and founded the Women's Income Generation Project (WIG) for the Afghans for Civil Society (ACS) in southern Afghanistan in an effort to provide women with a sustainable income. The project, which began with twenty-five women, employed four hundred by 2013. Among the works produced by the women are textiles featuring *khamak* silk thread embroidery, a style native to Kandahar. *Khamak* is a counted thread form of embroidery traditionally featured on the floor length men's shawls worn over men's western-style suits, table linens, women's head coverings, and trousseau textiles. Popular patterns include geometrics and florals as well as leaves and trees.[94] The textiles, which are sold on the internet, are seen as an expression of their desire for aesthetic beauty and a means of spiritual escape from the chaos brought by war. Their sales bring the women much needed income, giving them hope for a brighter future.

Despite American intervention in Iraq in 2003, post-war Iraqi women artists still face significant repression due to the rise of Islamic fundamentalism in the country. The conservative nature of Iraqi society forces women to keep their art a secret since women artists could be killed by their male family members for "shaming" the family by their art-making. Despite the danger and their fears, many women artists feel the need to have a voice to help institute cultural change. Unlike women artists elsewhere, they work in a void, a seeming lone voice crying for change. Still, Iraqi women artists feel that they are not so different from western women artists, and that they "share the same loves, the same creative drive, and right now, we are fighting similar cultural battles that will determine the paths our countries take … the struggle for control or freedom of culture is where the real front lines are, it's where the real wars are waged."[95]

Khulood Dami is a contemporary Arab Islamic artist who lives in London, but was born in Baghdad. She earned a bachelor's degree in fine arts from Baghdad University in 1979 and studied print making at the London School of Printing. She works primarily in ceramic, printing and textiles. War and the large-scale displacement of people resulting from war are the subjects of much of her art, in part due to her own status as an expatriate as well as to the loss of her brother Ali in the violence of war.[96] Shortly after her brother's death, she created a series of works in his honor, incorporating soil from their Iraqi homeland into the piece. The looting of the Iraqi Museum and the destruction of the Iraqi National Archives in 2003 has also influenced her work. The written word, in the form of Arabic calligraphy, cuneiform, Urdu, Chinese, Greek and Hebrew appears in many of her textiles, the result of her love of Sufi poetry.

In 2008, Dami created an installation titled *Solidarity with Palestine*, which included pieces made from men's neckties donated by the British journalist Jon Snow. The ties were coiled and knotted together to form commentaries on the state of the Arab world and its need to support those experiencing the violence and oppression caused by war.

In 2012, she created a number of *abayas* for an Iraqi childrens charity. An *abaya* is a simple, loose robe-like dress worn by women in parts of the Muslim world. Traditionally abayas are either a large black square of fabric draped from the shoulders or head or a long caftan, which covers the entire body except the face, hands and feet. Dami's *abayas* were done in a sheer black fabric printed with calligraphy. One dress bore the word *Iqra,* the first word in the Koran. The word means "read" and Dami is interested in the spiritual meaning of the word, which embodies light, knowledge, and enlightenment, all of which she hopes future generations of Iraqi children will experience. The charity works with children whose lives have been disrupted by the war in Iraq, a project Dami strongly supports.

As with their sisters in Iraq, many Iranian women artists work anonymously, fearful of repercussions from the conservative society in which they live. And like their Iraqi counterparts, many Iranian women artists believe they can play an important role in shaping Iranian society. Iranian-born installation artist Shirin Neshat has noted:

> It is through the study of women you can get to the heart—the truth of the culture ... it's the women who usually manifest [change]—through the way they dress, the way they behave.[97]

Mixed media artist Sara Rahbar was born in Tehran in 1976. For as long as she can remember, she has been interested in art, "piecing things together ... transforming things by changing their shape, positioning or color ... breaking them apart then piecing them back together again in a way that makes sense."[98] Her family fled Tehran after the Islamic Revolution and the Iran-Iraq War of the early 1980s. She studied at London's Central Saint Martins College of Art and Design and in an interdisciplinary studies program in New York City where she now lives and works. She sees her artistic process as organic, natural and cathartic, selecting objects and materials and piecing them together instinctively. Her work is largely autobiographically, a reflection of her personal sense of dislocation and disappointment. Through it she finds herself in a constant state of questioning, dissecting and attempting to understand herself and the world around her.

While she considers herself not to be political, she opposes war and finds the resulting violence that causes human suffering and desolation as a regression of the human race and civilization. Her *Flag Series*, begun in 2006, attracted international attention for her work. Each flag is a complex collage of carpet, embroidered fabrics and fringe sewn onto American or Iranian flags. Many flags contain text and religious and political symbols as well.[99] Her colorful piece *Cycles (Flag #7)* features vintage textiles, military badges, gold-colored guns and military aircraft pins on an Iranian flag. A commentary on the alternating periods of war and peace that have occurred for decades in Iran, it is now in the collection of the Queensland Art Gallery. *Glorious Haze 2012* features hand woven textiles, keys, military emblems, pins, buttons and bullet casings, colorful beads and tassels, and a sweetheart pendant from an American World War II soldier on a vintage American flag.

Her triptych, *Made in America,* was created during the summer of 2013 in reaction to events occurring in the United States and around the world. Her explanation reveals her frustration with contemporary events: "the Battle between the poor and the wealthy ... our fight for health care, education and quality of life ... the working class and the fight for the American dream ... war and deception.... I listen to independent radio and am so overwhelmed with the amount of deception and destruction.... I felt like a witness to a car accident; helpless and frustrated that I couldn't stop it, or save anyone ... these three works were

all that I could contribute, they were my silent rebellion."[100] The American flag serves as the foundation for all three sections of the triptych, the blue and white star field visible in each. On the left panel, Rahbar appliqued American army insignia, embroidered cloth name tags, bullet casings and octagonal shaped coins over the red and white stripes. The central panel features army rating badges, gun holsters, blue and white embroidered Iranian fabric and traditional silver jewelry appliqued along the flag's stripes. On the final panel, hundreds of bullet casings alternate with blue and white striped strips, white braiding and olive green webbing. Displayed together, they make a powerful statement about contemporary events.

Barriers of Separation and Distance (Flag #29) (C10) is a commentary on the political difficulties between Iran and the United States. Created in 2008, it features colorful fabrics in shades of red, white and blue, buttons, metal pendants and trim appliqued onto a seventy-nine inch by forty-seven inch American flag. Like the other flags in the series, it speaks to Rahbar's search for a feeling of safety and security in a world of chaos, as well as her interest in ideas about nationality and the need to belong to something, someone or somewhere, all things that those displaced by war are also seeking.

The countries that compose the areas known as the Middle East and Central Asia have experienced the violence and disruption that come from years of warfare. Like their female counterparts in other regions in the world, the women who live in the Middle East and Central Asia have used their native textile traditions to express the impact of war on their lives by creating textiles that support their country men as they participate in warfare, that protest the impact of warfare and support peace, that provide them with the ability to support their families and that document the activities of warfare. This tradition has been carried on for generations, and continues through the most recent wars in Iraq and Afghanistan. And most likely will carry on for generations to come.

Epilogue

This book has shown that for centuries the textiles made by women have served many roles for the women who created them, as well as for the society in which they live. The particular colors, patterns, and style of a textile convey key information about social status, sex, age, and cultural group. Textiles have served as symbols that mark membership in a group or movement, bonding individuals even if they are geographically separated. They have also been used as a political tool, a testament and record of historical events. During times of war, they have documented the horrors of war, commemorated individuals and lifestyles lost due to violence, patriotically supported the nation at war and in peace, and protested the violence of war.

Women in Chile, Peru, and El Salvador documented the disappearance of loved ones at the hand of their government during the 1980s by creating appliqué *arpilleras* containing scenes of the violence they encountered. These *arpilleras* were sold abroad, providing much needed economic support for the women and their families, and telling the world of the horrors they experienced. During the 1980s, women in Afghanistan documented the weapons of war used during the Soviet occupation in the rugs they created for their own use and sold to help support their families during the occupation. In England, Sandra Lawrence designed a series of paintings which were used as the cartoons for the Overlord Embroidery, which documented the events of the invasion of Normandy during World War II. The Embroidery's thirty-four panels contain detailed depictions of the operational planning, invasion of Normandy by Allied forces, battle scenes, and the London Blitz, capturing the resolve of the British people during time of war.

Women from different time periods and from a number of cultures used textiles to commemorate the loss of cultural traditions and the creation of new ones. One of the earliest textiles intended to commemorate the events of war is the Bayeux Tapestry, which tells the story of William of Normandy's conquest of England through embroidery. Centuries later, at the end of the Vietnam War, Hmong women in refugee camps created embroidered story cloths which tell the story of the destruction of their villages at the hands of the triumphant Viet Cong, as well as their hazardous crossing of the Mekong River to freedom, allowing them to share the story of their ordeal with the world. As recently as the summer of 2013, quilters in Baltimore, Maryland, created a replica of the flag made by Mary Pickersgill which flew over Fort McHenry during the War of 1812. Like the original flag, the replica measures forty-two feet by thirty feet, has stars that measure two feet wide and was completed in six weeks.[1] The original flag, which inspired Francis Scott Key to write the poem that became

the American National Anthem, served as a source of pride at a time when Americans were defining themselves as a nation. The new flag was flown at Fort McHenry on Defender's Day, September 14, 2013, the 99th anniversary of the original defense of Baltimore Harbor during the War of 1812. Like the original flag, the replica flag serves as a reminder of the difficulties early Americans overcame during the early years of the republic.

Throughout American history, women have used textiles to show their patriotism. During the American Revolution, women created quilts with patriotic names such as Whig Rose and during the westward expansion they wove coverlets with names such as Lee's Surrender and Braddock's Defeat to show their allegiance to their new nation. During World War I and II, American, Canadian, and British women knit socks, caps and sweaters for the troops and war refugees as a way of showing their support for the war effort. This tradition continues today as women knit caps for troops stationed in Iraq, Afghanistan and the mountainous areas of Israel.

In the United States, a number of volunteer quilting organizations have created quilts for wounded warriors and the families of those killed during the wars in Iraq and Afghanistan. The Home of the Brave Quilt Project is a national quilting movement dedicated to honoring fallen heroes of the wars in Iraq and Afghanistan by providing handmade quilts to the families left behind. The project was begun by Don Beld, a member of the Citrus Belt Quilters, in 2004 in Redlands, California with the idea of easing the suffering of the families of fallen heroes, and quickly spread to all fifty states and U.S. territories, and by the summer of 2013 had provided 5669 quilts to 4700 families.[2] All of the quilts, which are made of twelve inch square blocks and measure forty-eight inches by seventy-eight inches, are reproductions of a Civil War Sanitary Commission quilt in the collection of the A.K. Smiley Library, Lincoln Shrine, in Redlands, California. During the Civil War, members of the Union's U.S. Sanitary Commission created quilts for the wounded to support the war effort, and the reproduction quilts honor this tradition. The pattern is provided on the Home of the Brave Quilt Project's website and while each quilt is done in the same pattern, each is unique since the colors and fabrics are selected by the individual quilter. The Quilts of Valor Foundation's mission is to "cover all combat service members and veterans touched by war with comforting and healing Quilts of Valor."[3] Their Under Our Wings program allows people to participate in national service by creating quilts from the free patterns available on their website. Once a quilter has assembled the quilt top, he/she is put in touch with a longarmer who will provide guidance on quilting and assembling the quilt. Quilts range in size from fifty-five to seventy-two inches wide by sixty-five to ninety inches long. The quilter includes a note of encouragement and a coordinating bag or pillowcase for each quilt. As of September 2013, quilters have created and distributed 89,312 quilts.

Knitting has also been used to create war protest art, with women like Canadian textile artist Barbara Hunt creating knitted land mines and American textile artist Dixie Brown's knitted bombs. Both artists used a traditional women's craft, typically used to create items intended to warm and protect loved ones, to create objects associated with the destructive forces of war. The juxtaposition of the soft knit bombs with their normally hard, cold metal forms emphasizes the disruption of everyday life caused by war. Women from Denmark, the United Kingdom, the United States and other countries knitted enough pink squares to cover a World War II–era tank as a protest against their country's involvement in the war in Iraq.

Many of these textiles have served as a tool of healing, allowing survivors to recognize and acknowledge the traumas they have experienced.[4] They provide a vehicle for bonding in the public sphere, helping to build community and identity. They document human resilience and endurance and generate compassion from those who see them. The war textiles discussed in this book have allowed the women who created them to tell the story of their personal encounter with events that will later be considered part of history, a story often omitted from official historical narratives, but one that needs to be heard.[5]

These textiles also force us to examine the losses suffered in war within the larger framework of the loss of humanity that occurs during war as they reveal the unspeakable horrors and invite others to see and understand. As Yasmin Saikai has noted, by studying violence we can work to develop reconciliation between the perpetrators of the violence and their victims. Textiles, because of their texture and identification as women's work, can help with reconciliation and healing. Jacqueline Adams has commented that "'typically' feminine arts (such as applique) can be very powerful political tools.... Maternal (caring) emotions can be useful for [political] movements ... the shantytown women's maternal distress and concern for their families' welfare is in part what led them to create the *arpilleras*, useful for the movement in all the ways we have seen, the buyers' caring about the women led to them buying the *arpilleras*, and support anti–Pinochet efforts, bringing resources to the movement."[6] Atkins raises another important attribute related to the creation of textiles about war—that the sale of such textiles provides economic support for those whose livelihoods are disrupted by war. In many cases, the sale of such textiles, which is often aided by non-governmental organizations that provide aid to refugees, allows women to earn money to feed themselves and their children, such as the Advocacy Project in Washington, D.C., which has worked to raise awareness and funding for Bosnian women victimized by war.

In addition to recording the horrors of war and helping victims to heal, textiles can play a role in peace building. In the years immediately following pacification, Native American women in the Plains included American flags in their beaded gloves, moccasins and baby cradles as a way of showing that they recognized that they were now living under the jurisdiction of the United States government. New settlers in Canada created decorative hooked rugs that included the word "Canada" to show their loyalty to their new homeland.

On October 23, 1975, the American Needlepoint Guild presented the United Nations Peace Rug to Secretary-General Kurt Waldheim in honor of the thirtieth anniversary of the founding of the United Nations. The American Needlepoint Guild, whose initial membership totaled 300, was founded in May 1972 at the Birmingham (Alabama) Museum of Art. By 1975, the organization had 6000 members, with Princess Grace of Monaco serving as the group's honorary chair. The rug was the brainchild of Mrs. A. Page Sloss, Junior, of Birmingham, Alabama, who noted that the symbolism in the coats of arms represents "the best and noblest aspirations of man."[7]

The sixteen foot square rug contains needlepoint representations of the coats of arms of the 138 founding United Nations member nations.[8] A coat of arms is composed of a shield, supporters, crest and motto. Each design is a symbol unique to a particular individual, family or state. While coats of arms were used to identify military units during the Roman Empire, the first evidence of the individual use of coats of arms is found in the Bayeux Tapestry, where some of the soldiers are depicted carrying shields painted with crosses. Coats of arms came into general use by feudal knights and lords in battle during the twelfth century.

By the following century, coats of arms came into use as a flag or logo for members of European aristocratic families, passed from one generation to the next, and ultimately spread to towns and nations as a form of national identity.

Each square in the Peace Rug measures sixteen inches square and contains 256 stitches, or sixteen stitches per square inch. The canvases were painted by artists from Mona Spoor Associates. The countries are listed on the rug in alphabetical order and the emblems are all the same size, emphasizing the equal responsibility of all the member nations to work for peace. The gold background of each square symbolizes the golden era of peace that can be achieved if all nations work together. The United Nations flag, sixty-four inches square, is located at the center of the rug and a thirty-two inch signature square is located in the rug's lower right corner.

Many of the coats of arms contain images of weapons or relate to warfare. At the center of Argentina's, the clasped hands of fraternity and unity hold a liberty pole topped by a Phrygian cap of liberty, done in blue and white. The coat of arms' background colors are those worn by Patricios (patriots) during their fight for freedom. The Oman coat of arms contains images of traditional weaponry—crossed scimitars behind a curved dagger (*gambia*) above a horizontal sword sheath done in red and white; the red symbolizes Omani battles for independence, the white peace and prosperity. In the Burundi crest, native spears represent warriors while in the Finnish crest, a golden lion rampant with a sword tramples the scimitar of eastern enemies. The coats of arms of many African nations feature native shields and spears and that of Nepal contains two soldiers—one in a native uniform carrying a bow and arrow, the other in a British uniform with a rifle.

Not all of the coats of arms depicted on the Peace Rug contain war imagery. One coat of arms that contains images of peace is that of Cyprus. It features the dove of peace with an olive branch on a shield. The shield is surrounded by olive branches, a universally accepted symbol of peace.

Israeli artist Maly Cohen uses images of the dove of peace in her textile art, making it a counterpoint to the violence that is an almost daily occurrence in Israel. Michele Karch-Ackerman, a Canadian artist, created hundreds of tiny woolen sweaters to honor soldiers killed during the First World War, in the hopes that they would be the last to die under such circumstances.

Peace, the binary opposite of war, is a state mankind has striven to attain for millennia, with varying degrees of success. During times of peace, women have been able to devote their attention to the people and activities—including the production of textiles—that they love. War disrupts this ability, creating chaos and pain in the lives of both those who fight and those who are left behind. Unfortunately, as this book is completed, war rages on in Iraq, Afghanistan, Somalia, Sudan, and Syria, to name a few. As warfare has changed, more women find themselves involved in conflict, as participants in the actual fighting, as victims of the warfare or as innocent bystanders, impacted by the conflict. In Syria, women have directly joined the fighting during the current civil war. After personally experiencing the violence inflicted on her village by the regime of Bashar Al Assad, Khowleh, a thirty-five year old mother of seven, grandmother, protest leader and refugee became an armed rebel, leading a brigade of a half dozen women fighters. The brigade, the Khowleh bint Al Azwar, was named after a famous seventh century female Arab warrior. The brigade was disbanded in mid–2012 as the warfare intensified and thousands of civilians fled to Jordan to escape

the violence.[9] Because of the continuous warfare in these regions, normal life has been disrupted, depriving artists and the average citizen of the ability to tell their stories.

As has been shown in this book, women have responded to the chaos of war by creating textiles that record the impact of war on their lives, an activity that has often resulted in new textile traditions, modifications to old traditions, economic support for themselves and their families, and the creation of a vehicle for women to use to express their feelings about the conflict. As we move forward in the twenty-first century, it appears that such activities are continuing.

Glossary of Textile Terms

abaca—A species of banana native to the Philippines, grown as a commercial crop in the Philippines, Ecuador, and Costa Rica. Harvested for its fiber which is used for making twines and ropes; while most abaca is pulped and used in a variety of specialized paper products, it is also used to create fabric.

aniline dye—Chemical or synthetic dyes derived originally from coal tar.

animal skins—After cleaning and preservation, the skins of buffalo, deer, rabbits and other mammals were used by Native American women for clothing.

appliqué—A sewing technique in which a small piece of cloth is sewn to a larger ground cloth

backstitch—An embroidery technique where individual stitches are made backward to the general direction of sewing; these stitches form lines and are most often used to outline shapes or to add fine detail to an embroidered picture.

backstrap loom—A portable loom consisting of a series of bars. The top bar is attached by a cord to a fixed object such as a tree, and the bottom bar is attached to a belt that encircles the weaver, whose weight and backwards pressure against the loom hold the warp threads tight.

bast—Plant fiber collected from the inner bark or the skin surrounding the stem of certain, mainly dicotyledonous plants.

batik—The Javanese method of resist-dyeing using wax.

batten—In weaving, after the shuttle moves across the loom laying down the fill yarn, the weaver uses the reed to press (or batten) each filling yarn against the portion of the fabric that has already been formed but not yet rolled up on the takeup roll.

beading—The attaching of beads to one another or to cloth, usually by the use of a needle and thread or soft, flexible wire.

blanket stitch—A stitch used to reinforce the edge of thick materials.

bobbin—A weaving tool used to pass wefts through a shed consisting of a thin, carved wooden stick wound with thread.

brocade—A general term for any woven technique in which supplementary decorative threads float over the ground cloth; it is often difficult to distinguish from embroidery.

buttonhole stitch—Buttonhole stitches catch a loop of the thread on the surface of the fabric; the finished stitch resembles a letter "L" depending on the spacing of the stitches.

camelid fiber—The hair of native mountain New World camelids, including alpaca, llama, guanaco and vicuna.

canvas—An extremely heavy-duty plain-woven fabric used for making sails, tents, and other items for which sturdiness is required. It is also popularly used by artists as a painting surface, typically stretched across a wooden frame. Canvases such as Aida cloth are used for embroidery.

carding—The combing of raw fibers such as cotton or wool into parallel strands to facilitate spinning into thread.

chain stitch—A sewing and embroidery technique in which a series of looped stitches form a chain-like pattern.

cochineal—The natural red dye made from the bodily fluid of the cochineal beetle, a parasite on the prickly pear cactus.

combing—A method of separating long wool strands for weaving fine worsted cloth.

complementary—A relationship between threads in weaving, either warps or wefts, that move in the same direction and are coequal; when one thread goes to one side, the other goes to the other.

cotton—A soft, fluffy staple fiber that grows in a boll, or protective capsule, around the seeds of cotton plants of the genus *Gossypium*. The plant is native to tropical and subtropical regions around the world, including the Americas, Africa, and India, and was domesticated as early as 5000 BCE.

couching—A technique in which yarn or other materials are laid across the surface of the ground fabric and fastened in place with small stitches of the same or a different yarn.

crewel—A form of surface embroidery using wool and a variety of different embroidery stitches to follow a design outline applied to the fabric.

cross hatch—An embroidery technique of two or more sets of intersecting parallel lines; often used for shading.

cross stitch—An embroidery technique in which X-shaped stitches in a tiled pattern are used to form a picture; usually executed on easily countable even weave fabric.

damask—A reversible figured fabric of silk, wool, linen, cotton, or synthetic fibers, with a pattern formed by weaving with one warp yarn and one weft yarn, usually with the pattern in warp-faced satin weave and the ground in weft-faced or sateen weave.

darning stitch—A sewing technique for repairing holes or worn areas in fabric or knitting using needle and thread alone.

distaff—A tool used in spinning designed to hold the unspun fibers, keeping them untangled and thus easing the spinning process. It is most commonly used to hold flax, and sometimes wool.

draw loom—A hand loom capable of raising individual warps, suitable for weaving complicated patterns.

dye—A colorant that completely penetrates fibers; may be made of natural materials such as plants and minerals or may be synthetic.

embroidery—A needlework technique in which threads are sewn onto a ground cloth.

featherwork—The working of feathers into a cultural artifact.

felt—A non-woven textile that is produced by matting, condensing and pressing fibers together. It can be made of natural fibers such as wool or synthetic fibers.

flame stitch—A type of needlepoint embroidery consisting of upright flat stitches laid in a mathematical pattern to create motifs.

flax—A fiber crop that is grown in cooler regions of the world. Flax fibres are taken from the stem of the plant and are two to three times as strong as those of cotton and are naturally smooth and straight.

floats—Any thread that passes over more than one of the other element (warps over wefts in warp patterning).

forbidden stitch—A form of French knot, called seed knot in early centuries and also known as Peking knot, allegedly outlawed from embroidery factories in China for causing women to go blind in their extensive use of it.

gauze—A weave structure in which the warp yarns are arranged in pairs and are crossed before and after each weft yarn keeping the weft firmly in place

ground cloth—The base fabric, typically woven in plain weave, for a superstructural technique such as embroidery.

heddle—A stick onto which loops of thread are wound, the loops entwining with warp threads to create a shed; for example, in plain weave the loops pick up every other warp.

hemp—A commonly used term for varieties of the Cannabis plant and its products, which include fiber, oil, and seed.

herringbone stitch—A needlework stitch used in embroidery, knitting and crochet. It is so named as it resembles the bones of a fish extending from the spine of a herring fish.

hooked rug—A rug made by pulling loops of yarn or fabric through a stiff woven base such as burlap, linen, or rug warp.

indigo—A natural blue dye from the *indigofera* plant that is extremely difficult to extract.

interlocking—A join in which threads of the adjacent color areas turn back after looping around each other between warp threads.

jacquard loom—An automated system of raising heddles in a programmed order using punched cards.

kantha—A type of embroidery popular in Bangladesh and in West Bengal, India that uses saris as the base for embroidery made with decorative running stitch motifs.

kesi—A Chinese tapestry technique in which threads of adjacent color areas turn back without looping around each other between warps, creating a physical gap between adjacent color areas.

khamak embroidery—An intricate form of counted cross stitch embroidery that features geometric patterns worked in silk thread and is a trademark of Kandahar.

knit stitch—A basic stitch in knitting in which the yarn is held behind the needle, producing a smooth front and rough back.

knotting—A single-element technique in which a series of knots form a fabric.

lace—An openwork fabric, patterned with open holes in the work, made by machine or by hand, created when a thread is looped, twisted or braided to other threads independently from a backing fabric.

lane stitch—A Native American beading technique useful for creating (though not limited to) geometric designs. Can be done in parallel rows of equal numbers of beads using a guideline drawn on the leather. Also known as "lazy stitch."

linen—A textile made from the fibers of the flax plant valued for its exceptional coolness and freshness in hot weather

macramé—Coarse lace work made by weaving and knotting cords into a pattern.

madder—A southwest Asian perennial plant *(Rubia tinctorum)* with small yellow flowers, whorled leaves, and a red root which is used to produce red dye.

mordant—Mineral treatment for fiber that aids in its absorption of dye and enriches the color, such as iron, which darkens.

muslin—A loosely woven cotton fabric which originated in present-day Bangladesh, and was introduced to Europe from the Middle East in the 17th century. Because air moves easily through muslin, muslin clothing is suitable for hot, dry climates.

needlepoint—Decorative needlework on canvas, usually in a diagonal stitch covering the entire surface of the material.

netting—A single-element mesh secured by knots.

openwork—A general term for techniques in which the elements are widely spaced. Textural differences rather than color create a pattern.

petit point—A small stitch used in needlepoint.

plain weave—The most basic two-element weaving technique in which one element regularly crosses over and under the other.

ply—To retwist single threads together, typically in the direction opposite that in which the threads were spun; the ply direction can be either S (counterclockwise) or Z (clockwise).

purl stitch—A knitting technique where the yarn is held in front of the needle instead of the back, resulting in a rough texture.

quill work—A form of textile embellishment traditionally practiced by Native Americans that employs the quills of porcupines as a decorative element.

ramie—A flowering plant in the nettle family Urticaceae. One of the strongest natural fibers, it is known for its ability to hold shape, reduce wrinkling, and introduce a silky luster to the fabric appearance. It is not as durable as other fibers, and so is usually used as a blend with other fibers such as cotton or wool.

resist—A cloth-dyeing technique in which some part of the cloth is covered, by a resin being applied as in batik or by being tied off with a thread as in ikat or tie dye, in order to keep the fabric from absorbing the dye when the cloth is immersed in the dye bath.

reverse appliqué—A sewing technique where layered fabrics are cut away from the top layers to reveal the fabric(s) below.

running stitch—A simple line of over and under sewing or embroidery stitch, as in basting.

sampler—A piece of embroidery produced as a demonstration or test of skill in needlework. It often includes the alphabet, figures, motifs, decorative borders and sometimes the name of the person who embroidered it and the date.

satin stitch—A flat stitch, characterized by long stitches covering the entire width of the design element.

seed stitch—A pattern that consists of single knits and purls that alternate horizontally and vertically.

selvedge—The edge of a woven fabric where the weft begins its return run.

shed—Temporary opening between two planes of warp threads selectively separated for passage of the weft.

shed stick—A bar used to create a shed.

shuttle—A tool that carries the thread across the loom weft yarn while weaving. Shuttles are thrown or passed back and forth through the shed, between the yarn threads of the warp in order to weave in the weft.

silk—A natural protein fiber obtained from the cocoons of the larvae of the mulberry silkworm *Bombyx mori* reared in captivity (sericulture).

single ply—Thread that is spun but not plied with another thread.

skein—A wrapped ball of finished thread for storage or winding onto a bobbin.

spindle—A thin, carved pointed stick that is used as a tool to spin thread; with its tip on a surface, it can be turned to act as a weight and as a holder for the spun thread.

spindle whorl—A small bead "strung" on a spindle to help hold the thread and act as a weight.

sprang—A general term for a hand-weaving technique worked from both ends of affixed threads toward the middle.

stem stitch—An embroidery stitch in which the forward stitch is followed by a backwards stitch half as long, then another forward stitch, etc. to create slightly overlapping diagonals; used to cover extensive areas of cloth.

stockinette stitch—A knitting technique made by combining one row of knitting with one row of purling.

supplementary—Any discontinuous patterning thread woven in which cloth is being built up but not integral to the structure; typically found in brocade.

suspension loom—A loom where warps have weights attached to them to maintain the tension.

tanning—Soaking skins in acidic substances to make them supple and prevent decay.

tapa—Primary material used for clothing by Hawaiians, made from the bark of the paper mulberry plant.

tapestry—A weft patterned variant of plain weave in which discontinuous patterning wefts are packed down, completely obscuring the warps.

thread count—The number of threads of each element in a given unit of measure; higher thread counts indicate thinner threads, more thread used, and imply great skill on the part of spinners and weavers.

two-ply—Thread that is made up of two single-ply threads twisted together; typically used for weaving since it is strong and balanced.

warp—The load-bearing vertical element strung onto the loom first, usually the longer and stronger of the two elements.

warp-faced—Cloth in which the warp threads predominate on the face.

warp patterning—A general category of techniques in which the warp threads carry the design.

weft—The non-load-bearing horizontal element passed through the warps, usually the shorter and less strong of the two elements, usually carries patterning.

weft-faced—Cloth in which the weft threads predominate on the faces.

weft patterning—A general category of techniques in which the weft threads carry the design.

wool—A general term for animal fibers, typically taken from goats or sheep.

Chapter Notes

Introduction

1. In Chapter Three of *A Room of One's Own,* Woolf actually wrote, "I would venture to guess that Anon, who wrote so many poems without signing them, was often a woman." Virginia Woolf, *A Room of One's Own* (San Diego: Harcourt, Brace and World, 1957), p. 51.

2. Ruth B. Phillips, *Trading Identities: The Souvenir in Native American Art from the Northeast, 1700–1900* (Seattle: University of Washington Press, 1998), p. 183.

3. Chelsea Miller Goin, "Textile as Metaphor: The Weavings of Olgo de Amaral," in *A Woman's Gaze: Latin American Women Artists,* ed. Marjorie Agosin (Fredonia, NY: White Pine Press, 1998), pp. 57–58.

4. Rebecca Stone-Miller, *To Weave for the Sun* (London: Thames & Hudson, 1992), p. 13.

5. Jacqueline M. Atkins, *Wearing Propaganda: Textiles on the Home Front in Japan, Britain and the United States, 1931–1945* (New Haven: Yale University Press, 2006) p. 19.

6. G. Honor Fagan, "Women, War and Peace: Engendering Conflict in Poststructuralist Perspective," in *Postmodern Insurgencies: Political Violence, Identity Formation in Peacemaking in Compara-tive Perspectives,* ed. Ronaldo Munch and Purnaka L. da Silva (New York: Palgrave Macmillan, 2000), p. 2.

7. Mary Schoeser, *World Textiles: A Concise History* (London: Thames & Hudson, 2003), p. 10.

8. Valerie Steele, "Clothing," *Microsoft Online Encyclopedia,* http://www.encarta.msn.com (accessed October 28, 2012).

9. Stone-Miller, p. 11.

10. Schoeser, p. 15.

11. Steele, p. 5.

12. Victoria Z. Rivers, "Textiles, South Asian," in *The Encyclopedia of Clothing and Fashion* (New York: Charles Scribner's Sons, 2004), p. 309.

13. *Ibid.*

14. Schoeser, p, 57.

15. John Gillow and Brian Sentence, *World Textiles: A Visual Guide to Traditional Techniques* (London: Thames & Hudson, 1999), p. 10.

16. Diane Lee Carroll, *Looms and Textiles of the Copts* (Seattle: University of Washington Press, 1988), p. 8.

17. Ovid, *Metamorphosis* VI, trans. Sir Samuel Garth and John Dryden, http://classics.mit.edu/Ovid/metam.6.sixth/html (accessed October 25, 2012).

18. Gillow and Sentence, p. 13.

19. Anne Session Runyan, "Gender Relations and the Politics of Protection," *Peace Review* (Fall 1990): 28.

20. Heather Pritash, Iris Schaechterle, and Sue Carter Wood, "The Needle as the Pen: Intentionality, Needlework and the Production of Alternate Discourses of Power," in *Women and the Material Culture of Needlework and Textiles,* ed. Maureen Daly Goggin and Beth Fowkes Tobin (Burlington, VT: Ashgate, 2009), p. 15.

21. Mary C. Beaudry, *Findings: The Material Culture of Needlework and Sewing* (New Haven: Yale University Press, 2007), p. 5.

22. Pritash et al., p. 13. The abolitionist and woman's rights activity Sojourner Truth (born Isabella Baumfree), whose public image was that of a nontraditional, African American woman, used needlework to re-establish her femininity after the Civil War, posing for a formal portrait with knitting on her lap.

23. Jacqueline Adams, "Art in Social Movements: Shantytown Women's Protest in Pinochet's Chile," *Sociological Forum* 17 (March 2002): 26.

24. Teena Jennings-Rentenaar, *Kuna Mola Blouses: An Example of the Perpetuation of an Art Craft Form in a Small Scale Society* (Ph.D. diss, Ohio State University, 2005), p. 52.

25. Many cultures, such as the Hmong, Baluch, and Zulu, have only oral traditions and use pictorial textile imagery as alternative forms of communication.

26. Stella Kramrisch, "Kantha," *Journal of the Indian Society of Oriental Art* 7 (1993) in *Kantha,* ed. Darielle Mason (Philadelphia: Philadelphia Museum of Art, 2009), p. 172.

27. John Scheid and Jesper Svenbro, *The Craft of Zeus: Weaving and Fabric,* trans. Carol Volk (Cambridge: Harvard University Press, 1996), pp. 10–11. The women also participated in a female Olympic Games, composed of foot races. The winners were awarded crowns of olive branches, like the male participants.

28. Homer, *The Iliad,* Book III in *The Great Books of the Western World, Vol. 3,* ed. Mortimer J. Adler (Chicago: Encyclopaedia Britannica, 1990), p. 32.

29. Circe was the daughter of Helios, the Sun God, and Perse. Calypso enchanted Odysseus with her singing as she wove with a golden shuttle. In the end, Odysseus was able to break away from each of his captors.

30. Aristophanes, *Lysistrata* in *The Great Books of the Western World vol. 4,* ed. Mortimer J. Adler (Chicago: Encyclopaedia Britannica, 1990), pp. 833–384.

31. Edward Gibbon, *The Decline and Fall of the Roman Empire* in *The Great Books of the Western World, Vol. 38,* ed. Mortimer J. Adler (Chicago: Encyclopaedia Britannica, 1990), p. 349. Her pleas were ultimately successful and the captives were freed.

32. *Ibid.,* pp. 363–364.

33. Yasmin Saikia, *Women, War and the Making of Bangladesh: Remembering 1971* (Durham: Duke University Press, 2011), p. 10.

34. Ariel Zeitlin Cooke and Marsha MacDowell, eds., *Weavings of War: Fabrics of Memory* (East Lansing: Michigan State University Museum, 2005), p. 8.

35. Atkins, p. 19.

36. Cooke, p. 9.

37. Tin Myaing Thien, *Old and New Tapestries of Mandalay* (New York: Oxford University Press, 2000), p. 3.

38. *Ibid.,* pp. 44–45.

39. Phillips, p. 198.

40. *Ibid.,* p. 10. Daub and wattle is a composite building material for making walls. A woven lattice of wooden or reed strips, called wattle, is daubed with a sticky material, usually made of a combination of wet dirt, clay, sand, animal dung and straw. Daub and wattle has been used for at least 6000 years and is still an important construction material in many parts of the world, including Africa and the South Pacific.

41. Stone-Miller, p. 17.

42. *Ibid.,* p. 10.

43. Lola Ehrlich, ed., *Vogue Knitting* (New York: Pantheon, 1989), p. 2.

44. Schoeser, p. 172.

45. Ehrlich, p. 3.

46. Gillow and Sentence, p. 23.

47. *Ibid.,* p. 34.

48. Stone-Miller, p. 17.

49. Gillow and Sentence, p. 30.

50. *Ibid.,* pp. 70–90.

51. Stone-Miller, p. 17.

Chapter One

1. "Europe," map produced by the Central Intelligence Agency, www.lib.utexas.edu/maps/europe/europe_ref_2010.pdf (accessed June 19, 2013).

2. "Central and Eastern Europe, United Nations, www.un.org/Depts/Cartographic/map/profile/easteuro.pdf (accessed June 19, 2013).

3. Mary Schoeser, *World Textiles: A Concise History* (London: Thames & Hudson, 2003), p. 7.

4. *Ibid.*

5. *Ibid.*

6. *Ibid.*

7. *Ibid.,* p. 78.

8. Marilyn Stokstad, ed., *Art History* (New York: Prentice Hall and Harry N. Abrams, 1995), p. 7.

9. *Ibid.*

10. Schoeser, p. 87.

11. Jennifer Harris, ed., *Textiles: 5,000 Years* (New York: Harry N. Abrams, 1993), p. 10. Among the wars that led to the exchange of cultural ideas were the Crusades, military expeditions made by western European Christians in the 11th to 13th centuries to recover the Holy Land from the Saracen Muslims. One of the minor goals of the Crusades was the increase of trade between East and West. Many people, from nobles to peasants, were involved as the Pope promised the journey would count as full penance for the traveler's sins.

12. Museum of London, http://collections.museumoflondon.orguk/online/BrowseCollection.aspx (accessed July 1, 2013).

13. Lola Erlich, ed., *Vogue Knitting* (New York: Pantheon, 1989), p. 3.

14. *Ibid.,* p. 5.

15. Lela Nargi, *Knitting Around the World* (Minneapolis: Voyageur Press, 2011), p. 25.

16. *Ibid.*

17. Jennifer L. Carlson ,"Making a Monmouth Cap," www.personal.utulsa.edu/~marc-carlson/jennifer/Monmouth.html (accessed July 1, 2013). Military lists dated 1637 and 1642 called for supplying caps for soldiers and sailors. According to Anne L. Macdonald in *No Idle Hands: The Social History of American* Knitting (New York: Ballantine, 1988), p. 3, the Monmouth Caps were also worn by the colonists at the Jamestown Colony in the New World, as well as in the 1620's by the colonists in the Massachusetts Bay Colony.

18. "Primary History-World War II-The war effort," BBC online archives, www.bbc.co.uk/school/primaryhistory/world_war2/the_war_effort (accessed July 2, 2013).

19. Tina Selby, "Knitter's 5,000 hats for soldiers serving in Afghanistan, "www.bbc.co.uk/news/uk-wales-17471716?print=true (accessed July 2, 2013).

20. "Merci Train," www.mercitrain.org The website contains information concerning the current status of individual state railcars and in many cases, which local historical societies or museums have many of the items from the trains in their collections.

21. Ileana Grams-Moog, "The Knitted Gloves That Saved My Mother's Life," *Piecework* 20.1 (2012) 27.

22. Eileen Wheeler, "Delineating Women's Historical Lives through Textiles: A Latvian Knitter's Narrative of Memory," Textile Society of America Symposium Proceedings, Paper 309, September 2012.

23. "Knitting Artist Captures German Landmarks in Wool," www.dw.de/knitting-artist-captures-german-landmarks-in-wool (accessed July 1, 2013).

24. *Ibid.*

25. *Ibid.*

26. "Pink M.24 Caffee: A Tank Wrapped in Pink," www.marianneart.dk/ (accessed July 7, 2013).

27. "Teddies to help out in war zones," http://www.news.bbc.co.uk/hi/uk_news/england/wear/796.4208.stm (accessed July 7, 2013).

28. Patricia Murphy, "The Makers and Consumers of Youghal Needlepoint and Crochet Lace in the Late Nineteenth and Early Twentieth Centuries," a paper for the 2011 Undergraduate Awards (Lecturer Nomination) Competition, http://www.scribd.com/doc/104627777/The-Makers-and-Consumers-of-Youghal-Needlepoint-and-Crochet-Lace-in-the-Late-Nineteenth-and-Early-Twentieth-Centuries/ (accessed August 8, 2013).

29. Jules Kliot, Director, Lacis Museum of Lace and Textiles, Berkeley, California, Exhibit Catalogue, "Irish Cottage Lace: 150 Years of a Tradition," (April 1-July 30, 2005), www.lacemuseum.org/exhibit/IrishCrochet150Years/IrishCrochetLace.pdf (accessed August 8, 2013).

30. Paul Larmour, *The Arts and Crafts Movement in Ireland* (Belfast: Friars Bush Press, 1992), p, 11, quoted in Murphy.

31. Murphy. The rose is the symbol for England, the thistle for Scotland and the shamrock for Ireland.

32. "Irish Catholic Symbols," http://globerove.com/ireland/irish-catholic-symbols/1977 (accessed December 1, 2013). The Irish Catholic claddagh features two hands encircling a heart and stands for friendship, love and loyalty. The Celtic cross is thought to be the combination of two symbols, the Greek letters Chi-Roh associated with the name of Christ and laurel wreath, which were associated with Emperor Constantine's declaration of Christianity as the state religion of the Roman Empire.

33. Elizabeth Wayland Barber, *Women's Work: The First 20,000 Years* (New York: W.W. Norton, 1994), p. 139.

34. "Lekythos," Heilbrunn Timeline of Art, The Metropolitan Museum of Art, http://www.metmuseum.org/toah/works-of-art/31.11.10 (accessed December 1, 2013).

35. Barber, p. 18.

36. "Danish Textile Costume," http://ctr.hum.ku.dk/danish_textile_costume/textiles_in_war/ (accessed July 16, 2013).

37. "The Oseberg Finds," University of Oslo Museum of Cultural History, http://www.khm.uio.no/english/ (accessed December 1, 2013).

38. Anne Stine Ingstad, "The textiles in the Oseberg ship," http://forest.gen.nz/Medieval/articles/Osberg/textiles/TEXTILES.html (accessed November 21, 2013). Ingstad, a Norwegian archaeologist, is the co-discoverer of a Viking settlement at L'anse aux Meadows, Newfoundland, in 1960. The site has been designated as a UNESCO World Heritage site and a National Historic Site of Canada.

39. Schoeser, p. 44.

40. Barber, p. 65.

41. *Ibid.*

42. *Ibid.*

43. Additional information on the sprang technique, along with videos, can be found at www.regia.org/sprang.html (accessed on July 16, 2013). Carol James presented a paper at the Textile Society of America Biennial Symposium in September 2012 on "Recreating Military Sashes: Reviving the Sprang Technique." She has created many sprang military sashes to be worn as part of military costumes for re-enactments and events commemorating the 200th anniversary of the War of 1812. Ms. James lives in Canada.

44. Schoeser, p. 123.

45. *Ibid.*

46. Barber, p. 243.

47. Linell Smith, "Rug project gives women a connection," Baltimore Sun, http://articles.baltimoresun.com/2003-07-26/features/0307270056_cameron-rugs-kilim (accessed July 22, 2013).

48. The story in the press release is from the University of Nottingham, which has been described by *The Sunday Times University Guide 2011* as "the embodiment of the modern international university," has campuses in the United Kingdom, China and Malaysia, with 40,000 students. This article can be found at http://www.nottingham.ac.uk/news/pressreleases/2011/march/weavingpeaceinbosnia.aspx (accessed July 22, 2013).

49. Barber, p. 243.

50. The author's statement can be found on her website at www.azraaksamija.net and from a personal communication between the artist and Paula Calvin. Ms. Aksamija presented a paper at the Textile Society of America Biennial Symposium in September 2012 on "Weaving to Decontaminate History: A Response to Bosnia's Ethnic Cleansing." In this paper she discussed the "Monument in Waiting" Project. She also responded to an artist questionnaire sent to her by these authors.

51. *Ibid.*

52. Schoeser, p. 40.

53. Tacitus, *The Annals,* trans. Alfred John Church and William Jackson Brodribb, *The Great Books of the Western World,* vol. 14 (Chicago: Encyclopaedia Britannica, 2007), p. 150.

54. Barber, p. 153.

55. *Ibid.*, p. 229.

56. *Ibid.*., p. 229.

57. Helen Cowans, *A History of English Embroidery, http://historyofembroidery.blogspot.com/* (accessed September 23, 2013).

58. *Ibid.* Byrhnoth was the leader of the Anglo-Saxon forces and stood six feet tall. He is buried at Ely Cathedral. His wife was the sister of the Dowager Queen Æthelflæd of Damerham. A statue of Byrhtnoth, created by John Doubleday, stands at the end of the Maldon Promenade Walk.

59. "Millennium Embroidery," http://www.com-news.co.uk/about/Millembrod.html (accessed November 21, 2013) and Viola.bz blog, http://viola.bz.millennium-history-embroidered-in-unique-maldon-tapestry (accessed November 21, 2103).

60. Howard R. Bloch, *A Needle in the Right Hand of God* (New York: Random House, 2006), p. 106.

61. Jan Messent, *The Bayeux Tapestry Embroiderer's Story* (Turnbridge Wells, Kent: Search Press, 2010), p. 81.

62. Jennifer Harris, ed. *Textiles: 5,000 Years* (New York: Harry N. Abrams, 1993), p. 200.

63. *Ibid.*, p. 100. The discussion of the working conditions is also taken from Messent, pp. 96–97.

64. The term "embroidered text" is used by Biljana

Dojcinovic in her paper on "Embroidery-Textile and/or Textual Art," presented at the NEWW International Conferences, Belgrade, April 2011, http://www.womenwriters.nl/index.php/Embroidery_%E2%80%93_textile_and/or_textual_art (accessed March 5, 2013.)

65. *Ibid.*

66. Sarah Lawrence, designer and painter, http://www.sandralawrence.co.uk/OverlordEmbroideries/html (accessed June 24, 2012).

67. "The Overlord Embroidery" brochure published by Whitbread and Co. Ltd. by arrangement with the Trustees of the Overlord Embroidery Trust, 1978. The embroidery can be seen at the D-Day Museum in Portsmouth, England.

68. "A History of the World," BBC, http://www.bbc.co.uk/ahistoryoftheworld/objects/ZLhpliEQ7C358gryJt9Q (accessed June 25, 2012).

69. "Fabric of Survival: Embroidered panels tell story of Holocaust survival," *The North County Times*, http://www.nctimes.com/entertainment/art-and-theater/visual/fabric-of-remembrance (accessed June 6, 2012).

70. Sarah Davies, "Quilt History," quoting Averill Colby in *Quilting* (New York: Charles Scribner's Sons, 1971), http://www.quilthistory.com/quilting.html (accessed January 20, 2013).

71. *Ibid.*

72. Dirk H. Breiding, "The Function of Armor in Medieval and Renaissance Europe." http://www.metmuseum.org/toah/hd/ufarm/hd_ufarm.html (accessed August 29, 2013).

73. Kathryn Berenson, "Tales from the 'Coilte,'" *V & V Online Journal*, http://www.vam.ac.uk/journals/research-journal/issue-02/tales-from-the-coilte.html (accessed June 16, 3013).

74. *Ibid.* Tristan is the hero of the legend but fell in love with Iseult, who was meant to be the bride of King Mark, who was his uncle. This tale is part of the Arthurian cycle. According to Berenson, this tale of irresistible love constrained by knightly loyalty, and leading to doom, pervaded medieval culture.

75. "Marseille: White Corded Quilting," International Quilt Study Center & Museum, University of Nebraska–Lincoln, http://www.quiltstudy.org/exhibitions/online_exhibitions/marseille (accessed August 26, 2013).

76. *Ibid.*

77. *Ibid.*

78. The Quilt Museum, York, England, http://www.quiltmuseum.uk/collections/heritage (accessed June 24, 2012). The museum is managed by the Quilters Guild of the British Isles, an educational charity founded in 1979.

79. *Ibid.*

80. The Quilt Association, http://www.quilt.orguk/quilt-140-2004_1_B+suffolk+puffs+table+coverlet (accessed June 24, 2012).

81. The Boissevain family, http://www.boissevain/org/En/frames/bulletinen1994.html (accessed September 2, 2013) and "Nationale Feestrok," Rijksmuseum, http://api.rijksmuseum.nl/nationale-feestrok?lang=en (accessed December 5, 2013). These skirts

were seen as being so important to the war recovery that there was even a song composed in homage to the Nationale Feestrok, which began with the following, 'Weave the pattern of your life into your skirt.'

82. Elizabeth Sanderson, "My Tenko Quilt: the 78-year-old reunited with the quilt she made secretly in Japanese camp," *Mail Online*, March 20, 2010. http://www.dailymail.co.uk/femail/article-1259522/My-Tenko-Quilt-the-78-year-old-reunited-with-the-quilt (accessed September 28, 2013).

83. "History of the Changi Quilts," Australian War Memorial, http://www.awm.gov.au/encyclopedia/quilt/history (accessed June 24, 2012).

84. Magdalena Abakanowicz, http://www/abakanowicz.art.pl/about/-about.php (accessed March 12, 2013). Abakanowicz's work is found in the collection of the Metropolitan Museum of Art in New York as well as a number of important collections.

85. Rita Reif, "The Jackboot Has lifted. Now the Crowds Crush," *The New York Times*, June 3, 2001, Section 2, Arts and Leisure, p. 34.

86. Rozanne Hawksley, http://www.rozannehawksley.com (accessed June 20, 2013).

87. Mary Schoeser, "Hawksley: humiliation to new hope," in *Rozanne Hawksley* (Farnham: Lund Humphries, 2009), reviewed by Lesley Millar in *Crafts* (July/August 2009), http://www.rozannehawksley.com (accessed June 20, 2013).

88. Mary Schoeser, *Textiles, The Art of Mankind* (London: Thames & Hudson, 2012).

89. Jennifer Vickers, http://jbvickers.wordpress.com/portfolio/ (accessed September 23, 2013).

90. Shoshana Brickman, ed. *The Art Quilt Collection* (New York: Sixth & Spring Books, 2010), p. 147.

91. *Ibid.*, p. 24.

92. Anne Jackson, Curator, "The Power of Slow," American Tapestry Alliance, http://americantapestryalliance.org/exhibitions/tex_ata/the-power-of-slow/ (accessed July 25, 2013).

93. Ulrikka Mokda is quoted in a Weekly Artist Fibre Interview at the World of Threads Festival, http://www.worldofthreadsfestival.com/artist_interviews/001_ulrikka_mokdad_11.html (accessed September 11, 2013).

94. Quoted in "Kunstall Oslo Opens Hannan Ryggen Retrospective," http://museumpublicity.com/2011/03/06/kunstall-oslo-opens-hannah-ryggen-retrospective (accessed September 11, 2013).

95. "The European Textile Network," http://www.etn-net.org (accessed September 11, 2013).

Chapter Two

1. "Marsha L. MacDowell and C. Kurt Dewhurst, *To Honor and Comfort: Native Quilting Traditions* (Santa Fe: University of New Mexico Press in association with Michigan State University Museum, 1997), p. 93.

2. Laura Peers, "To Please the Spirits: Native American Clothing," lecture at Pitt Rivers Museum, http://www.prm.ox (accessed December 11, 2012).

3. Georgiana Brown Harbeson, *American Needlework* (New York: Bonanza Books, 1938), p. 98.

4. Paula Calvin and Deborah Deacon, *American Women Artists in Wartime, 1776–2010* (Jefferson, NC: McFarland, 2010), p. 20.

5. David P. Martucci, "Star Spangled Flag Makers," http://www.midcoast.com/~martucci/flags/usflgmkr.html (accessed January 3, 2013).

6. Harbeson, pp. 98–99. The flag was officially adopted by the Continental Congress on June 14, 1777.

7. Martucci.

8. "Mary Pickersgill," Maryland Women's Hall of Fame, Maryland State Archives, http://msa.maryland.gov/msa/educ/exhibits/womenshal/html/pickersgill.html (accessed January 9, 2013).

9. "Oregon's First American Flag," Oregon Historical Society, http://ohs.org/exhibits/current/oregons-first-american-flag.com (accessed November 23, 2012).

10. *Ibid.*

11. Calvin and Deacon, p. 41.

12. Sally Jenkens, "Glory, Glory," *Smithsonian* 44 (October 2013): pp. 66–69. The flag was very important to Driver, who saw it as the embodiment of America; however, his two sons, who served in the Confederate army, saw it differently. While the Smithsonian claims ownership of the original flag, there is some confusion as to which flag is the original and which is the one made during the Civil War.

13. American Unofficial Collection of World War I Photographs, 1917–1918, U.S. National Archives and Records Administration, http://research.archives.gov/description/533657 (accessed January 9, 2013).

14. Theresa Kaminski, *Prisoners in Paradise* (Lawrence: University Press of Kansas, 2000), p. 76.

15. *Ibid.,* p. 223.

16. Calvin and Deacon, p. 24.

17. Harbeson, p. 24.

18. Robert Bishop, *Quilts, Coverlets, Rugs & Samplers* (New York: Alfred A. Knopf, 1982), p. 318.

19. *Ibid.*, p. 319.

20. Mary Jane Edmonds, *Samplers & Samplermakers: An American Schoolgirl Art 1770–1850* (New York: Rizzoli and Los Angeles: Los Angeles County Museum of Art, 1991), p. 37. The discussion in this paragraph is based on Ms. Edmonds' discussion.

21. *Ibid.*

22. Ethel Stanwood Bolton and Eva Johnston Coe, *American Samplers* (New York: Dover, 1973), p. 22.

23. The image is included in Bishop, p. 338.

24. *Ibid.*, p. 339.

25. Harbeson, p. 82, quoted in Calvin and Deacon, p. 25.

26. Bolton, p. 249.

27. *Ibid.*

28. Edmonds, p. 149.

29. Calvin and Deacon, p. 94. This section was included in the authors' previous book, *American Women Artists in Wartime, 1776–2010.*

30. Susan Burrows Swan, *A Winterthur Guide to American Needlework* (New York: Crown Publishers, 1976), p. 176, quoted in Calvin and Deacon, p. 94.

31. Paula Bradsheet Richter, *Painted with Thread: The Art of American Embroidery* (Salem, MA: The Peabody Essex Museum, 2000), p. 126, quoted in Calvin and Deacon, p. 95.

32. Robert Shaw, *American Quilts: The Democratic Art 1780–2007* (New York: Sterling Publishing, 2009).

33. Calvin and Deacon, p. 23.

34. Patricia Mainardi, *Quilts: The Great American Art* (San Pedro, CA: Miles and Weir, 1978), pp. 331–334, quoted in Calvin and Deacon, p. 23.

35. Shaw, p. 20.

36. *Ibid.*, p. 90.

37. Robert Bishop, *Quilts, Coverlets, Rugs & Samplers* (New York: Alfred A. Knopf, 1982), p. 134.

38. "1846 Mary C. Nelson's 'Eagle' Quilt," National Museum of American History, http://americanhistory.si.edu/collections/search/object/nmah_556430 (accessed January 14, 2013).

39. Quilt, *Unequal Nine Patch,* c. 1840, maker unknown, La Connor Quilt and Textile Museum, La Conner, Washington. Information courtesy of the museum.

40. Shaw, p. 80.

41. "1861 Mary Rockford Teter Civil War Quilt," National Museum of American History, http://americanhistory.si.edu/collections/search/object/nmah_556328 (accessed January 14, 2013).

42. "1863 Susannah Pullen's Civil War Quilt," National Museum of American History, http://americanhistory.si.edu/collections/search/object/nmah_556337 (accessed January 14, 2013).

43. *Ibid.*

44. To coordinate relief efforts for Union soldiers, nearly four thousand leaders gathered in New York on April 21, 1861, to establish the United States Sanitary Commission, a precursor to the American Red Cross. It served and an umbrella agency for all private donations and made sure that supplies were sent where they were most needed. Women responded in the thousands and sent bedding such as quilts, as well as knitted goods and other items.

45. Welthea B. Thoday's World War II Friendship Quilt, National Museum of American History, http://americanhistory.si.edu/collections/search/object/nmah_556260 (accessed January 14, 2013).

46. Minia Moszenberg, *We never said goodbye, separated April 1942,* The National Holocaust Museum, http://collections.ushmm.org/search/catalog/irn521297 (accessed September 23, 2013). The quilt was donated to the museum by its creator in 2004.

47. Ann Barry, "Festival of Quilts Opens on Pier 42," *New York Times,* http://nytimes.com/1986/04/24/garden/festival-of-quilts-on-pier-92.html (accessed December 14, 2013).

48. Ruth Carol Combes, Quilt: *Liberty in America,* 1986, La Conner Quilt and Textile Museum, La Conner, Washington. Information courtesy of the museum.

49. Calvin and Deacon, p. 172.

50. Marsha L. MacDowell and C. Kurt Dewhurst, ed., *To Honor and Comfort: Native Quilting Traditions* (Albuquerque: Museum of New Mexico Press in association with Michigan State University Museum, 1997), p. ix.

51. *Ibid.*, p. 114.

52. *To Honor and Comfort: Native Quilting Tradi-*

tions, National Museum of the American Indian, http: //nmai.si.edu/sites/1/files/pdf/education/quilts.pdf (accessed January 14, 2013).

53. *Ibid.,* p. 12.

54. In *To Honor and Comfort,* Marsha MacDowell states that some quilters chose black as a symbol of grief or a troubling time, p. 31.

55. *Ibid.,* p. 180.

56. All of the quilts in this section are part of The African American Quilt Collection at the Michigan State University Great Lakes Quilt Collection. This collection grew out of an effort begun in 1985 to aggressively collect information on African American quilting history in the state. Over several years and with the active involvement of the African American community they were able to identify many quilts and quilt makers. The collection does not reflect a "typical African American" quilt type, but a diversity of styles, pattern names, techniques and uses found within the Michigan African American experience. This information may be accessed online at http://www.muse um.msu.edu/glqc/collections_special_aa/html (accessed January 22, 2013). Many of the quilt makers were from the South due to great waves of immigration, the last occurring during World War II.

57. Anne L. Macdonald, *No Idle Hands: The Social History of American Knitting* (New York: Ballantine, 1988), p. 27.

58. *Ibid.,* p. 199.

59. "World War I," The American Red Cross Museum, http://www.redcross.org/museum/tour_2/pag e_6.html (accessed February 17, 2007), quoted in Calvin and Deacon, p. 92.

60. Marlys Anderson, Caps for Soldiers, http:// www.capsforsoldiers.com (accessed July 2, 2010 and December 1, 2010) and interview by Deborah Deacon, February 9, 2010; quoted in Calvin and Deacon, p. 180.

61. CODEPINK: A Radical Act of Knitting in honor of Mother's Day, www.codepinkalert.org/ article.php?id=4795 (accessed July 7, 2013).

62. Mary Schoeser, *World Textiles: A Concise History* (London: Thames & Hudson 2003), p. 194.

63. Alyson Kuhn, "Combat Paper: 'From uniform to pulp, battlefield to workshop, warrior to artist'" *Felt & Wire,* www.feltandwire.com/2010/10/7/combat-paper-"from-uniform-to-pulp-battlefield-to-workshop-warrior-to-artist (accessed February 10, 2013). All of this discussion is from the article.

64. "Combat Paper Project," http://www.combat paper.org/about.html (accessed February 10, 2013).

65. *Ibid.*

66. Cathy Erickson, Fiber Artist, http://www. cathyerickson.net/Pages/AboutCathy.html (accessed January 30, 2013).

67. Lisa Van Doren, *Story Rugs: Tales of Freedom* (Bellingham, WA: Whatcom Museum of History & Art, 2003), p. 9. This catalogue was published in conjunction with the exhibition *Story Rugs—Tales of Freedom: The Work of Dale Gottlieb,* November 16, 2003-March 7, 2004.

68. *Ibid.,* p. 10–11.

69. Katherine Knauer, interview with the artist,

Textile Study Group of New York blog, http://tsgny blog.org/index.php/2011/09/katherine-knauer/ (accessed June 5, 2012). Additional information is taken from Knauer's website, http://katherineknauer.com/ templates/about.html (accessed February 11, 2013).

70. Penny Mateer, "Protest Series," http://www. pennymateer.com/section/191893_Protest_Series html (accessed January 30, 2013).

71. Penny Mateer blog, www.piecingthoughts together.blogspot.com (accessed January 30, 2013).

72. "West Seattle woman weaves 9/11 newspapers into art," http://www.king5.com/video/featured-videos/West-Seattle-woman-weaves-9/11-into-art. html (accessed February 13, 2013) and "911knit," http://www.kickstarter.com/projects/clairerenault/ 9-11-knit.html (accessed February 13, 2013).

Chapter Three

1. Eve Prefontaine, "The Settlement of Canada: An Overview," http://mccord-museum.qc.ca/explore. php. (accessed July 5, 2012).

2. Olive Patricia Dickason, *Canada's First Nations* (Norman: University of Oklahoma Press, 1992), p. 25.

3. *Ibid.* All of the population figures are taken from this source.

4. P. Whitney Lackenbauer, John Moses, R. Scott Sheffield and Maxime Gohier, "Aboriginal People in the Canadian Military," National Defence and the Canadian Forces, http://www.cmp-cpm.forces.gc.ca/ dhh-dhp/pub/boo-bro/abo-aut/index-eng.asp (accessed September 23, 2013).

5. Dickason, p. 25.

6. Arthur Ray, "Colonization and Conflict: New France and Its Rivals, 1600–1760," in *The Illustrated History of Canada* , ed. Craig Brown (Toronto: Key Porter Books, 2000), p. 34.

7. The aboriginal peoples of Canada are divided into twelve linguistic groups: the Inuit living in the Far north; the Beothuks in Newfoundland; the Algonquians, in the central region (Prairies, Ontario, Quebec and the Maritimes); the Iroquoians in the St. Lawrence lowlands and Great Lakes region; and the Huron and Sioux in Manitoba near Lake Winnipeg. On the West Coast, several different groups live along the Pacific Ocean.

8. Ray, p. 50. In an example of art produced for sale to other native groups, the Assiniboine and Plains Cree prized Mandan arts and traded for them, while the Mandan obtained objects from tribes living to the west and south west.

9. *Ibid.,* p. 64.

10. *Ibid.,* p. 57. Ray's chapter contains an illustration of a woman weaving, done in 1778 by John Webber, a member of Captain James Cook's crew on his exploration of the Pacific.

11. Dickason, p. 104.

12. Joan N. Vastokas, "Contemporary Aboriginal Art in Canada," *The Canadian Encyclopedia,* http:// thecanadianencyclopedia.com (accessed June 26, 2012). According to the author, native art in Canada may be divided into seven regional subdivisions: East-

ern Subarctic (eastern Canadian Shield); Western Sub-arctic (western Canadian Shield and Mackenzie River drainage area); Southern Great Lakes and Upper St. Lawrence Valley; Prairies (southern Manitoba, Saskatchewan and Alberta); Plateau (interior southern British Columbia); Northwest Coast (BC coast); and Arctic (arctic coastline and offshore islands eastward to Newfoundland).

13. This war shirt is one of several in the collection of the University of Pennsylvania Museum of Archeology and Anthropology. It can be seen on the Museum's website at http://www.penn.museum/collection/object/1664 (accessed July 8, 2012).

14. Man's Shirt and Leggings, Treasures Gallery, Canadian Museum of Civilization, http://civilization.ca/cmc/exhibitions/tresors/treasure/245eng.shtml (accessed July 10, 2012).

15. Pipe bag, Canadian Tapestry, Textile Museum of Canada, http://www.canadiantapestry.ca/en/det-T96_0181.html (accessed June 26, 2912).

16. *Ibid.*

17. Ruth B. Phillips, *Trading Identities: The Souvenir in Native North American Art from the Northeast, 1700–1900* (Seattle: University of Washington Press and Montreal and Kingston: McGill-Queen's University Press, 1998), p. 155.

18. *Ibid.*

19. *Ibid.*, p. 196.

20. This term is used by Ruth B. Phillips in *Trading Identities: The Souvenir in Native North American Art from the Northeast, 1700–1900*, on page 3. We are using it to also apply to the same type of art made in other regions of North America. According to Phillips, "similar art forms have sprung up all over the world during the past four centuries, emerging with seeming inevitability in the encounters between Western systems of aesthetics and ...those of indigenous peoples." We are interested in this art in light of its reflection of the impacts of war on Aboriginal women through design and production changes that resulted in Pre-Contact art.

21. "Aboriginal Art in Canada," *The Canadian Encyclopedia,* http://www.the canadianencyclopedia.com/nativeart. (accessed June 26, 2012).

22. Phillips, *Trading Identities,* Plate 1.

23. *Ibid.*, Plate 3.

24. Metis Pouch, Collections, Canadian Museum of Civilization, http://civilization.ca/cmc/exhibitions/tresors/treasure/247eng.shtml (accessed July 10, 2012).

25. *Ibid.*

26. Phillips, *Trading Identities,* p. 175.

27. Christopher Moore, "On the Margins of Empire, 1760–1840," in *The Illustrated History of Canada,* ed. Craig Brown (Toronto: Key Porter Books, 2000), p. 107.

28. Eve Prefontaine, *The Settlement of Canada: An Overview,* http://www.mccord-museum.qc.ca/scripts (accessed July 5, 2012).

29. *Ibid.*

30. Max Allen, "Rugs and Rug Making," *The Canadian Encyclopedia,* http://www.thecanadianencyclopedia.com (accessed July 1, 2012).

31. "Hooked Rugs," Collections, The Canadian Museum of Civilization, http://www.civilization.ca/cmc/exhibitions/arts/rugs/rugs02e.shtml (accessed July 10, 2012).

32. *Ibid.*

33. Sharyn Rohlfse Udall, *Carr, O'Keefe, Kahlo: Places of Their Own* (New Haven: Yale University Press, 2000), p. 43, Emily Carr, The Vancouver Artgallery, http://www.vanartgallery.bc.ca/collection_and_research/emily_carr.html and Emily Carr University of Art and Design, http://www.ecuad.ca/about (accessed June 24, 2012).

34. Prince Edward Island Women's Institute, http://www.gov.pe.ca/wi/index/php3?number=101833 (accessed June 24, 2012).

35. This discussion is taken from http://www.royalalbertamuseum.ca/human/wcanhist/collects/quilts.html (accessed June 24, 2012).

36. Suit Wools Canadian Red Cross Quilt, Quilt Museum and Gallery, http://www.quiltmuseum.orguk/collections/heritage/suit-wools-canadian (accessed June 24, 2012).

37. Canadian Red Cross Quilt, Collections, The Quilt Association, http://www.quilt.orguk/quilt-126-2007_4_A+Red+Cross+quilt.html (accessed June 24, 2012).

38. "Remember Local Veterans by Viewing Quilt," *Fort Frances Times Online* (November 17, 1999), http://www.fftimes.com/ (accessed June 24, 2012).

39. This quilt is in the collection of the Royal Alberta Museum and can be seen at http://www.royalalbertmuseum.ca/human/wcanhist/collects/quilts.html (accessed June 24, 2012).

40. The Canadian Comfort and Remembrance Project, http://www.ccrquilts.ca (accessed June 24, 2012).

41. Carolyn, "Almost Deleted and the History of Knitting in Canada at Least," *Letters from the Bush,* December 16, 2012, http://taleweaversramblings.blogspot.com/2012/12/almost-deleted-and-history-of-knitting.html (accessed October 7, 2013).

42. Micaela Hardy-Moffat, "Feminism and the Art of 'Craftivism': Knitting for Social Change Under the Principles of the Arts and Crafts Movement," *Concordia Undergraduate Journal of Art History* 5 (2008–2009), p. 1, http://cujah.org/past-volumes/volume-v/ (accessed July 15, 2013).

43. "Remembering: How Girl Guides Contributed to War Efforts," GirlGuidesCANBlog, comment posted November 11, 2011, http://girlguidescanblog.ca/2011/11/11/girl-guides-war-contributions (accessed November 15, 2013).

44. *Knitting Instructions for War Work,* The Canadian Red Cross Society. The 32-page booklet, which measures 3½ inches by 6⅞ inches, contains more than 30 patterns for a variety of types of clothing as well as an indication of the difficulty of each pattern.

45. *The Forgotten Knitting,* Bala's Museum, http://www.bala.net/museum/wartime-knitting.asp (accessed July 2, 2013).

46. Hardy-Moffat, p. 3.

47. "Knitting for Canada's Troops!!!," Elann Community Chat Center, http://www.elann.com/commerce.web/forums/topic150659-knitting-for-canadas-troops.aspx (accessed October 7, 2013).

48. "Knitting Project for Canadian Troops Draws

Interest," *Perth Ontario News* (September 9, 2010), http://www.communityexplore.com/perthontario/tag/knitted-hats-for-canadian-troops (accessed October 7, 2013).

49. "Boomer Caps," Boomer's Legacy Foundation. http://www.boomerslegacy.ca/boomercaps/ (accessed September 28, 2013).

50. Dickason, p. 419.

51. "Contemporary Aboriginal Art in Canada," *The Canadian Encyclopedia,* http://thecanadianencyclopedia.com/contemporarynativeart (accessed June 26, 2012).

52. Nadia Myre, About, http://nadiamyre.com/Nadia_Myre/about.html (accessed July 1, 2012).

53. Ruth Cuthand, About the Artist, htpp://www.artsask.ca/en/collections/themes/artistasactivist/ruthcuthand. (accessed July 12, 2012).

54. Frances Dorsey, in her own words, http://francesdorsey.com/statement.html (accessed October 2, 2012).

55. *Ibid.*

56. Personal communication between Frances Dorsey and Paula Calvin, October 15, 2012.

57. Barbara Heller, interview by Gareth Bate and Dawne Rudman, http://www.worldofthreadsfestival.com/artist_interviews/059_barbara_heller_12.html (accessed July 23, 2012).

58. Barbara Heller, Biography, http://barbara-heller.ca/the-artist/ (accessed July 19, 2012).

59. *Ibid.*

60. Barbara Hunt, "Mourning," http://www.barbhunt.com (accessed June 3, 2012).

61. Sylvan Barnet, *A Short Guide to Writing About Art* (New York: Longman, 2000), p. 4.

62. Michele Karch-Ackerman, *Perspectives of Innocence* exhibition, The Clay and Glass Gallery of Ontario, March 28-June 6, 2010, http://www.theclayandglass.ca/exhibitions/past-exhibitions/perspectivesofinnocence (accessed July 24, 2012).

63. "Fashionality: Dress and Identity in Contemporary Canadian Art," The McMichael Canadian Art Collection, http://www.mcmichael.com/exhibitions/fashionality/michelekarchackerman/ (accessed July 24, 2012).

64. Rochelle Rubenstein Fibre Artist Interview, The World of Threads Festival, http://www.worldofthreadsfestival.com/artist_interview/030_rochelle_rubenstein-12.html (accessed July 23, 2012).

65. Vita Plume interview with Paula Calvin, October 2012.

66. *Ibid.*

67. Barbara Todd, Art Mur, - (accessed June 19, 2012).

68. Helene Vosters, "Piece/Peace Work: Engendering 'Rationalities of Care' Through a *Thread-By-Thread* Deconstruction of Militarism," *Performance Research: A Journal of the Performing Arts* 18 (2013), http://helenevosters.com/about-unravel (accessed November 15, 2013).

69. *Ibid.*

70. Helene Vosters, "Call for Performers," September 19, 2013, http://helenevosters.com (accessed November 15, 2013).

Chapter Four

1. Janice Graf, "A Journey to a New Land," Simon Fraser University Museum of Archaeology and Ethnology, http://www.sfu.museum/journey/an-en/equipe_de_realisation-credits (accessed July 7, 2012).

2. Rebecca Stone-Miller, *To Weave for the Sun* (London: Thames & Hudson, 1992), p. 13. While Mesoamerican textiles have survived in the dry climate of coastal Peru, those produced in the more tropical climate of Mexico survived in fewer numbers.

3. Patricia R. Anawalt, "Textile Research from the Mesoamerican Perspective," in *Beyond Cloth and Cordage,* ed. Penelope Ballard Drooker and Laurie D. Webster (Salt Lake City: University of Utah Press, 2000), p. 213. In modern times, in Ecuador and parts of Northern Peru men do most of the cloth weaving on wide backstrap looms, while in central and southern Peru, Bolivia, and Chile, women weave.

4. Elizabeth H. Boone, "Introduction: Writing and Recording Knowledge," in *Writing Without Words,* ed. Elizabeth Hill Boone and Walter D. Mignolo (Durham: Duke University Press, 1994), p. 20. The Maya and Zapotec used a hieroglyphic system for written communication, where phonetic glyphs function like letters in an alphabet; other glyphs function as morphemes, the smallest semantic unit of language. Mextecs and Aztecs used semasiographic writing systems where the picture itself was the text.

5. John P. Schmal, "The Rise of the Aztec Empire," www.houstonculture.org/mexico/aztecs.html (accessed June 23, 2012).

6. Elizabeth H. Boone, *The Aztec World* (Washington, D.C.: Smithsonian Books, 1994), p. 52. Franciscan friar Bernardino de Sahagun arrived in New Spain (Mexico) in 1529 as part of a mission to convert the natives to Catholicism. An avid ethnographer and historian, he spent fifty years studying the culture and language (Nahuatl) of the Aztecs. His *Historia general de las cosas de la Nueva España* provided a comprehensive written account of Aztec culture, religion and language. J. Mooney, "Bernardino de Sahagun," in *The Catholic Encyclopedia* (New York: Robert Appleton, 1907–1912), http://www.newadvent.org/cathen/13325a.htm (accessed July 7, 2012)

7. *Ibid.,* p. 52.

8. Yona Williams, "Aztec Goddesses of Fertility: Cihuacoatl and Xochiquetzal," http://www.unexplainable.net/ancients/aztec-goddesses-of-fertility-chihuacoatl-Xochiquetzal (accessed June 27, 2012). Her twin Xochipilli is the god of art, beauty, games, dance, song and corn.

9. Anawalt, p. 213.

10. Stone-Miller, p. 168.

11. Amy Oakland Rodman, "Andean Textiles from Village and Cemetery: *Caserones* in Tarapaca Valley, Northern Chile," in *Beyond Cloth and Cordage,* ed. Penelope Ballard Drooker and Laurie D. Webster (Salt Lake City: University of Utah Press, 2000), p. 234.

12. Linda Kreft, "Art and Artifacts of the Paracas," http://www.lindakreft.com/pdf/paracas_art.pdf (accessed July 7, 2012) and "Textiles of the Paracas Culture," http://agutie.homestead.com/files/geometric_

art/paracas_fabric_textile_1.html (accessed July 7, 2012).

13. Cora E. Stafford, *Paracas Embroideries* (New York: J.J. Augustin, 1941), pp. 16–24.

14. Stone-Miller, p. 129.

15. Jane W. Rehl, "Weaving Principles for Life: Discontinuous Warp and Weft Textiles of Ancient Peru," in *Andean Textile Traditions*, ed. Margaret Young-Sanchez and Fronia W. Simpson (Denver: Denver Art Museum, 2006), p. 13.

16. Vicki Cassman, "Prehistoric Andean Ethnicity and Status: The Textile Evidence," in *Beyond Cloth and Cordage,* ed. Penelope Ballard Drooker and Laurie D. Webster (Salt Lake City: University of Utah Press, 2000), p. 255.

17. Marianne Hogue, "Cosmology in Inca Tunics and Tectonics," in *Andean Textile Traditions,* ed. Margaret Young-Sanchez and Fronia W. Simpson (Denver: Denver Art Museum, 2006), p. 116.

18. Joanne Pillsbury, "Inca Colonial Tunics: A Case Study of the Bandelier Set," in *Andean Textile Traditions,* ed. Margaret Young-Sanchez and Fronia W. Simpson (Denver: Denver Art Museum, 2006), p. 127.

19. Rodman, p. 231.

20. Hogue, pp. 113–115.

21. Pillsbury, p. 133.

22. *Ibid.,* p. 135.

23. Ann Hecht, *Guatemalan Textiles in the British Museum* (London: The British Museum Press, 2001), pp. 1–2.

24. Mari Haas, "Weaving and Life in Guatemala: Life and Weaving in Guatemala," *The NECTFL Review* 61(Fall/Winter 2007/2008), p. 166.

25. Hecht, p. 1.

26. *Ibid.,* p. 2.

27. Carol Hendrickson, *Weaving Identities: Construction of Dress and Self in a Highland Guatemala Town* (Austin: University of Texas Press, 1995), p. 6.

28. Carol Brault, "Textiles as Art Therapy: Latin American Weavings, Molas and Arpilleras," Master of Science thesis in International Studies, Latin America, Central Connecticut State University, 2010, p. vii.

29. *Ibid.,* p. 13.

30. Hendrickson, p. 152. The pressure to weave caused many women who abandoned the tradition which they considered to be backward to rationalize their decision by saying weaving was too time consuming. Many of these women took up other hobbies such as embroidery to ease their consciences.

31. Hecht, p. 4. Men weave in cotton, wool and rayon, making larger, wider bolts of cloth more quickly on their treadle looms than women can make on backstrap looms.

32. *Ibid.*

33. Ramelle Gonzales, *Threads Breaking the Silence* (Guatemala: Foundations for Education, 2005), p. 18.

34. Email from Ramelle Gonzales to Deborah Deacon dated October 26, 2012.

35. Gonzales, p. 3.

36. *Ibid.,* p. 141.

37. The United States invaded several countries in Latin America as well as providing unofficial military support to fight against a number of left-wing governments in the region. Among the best known are the 1989 invasion of Panama which ousted Manuel Noriega, who was ultimately convicted of drug trafficking, racketeering and money laundering and served a 15-year prison sentence in the U.S. The U.S. intervened in Nicaragua four times between 1850 and 1857, in Honduras five times between 1905 and 1925, in Cuba at least 3 times, Panama at least four times, and had several incursions into Mexico during the late 19th and early 20th centuries.

38. The Cuban Revolution, led by Fidel Castro against the dictator Fulgencio Batista, began in July 1953 and finally ousted Batista on January 1, 1959. During the ensuing years, Castro's government was realigned along communist lines. The Tupamaro Civil War in Uruguay, named for the last member of the Inca royal family, began with student rioting and ended in 1972 with the entry of the Army into the chaos. Their use of mass arrests and torture ended the Tupamaro uprising. The revolution in Nicaragua occurred between the Somoza government and members of the Sandanista National Liberation Front (Frente Sandanista de Liberación Nacional [FSLN]), ultimately leading to the violent ouster of Somoza in 1979. Because the ultimate goal of the revolution was anti-imperialist, classist, popular and revolutionary, as early as 1981 a counter-revolution began to form against it. The Contras were heavily backed by the CIA. In November 1990, a general election was held, spreading government control across a number of political parties.

39. Sarah McCracken, "Arpilleras: A Visual History of the Poor under Pinochet," *Prospect: Journal of International Affairs at the University of California San Diego,* http://prospectjournal.ucsd.edu/index.php/2011/08/arpilleras-a-visual-history-of-the-poor-under-pinochet.html (accessed June 18, 2012). Throughout Pinochet's reign of terror, the United States supported his efforts to "oppress communism" in the region.

40. Peter Kornbluh, *Identity, Nation, Discourse* (Lanham, MD: Scarecrow Press, 2003), pp. 2–7. In 1990, popular and international opposition to Pinochet succeeded in isolating and condemning Pinochet, forcing him from office and allowing for the reestablishment of civilian rule in Chile. Pincohet died in exile on December 19, 2006.

41. Elsa Chaney, *Supermadre: Women in Politics in Latin America* (Austin: University of Texas Press, 1979), pp. 34–35.

42. Jacqueline Adams, "Art in Social Movements: Shantytown Women's Protest in Pinochet's Chile," *Sociological Forum* 17 (March 2002): pp. 30–31. Despite church protection, the workshops did experience difficulties. They were seen as subversive and were subjected to bad press, the women harassed as they left the churches.

43. Eliana Moya-Raggio, "Arpilleras: Chilean Culture of Resistance," *Feminist Studies* 10 (Summer 1984), p. 280. The term *arpillera*, which means burlap, comes from the fact that burlap was used as the backing material for these textiles.

44. Sarah McCracken, "Arpilleras: A Visual History of the Poor Under Pinochet." *Prospect: Journal of International Affairs at University of California San*

Diego, p. 3, http://prospectjournal.ucsd.edu/index.php/2011/08/arpilleras-a-visual-history-of-the-poor-under-pinochet.html (accessed June 18, 2012). In 1967, Leonora Soberena de Vera organized the women of Isla Negra to sell their brightly colored *arpilleras* in Santiago. At that same time, Parra introduced new themes to the tradition, depicting people and human experiences to her arpilleras. She and Chilean poet Pable Neruda promoted *arpilleras* as important conveyers of Chilean history and folklore.

45. Roberta Bacic, "Readings in Nonviolence," blog entry posted September 2009, http://www.innalenonviolence.org/readings/2009_09_.shtml (accessed June 18, 2012).

46. Manual Paivia and Maria Hernandez, *Arpilleras* (Chile, 1983), pp. 28–30.

47. Adams, p. 34.

48. Marjorie Agosin, *Tapestries of Hope, Threads of Love* (Lanham, MD: Rowman & Littlefield, Inc., 2008), p. 58. *Arpilleras* are anonymous creations. Some contain the embroidered initials of their creator, while others contain handwritten messages tucked into a pocket on the pieces's reverse, but almost none are signed.

49. Adams, p. 42.

50. Agosin, "Arpilleras of Chile" *Heresies* 6 (1987), p. 33. The *arpilleras* could be purchased directly from the Vicariate of Solidarity for $26 in 1986.

51. McCracken, pp. 13 and 73. The gallery of Paulina Waugh, an early supporter of the arpillerista movement, was destroyed by "unknown" persons. No one was ever charged with the crime.

52. Kornbluh, p. 9. In 1980, an *arpillera* calendar was sold n the United States. Amnesty International published a series of greeting cards featuring images of *arpilleras*. Senator Christopher Dodd, D-CT, Chairman of the Senate Foreign Relations Subcommittee on Western Hemisphere Affairs and the Peace Corps, commissioned an *arpillera* from the Vicariate of Solidarity. The twelve sections of the 64inch by 80 inch *arpillera* contain depictions of protests against the Pinochet regime, people voting, and scenes of the normal activities of daily life, a representation of the creators' hopes and dreams for the future. Ruth Robinson, "Subtle Protests You Can Hang on the Wall," *New York Times* (24 August 1989), www.newyorktimes.com/1989/08/24/garden/subtle-protests-you-can-hang-on-the-wall.html (accessed June 15, 2012).

53. Agosin, *Tapestries of Hope*, p. 45.

54. Bocic, p. 7. The name *Sendaro Luminoso* was taken from Marxism by Jose Carlos Mariategui, who founded the Peruvian Communist Party in the 1920s. The quote reads, "*El Marxismo-Leninismo abrirá el sendaro luminoso hacia la revolución*" (Marxism-Leninism will open the shining path to revolution), "Shining Path," http://www.Britannica.com (accessed July 7, 2012).

55. "Background to the Arpillera Project," http://www.family-roberts.homecall.co.uk/arpillera/background.htm (accessed July 7, 2012). The term *cuadro* means "scene" in Spanish.

56. Ariel Zeitlin Cooke, "Common Threads: The Creation of War Textiles Around the World," in *Weavings of War: Fabrics of Memory*, ed. Ariel Zeitlin Cooke and Marsha MacDowell (East Lansing: Michigan State University Museum, 2005), p. 20. Lopez helped the women market their works in Europe.

57. Margaret Snook, "The Story of the Textiles," *Threads of Hope*, http://www.tohtexas.org/textiles.php (accessed July 7, 2012).

58. Public Broadcasting Service, *Enemies of War*, www.pbs.org/itvs/enemiesofwar/elsalvador2.html (accessed June 11, 2012).

59. The names are Elva, Ofrelia, Sandra, Evelia, Dora, Edis, Vilma, Sonia, Ana, Julia, Lidia, Fidelina, Blanca, Morena, and Florinda.

60. Agosin, *Threads of Hope*, p. 15.

61. Carmen Benavente, *Embroiderers of Ninhue* (Lubbock: Texas Tech University Press, 2010), pp. 6–8. Benavente's family was the subject of numerous death threats and violence during the political upheaval in the region; however, many of the tensions were eased as the result of her needlework workshop.

62. Mildred Graves Ryan, *The Complete Encyclopedia of Stitchery* (Garden City, NY: Doubleday, 1979), p. 334.

63. Benavente, p. 115.

64. "Juan Peron," http://www.britannica.com/EBchecked/topic/452378/Juan-Peron (accessed July 7, 2012). Perón (1895–1974) began his career as an army officer, joining the United Officers Group (*Grupo de Oficiales Unidos*), a military group that engineered the coup that overthrew the civilian government in 1943. Perón held a series of positions within the government of President General Edelmiro J. Farrell, building his popularity and authority in the army. In 1946 he was elected president, following a campaign marked by repression of the liberal opposition. Under Perón's election, he set about modernizing the country, aimed at providing greater social and economic benefits for members of the working class, aided by his wife, the popular actress Eva Durate (Evita). He restricted and eliminated many constitutional liberties, his policies enforced by the military. After being popularly re-elected President in 1951, he was overflown in 1955 by a military junta inspired by growing popular discontent with inflation, corruption, and oppression. Perón lived in exile in Madrid, returning to Argentina in 1973 after the Peronista party won a majority in the legislature. In a special election in October of that year, he was elected president, and his wife became vice president, despite opposition from numerous groups.

65. G. Honor Fagan, "Women, War and Peace: Engendering Conflict in Poststructuralist Perspective," in *Postmodern Insurgency: Political Identity, Conflict and Conflict Resolution*, ed. Ronaldo Munck and Purnaka L. de Silva (New York: Macmillan, 2000), pp. 10–13.

66. Sharon M. Scott, "*Muñecas y Mascaras: Dolls of the Zapatista Rebellion*," www.zapatistadolls.com (accessed June 18, 2012).

67. *Ibid.*, pp. 1–2.

68. Teena Jennings-Rentenaar, *Kuna Mola Blouses: An Example of the Perpetuation of an Art/Craft Form in a Small Scale Society*, dissertation, Ohio State University, 2005, pp. 21–2.

69. James Howe, *A People Who Would Not Kneel:*

Panama, the United States and the San Blas Kuna (Washington, D.C.: Smithsonian Institute Press, 1998), p. 14.

70. Michel Perrin, *Magnificent Molas: The Art of the Kuna Indians* (Paris: Flammarion, 1999), p. 25.

71. Jennings-Rentenaar, pp. 25–26. The oldest extant molas can be found in ethnographic museum collections including those of Denison University, the Field Museum and the National Museum of Natural History. Between 1904 and 1908, Eleanor Yorke Bell sailed the San Blas islands with her husband, famed photographer William H. Bell, procuring thirty blouses which are part of the National Museum of Natural History. Bell was the first to publish photographs of the Kuna and their molas.

72. Perrin, pp. 21–22, and Adolf Nordenskiold, *An Historical and Ethnological Survey of the Cuna Indians* (Goteborg: Goteborh Sweden Etnografiska Avdelningen, 1938), p. 135. While some Kuna converted to Christianity/Catholicism as the result of the waves of missionaries in the region, most retain their native animistic beliefs.

73. Jennings-Rentenaar, p. 26.

74. Jennings-Rentenaar, an associate professor of Family and Consumer Sciences at the University of Akron, wrote her dissertation on the mola blouses in the collection of the Denison University Museum Art Museum while studying at the Ohio State University.

75. *Ibid.*, p. 61.

76. Perrin, p. 40.

77. Karin Tice, *Kuna Crafts, Gender, and the Global Economy* (Austin: University of Texas Press, 1995), p. 101. The Peace Corps initiative, *Los Porductores de Molas,* began in 1967 and was intended to generate income for the Kuna women by having them create items to be sold to tourists.

78. Perrin, p. 191.

79. Ann Parker and Avon Neal, *Molas: Folk Art of the Cuna Indians* (Barre, MA: Barre, 1977), p. 118.

80. The 29th Weapons Squadron was based at Forbes Air Force Base, Kansas, in the 1960s, flying C-130 Hercules cargo aircraft. The squadron has a long, storied history, which began as its activation as a C-47 Transport squadron during World War II. "29 Weapons Squadron (AMC) fact sheet," http://www.afhra.af.mil/factsheets/factsheet.asp?id=1019 (accessed May 22, 2012).

81. Erwin Panofsky, *Meaning in the Visual Arts* (Harmondsworth: Penguin, 1993), p. 35.

82. Rick Kearns, "Colombian indigenous still in danger of extinction," *Indian Country Today*, 3 November 2010, p. 1.

83. J. Velasquez Runk, "Wounaan and Embera Use and Management of the Fiber Palm *Astrocaryum standleyanum (Arecaceae)* for Basketry in Eastern Panama," *Economic Botany* 55 (2001), p. 74. There are approximately seven thousand Wounaan living in sixteen communities in the Darien, while the Embera are more numerous.

84. "Processing the Materials," *Wounaan and Embera baskets*, www.panart.com/bask_info.htm (accessed June 15, 2012). The scientific name for the black palm is *astrocaryum slandleyanum* and for the Panama

hat palm is *carludovica palmate.* Chunga is also used for hats, hammocks, mats and furniture.

85. Runk, p. 75.

86. *Wounaan and Embera baskets,* p. 4.

87. Runk, p. 77, and *Wounaan and Embera baskets,* p. 7.

88. "A Brief History of SIL International," www.sil.org (accessed on July 13, 2012). The principal founder of the Summer Institute of Linguistics was William Cameron Townsend (1896–1982), who began cross-cultural work with the Mayan Cakchiquel people of Guatemala in 1919. Townsend founded a language training school in 1934 to work with several ethnolinguistic groups in Mexico, eventually expanding the training to a number of groups in Latin America.

89. Margo M. Callaghan, "Wounaan Indian Baskets and Tagua Carvings of the Darien Rainforest of Panama," Michael Smith Gallery, www.michaelsmithgallery.com (accessed on June 15, 2012).

90. *Ibid.* In the early 1980s, Llori Gibson and Eleanor Gale opened the Darien Indian Museum in Gamboa. Run by the Panama Audubon Society, it featured artifacts crafted by several of the indigenous groups in Panama, including Wounaan-Embera baskets and molas. In 1994 the New World Gallery opened in Balboa, specializing in Wounaan-Embera baskets. Internet prices for the baskets vary between $50 and $500 each. Weavers at the turn of the twenty-first century earn between $15 and $500 per month for their baskets, allowing them to make a substantial contribution to their family incomes, which averages $150 a month.

91. The Puerto Rican painter Damary Burgos exhibited her work *Ligando a Patria* at the Dialogo365 Latin American Art Exhibition "Celebrating Freedom, Liberty and Independence" in the fall of 2011 in Philadelphia. The enamel and acrylic on soap scum and shower curtain painting reflects Burgos' interest in environmental, social and political issues. The painting references Puerto Rico's status as a colony of the United States, a "Latin American nation that lives in isolation from her sister countries and serves the numerous (military, tourist, economical) needs of a predominantly racist Anglo-Saxon country." "Celebrating Freedom, Liberty and Independence," http://dialogo365.files.wordpress.com/2011/10/dialogo365_final_invite.png (accessed June 28, 2012). Mexican sculptor Marta Palau's works typically reference nature in somewhat abstracted forms, however, with the beginning of the war in Iraq and Afghanistan, she created two war installations, *War Games* and *Todas las guerras,* which address the violence associated with warfare. "Voices for Marta Palau," www.martapalau.com/uploads/martapalau_fourvoices.htm (accessed June 27, 2012).

92. Olga de Amaral, who was born in Bogota, Colombia, was a leading figures in the international textile artistic community in the 1970s and played a key role in the transformation of the two dimensional textile tradition into the three dimensional sculptural format popular among modern textile artists. Argentinian textile artist Ana Mazzone's tapestries reflect the traditional geometric imagery found in Mesoamerican textiles.

93. *Delirios* was originally exhibited in "Marking Time, 1995–2005: Contemporary Art from Chile" at

the University of Texas, Austin, in 2005 and has since been accessed into the Benson Latin American Collection at the university's Blanton Museum of Art. "Josefina Fontecilla: Exploring the passage of time through brocade," www.tumblr.com/tagged/josefina_fontecilla (accessed July 20, 2012).

94. Claire Taylor, ed., *Identity, Nation, Discourse: Latin American Women Writers and Artists* (Newcastle Upon Tyne: Cambridge Scholars, 2009), p. 1.

95. "Artes de Nadia," http://artesdenydia.blogspot.com/2011/11/son-las-cosas-que-te-rodean-las-que-te.html (accessed July 5, 2012).

96. Andrea Arzaba, "Mexico: Embroidering for Peace," (entry posted August 1, 2012, on the Global Voices blog, http://globalvoicesonline.org/author/andrea-arzaba/ (accessed December 13, 2012).

97. *Ibid.*

Chapter Five

1. Sherman E. Lee, *A History of Far Eastern Art,* ed. by Naomi Noble Richard (Englewood Cliffs, NJ and New York: Prentice Hall, and Harry N. Abrams, 1993), pp. 26–33.

2. Victoria Z. Rivers, "Textiles, South Asian," in *Encyclopedia of Clothing and Fashion* (New York: Charles Scribner's & Sons, 2004, p. 309.

3. Francesca Bray, *Technology and Gender: Fabrics of Power in Late Imperial China* (Berkeley: University of California Press, 1997), p. 190. Song Yingxing was a Ming Dynasty scientist and encyclopedist who published his work in 1637. The encyclopedia covered a wide range of technical issues, including the use of various gunpowder weapons. He devoted an entire chapter to sericulture and textile production.

4. *Ibid.*, p. 180.

5. Claudia Brown, *Weaving China's Past: The Amy S. Clague Collection of Chinese Textiles* (Seattle: University of Washington Press, 2000), p. 20.

6. Bray, pp. 184–7.

7. *Ibid.*, p. 215. The tradition of peasant women growing and weaving cotton for home produced cloth continued from the Yuan Dynasty into the mid–20th century. Excess fabric was often sold to help with household expenses. Huang Daopo is a well known and popular figure in Chinese history. In 2010, a thirty-six episode series titled "A Weaver on the Horizon," loosely based on the life of Huang Daopo aired on Chinese television.

8. Mary Schoeser, *World Textiles: A Concise History* (London: Thames & Hudson, 2003), p. 64.

9. Bray, p. 191. In peasant households up until the mid–20th century, girls also produced the textiles for their trousseaux and dowries.

10. Literati were scholar-bureaucrats in imperial China whose poetry, calligraphy, and paintings were supposed primarily to reveal their cultivation and express their personal feelings rather than demonstrate professional skill. The concept of literati painters was first formulated in China in the Northern Song Dynasty and survived to the end of Qing Dynasty.

11. Melissa Brown, Laurel Bossen, Gates Hill, and Damian Satterthwaite-Phillips, "Marriage, Mobility and Footbinding in Pre–1949 Rural China: A Reconsideration of Gender, Economics, and Meaning in Social Causation," *Journal of Asian Studies* 71 (November 2012), p. 1044.

12. Michael Sullivan, *The Arts of China* (Berkeley: University of California Press, 1999), p. 234.

13. "Cut Silk," Ministry of Culture, People's Republic of China, www.chinaculture.org/gb/en_madeinchina/2005-06/10/10content_69579.htm (accessed October 28, 2012).

14. Brown, et al., p. 97.

15. The Pujiu Temple, which was originally constructed during the Tang Dynasty, is located in Shanxi Province. The original structure was destroyed over time by war and earthquakes, and rebuilt during the Ming Dynasty.

16. In addition to the depiction of military training, several figures are depicted playing polo, a favorite sport of the Qing court. The emperor and his court are shown seated on a stepped platform, overseeing events, while musicians play a long horn and kettle drum, perhaps heralding the arrival of a tributary mission.

17. *Rank and Style: Power Dressing in Imperial China,* Pacific Asia Museum online exhibition, www.pacificasiamuseum.org/rankandstyle/base.stm (accessed July 9, 2013).

18. "Chinese Rank Badges," *The Journal of Antiques and Collectibles* (January 2005), http://journalofantiques.com/2005/features/Chinese-rank-badges (accessed July 12, 2013). During the Ming Dynasty, rank badges for military members were ordered (from highest rank to lowest): first rank—lion; second rank—lion; third rank—tiger or leopard; fourth rank—tiger or leopard; fifth rank—bear; sixth rank—panther; seventh rank—panther; eighth rank—rhinoceros; ninth rank—rhinoceros. During the Qing dynasty, rank badges for military members were ordered (from highest to lowest): first rank—qilin; second rank—lion; third rank—leopard; fourth rank—tiger; fifth rank—bear; sixth rank—panther; seventh rank—rhinoceros; eighth rank—rhinoceros; ninth rank—sea horse. During the Qing dynasty, rank badges for civil officials members were ordered (from highest to lowest) : first rank –crane; second rank—golden pheasant; third rank—peacock; fourth rank—wild goose; fifth rank—silver pheasant; sixth rank—egret; seventh rank—mandarin duck; eighth rank—quail; ninth rank—paradise fly catcher.

19. Helen Benton Minnich, *Japanese Costume and the Makers of the Elegant Tradition* (Rutland, VT: Charles E. Tuttle, 1963), p. 46.

20. Shuji Tamura, *The Techniques of Japanese Embroidery* (Ida, WI: Krause, 1998), p. 10.

21. *Ibid.*, pp. 26–27.

22. Jacqueline M. Atkins, "Propaganda on the Home Fronts," in *Wearing Propaganda: Textiles on the Home Front in Japan, Britain, and the United States, 1931–1945,* ed. Jacqueline M. Atkins (New Haven: Yale University Press, 2006), p. 65.

23. Tamara K. Hareven, *The Silk Weavers of Kyoto* (Berkeley: University of California Press, 2002), p. 56.

24. Jacqueline M. Atkins, "Extravagance is the Enemy," in *Wearing Propaganda: Textiles on the Home Front in Japan, Britain, and the United States, 1931–1945*, ed. Jacqueline M. Atkins (New Haven: Yale University Press, 2006), p. 157.

25. Minnich, p. 159.

26. Kimonoboy, "Antique Japanese Textile History," http://www.kimonoboy.com (accessed December 12, 2012).

27. Minnich, p. 159.

28. Liza Crihfield Dalby, *Kimono: Fashioning Culture* (New Haven: Yale University Press, 1993), p. 71.

29. *Ibid.*, p. 31.

30. The postcard, which was printed in February, 1933, was mailed in August of 1945 to Sumatra Island, Medan City, Chiyoda Street, South 1, 8. Japan Shisso Corporation and features a 5-sen red Togo stamp. It was inspected by the Civil Censorship Detachment of the U.S. General Headquarters in Occupied Japan. Marshal-Admiral of the Navy Togo Heihachiro was a Japanese naval hero from both the Sino-Japanese and Russo-Japanese Wars. As Commander-in-Chief of the Combined Fleet of the Imperial Japanese Navy, he destroyed the Russian Baltic Fleet at the Battle of Tsushima in 1905, the first time a modern western power was defeated by an Asian power.

31. Wakakewa Midori, "War-Promoting Kimono," in *Wearing Propaganda: Textiles on the Home Front in Japan, Britain, and the United States, 1931–1941,* ed. Jacqueline M. Atkins (New Haven: Yale University Press, 2006), p. 191.

32. Atkins, *Wearing Propaganda*, p. 20.

33. Midori, p. 191. *Tenugui,* flags and *senninbari* were popular souvenirs collected by members of the Allied Forces during the occupation of Japan immediately following World War II.

34. Victoria Z. Rivers, "Textiles, South Asian," in *Encyclopedia of Clothing and Fashion* (New York: Charles Scribner's & Sons, 2004), page 308.

35. Patrick J. Finn, "Indo-Portuguese Quilting Tradition: The Cross-Cultural Context," in *Proceedings of the Fourth Biennial Symposium of the International Quilt Study Center and Museum* (Lincoln: University of Nebraska, 2009), p. 9. In 1519, Duarte Barbosa was part of the first expedition to circumnavigate the world, led by is brother-in-law Ferdinand Magellan. He died in 1521 at the feast of Rajah Humabon in Cebu, the Philippines.

36. *Ibid.*, p. 4.

37. Museu Nacional Machado, "Textiles," http://www.museumachadocastro.pt/en/GB/4%20coleccoes/textiles/ContentList.aspx (accessed March 22, 2012).

38. Rosemary Crill, "Indian Embroidery in the Victoria and Albert Museum," *Arts of Asia* 33 (March–April 2003), p. 46.

39. Anne Peranteau, "A Many Splendered Thing: Kantha Technique and Design," in *Kantha,* ed. Darielle Mason (Philadelphia: Philadelphia Museum of Art, 2009), p. 41.

40. Rivers, p. 310.

41. Darielle Mason, "Background Texture: Lives and Landscapes of Bengal's Embroidered Quilts," in *Kantha,* ed. Darielle Mason (Philadelphia: Philadelphia Museum of Art, 2009), p. 6. The term kantha means "a patched cloth made of rags."

42. Stella Kramrisch, "Kantha" *Journal of the Indian Society of Oriental Art* 7(1939) as reprinted in *Kantha,* ed. Darielle Mason (Philadelphia: Philadelphia Museum of Art, 2009) p. 158.

43. Peranteau, pp. 148–150.

44. Peka Ghosh, "From Rags to Riches: Valuing Kanthas in Bengali Households," in *Kantha*, ed. Darielle Mason (Philadelphia: Philadelphia Museum of Art, 2009), p. 40.

45. Niaz Zaman, "Women's Words/Women's Voices in the Kantha," in *Kantha*, ed. Darielle Mason (Philadelphia: Philadelphia Museum of Art, 2009), p. 130.

46. Mary Schoeser, *World Textiles: A Concise History* (London: Thames & Hudson, 2003), p. 209.

47. Yasmin Saikia, *Women, War and the Making of Bangladesh: Remembering 1971* (Durham: Duke University Press, 2001), pp. 18–19.

48. Mason, p. 18.

49. Zaman, p. 116.

50. Bianca DiBease, "Accidental Saint," *HandEye* (March 4, 2010), http://handeyemagazine.com/content/accidental-saint (accessed December 17, 2012).

51. "Threads: The Art and Life of Surayia Rahman," http://media.gfem.org/node/12456 (accessed December 17, 2012). After twenty-five years, at almost eighty, Surayia was forced to close her workshop, known as Arshi (Mirror), which had taught hundreds of girls the art of kantha embroidery, due to ill health. A documentary entitled, *Threads: The Art and Life of Surayia Rahman* is currently being undertaken.

52. There is some controversy surrounding the production of *sujuni*. The women who create them work on commission; sometimes the commissioner dictates the image to be produced, denying the women a certain amount of creativity. J. Livingstone and J. Ploof, ed., *The Object of Labor: Art, Cloth and Cultural Production* (Cambridge: MIT Press, 2007).

53. H. Leedom Lefferts, Jr., "Tai Textiles in Vietnam: Three Landscapes," *Asian Arts and Culture* 7 (May 1995), p. 316. The nations of Southeast Asia are: Myanmar (Burma), Thailand, Laos, Cambodia, Vietnam, Singapore, Malaysia, Indonesia, the Philippines, Brunai, East Malaysia, East Timor, and Christmas Island.

54. Rens Heringa and Harmen C. Veldhuisent, *Fabric of Enchantment* (New York: Weatherhill, Inc., 1996), p. 35.

55. *Ibid.,* p. 39. Another smaller surge in demand for batik occurred during World War I, when access to European trade was cut off. This increased demand shrank during the Great Depression of the 1930s.

56. Michael C. Howard, "Indonesian Textiles from Dress to Art," www.lar.ubc.ca/centres/webpage/3-howard.pdf (accessed June 12, 2012), pp. 37–42.

57. Joseph Fischer, *Story Cloths of Bali* (Berkeley: Ten Speed Press, 2004), p. xiv.

58. *Ibid.,* pp. 2–5.

59. *Ibid.,* pp. 13–15.

60. *The Mahabharta* , trans. John D. Smith (New York: Penguin, 2009).

61. Fischer, p. 7. The *Ramayana,* which is traditionally attributed to Valmiki, regarded as India's first poet, dates to the 4th or 5th century BCE and consists of 24,000 verses in seven books, known as *kandas,* and 500 *cantos* known as *sargas.* Exploring human values and the concept of dharma, it depicts the duties of social relationships, portraying familial roles such as the ideal father, ideal brother, ideal wife and the ideal king. The epic is popular in India and Nepal, as well as Java and Bali. In, Laos, Thailand and Cambodia, the stories have been adapted into the Buddhist canon, while other adaptations are popular in Mindanao (Philippines) and Burma.

62. Rebecca Winters, *Buibere: Voice of East Timorese Women,* vol.1 (Darwin NT, Australia: Night Cliff, 1999), p. i-xi.

63. Sara Niner, "Strong Cloth: East Timor's Tais," *Craft Culture,* 2 September 2003.

64. Xanana Gusmão served as president of East Timor from 2002 to 2007 and is currently serving as the country's fourth prime minister.

65. Email correspondence between Chris Lundry and Deborah Deacon, Thursday, July 11, 2013. The country's new official name is "Timor Loro Sae" in the Tetum language, which means, "Timor, Rising Sun."

66. Sylvia Fraser-Lu, *Handwoven Textiles of Southeast Asia* (New York: Oxford University Press, 1988), p. 133. One of the primary groups of "Montagnards" is the 30 or so Degar tribes in the Central Highlands who comprise more than six different ethnic groups speaking languages drawn primarily from the Malayo-Polynesian, Tai, and Mon-Khmer language families. Because the term "Montagnard" is seen as derogatory, today they are referred to as Người dân tộc thiểu số, which literally means minority people in Vietnamese.

67. *Ibid.,* p. 135.

68. Ariel Zeitlin Cooke, "Common Threads: The Creation of War Textiles Around the World," in *Weavings of War: Fabrics of Memory* ed. Ariel Zeitlin Cook and Marshal MacDowell (East Lansing: Michigan State University Museum, 2005), p. 16.

69. Suzanne L. Bessac, *Embroidered Hmong Story Cloths* (Mizzoula: University of Montana Press, 1988), p. i.

70. Philip Courtenay and Maria Wronska-Friend, "Expatriate Art of the Laotian Hmong," *Arts of Asia* 27(May-June 1997), p. 18.

71. *Ibid.,* pp. 105–106. Other fabrics and colors, including hot pink and chartreuse, have been introduced through trade.

72. Marsha MacDowell, *Stories in Thread: Hmong Pictorial Embroidery* (East Lansing: Michigan State University, 1989), p. 1.

73. Paul and Elaine Lewis, *Peoples of the Golden Triangle* (London: Thames & Hudson, 1998), p. 108.

74. Cooke, p. 16.

75. MacDowell, pp. 3–5.

76. *Ibid.,* p. 7.

77. *Ibid.,* p. 11.

78. Bessac, pp. 26–28.

79. Jean Henry, "Hmong and Pennsylvania German Textiles: Needlework Traditions in Transition in Lancaster County," *Folk Art* (Summer 1995), p. 43. Hmong textiles have continued to evolve over time. In Lancaster County, Pennsylvania, Hmong women have entered into a cooperative effort with Amish women, producing unique applique quilts that combine the traditions of both groups.

80. "Carol Cassidy and the Lao Textiles Studio," *Weaving Tradition: Carol Cassidy and Woven Silks of Laos* (San Francisco: Museum of Craft and Folk Art, 2004), p. 90. Cassidy studied weaving in Norway beginning at the age of seventeen at the Folk High School, Bergen College of Applied and Fine Arts, and the University of Helsinki and earned a BFA from the University of Michigan in 1980.

81. Nick Cumming-Bruce, "Charity weaves a new Cambodia," *New York Times,* http://www.nytimes.com/2005/05/06/world/asia/06iht-cambo.html?pagewanted=all&_r=0 (accessed April 2, 2013).

82. "Weaves of Cambodia," http://www.weavescambodia.com/ (accessed April 10, 2013).

83. Liz Jeneid, "Educational Blog: Tapestry—fiberart.blog," http://tapestry-fiberart.blogspot.com/2012/03/Australian-textile-artby-lizjeneid.html (accessed September 27, 2013).

84. Diane Rutherford, "'Our Hero We're Proud of Him': Patriotic Crochet in the First World War," http://www.awm.gov.au/blog/2011/03/04/our-hero-were-proud-of-him-patriotic-crochet-in-the-first-war.htm (accessed September 25, 2013).

85. "WWI Knitted Sock Tradition Kept Alive in Australia," Rowan, http://www.knitrowan.com/industry-news/article/wwi-knitted-socks-tradition-kept-alive-in-australia.htm (accessed September 26, 2013).

86. Neil Mitchell, "Knit for our Afghanistan Diggers," 3AW Radio, July 26, 2011. http://www.3aw.comau/blogs/neil-mitchell-blog/knit-for-our-afghanistan-diggers/201107.htm (accessed September 26, 2013).

87. "Tramway Underpants," Australian Museum of Clothing and Textiles, http://sites.google.com/site/amcatmuseum/collection-highlights (accessed September 26, 2013).

88. Aussie Hero Quilts (and laundry bags), http://aussieheroquilts.blogspot.com/2013/08/vietnam-veterans-day-and-cherry-sundaes.html (accessed September 28, 2013).

89. Sewers are reminded to pre-wash the brightly colored fabrics they are using for the laundry bags since in some cases the clothes are washed in the bag. That way, no one ends up with pink underwear.

90. Goodies that can be sent to the troops include dried fruit, tea bags, biscuits (cookies), beef jerky, gum, canned tuna, wet wipes, lip balm, sun screen, emery boards, baby powder, writing paper, game books, and black or white socks.

91. Soldier On, http://soldieron.orgau (accessed September 26, 2013).

92. Judy Newman, "Art Quilt for Soldiers," Into Craft, http://www.intocraft.comau/2013/04/art-quilt-for-soldiers (accessed September 28, 2013).

93. Lucy Carroll, "Sydney Quilt Show," Lucy Car-

roll Textiles, http://lucycarrolltextiles.com/category/soldier-on-quilt (accessed September 25, 2013).

94. "Why the poppy," BBC, http://www.bbc.co.uk/remembrance/how/poppy.shtml (accessed September 28, 2013).

95. Kerryn Pollock, "Sewing, knitting and textile crafts—Knitting, spinning and weaving," *Te Ara*—the Encyclopedia of New Zealand, updated 8-Jul-13, http://www.TeAra.govt.nz/en/sewing-knitting-and-textile-crafts/p3 (accessed September 25, 2013).

96. "Patriotic Quilt 2006/103/1, Toitu Otago Settlers Museum, http://www.nzmuseums.co.nz/account/3242/object/27642/Patriotic_Quilt (accessed September 28, 2013).

97. Elain, p. 124. "Moneymore, New Zealand Quilt," YouTube, www.youtube.com/watch?v=ejCGA EfYb7g, uploaded August 22, 2010 (accessed September 28, 2013).

Chapter Six

1. Janet Harvey, *Traditional Textiles of Central Asia* (London: Thames & Hudson, 1996), p. 113.

2. *Ibid.*, p. 46. Throughout Central Asia, both men and women knit, producing socks, sweaters and hats.

3. *Ibid.*, pp. 7–8.

4. Marie-Hélène Rutschowscaya, *Coptic Fabrics* (Paris: Éditions Adam Biro, 1990), p. 36.

5. Edward Gibbon, *The Decline and Fall of the Roman Empire,* vol. 37 (Chicago: Encyclopaedia Britannica, 2007), pp. 122–125. Zenobia has been a popular figure in artistic depictions in Syria and the west. The American sculptor Harriet Hosmer, for instance, chose Zenobia as the subject of her 1859 work *Zenobia in Chains.*

6. Cynthia Finlayson, "The Women of Palmyra—Textile Workshops and the Influence of the Silk Trade in Roman Syria," Textile Society of American Symposium Proceedings, 2002, pp. 70–73, http://digitalcommons.unl.edu/cgi/viewcontent.cgi?article+1415 (accessed December 14, 2010).

7. *Ibid.*, p. 79.

8. Nancy Arthur Hoskins, *The Coptic Tapestry Albums and the Archaeologist of Antinoé, Albert Gayet* (Seattle: University of Washington Press, 2004), pp. 24–25. The term "Copt" typically describes the Christian population of Egypt; however, in the first few centuries CE, Copts had not yet been converted to Christianity.

9. Diane Lee Carroll, *Looms and Textiles of the Copts* (Seattle: University of Washington Press, 1988), p. 101.

10. Anna Muthesius, *Studies in Byzantine and Islamic Silk Weaving* (London: The Pindar Press, 1995), p. 306. The Edict of Diocletian, or the Edict on Maximum Prices, from 301 CE, which is known from surviving fragments, was intended to bring stability to the empire's economy and in part estimated prices for goods and services. The Theodosian Code was a 5th century compilation of Roman Law, intended to streamline the body of imperial laws that had been promulgated since the reign of Emperor Constantine.

It made Christianity the official religion of the Roman Empire, outlawing all other religions.

11. *Ibid.,* p. 299.

12. *Ibid.,* p. 45. As the Byzantine Empire fell, victim of the Fourth Crusade in 1204, the Italian silk weaving industry was coming into prominence, ultimately filling the void left by the collapse of the Byzantine Empire.

13. R. B. Serjeant, *Islamic Textiles: Material for a History Up to the Mongol Conquest* (Beirut: Librairie du Leban, 1972), p. 22.

14. Schoeser, pp. 84–85.

15. *Arabian Nights,* trans. E.W. Laine (New York: 1927), p 493.

16. *The Travels of Marco Polo* (New York: The Orion Press, n.d.), pp. 36–37).

17. Serjeant, p. 71.

18. The Russian desire to acquire a warm water port led to the development of a Russian naval fleet. By 1768, the Russian Black Sea fleet, under the command of Count Alexi Orlov, began engaging the Turkish fleet. On July 5, 1770, they met in Çeşme Bay, western Anatolia. Despite the superior size and armaments of the Ottoman fleet, by the end of the battle, the Ottomans suffered their greatest naval defeat since their loss to the Spanish at the Battle of Lepanto in 1571. Their success in the Battle of Çeşme gave the Russians control of the Aegean Sea and led to increased rebellions by a number of minority groups in the Ottoman Empire, including the Armenians and Christian groups in the Balkans. Catherine the Great commissioned several monuments to commemorate the Russian fleet's victory, as well as the oil painting *The Destruction of the Turkish Fleet at the Bay of Çeşme* (1772) by Jacob Philip Hackert. The dramatic painting features several small rowboats in the foreground and three-masted ships in the mid-ground done in shades of browns, greys and beiges. The central ship is silhouetted against a brightly colored smoke and fire filled background. Catherine the Great is reported to have ordered the burning of a Russian ship so the artist could accurately depict the scene a year after the battle.

19. The Muslims rejected the Red Cross international relief agency, despite its neutrality, viewing the red cross emblem as reminiscent of the red crosses worn by Christian invaders during the Fourth Crusade. Great Britain and Austria-Hungary intervened to end the Russian territorial expansion by forcing them to sign the Treaty of Berlin and give up the newly won territory.

20. Sarah Cohan, "A Brief History of the Armenian Genocide," *Social Education* 69 (October 1, 2005), p. 383.

21. "Armenian Embroidery," *Design, Decoration and Craft at The Textile Blog,* http://thetextileblog.blogspot.com/2009/09/armenian-embroicery.html (accessed January 23, 2013). Religious embroidery, found on church vestments and décor, was created by professional embroiderers and includes religious symbols as well as florals and geometrics.

22. Worthpoint, http://www.worthpoint.com/worthopedia/kimport-greece-greek-all-cloth-30s-133803205 (accessed March 22, 2013).

23. Susan Hendrick and Vilma Matchette, *World Colors: Dolls and Dress* (Grantsville, MD: Hobby House Press, 1977), p. 87. These dolls are included in the collection of the Rosalie Whyel Museum of Doll Art, located in Bellevue, Washington. Established in 1992, the museum housed more than 3000 dolls and toys in its collection. It closed in March 2012, but still maintains a website (http://www.dollart.com/).

24. Irina Bogoslovskaya and Larissa Levteeva, *Skullcaps of Uzbekistan 19th–20th Centuries* (Tashkent, 2006), p. 21.

25. Harvey, p. 119.

26. Bogoslovskaya and Levteeva, p. 38.

27. *Ibid.*, pp. 55–58.

28. Irina Bogoslovskaya, "The Soviet 'Invasion' of Central Asian Applied Arts: How Artisans Incorporated Communist Political Messages and Symbols," presentation at *Textiles and Politics,* 13th Biennial Symposium of the Textile Society of America, September 19–22, 2012.

29. In Turkestan, Muslim men produce traditional woven textiles such as these ikat fabrics, not women.

30. Bogoslovskaya, "The Soviet 'Invasion' of Central Asian Applied Arts." The red star is seen as representing the five fingers of a worker's hand or the five social groups expected to lead Russia under communism: youth, the military, the industrial laborers, agricultural workers (peasants) and the intelligentsia. In non-communist countries, it is often seen as a symbol of totalitarian ideology.

31. Abdul Hakeen, "Turkmen Carpets," http://www.turkmencarpets.com (accessed July 1, 2013).

32. "Kyrgyzstan," Central Intelligence Agency, *The World Factbook,* https://www.cia.gov/library/publications/the-world-factbook/geos/kg.html (accessed January 15, 2013).

33. Bunn, p. 1.

34. Shelagh Weir, *Embroidery from Palestine* (Seattle: University of Washington Press, 2006), pp. 8–11.

35. *Ibid.*, p. 16.

36. "Embroidered Souvenir of Palestine 1941: Corporal A. C. Carter, 2/3 Australian Field Workshop," mthml:file://C:\Users\Deb\Downloads\Embroidered_Souvenir_of_Palestine_1941_1941_Corps (accessed October 17, 2012).

37. *Ibid.*

38. Jeni Allenby,"Symbolic Defiance: Questions of Nationalism and Tradition in Middle Eastern Textiles," presentation at *Textiles and Politics,* 13th Biennial Symposium of the Textile Society of America, September 19–22, 2012, p. 169.

39. Leila el Khalidi, "Refugee Camp Embroidery Projects," http://palestinecostumearchive.com/refugee_camps.htm (accessed March 22, 2013).

40. *Ibid.,* p. 4, "Refugee camp embroidery projects," http://palestiniancostumearchive.com (accessed March 22, 2013).

41. *Ibid.*, pp. 4–5.

42. "ANAT Design," The ANAT Workshop, http://www.anat-sy.org/anatdesign.php (accessed March 12, 2013).

43. el Khalidi, pp. 11–15.

44. Allenby, p. 172.

45. "Portraits without Names," Palestinian Costume Archive exhibitions, http://palestiniancostumearchive.com (accessed October 23, 2012). Edward Said (1935–2003) was a Palestinian Arab born in Jerusalem but is best known as a professor of English and Comparative Literature at Columbia University. He was a founding figure of Post-colonial theory. His best known book, *Orientalism,* provided an analysis of the cultural representations that are the basis of Western ideas about Eastern cultures, which he saw as being rooted in western imperialist practices.

46. Palestinian Costume Archive. The Al Aqsa Intifada was the second Palestinian uprising again the Israelis. It began in September 2000 and ended in 2005. During the intifada, approximately 3000 Palestinians and 1000 Israelis died, most of whom were not directly tied to the violence.

47. Mary Tuma, Artist Questions. Tuma's works have been published in numerous periodicals and are included in the collections of the Crocker Art Museum and Station Museum. She has shown her work in national and international exhibitions. She currently teaches at the University of North Carolina, Charlotte.

48. Mary Tuma, Artist's Notes, Palestine Archive Research Library, as quoted in Allenby, p. 171.

49. Tuma, Artist Statement from artist questionnaire.

50. Allenby, pp. 166–167.

51. Lillian S. Freehof and Bucky King, *Embroideries and Fabrics for Synagogue and Home* (New York: Hearthside Press, 1966), p. 6.

52. Job 7:6 (KJV).

53. Exodus 28:39.

54. Freehof and King, p. 19.

55. *Ibid.* The first known embroiderer was actually a man named Baruch who was sent from Jerusalem to Spain by the Roman Emperor Titus (39–81 CE) to create luxury textiles for the governor of Spain. In 1592, an Ark curtain was designed by Salomon Perlsticker of Prague, making it the oldest known signed piece of embroidery.

56. Esther 2: 7, 3. Mordecai resided in Susa, Persia. He raised his adopted daughter Esther as his own and when young virgins were sought by the king, she was selected as queen. He foiled a plot against the king, but despite his high status, when he refused to prostrate himself before Haman, a high official, Haman vowed to exterminate all of the Jews in Persia. Mordecai notified Queen Esther who convinced the King to stop the slaughter. Mordecai was given a high status at court and Haman was hanged on the gallows he had erected for Mordecai.

57. "Wall Carpets," The EWMN Center, http://www.ewmncenter.com (accessed December 11, 2012). Eshkol was also an academic, serving as professor in the Faculty of Visual and Performing Arts at Tel Aviv University and as a Fulbright fellow at the University of Illinois, Urbana-Champaign in 1968–1969. Her textiles have been exhibited at the Danish Museum of Decorative Arts, Copenhagen; the Museum of Art, Ein Harod, Israel; the Israel Museum, Jerusalem; the Los Angeles County Museum of Art; and the Jewish Museum, New York.

58. Channah Koppel, "Hats for Israeli Soldiers," www.hatsforisraelisoldiers.blogspot.com (accessed April 1, 2013).

59. Shields for Magen, p. 1.

60. Maly Cohen, "Textile Artist," http://www.britam.org/malybanners.html (accessed April 3, 2012).

61. Ilene R. Prusher, "People making a difference: Andi Arnovitz," *The Christian Science Monitor* (May 28, 2009), http://www.csmonitor.com/World/Making-a-difference/2009/0528/p.47s01-lign.html (accessed July 28, 2013).

62. "A Bundle of Letters: Art Quilts by Maya Chaimovich," https://www.spacetaker.org/culture_guide/event/bundle-letters-art-quilts-maya-chaimovich (accessed August 14, 2013).

63. "Local Visions: Landscapes of Israel—Bella Kaplan Art Quilt," http://bellakaplan.com/?page_id=244&lang+en) (accessed August 14, 2013).

64. David C. Isby, *War in a Distant Country Afghanistan: Invasion and Resistance* (New York: Sterling, 1989), p. 12. Events associated with the "Great Game" were chronicled by Rudyard Kipling in his novella *The Man Who Would Be King*, a cautionary tale of the perils of western intervention in the region.

65. Barbara Harlow and Mia Carter, *Imperialism and Orientalism: A Documentary Sourcebook* (Malden, MA: Blackwell Publishers, 1999), pp. 185–189. By 1987, the Soviets were experiencing military defeats at the hands of the *mujahideen*, the result of their acquisition of U.S. Stinger missiles from the CIA and an influx of fundamentalist fighters from across the Islamic world. By late 1988, the Afghanis had a adopted a new constitution and the Soviets began to negotiate for the withdrawl of their troops from the region, which occurred the following year.

66. Dietrich H. G. Wegner, "Pile Rugs of the Baluch and Their Neighbors," trans. Lola Froehlich, *Oriental Rug Review* 5 (July 1985), http://www.tcoletribalrugs.com/article9baluch.html (accessed July 18, 2007).

67. Ron O'Callaghan, "Afghan War Rugs: A Subgroup with Iranian Influence," http://www.rugreview.com/stuf/afgwar.html (accessed May 2, 2001).

68. Andrew Hale, "Talking 'Baluch' with Jerry Anderson," *Hali* 76 (1994), p. 16.

69. *Ibid.*, p. 15.

70. Jane Przybysz," Afghan War Rugs and the Sounds of Silence," in *Woven Witness: Afghan War Rugs* (San Jose: San Jose Museum of Quilts and Textiles, 2007), p. 6. In order to sustain such long hours, the women often use opium and other drugs to overcome the pain and fatigue that comes from sitting before the loom. In 1981, there were approximately 300,000 individuals, primarily women, engaged in rug production in the camps. By 2004, more than a million worked in the rug industry; many of these weavers were men, driven by the money to be made by rug production.

71. O'Callaghan, "Afghan War Rugs," http://www.rugreview.com/barrwar.html (accessed April 29, 1999).

72. Tim Bonyhady, "Out of Afghanistan," in *Woven Witness: Afghan War Rugs* (San Jose: San Jose Museum of Quilts and Textiles, 2007), p. 42.

73. Joyce C. Ware, "The Afghan War Rugs," *FibreArts* 17 (Summer 1990): pp. 41–42

74. Enrico Mascelloni, *War Rugs: The Nightmare of Modernism* (Milano: Skira Editore, 2009), p. 69.

75. G. Gower, "Afghan War Rugs," http://mysite.wanadoo-members.co.uk/Afghanwarrugs/page4.html (accessed July 5, 2007).

76. O'Callaghan, p. 8. The MI-8 Hip transport helicopter carried two pilots and two gunners armed with PKM 7.62 mm machine guns to protect the troops being transported.

77. Deborah Corsini,"Woven Witness: Afghan War Rugs," in *Woven Witness: Afghan War Rugs* (San Jose: San Jose Museum of Quilts and Textiles, 2007), p. 19.

78. O'Callaghan, p. 11. The blunt-ended AK-74 was the weapon of choice for Soviet paratroopers because of its more compact size.

79. Eve Ziebart, "The Weavings of War," (November 12, 1998), http://www.digizen.net/member/janus/postw.html (accessed April 29, 1999).

80. Isby, p. 8.

81. Bonyhady, p. 41. In 1988, the pivotal exhibition, "Russian-Afghan War Carpets," featured the collection of Luca Brancari. This was the first time these rugs were treated as works of contemporary art. Additional important exhibitions of war rugs included Ariel Zeitlin Cooke's traveling exhibition "Weavings of War," Deborah Deacon's "Stitches of War," and three exhibitions at the San Jose Museum of Quilts and Textiles.

82. *Ibid.*

83. J. Barry O'Connell, "Afghan War Rugs," http://www.rugreview.com/barrwar.html/, pp. 3–15 (accessed April 29, 1999).

84. Ron O'Callaghan, p. 15.

85. Joyce C. Ware, "The Afghan War Rugs." *FiberArts,* 17 (Summer 1990), p. 42. Initially the United States strongly protested the Soviet invasion, going so far as to boycott the 1980 Summer Olympics in Moscow and to send money and weapons to the Afghan resistance. While CIA and American Special Forces personnel did act as advisors to the *mujahedeen* fighters, the United States Congress did not support full American involvement in the conflict and eventually withheld support from the refugees.

86. Jaseen Dhamija, "This Space is Mine," *The Rugs of War* (exhibition catalog), Australian National University, 2003.

87. Pamela Constable, "Assignment Afghanistan," *Smithsonian* 35 (February 2005), p. 117.

88. Ware, p. 42.

89. Melanie Gadener, "Afghan Freedom Quilt: Silenced Voices of the Afghan Diaspora," in *Woven Witness: Afghan War Rugs* (San Jose: San Jose Museum of Quilts and Textiles, 2007), p. 58.

90. Przybysz, p. 5. The quilt was exhibited in the exhibition "Afghan Freedom Quilt: Silenced Voices of the Afghan Diaspora" at the San Jose Museum of Quilts and Textiles between July 17 and September 23, 2007, and was the subject of a roundtable discussion that included Arsala, several scholars, and art patrons.

91. Carol Malt, *Women's Voices in Middle East*

Museums: Case Studies in Jordan (Syracuse: Syracuse University Press, 2005), p. 27.

92. Bokja, "Our Story," http://www.bokjadesign.com/index.html (accessed April 15, 2013).

93. *Ibid.*

94. Kandahar Treasure, http://kandahartreasure.com/history.html (accessed October 23, 2012).

95. "The Post-War Iraqi Woman Artist: Fighting a New Battle," *Ethika Politika,* http://ethikapolitika.org/2012/03/14/post-war-iraqi-woman-artist (accessed April 15, 2013).

96. Khulood Da'mi, Contemporary Islamic Arab Artist, http://www.khulooddami.co.uk/gallery_textile.html (accessed November 23, 2012). Her works are included in the collection of the British Museum and the National Gallery of Jordan.

97. Shirin Neshat, quoted in Susan Tenagla, "The Power of the Veil: Shirin Neshat's Iran," *World and I* (December 2002): 96–98. The daughter of a wealthy physician, she was educated in the United States, remaining in California after the Islamic Revolution of 1979. Her photographic series *Women of Allah,* created between 1993 and 1997, examines the status of women after the Islamic Revolution of 1979 by overlaying the chadors of gun-bearing women with the works of Persian feminist poets in calligraphy to show the change in the fortunes of women under the repressive regime.

98. Sara Rahbar, artist questionnaire, April 26, 2013.

99. Sara Rahbar, Queensland Art Gallery, http://www.qagoma.qld.gov.au/exhibitions/past/2012/apt7_asia_pacific_triennial_of_contemporary_art/artists/sara_rahbar (accessed March 23, 2013). Her flags can be found in numerous collections including those of the Centre Pompidou, the Queensland Art Gallery, and the Taiwan Museum of Fine Arts.

100. Email from Sara Rahbar to Deborah Deacon of October 25, 2013.

Epilogue

1. Charles Osgood, "The Star Spangled Banner yet waves anew," *CBS Sunday Morning,* September 15, 2013, http://www.cbsnews.com/8301-3445_162-57602975/the-star-spangled-banner-yet-waves-anew (accessed September 15, 2013). Like the original, which hangs in the Museum of American History in Washington, D.C., the replica was completely assembled by hand, using at least 150,000 stitches. The volunteer quilters worked in eight hour shifts during the six weeks it took to complete the flag. The work was done at the Maryland Historical Society Museum and visitors to the museum were invited to add a stitch to the project.

2. Home of the Brave Quilt Project, http://www.homeofthebravequilts.com (accessed September 19, 2013).

3. Quilts of Valor Foundation, http://www.qovf.org (accessed September 19, 2013). The Quilts of Valor Foundation has partnered with Northcott Silk, Inc. to make quality cotton fabric available to quilters for their projects. The Stonehenge Stars and Stripes Collection, designed by Linda Ludovico, includess coordinating fabrics in patriotic red, white and blue cotton, augmented with images of the American flag, American eagle and other patriotic emblems.

4. Yasmin Saikia, *Women, War and the Making of Bangladesh: Remembering 1971* (Durham: Duke University Press, 2011), p. 6.

5. *Ibid.,* p. xi.

6. Jacqueline Adams, "Art in Social Movements: Shantytown Women's Protest in Pinochet's Chile," *Sociological Forum* 17 (March 2002), p. 25.

7. Catherine and Charles Lawrence Crenshaw, *The United Nations Peace Rug* (Inman, SC: C.L. Crenshaw, 1975), p. 3. A total of 9,200,000 stitches were required to complete the rug, which was completed in 30,000 hours of stitching.

8. *Ibid.* The nations represented in the rug are: Afghanistan, Albania, Algeria, Argentina, Australia, Austria, Bahamas, Bahrain, Bangladesh, Barbados, Belgium, Bhutan, Bolivia, Botswana, Brazil, Bulgaria, Burma, Burundi, Byelorussian Soviet Socialist Republic, Cambodia, Canada, Central African Republic, Chad, Chile, China, Colombia, Congo, Costa Rica, Cuba, Cyprus, Czechoslovakia, Dahomey, Democratic Yemen, Denmark, Dominican Republic, Ecuador, Egypt, El Salvador, Equatorial Guinea, Ethiopia, Fiji, Finland, France, Gabon, Gambia, German Democratic Republic, Federal Republic of Germany, Ghana, Greece, Grenada, Guatemala, Guinea, Guinea-Bissau, Guyana, Haiti, Honduras, Hungary, Iceland, India, Indonesia, Iran, Iraq, Ireland, Israel, Italy, Ivory Coast, Jamaica, Japan, Jordan, Kenya, Kuwait, Laos, Lebanon, Lesotho, Liberia, Libyan Arab Republic, Luxembourg, Madagascar, Malawi, Malaysia, Maldives, Mali, Malta, Mauretania, Mauritius, Mexico, Mongolia, Morocco, Nepal, Netherlands, New Zealand, Nicaragua, Niger, Nigeria, Norway, Oman, Pakistan, Panama, Paraguay, Peru, Philippines, Poland, Portugal, Qatar, Romania, Rwanda, Saudi Arabia, Senegal, Sierra Leone, Singapore, Somalia, South Africa, Spain, Sri Lanka, Sudan, Swaziland, Thailand, Togo, Trinidad and Tobago, Tunisia, Turkey, Uganda, Ukrainian Soviet Socialist Republic, Union of Soviet Socialist Republic, United Arab Emirates, United Kingdom of Great Britain and Northern Ireland, United Republic of Cameroon, United Republic of Tanzania, United States of America, Upper Volta, Uruguay, Venezuela, Yemen, Yugoslavia, Zaire, and Zambia.

9. Phil Sands and Suha Maayeh, "Syria's rebel warrior queen dreams of reforming her brigade," *The National,* November 17, 2013, pp. 1–3, http://www.thenational.ae/world/middle-east (accessed December 1, 2013).

Bibliography

Interviews and Artist Questionnaires

Azra Aksamika
Marlys Anderson
Irina Bogoslovskaya
Jackie Butler-Diaz
Frances Dorsey
Ramelle Gonzales

Barbara Heller
Barb Hunt
Vita Plume
Sara Rahbar
Barbara Todd
Mary Tuma

Archives and Museums

American Museum of Natural History
American Red Cross Museum
Art Gallery of Ontario
Asian Art Museum San Francisco
Australian Museum of Clothing and Textiles
Australian War Memorial
Bala's Museum
Boomer's Legacy Foundation
British Broadcasting Corporation
British Imperial War Museum
Canadian Museum of Civilization
Canadian Red Cross
Canadian War Museum
Canadian Women Artists History Initiative
Central Intelligence Agency
Denison University Museum
Emily Carr University of Art and Design
Girl Guides Canada
International Quilt Study Center and Museum,
 University of Nebraska–Lincoln
The Lace Museum
LaConnor Quilt and Textile Museum
Lafayette College Skillman Library East Asian
 Image Collection
Los Angeles County Museum of Art
Manitoba Crafts Museum
Manitoba Museum of Man and Nature
Maryland State Archives
McCord Museum
McMichael Canadian Art Collection
Metropolitan Museum of Art

Michigan State University Great Lakes Quilt
 Collection
Museu Nacional Machado de Castro
Museum of Anthropology at the University
 of British Columbia
Museum of Civilization, Canada
Museum of London
National Gallery of Canada
National Holocaust Museum
National Museum of American History
National Museum of the American Indian
National Museum of Decorative Arts, Madrid
Oregon Historical Society
Oslo Museum of Cultural History
Pacific Asia Museum
Palestine Costume Archive
Penn Museum
Philadelphia Museum of Art
Phoenix Art Museum
Portland Art Museum
Quilt Association, United Kingdom
Quilt Museum, York, England
Royal Alberta Museum
San Jose Museum of Quilts and Textiles
Simon Fraser University Museum of Archaeology
 and Ethnology
Textile Museum of Canada
Toitu Otago Settlers Museum
United Nations
United States National Archives and Records
 Administration
University of Alberta
University of British Columbia Museum
 of Anthropology
University of Nebraska–Lincoln International
 Quilt Study Center and Museum
University of Texas Library
Vancouver Art Gallery
Victoria and Alberta Museum
Western Canadian Pictorial Index
The Winnipeg Art Gallery

Print and Electronic Sources

Abakanowicz, Magdalena. http://www.abakano wicz.art.pl/about/-about.php (accessed March 12, 2013).

Abu-Lughod, Lila. *Writing Women's World: Bedouin Stories.* Berkeley: University of California Press, 1993.

Adams, Jacqueline. "Art in Social Movements: Shantytown Women's Protest in Pinochet's Chile." *Sociological Forum* 17 (March 2002): 21–56.

Agosin, Marjorie. "Arpilleras of Chile." *Heresies* 6 (1987): 33

_____. *Scraps of Life: Chilean Arpilleras.* Trans. Cola Franzen. Toronto: Williams-Wallace, 1987.

_____. *Tapestries of Hope, Threads of Love.* Lanham, MD: Rowman and Littlefield, 2008.

Aksamija, Azra. "Weaving to Decontaminate History: A Response to Bosnia's Ethnic Cleansing." Textile Society of America Biennial Symposium. September 2012.

al Funun, Darat. Samia Zaru. http://www.daratul funun.org/main/resource/exhibit/zaru/zaru.h tml (accessed April 15, 2013).

Allen, Max. *Rugs and Rugmaking.* http://www. thecanadianencyclopedia.com (accessed July 1, 2012).

Allenby, Jeni. *Symbolic Defiance: Palestinian Costume and Embroidery Since 1948.*Netherlands: Brill Academic, 2003.

_____. "Symbolic Defiance: Questions of Nationalism and Tradition in Middle Eastern Textiles." *Textile Society of America Symposium Proceedings* (2004). http://digitalcommons.unl.edu/tsaconf /446 (accessed September 17, 2012).

American Red Cross Museum. "World War I." http://www.redcross.org/museum/tour_2/ page_6.html (accessed February 17, 2007).

"ANAT Design." The ANAT Workshop. http:// www.anat-sy.org/anatdesign.php (accessed-March 12, 2013).

Anawalt, Patricia R. "Textile Research from the Mesoamerican Perspective." In *Beyond Cloth and Cordage,* edited by Penelope Ballard Drooker and Laurie D. Webster. 205–228. Salt Lake City: University of Utah Press, 2000.

Anderson, Marlys. "Caps for Soldiers." http:// www.capsforsoldiers.com (accessed July 2, 2010).

Anderson, R., and K. Fields. *Art in Small Scale Societies: Contemporary Readings.* Englewood Cliffs, NJ: Prentice Hall, 1991.

Arabian Nights. Trans. E.W. Laine. New York: 1927.

Aristophanes. *Lysistrata.* In *The Great Books of the Western World.* Edited by Mortimer J. Adler. Chicago: Encyclopaedia Britannica, 1999.

"Armenian Embroidery." *Design, Decoration and Craft at the Textile Blog.* http://thetextileblog. blogspot.com/2009/09/armenian-embroidery. html (accessed January 23, 2013).

Arzaba, Andrea. "Mexico: Embroidering for Peace." Global Voices blog. http://globalvoicesonline. org/2012/08/01/Mexico-embroidering-for-peace (accessed October 8, 2012).

Ashis, Nandy. "History's Forgotten Doubles" in "World Historians and Their Critics" Special Issue, *History and Theory* 34 (May 1995): 44–56.

Atkins, Jacqueline M. "An Arsenal of Design: Themes, Motifs, and Metaphors in Propaganda-Textiles." In *Wearing Propaganda: Textiles on the Home Front in Japan, Britain, and the United States, 1931–1945,* edited by Jacqueline M. Atkins. 259–363. New Haven: Yale University Press, 2006.

_____. "Extravagance is the Enemy." In *Wearing Propaganda: Textiles on the Home Front in Japan, Britain, and the United States, 1931–1945,* edited by Jacqueline M. Atkins. 157–170. New Haven: Yale University Press, 2006.

_____. "Propaganda on the Home Fronts." In *Wearing Propaganda: Textiles on the Home Front in Japan, Britain, and the United States, 1931–1945,* edited by Jacqueline M. Atkins. 51–73. New Haven: Yale University Press, 2006.

_____. "Wearing Novelty." In *The Brittle Decade: Visualizing Japan in the 1930s.* Boston: Museum of Fine Arts, Boston, 2012.

_____. *Wearing Propaganda: Textiles on the Home Front in Japan, Britain and the United States 1931–1945.* New Haven: Yale University Press, 2005.

_____, and Miyuki Otaka. "Propaganda Precedents." In *Wearing Propaganda: Textiles on the Home Front in Japan, Britain, and the United States, 1931–1945,* edited by Jacqueline M. Atkins. 75–90. New Haven: Yale University Press, 2006.

Aussie Hero Quilts (and laundry bags). http://aus sieheroquilts.blogspot.com/2013/08/vietnam-veterans-day-and-cherry-sundaes.html (accessed September 28, 2013).

Bacic, Roberta. "Readings in Nonviolence." Blog entry posted September 2009. www.innatenon-violence.org/readings/2009_09.shtml (accessed June 18, 2012).

Barber, Elizabeth Wayland. *Women's Work: The First 20,000 Years.* New York: W.W. Norton, 1994.

Barnet, Sylvan. *A Short Guice to Writing About Art.* New York: Longman, 2006.

BBC. "Primary History-World War II." www.bbc. co.uk/school/primaryhistory/world_war_2/th e_war_effort (accessed July 2, 2013).

Beaudry, Mary C. *Findings: The Material Culture of Needlework and Sewing.* New Haven: Yale University Press, 2007.

Behar, Ruth. *Translated Women: Crossing the Border with Esperanza's Story.* Boston: BeaconPress, 1993.

Benavente, Carmen. *Embroiderers of Ninhue.* Lubbock: Texas Tech University Press, 2010.

Berenson, Kathryn. "Tales from the 'Coilte.'" *V&A Online Journal.* http://www.vam.ac.uk/journals /research-journal/issue-02/tales-from-the-coilte.htm (accessed June 16, 2013).

Berlyne, Daniel. *Aesthetics and Psychobiology.* New York: Appleton-Century Crofts, 1974.

Bessac, Susanne L. *Embroidered Hmong Story Cloths.* Missoula: University of Montana Press, 1988.

Bishop, Robert. *Quilts, Coverlets, Rugs and Samplers.* New York: Alfred A. Knopf, 1982.

Blier, Suzanne Preston. *The Royal Arts of Africa.* New York: Prentice Hall, 1988.

Bloch, Howard R. *A Needle in the Right Hand of God.* New York: Random House, 2006.

Blood Red and Revolution Green: Works from Iran's Underground Art Scene. http://www.spiegel.de/international/world/blood-red-and-revolution-green-works-from-Iran's-underground-art-scene (accessed April 15, 2013).

Boas, Franz. *Primitive Art.* New York: Dover, 1955.

Bodner, John E. *Remaking America: Public Memory, Commemoration and Patriotism in the Twentieth Century.* Princeton: Princeton University Press, 1992.

Bogoslovskaya, Irina. "The Soviet 'Invasion' of Central Asian Appliqued Arts: How ArtisansIncorporated Communist Political Messages and Symbols." Paper presented at 2012Textile Society of America Conference, Washington, D.C., September 21, 2012.

_____, and Larisa Levteeva. *Skullcaps of Uzbekistan: 19th– 20th Centuries.* Tashkent, 2006.

The Boissevain Family Archive. http://www.boissevain.org/EN/archievenvandefamilieboissevain.htm (accessed June 23, 2013).

Bokja. "Our Story." http://www.bokjadesign.com/index.html (accessed April 15, 2013).

"Bokja's Crafty Arab Spring-Inspired Textiles Are Oddly Compelling." In Erik Kessel's "It's nice that." http://www.itsnicethat.com/articles/bokja-and-then-there-were-none (accessed June 21, 2013).

Bolton, Ethel Stanwood, and Eva Johnston Coe. *American Samplers.* New York: Dover, 1973.

Bonnell, Victoria E. *Iconography of Power.* Berkeley: University of California Press, 1997.

Bonyhady, Tim. "Out of Afghanistan." In *Woven Witness: Afghan War Rugs.* 40–49. San Jose: San Jose Museum of Quilts and Textiles, 2007.

Book Review of *Scraps of Life: Chilean Arpilleras* by Marjorie Agostin. *Woman's Art Journal* (1987): 53–54.

Boone, Elizabeth Hill. *The Aztec World.* Washington, D.C.: Smithsonian, 1994.

_____. "Introduction: Writing and Recording Knowledge." In *Writing Without Words*, edited byElizabeth Hill Boone and Walter D. Mignolo. 3–26. Durham: Duke University Press, 1994.

_____, and Walter D. Mignolo, ed. *Writing Without Words.* Durham: Duke University Press, 1994.

Brault, Carol. *Textiles as Art Therapy: Latin American Weavings, Molas and Arpilleras.* M.S. Thesis in International Studies, Latin America. Central Connecticut State University. April 2010.

Bray, Francesca. *Technology and Gender: Fabrics of Power in Late Imperial China.* Berkeley: University of California Press, 1997.

Breiding, Dirk H. "The Function of Armor in Medieval and Renaissance Europe." http://www.metmuseum.org/toah/hd/ufarm/hd_ufarm.htm (accessed August 29, 2013).

Brickman, Shoshana, ed. *The Art Quilt Collection.* New York: Sixth & Spring, 2010.

Brown, Claudia. *Weaving China's Past: The Amy S. Clague Collection of Chinese Textiles.* Seattle: University of Washington Press, 2000.

Brown, Craig, ed. *The Illustrated History of Canada.* Toronto: Key Porter Books Ltd., 2000.

Brown, Judith K. "A Note on the Division of Labor by Sex." *American Anthropoligist* 27 (October 2009).

Brown, Melissa, Laurel Bossen, Hill Gates and Damian Satterthwaite-Phillips, "Marriage, Mobility and Footbinding in Pre–1949 Rural China: A Reconsideration of Gender, Economics, and Meaning in Social Causation." *Journal of Asian Studies* 71 (November 2012): 1035–1067.

Bruce, Richard Issaq. *The Forward Policy and Its Results.* London: Longmans, Green, 1900.

Buckingham, J.S. *Travels in Assyria, Media and Persea.* London, 1829.

Buckton, Henry. *Artists and Authors at War.* New York: Leo Cooper, 1999.

Bynam, Victoria. *Unruly Women: The Politics of Social and Sexual Control in the Old South.* Chapel Hill: University of North Carolina Press, 1992.

Callaghan, Margo M. "Wounaan Indian Baskets and Tauga Carvings of the Darien." Rainforest of Panama. Michael Smith Gallery. http://michaelsmithgallery.com/node/80 (accessed June 15, 2012).

Calvin, Paula E. and Deborah A. Deacon. *American Women Artists in Wartime, 1776–2010.* Jefferson, NC: McFarland, 2010.

The Canadian Encyclopedia. http://www.thecanadianencyclopedia.com (accessed June 23,2012).

The Canadian Museum of Civilization. http://civilization.ca/cmc/exhibitons (accessed July 23, 2012).

Carlson, Jennifer L. "Making a Monmouth Cap." http://www.personal.utulsa.edu/~marc-carlson/jennifer/Monmouth.html (accessed July 1, 2013).

"Carol Cassidy and the Lao Textiles Studio." *Weaving Tradition: Carol Cassidy and Woven Silks of Laos.* San Francisco: Museum of Craft and Folk Art, 2004.

Carr, Emily. "Biography." The Vancouver Art Gallery. http://www.vanartgallery.bc.ca (accessed June 23, 2012).

Carroll, Diane Lee. *Looms and Textiles of the Copts.* Seattle: University of Washington Press,1988.

Carroll, Lucy. "Sydney Quilt Show." Lucy Carroll Textiles. http://lucycarrolltextiles.com/category /soldier-on-quilt (accessed September 25, 2013).

Cassman, Vicki. "Prehistoric Andean Ethnicity and Status: The Textile Evidence." In *BeyondCloth and Cordage,* edited by Penelope Ballard Drooker and Laurie D. Webster. 253–266. Salt Lake City: University of Utah Press, 2000.

Central Intelligence Agency. Europe. *The World Factbook.* http://www.lib.utexas.edu/maps/eur ope/europe_ref_2010.pdf (accessed June 19, 2013).

_____. Kyrgyzstan, *The World Factbook.* https:// cia.gov/library/publications/the-world-fact book/geos/kg.html (accessed January 15, 2013).

Chaney, Elsa. *Supermadre: Women in Politics in Latin America.* Austin: University of TexasPress, 1979.

Chilean Arpilleras. http://www.art.ttu/edu/arted/ syllabi/aly/WEEK%204/3transfor.html (accessed December 15, 2001).

"Chinese Rank Badges." *The Journal of Antiques and Collectibles* (January 2005). http://journalofan tiques.com/2005/features/Chinese-rank-badges (accessed July 12, 2013).

Clark, T.J. *The Absolute Bourgeois: Artists and Politics in France 1848–51.* Berkeley: University of California Press, 1999.

CODEPINK: A Radical Act of Knitting in honor of Mother's Day. http://www.codepinkalert.org/ article.php?id=4795 (accessed July 7, 2013).

Cohan, Sarah. "A Brief History of the Armenian Genocide." *Social Education* 69 (October 1, 2005): 333–337.

Cohen, Maly. "Textile Artist." http://www.britam. org/malybanners.html (accessed April 3, 2012).

Colchester, Chloe. *Textiles Today: A Global Survey of Trends and Traditions.* New York: Thames and Hudson, 2007.

Cole, Thomas. "Raising the Bar." *Hali* 128 (2003): 1–5.

Combat Paper Project. http://www.combatpaper. org/about.html (accessed February 10, 2013).

Connors, Mary F. *Leo Textiles and Traditions.* London: Oxford University Press, 1996.

Constable, Pamela. "Assignment Afghanistan." *Smithsonian* 35 (February 2005): 108–123.

Conway, Susan. *Thailand: Weaving and the Rice Cycle.* Farnham, Surrey: College of Art and Design, 1990.

Cooke, Ariel Zeitlin. "Common Threads: The Creation of War Textiles Around the World." In *Weavings of War: Fabrics of Memory,* edited by Ariel Zeitlin Cook and MarshaMacDowell. East Lansing: Michigan State University Museum, 2005.

_____, and Marsha MacDowell, ed. *Weavings of War: Fabrics of Memory.* East Lansing: Michigan State University Museum, 2005.

Corsini, Deborah. "Patriot Art." In *Woven Witness: Afghan War Rugs* Gallery Guide. San Jose: San Jose Museum of Quilts and Textiles, 2007.

_____. "Woven Witness: Afghan War Rugs." In *Woven Witness: Afghan War Rugs.* San Jose: San Jose Museum of Quilts and Textiles, 2007.

"Costumes." Palestinian Heritage Foundation. April 10, 2012. http://www.palestineheritage.o rg/tc-Bethlehem.htm (accessed March 24, 2013).

Courtney, Philip, and Maria Wronska-Friend. "Expatriate Art of the Laotian Hmong." *Arts of Asia* 27 (May-June 1997): 104–111.

Cowans, Helen. *A History of English Embroidery.* *http://historyofembroidery.blogspot.com* (accessed September 23, 2013).

Crenshaw, Catherine, and Charles Lawrence. *The United Nations Peace Rug.* Inman, SC: C. L. Crenshaw, 1975.

Crill, Rosemary. "Indian Embroidery in the Victoria and Albert Museum." *Arts of Asia* 33 (March–April 2003): 46–55.

Crystal, Eric. "Hmong Traditions in the Crucible of Social Change." In *Michigan Hmong Arts: Textiles in Transition,* edited by C. Kurt Dewhurst and Marshal MacDowell. East Lansing: Michigan State University, 1983.

Cuthand, Ruth. About the Artist. http://www.art sask.ca/en/collections/theme/artistasactivist/ ruthcuthand (accessed July 12, 2012).

Dalby, Liza Crihfield. *Kimono: Fashioning Culture.* New Haven: Yale UniversityPress, 1993.

Da'mi, Khulood. Contemporary Islamic Arab Artist. http://www.khulooddami.co.uk/about (accessed April 15, 2013).

Davies, Sarah, "Quilt History." *Quilting* http://www. quilthistory.com/quilting.html (accessed January 20, 2013).

Dhamija, Jaseen. "This Space Is Mine." *The Rugs of War* exhibition catalog. Canberra: Australian National University, 2003.

DiBease, Bianca. "Accidental Saint." *HandEye* (March 4, 2010). http://www.khulooddame.co. com/accidental-saint (accessed December 17, 2012).

Dickason, Olive Patricia. *Canada's First Nations: A History of Founding Peoples from the Earliest Times.* Norman: University of Oklahoma Press, 1992.

Dickens, Charles. *A Tale of Two Cities.* New York: Oxford University Press, 2008.

Don, Sarah. *Traditional Samplers.* New York: Viking Penguin, 1986.

Drooker, Penelope Ballard, and Laurie D. Webster, ed. *Beyond Cloth and Cordage.* Salt LakeCity: University of Utah Press, 2000.

Eden Rugs Afghan War Collection. http://www.cloudband.com/arcade/arcade.html (accessed October 15, 2001).

Edmonds, Mary Jane. *Samplers and Samplermakers: An American Schoolgirl Art 1770–1850.* New York: Rizzoli, 1991.

Ehrlich, Lola, ed. *Vogue Knitting.* New York: Pantheon, 1989.

el Khalidi, Leila. "Refugee camp embroidery projects." http://palestinecostumearchive.com (accessed March 22, 2013).

Elain 124. "Moneymore NZ Quilt." YouTube video. Uploaded August 22, 2010. www.youtube.com/watch?v=ejCGAEfYb7g (accessed September 28, 2013).

Eliade, Mircea. *The Sacred and the Profane.* New York: Harcourt, Brace and World, 1959.

Ellis, Deborah. *Women of the Afghan War.* Westport, CT: Praeger, 2000.

"Embroidered Souvenir of Palestine 1941: Corporal A.C. Carter, 2/3 Australian Field Workshop," mhtml:file://C:\Users\Deb\Downloads\Embroidered_Souvenir_of_Palestine_1941_1941_C orps (accessed October 17, 2012).

Erickson, Cathy. http://cathyerickson.net/Pages/AboutCathy.html (accessed January 30, 2013).

European Textile Network. http://www.etn-net.org (accessed January 22, 2013).

"The Fabric of Dance at LACMA." *Jewish Journal.* http://www.jewishjournal.com/summer_sneaks/article/the-fabric-of-dance-at-lacma-2013 (accessed April 15 2013).

"Fabric of Survival: Embroidered panels tell story of Holocaust survival." *The North County Times.* http://www.nctimes.com/entertainment/art-and-theater/visual/fabric-of-remembrance (accessed June 6, 2012).

Fagan, G. Honor. "Women, War and Peace: Engendering Conflict in PoststructuralistPerspective." In *PostmodernInsurgencies: Political Violence, Identity Formation and Peacemaking in Comparative Perspective,* edited by Ronaldo Munch and Purnaka L. de Silva. New York: Palgrave Macmillan, 2000.

Finlayson, Cynthia. "The Women of Palmyra—Textile Workshops and the Influence of the Silk Trade in Roman Syria." *Textile Society of America Symposium Proceedings,* 2002, 70–80. http://digitalcommons.unl.edu/cgi/viewcontent.cgi?article=1514 (accessed December 14, 2012).

Finn, Patrick J. "Indo-Portuguese Quilting Tradition: The Cross-Cultural Context." in *Proceedings of the Fourth Biennial Symposium of the International Quilt Study Center and Museum.* Lincoln: University of Nebraska, 2009.

Fisch, Elizabeth. *Guernica by Picasso.* Lewistown: Bucknell University Press, 1983.

Fischer, Joseph. *Story Cloths of Bali.* Berkeley: Ten Speed Press, 2004.

Flensburg, Katrina. "Quilts and Quilting in the 18th Century." *Duran Textiles Newsletter.* www.durantextiles.com/newsletter/documents/news_6de_07.asp (accessed on August 4, 2012).

Fong, Mary H. "Hmong Art in the USA." In *Michigan Hmong Textiles in Transition,* edited byC. Kurt Dewhurst and Marsha MacDowell. East Lansing: Michigan State University, 1983.

Forsythe, Margaret G. "Vietnamese Embroidered Pictures." *Arts of Asia* 31 (May-June 2001):138–141.

Fort Frances Times Online.

Foucault, Michel. *The Archaeology of Knowledge and the Discourse of Language.* Translated by A.M. Sheridan Smith. New York: Dorset Press, 1972.

Franger, Gaby. *Arpilleras: Cuadros que hablan.* Lima: Movimiento Manuela Ramos, 1988.

Fraser-Lu, Sylvia. *Handwoven Textiles of Southeast Asia.* New York: Oxford University Press,1988.

Freehof, Lillian S., and Bucky King. *Embroideries and Fabrics for Synagogue and Home.* New York: Hearthside Press, 1966.

Freud, Sigmund. "Mourning and Melancholia." In *On Metapsychology.* Hammondsworth: Penguin, 1984.

Gadner, Melanie. "Afghan Freedom Quilt: Silenced Voices of the Afghan Diaspora." In *Woven Witness: Afghan War Rugs.* San Jose: San Jose Museum of Quilts and Textiles, 2007.

Garth, Sir Samuel and John Dryden. *Ovid's Metamorphoses.* Book 6. http://classics.mit.edu/Ovid/metam.6.sixth.html (accessed October 25, 2012).

Ghosh, Peka. "Embroidering Bengal: Kantha Imagery and Regional Identity." In *Kantha,* edited by Darielle Mason. 80–113. Philadelphia: Philadelphia Museum of Art, 2009.

_____. "From Rags to Riches: Valuing Kanthas in Bengali Households." In *Kantha,* edited by Darielle Mason. 30–57. Philadelphia: Philadelphia Museum of Art, 2009.

Gibbon, Edward. *The Decline and Fall of the Roman Empire,* vol. 2. In *The Great Books of the Western World,* edited by Mortimer J. Adler. Chicago: EncyclopaediaBritannica, 2007.

Gillow, John and Bryan Sentence. *World Textiles: A Visual Guide to Traditional Techniques.* London: Thames and Hudson, 1999.

Gilman, Maki Aizawa. "The Senninbari Project." www.violaflowers.com/senninbari (accessed June 22, 2012).

Goggin, Maureen Daley, and Beth Fowkes Tobin, ed. *Woven and the Material Culture of Needlework and Textiles 1750–1950.* Burlington, VT: Ashgate, 2009.

Goin, Chelsea Miller. "Textile as Metaphor: The Weavings of Olgo de Amaral." In *A Woman's Gaze: Latin American Women Artists,* edited by Marjorie Agosin. Fredonia, NY: White Pine Press, 1998.

Gonzales, Ramelle. *Threads Breaking the Silence: Stories of the Women of the CPR-Sierra from the Civil War in Guatemala.* La Antigua Guatemala: Foundations for Education, Inc., 2005.

Goodall, Hollis. *Kimono in the 20th Century.* Pasadena: Pacific Asia Museum, 2012–2013.

Goodey, Jack. *The Domestication of the Savage Mind.* Cambridge: Cambridge University Press, 1977.

Gower, G. "Afghan War Rugs." http://mysite. wanadoo-members.co.uk/Afghanwarrugs/page 4.html (accessed July 5, 2007). Pages 1–12.

Graburn, Nelson. *Ethnic and Tourist Art: Cultural Expressions from the Fourth World.* Berkeley: University of California Press, 1976.

_____. "Introduction: Arts of the Fourth World." In *Ethnics and Tourist Arts: Cultural Expressions from the Fourth World,* edited by Nelson H.H. Graburn. Berkeley: University of California Press, 1976.

Graff, Janice. "A Journey to a New Land." Simon Fraser University Museum of Archaeology and Ethnology. http://www.sfu.museum/journey/ an-en/equipe_de_realisation_credits (accessed July 7, 2012).

Grams-Moog, Ileana. "The Knitted Gloves that Saved My Mother's Life." *Piecework* 20 (2012).

Grayzel, Susan R. *Women's Identities at War.* Chapel Hill: University of North Carolina Press,1999.

Haas, Mari. "Weaving and Life in Guatemala: Life and Weaving in Guatemala." *The NECTFL Review* 61 (Fall/Winter 2007/2008): 166–186.

Hacker, Katherine. "In Search of 'Living Traditions': Gurusaday Dutt, Zainiel Abedin, and the Institutional Life of Kanthas." In *Kantha,* edited by Danielle Mason. 58–79. Philadelphia: Philadelphia Museum of Art, 2009.

Hacker, Katherine F., and Krista Jensen Turnbull. *Courtyard, Bazaar, Temple: Traditions of Textile Expression in India.* Seattle: University of Washington Press, 1982.

Hafer, Philip. *The Disasters of War by Francisco Goya.* New York: Dover, 1967.

Hakeen, Abdul. "Turkmen Carpets." http://www. turkmencarpets.com (accessed July 1, 2013).

Hale, Andrew. "Talking 'Baluch' with Jerry Anderson." *Hali* 76 (1994): 1–30.

Harbeson, Georgiana Brown. *American Needlework.* New York: Bonanza, 1938.

Hardy-Moffat, Micala. "Feminism and the Art of 'Craftivism': Knitting for Social Change Under the Principles of the Arts and Crafts Movement." *Concordia Undergraduate Journal of Art History* 5 (2008–2009).

Hareven, Tamara K. *The Silk Weavers of Kyoto.* Berkeley: University of California Press, 2002.

Harlow, Barbara, and Mia Carter. *Imperialism and Orientalism: A Documentary Sourcebook.* Malden, MA: Blackwell, 1999.

Harper, Donald J., et al. *Javanese and Sumatran Batiks from Courts and Palaces.* Koln: GalerieSmend, 2000.

Harris, Jennifer, ed. *Textiles: 5,000 Years.* New York: Harry N. Abrams, 1993.

Harvey, Janet. *Traditional Textiles of Central Asia.* London: Thames and Hudson, 1996.

Hawksley, Rozanne. http://www.rozannehawksley. com (accessed June 20, 2013).

Hecht, Ann. *Guatemalan Textiles in the British Museum.* London: The British Museum Press, 2001.

Heller, Jonathan, ed. *War and Conflict.* Washington, D.C.: National Archives and Records Administration, 1990.

Hendrick, Susan, and Vilma Matchette. *World Colors: Doll and Dress.* Grantsville, MD: Hobby House Press, 1997.

Hendrickson, Carol. *Weaving Identities: Construction of Dress and Self in a Highland Guatemala Town.* Austin: University of Texas Press, 1995.

Henry, Jean. "Hmong and Pennsylvania German Textiles: Needlework Traditions in Transition in Lancaster County." *Folk Art* (Summer 1995): 40–46.

Heringa, Rens, and Harmen C. Veldheusen. *Fabric of Enchantment: Batik from the North Coast of Java.* New York: Weatherhill, 1996.

Herodotus. *The History of Herodotus.* In *The Great Books of the Western World,* edited by Mortimer J. Adler. Chicago: Encyclopaedia Britannica, 2007.

Hiroshi, Kashiwagi. "Design and War." In *Wearing Propaganda: Textiles on the Home Front in Japan, Britain and the United States, 1931–1945,* edited by Jacqueline M. Atkins. 171–181. New Haven: Yale University Press, 2006.

"History of 'La Lucha' Zapista." www.zapatistado lls.com (accessed June 18, 2012). .

Hogue, Marianne. "Cosmology in Inca Tunics and Tectonics." In *Andean Textile Traditions,* edited by Margaret Young-Sanchez and Fronia W. Simpson. 101–119. Denver: Denver Art Museum, 2006.

Holme, Geoffrey, ed. *A Book of Old Embroidery.* London: The Studio Magazine, 1921.

Homer. *The Iliad.* In *Great Books of the Western World,* vol. 3. Edited by Mortimer Adler. Chicago: Encyclopaedia Britannica, 1990.

Horlyck, Charlotte. "Colour in Korean Textiles." *Arts of Asia* 33 (March–April 2003): 110–117.

Hoskins, Nancy Arthur. *The Coptic Tapestry Albums and the Archaeologist of Antinoé, Albert Gayet.* Seattle: University of Washington Press, 2004.

Howard, Michael C. "Indonesian Textiles from Dress to Art." www.lar.ubc.ca/centres/webpage/ 3-howard.pdf (accessed June 12, 2012).

Howe, James. *The Kuna Gathering: A Contemporary Village Politics in Panama.* Austin: University of Texas Press, 1986.

_____. *A People Who Would Not Kneel: Panama, The U.S, and the San Blas Kuna 1998.* Washington, D.C.: Smithsonian Institute Press, 1998.

Hunt, Barbara. "Mourning." http://www.barbhunt.com (accessed June 3, 2012).

Ingstad, Anne Stine. "The textiles in the Oseberg ship." http://forest.gen.nz/Medieval/articles/Oseberg/textiles/TEXTILES.html (accessed November 21, 2013).

Isby, David C. *War in a Distant Country Afghanistan: Invasion and Resistance.* New York: Sterling, 1989.

Jackson, Anne. "The Power of Slow." American Tapestry Alliance. http://americantapestryalliance.org/exhibitions/tex_ata/the-power-of-slow (accessed July 25, 2013).

James, Carol. "Re-creating Military Sashes, Reviving the Sprang Techniques." Paper presented at the 2012 Textiles Society of America Conference, Washington, D.C., September 22, 2012.

Janson, Anthony. "Art as Experience: Works by Vietnam Veterans." In *Vietnam: Reflexes and Reflections,* edited by Eve Sinaka. 199–208. New York: Harry N. Abrams, 1998.

Javanese and Sumatran Batiks from Courts and Palaces: Rudolf G. Smend Collection. Koln: Verlag der Galerie Smend, 2000.

Jeneid, Liz. "Educational Blog: Tapestry—fiberart.blog." http://tapestry-fiberart.blogspot.com/2012/03/australian-textile-artby-lizjeneid.html (accessed September 27, 2013).

Jenkins, Sally. "Glory, Glory." *Smithsonian* 44 (October 2013): 66–69.

Jennings-Rentenaar, Teena. *Kuna Mola Blouses: An Example of the Perpetuation of an Art Craft Form in a Small Scale Society.* Ph.D. Dissertation, Ohio State University, 2005.

Jonaitis, Aldona. *Art of the Northwest Coast.* Seattle: University of Washington Press, 2006.

Kahn, Eve M. "Vintage Neon Signs and the Neon Museum in Las Vegas." *New York Times.*http://www.nytimes.com/2012/10/19/arts/design/vintage-neon-signs-and-the-neon-museum.html (accessed October 19, 2012).

Kaminski, Theresa. *Prisoners in Paradise: American Women in the Wartime South Pacific.* Lawrence: University Press of Kansas, 2000.

"Kandahar Treasure." http://kandahartreasure.com/history.html (accessed October 23, 2012).

Kearns, Rich. "Columbian Indigenous Still in Danger of Extinction." *Indian Country Today* (November 3, 2010): 1–2.

Keeler, Clyde. *Cuna Indian Art.* New York: Exportion Press, 1969.

Kimonoboy. "Antique Japanese Textile History." http://www.kimonoboy.com (accessed December 12, 2012).

Kliot, Jules. *Irish Cottage Lace: 150 Years of a Tradition* exhibition catalog. Berkeley: University of California, 2005.

"Knitting Project for Canadian Troops Draws Interest." *Perth Ontario News* (September 9, 2010). http://www.communityexplore.com/perthontario/tag/knitting-for-canadian-troops.aspx (accessed October 7, 2013).

Koppel, Channah. "Hats for Israeli Soldiers." http://www.hatsforisraelisoldiers.blogspot.com (accessed April 1, 2013).

Kornbluh, Peter. *Identity, Nation, Discourse.* Lanham, MD: Scarecrow Press, 2003.

_____. "Introduction." In *Tapestries of Hope, Threads of Love,* edited by Marjorie M. Agosin. 1–12. Lanham, MD: Rowan and Littlefield, 2008.

Kramrisch, Stella. "Kantha." *Journal of the Indian Society of Oriental Art* 7 (1939) as reprinted in *Kantha,* edited by Darielle Mason. 169–183. Philadelphia: Philadelphia Museum of Art, 2009.

Kreft, Linda. "Art and Artifacts of the Paracas." http://www.lindakreft.com/pdf/paracas-art.pdf (accessed July 2, 2012).

Kuhn, Alyson. "Combat Paper: From uniform to pulp, battlefield to workshop, warrior to artist." *Felt & Wire.* http://www.feltandwire.com/2010/10/7/combat-paper-"from-uniform-to-pulp-battlefield-to-workshop-warrior-to-artist (accessed February 10, 2013).

Kuryluk, Ewa. "The Afghan War Rugs." *Arts Magazine* 63 (February 1989): 73–75.

Kwon, Yoon-Hee (Suk). *Symbolic and Decorative Motifs of Korean Silk: 1875–1975.* Seoul: IL JI SA, 1988.

Lacan, Jacques. *Ecrits: A Selection.* Translated by Alan Sheridan. New York: Norton Press, 1977.

Lackenbauer, P. Whitney, John Moses, K. Scott Sheffield and Maxine Gohier. "Aboriginal People in the Canadian Military." National Defence and the Canadian Forces. http://www.cmp.cpm.forces.gc.ca/dhh-dhp/pub/boo-bro/aboaut/index-eng.asp (accessed September 23, 2013.)

Larmour, Paul. *The Arts and Crafts Movement in Ireland.* Belfast: Friars Bush Press, 1992.

Lawrence, Sarah. "The Overlord Embroideries." http://www.sandralawrence.co.uk/Overlord Embroideries/html (accessed June 24, 2012)

Lee, Jack. "Threads of War." *Raw Vision* 35 (Summer 2001): 56–58.

Lee, Sherman E. *A History of Far Eastern Art.* Edited by Naomi Noble Richard. New York: Prentice Hall, and Harry N. Abrams, 1993.

Lefferts, H. Leedom, Jr. "Tai Textiles in Vietnam: Three Landscapes." *Asian Arts and Culture* 7 (May 1995): 63–78.

_____. "Textiles, Southeast Asia Mainland." In *Encyclopedia of Clothing and Fashion.* New York: Scribner's, 2004. pp. 308–312.

Leigh, Bobbie. "Embroidered Symbolism." *Art and Antiques* (March–April 2003): 62–64.

Lenden, Nigel. "Near and Far." In *Woven Witness: Afghan War Rugs.* San Jose: San Jose Museum of Quilts and Textiles, 2007.

Lewis, Paul and Elaine. *Peoples of the Golden Triangle.* London: Thames and Hudson, 1998.

Licht, Fred. *Goya: The Origins of the Modern Temper of Art.* New York: Harper & Row, 1983.

Lowe, Viviane. *Women in Arms: Gender and Nation in the Democratic Republic of Vietnam 1965–1975.* M.A. Thesis, Australian National University, 1996.

Lubell, Cecil, ed. *Textile Collections of the World: Volume 2 United Kingdom and Ireland.* New York: Van Nostrand Reinhold, 1976.

MacDonald, Anne L. *No Idle Hands: The Social History of American Knitting.* New York: Ballantine, 1988.

MacDowell, Marsha. *Stories in Thread: Hmong Pictorial Embroidery.* East Lansing: MichiganState University, 1989.

_____, and C. Kurt Dewhurst. *To Honor and Comfort: Native Quilting Traditions.* Santa Fe: University of New Mexico Press, 1997).

Mahabharata. Translated by John d. Smith. New York: Penguin, 2009.

Mainardi, Patricia. *Quilts: The Great American Art.* San Pedro, CA: Miles and Weir, 1978.

Mallinson, Jane, Nancy Donnelly and Ly Hang. *Hmong Batik: A Textile Technique from Laos.* Seattle: University of Washington Press, 1982.

Malt, Carol. *Women's Voices in Middle East Museums: Case Studies in Jordan.* Syracuse: Syracuse University Press, 2005.

"Marseille: White Corded Quilting." International Quilt Study Center and Museum. University of Nebraska-Lincoln. http://www.quiltstudy.org/exhibitions/online_exhibitions/marseille (accessed August 26, 2013).

Martucci, David P. "Star Spangled Flag Makers." http://www.midcoast.com/~martucci/flags/usflgmkr.html (accessed January 3, 2013).

Mascelloni, Enrico. *War Rugs: The Nightmare of Modernism.* Milano: SIRA Editore, 2009.

Mason, Darielle. "Background Texture: Lives and Landscapes of Bengal's Embroidered Quilts." In *Kantha,* edited by Darielle Mason. 1–29. Philadelphia: Philadelphia Museum of Art, 2009.

_____. "Interwoven in the Pattern of Time." In *Kantha,* edited by Darielle Mason. 158–168. Philadelphia: Philadelphia Museum of Art, 2009.

_____, ed. *Kantha.* Philadelphia: Philadelphia Museum of Art, 2009.

Massey, Mary Elizabeth. *Women in the Civil War.* Lincoln: University of Nebraska Press, 1966.

Mateer, Penny. Blog. http://www.piecingthoughts togehter.blogspot.com (accessed January 30, 2013).

_____. "Protest Series." http://www.pennymateer.com/section/191893_Protest_Series.html (accessed January 30, 2013).

Matthews, J. "Daughtering in War: Two 'Case Studies' from Mexico and Guatemala." In *Gendering War Talk,* edited by M. Cooke and A. Woollacott. Princeton: Princeton University Press, 1993.

Mayo, James M. "War Memorials as Political Memory." *Geographical Review* (1988): 62–75.

McAlpine, Alistair. "White Thai and Tales." *World of Interiors* 20 (March 2000): 220.

McClosky, Kathy. "Trading is a whiter man's game: the appropriation of women's weaving." In *Ethnographic Feminisms: Essays in Anthropology,* edited by Sally Cole and Lynne Phillips: 97–118. Ottawa: Carleton University Press, 1996.

McCracken, Sarah. "*Arpilleras:* A Visual History of the Poor Under Pinochet." *Prospect: Journal of International Affairs at University of California San Diego.* http://prospectjournal.ucsd.edu/index.php/2011/08/arpilleras-a-visual-history-of-the-poor-under-pinochet.html (accessed June 18, 2012).

"Merci Train." www.mercitrain.org (accessed Jun3 15, 2013).

Mermelst, Hannah. "Compañeras: A Quilted Conspiracy of Hope." Blog entry of 2002. www.quiltedconspiracy.com/about%20the%20quilt.htm (accessed June 15, 2012).

Messent, Jan. *The Bayeux Tapestry Embroiderer's Story.* Turnbridge Wells, Kent: Search Press, 2010.

Midori, Wakakewa. "War-Promoting Kimono." In *Wearing Propaganda: Textiles on the Home Front in Japan, Britain, and the United States, 1931–1941.* Ed. Jacqueline M. Atkins. New Haven: Yale University Press, 2006.

Ministry of Culture, People's Republic of China. "Cut Silk (kesi)." www.chinaculture.org/gb/en_madeinchina/2005-06/10/content_69579.htm (accessed October 28, 2012).

Minnich, Helen Benton. *Japanese Costume and the Makers of the Elegant Tradition.* Rutland, VT: Charles E. Tuttle Company, 1963.

Mirjam. "Exhibit: Shields for Magen." *The Electric Camel* 1 (October 2000): 1–5.

Mitchell, Neil. "Knit for our Afghanistan Diggers." 3AW Radio. July 26, 2011. http://www.3aw.com.au/blogs/neil-mitchell-blog/knit-for-our-afghanistan-diggers/201107.htm (accessed September 26, 2013).

Moeller, Ann Marie. "Tradition Embraces "The New": Depictions of Modernity on JapaneseKurume E-gasuri Futon-ji." *Textile Society of America Symposium Proceedings, Paper 40.* http://digitalcommons.unl.edu/Tsaconf/40 (accessed December 12, 2012).

Monem, Nadine, ed. *Contemporary Textiles: The Fabric of Fine Art*. London: Black Dog, 2011.

Moore, Christopher. "On the Margins of Empire, 1760–1840." In *The Illustrated History of Canada*. Edited by Craig Brown. Toronto: Key Porter, 2000.

Moya-Raggio, Eliana. "Arpilleras: Chilean Culture of Resistance." *Feminist Studies* 10 (Summer 1984): 277–290.

Mullin, Molly H. *Culture in the Marketplace: Gender, Art and Value in the American Southwest*. Durham: Duke University Press, 2001.

Munro, Thomas. *Evolution in the Arts and Other Theories of Cultural History*. Cleveland: Cleveland Museum of Art, 1963.

Murphy, Patricia. "The Makers and Consumers of Younghal Needlepoint and Crochet Lace in the Late Nineteenth and Early Twentieth Centuries." Paper for the 2011 Undergraduate Awards (Lecturer Nomination) Competition. http://www.scribd.com/doc/104627777/The-Makers-and-Consumers-of-Youghal-Needle point-and-Crochet-Lace-in-the-Late-Nine teenth-and-Early-Twentieth-Centuries (accessed August 8, 2013)

Muthesius, Anna. *Studies in Byzantine and Islamic Silk Weaving*. London: The Pindar Press, 1995.

Myre, Nadia. ART MUR. http://nadiamyre.com/nadia_myre/about.html (accessed July 1, 2012).

Nargi, Lela. *Knitting Around the World*. Minneapolis: Voyageur Press, 2011.

Neave, Marissa. "Chilean Arpilleras." www.marissaneave.com/2007/10/chilean-arpilleras (accessed June 15, 2012).

Neshat, Shirin quoted in Susan Tenaglia. "The Power of the Veil: Shirin Neshat's Iran." *World and I* (December 2002).

Newman, Judy. "Art Quilt for Soldiers." *Into Craft*. http://www.intocraft.com.au/2013/04/art-quil t-for-soldiers (accessed September 28, 2013).

Niessen, Sandra. "Threads of Tradition, Threads of Invention." In *Unpacking Culture*, edited by Ruth B. Phillips and Christopher B. Steiner. 162–177. Berkeley: University of California Press, 1999.

Niner, Sara. "Strong Cloth: East Timor's Tais." *Craft Culture* (September 2, 2003).

Nogi, Saho. "Stitches of 1000 women: Senninbari." *Needleprint* (November 25, 2009). http://needle print.blogspot.com/2009/11/stitches-of-1000-women-sennin-bari.html (accessed June 22, 2012).

Nordenskold, E. *An Historical and Ethnological Survey of the Cuna Indians*. Goteborg, Sweden: Goteborg Sweden Etnografiska Avdelningen, 1938.

O'Callaghan, Ron. "Afghan War Rugs: A Subgroup with Iranian Influence."http://www.rugr eview.com/stuf/afgwar.html (accessed May 2, 2001).

Ochi, Kahori. "Bored being in a kimono shop owner's family." http://english.kimono-sakaeya .com (accessed October 28, 2002).

O'Connell, J. Barry, Jr. "Afghan War Rugs,: http://www.rugreview.com/barrwar.html (accessed April 29, 1999).

Ofer, Dalia, and Lenore Weitzman, ed. *Women in the Holocaust*. New Haven: Yale UniversityPress, 1998.

Ong, Walter. "World as View and World as Event." *American Anthropologist* 71 (1969): 634–647.

The Oriental Rug Shop. http://www.selectoriental rugs.co.uk/tribal.php (accessed July 18,2007).

Osgood, Charles. "The Star Spangled Banner Yet Waves Anew." CBS Sunday Morning. September 15, 2013. http://www.cbsnews.com/8301-3445_162-57602975/the-star-spangled-banner-yet-waves-anew (accessed September 15, 2013).

The Overlord Embroidery. England: Capel and Company, 1978.

Ovid. *The Metamorphoses*. Translated by Allen Mandelbaum. New York: Harcourt Brace, 1995.

Paiva, Manuel, and Maria Hernandez. *Arpilleras*. Chile: 1983.

Panofsky, Erwin. *Meaning in the Visual Arts*. Harmondsworth: Penguin, 1993.

Parker, Ann, and Avon Neal. *Molas: Folk Art of the Cuna Indians*. Barre, MA: Barre Publishing, 1997.

Parra, Violeta. "Biography." www.thisischild.cl/69 28/2/violeta-parra/News.aspx (accessed June 18, 2012).

Parsons, Ann Wright. "Textiles, Southeast Asian Islands." In *Encyclopedia of Clothing and Fashion*. 308–312. New York: Charles Scribner's & Sons, 2004.

"Patriotic Quilt 2006/103/1." Toitu Otago Settlers Museum. http://www.nzmuseums.co.nz/accou nt/3242/object/27642/Patriotic_Quilt (accessed September 28, 2013).

PBS. "Enemies of War –El Salvador Civil War." www.pbs.org/itus/enemiesofwar/elsalvador2.h tml (accessed June 1, 2012).

Peers, Laura. "To Please the Spirits: Native American Clothing." http://www.prm.ox (accessed December 11, 2012).

Peranteau, Anne. "A Many Splendored Thing: Kantha Technique and Design." In *Kantha,* edited by Darielle Mason. 138–154. Philadelphia: Philadelphia Museum of Art, 2009.

Perrin, Michel. *Magnificent Molas: The Art of the Kuna Indians*. Paris: Flammarion, 1999.

Perth Ontario News.

Peterson, Spike. "The Politics of Identify and Gendered Nationalism." In *Foreign Policy Analysis: Continuity and Change in its Second Generation,* edited by Laura Neak, Patrick J. Haney, and

Jeanne Hey. Englewood Cliffs, NJ: Prentice Hall, 1995.

Pettman, J. J. *Worlding Women, a Feminist International Politics*. London: Routledge, 1996.

Phillips, Barty. *Tapestry*. London: Phaidon Press Limited, 1994.

Phillips, Ruth B. *Trading Identities: The Souvenir in Native North American Art from the Northeast, 1700–1900*. Seattle: University of Washington Press, 1998.

_____, and Christopher B. Steiner, eds. *Unpacking Culture: Art and Commodity in Colonial and Postcolonial Worlds*. Berkeley: University of California Press, 1999.

Pillsbury, Joanne. "Inca-Colonial Tunics: A Case Study of the Bandelier Set." In *Andean Textile Traditions,* edited by Margaret Young-Sanchez and Fronia W. Simpson. 123–168. Denver: Denver Art Museum, 2006.

Pollock, Griselda. *Differencing the Canon: Feminist Desire and the Writing of Art Histories*. New York: Routledge, 1999.

Pollock, Kerryn. "Sewing, knitting and textile crafts—Knitting, spinning and weaving." *Te Ara—the Encyclopedia of New Zealand*. Updated July 8, 2013. http://www.TeAra.govt.nz/en/sewing-knitting-and-textile-crafts/p3 (accessed September 25, 2013).

Polo, Marco. *The Travels of Marco Polo*. New York: The Orion Press, n.d.

"Portraits Without Names." Palestine Costume Archive exhibitions. http://palestinecostumearchive.com/exhibitions.htm (accessed October 23, 2012).

"The Post-War Iraqi Woman Artist: Fighting a New Battle." *Ethika Politika*. http://ethikapolitika.org/2012/03/14/post-war-iraqi-woman-artist (accessed April 15, 2013).

Pratt, Ray. *Rhythm and Resistance: Explorations in the Political Uses of Popular Music*. NewYork: Praeger, 1992.

Prefontane, Eve. *The Settlement of Canada: An Overview*. http://www.mccord-museum.qc.ca/scripts (accessed July 5, 2012).

Pristash, Heather, Inez Schaechterle and Sue Carter Wood. "The Needle as the Pen: Intentionality, Needlework, and the Production of Alternate Discourses of Power." In *Women and the Material Culture of Needlework and Textiles,* edited by Maureen Daly Goggin and Beth Fowkes Tobin. Burlington, VT: Ashgate, 2009.

Pritzker, Barry M. *A Native American Encyclopedia: History, Culture and Peoples*. London: Thames & Hudson, 2003.

Prusher, Ilene R. "People making difference: Andi Arnovitz." *The Christian Science Monitor* (May 28, 2009). http://www.csmonitor.com/World/Making-a-difference/2009/0528/p.47s01-lign.html (accessed July 28, 2013).

Przybysz, Jane. "Afghan War Rugs and the Sounds of Silence." In *Woven Witness: Afghan War Rugs*. San Jose: San Jose Museum of Quilts and Textiles, 2007.

_____. *Woven Witness: Afghan War Rugs*. San Jose: San Jose Museum of Quilts and Textiles, 2007.

Puydt, Lucien de. "Account of Scientific Explorations in the Isthmus of Dorien in the Years 1861 and 1865." *Journal of the Royal Geographic Society* 38 (1868): 97.

Pye, David. *The Nature and Aesthetics of Design*. Bethel, CT: Cambian Press, 1978.

Rahbar, Sara. "Biography." http://www.sararahbar.com/index.php?page=25 (accessed April 15, 2013).

_____. Queensland Art Gallery. http://www.qagoma.qlil.gov.au/exhibitions/past/2012/apt7 (accessed April 15, 2013).

Randall, Joan. *Art of the Hmong-Americans*. Berkeley: University of California Press, 1984.

Ray, Arthur. *The Illustrated History of Canada*. Toronto: Key Porter, 2000.

Reclus, Armen. *Panama et Darien: Voyages d'exploration*. Paris: Hachette, 1888.

Rehl, Jane W. "Weaving Principles for Life: Discontinuous Warp and Weft Textiles of Ancient Peru." In *Andean Textile Traditions*, edited by. Margaret Young-Sanchez and Fronia W. Simpson. 13–42. Denver: Denver Art Museum, 2006.

Reif, Rita. "The Jackboot Has Lifted. Now the Crowds Crush." *The New York Times*, June 3, 2001.

Richter, Paula Bradsheet. *Painted With Thread: The Art of American Embroidery*. Salem, MA: The Peabody Essex Museum, 2000.

Rivers, Victoria Z. "Textiles, South Asian." In *Encyclopedia of Clothing and Fashion*. 308–312. New York: Charles Scribner's & Sons, 2004.

Robinson, Ruth. "Subtle Protests You can Hang on the Wall." *New York Times*, August 24,1989. www.nytimes.com/1989/08/24/garden/subtle-protests-you-can-hang-on-the-wall.html (accessed June 15, 2012).

Rodman, Amy Oakland. "Andean Textiles from Village and Cemetery: Caserones in theTarapaca Valley, North Chile." In *Beyond Cloth and Cordage*, edited by Penelope Ballard Drooker and Laurie D. Webster. 229–251. Salt Lake City: University of Utah Press, 2000.

Rosen, Steven W. *Art and Artifacts of the San Blas Cuna: An Exhibition from the Denison University Collection*. Granville, OH: Denison University, 1976.

Rosenbaum, Brenda P. "Mayan Women, Weaving and Ethnic Identity: A Historical Essay." In *Mayan Clothing and Weaving Through the Ages*. 157–169. Guatemala: Museo Ixchel del Traje Indigena, 1999.

Rothblum, Esther D., and Ellen Cole, ed. "A

Woman's Recovery from the Trauma of War." *Women and Therapy* 5 (1986): 7–11.

Rubin, Elizabeth. "Veiled Rebellion." *National Geographic.* 218 (December 2010): 28–53.

Runk, J. Velasquez. "Wounaan and Embera Use and Management of the Fiber Palm *Astrocaryum standleyanum (Arecaceae)* for Basketry in Eastern Panama." *Economic Botany* 55 (2001): 72–82.

_____, Gervacio Ortiz Negria, Wilio Quintero Garcia, and Cristobalino Quiroz Ismare. "Political Economic History, Culture and Wounaan Livelihood Diversity in Eastern Panama." *Agriculture and Human Values* 24 (2007): 93–106.

Runyan, Anne Sisson. "Gender Relations and the Politics of Protection." *Peace Review* (Fall 1990): 28–31.

Rutherford, Dianne. "'Our Hero We're Proud of Him': Patriotic Crochet in the First World War." http://www.awm.gov.au/blog/2011/03/04/our-hero-were-proud-of-him-patriotic-hero-were-proud-of-him-patriotic-crochet-in-the-first-war.htm (accessed September 25, 2013).

Rutschowscaya, Marie- Hélène. *Coptic Fabrics.* Paris: Editions Adam Biro, 1990.

Ryan, Mildred Graves. *The Complete Encyclopedia of Stitchery.* Garden City, NY: Doubleday, 1979.

Sacramento Chinese Culture Foundation. "Cotton and Silk Textiles in Ancient China." www.sccfsac.org/textiles.html (accessed October 25, 2012).

Saikia, Yasmin. *Women, War and the Making of Bangladesh: Remembering 1971.* Durham: Duke University Press, 2011.

Salvador, Mari Lyn. *Molas of the Cuna Indians: A Case Study of Artistic Criticism and Ethno-Aesthetics.* Ph.D. Dissertation: University of California–Berkeley, 1971.

Sanderson, Elizabeth. "My Tenko Quilt: the 78-year-old reunited with the quilt she made secretly in Japanese camp," *Mail Online,* March 20, 2010.

Sands, Phil and Suha Maayeh, "Syria's rebel warrior queen dreams of reforming her brigade." *The National,* November 17, 2013, pp. 1–3, http://www.thenational.ae/world/middle-east (accessed December 1, 2013).

Scheid, John, and Jesper Svenbro. *The Craft of Zeus: Myths of Weaving and Fabric.* Translated by Carol Volk. Cambridge: Harvard University Press, 1996.

Schmal, John P. "The Rise of the Aztec Empire." www.houstonculture.org/mexico/aztecs.html (accessed June 23, 2012).

Schoeser, Mary. *Textiles: The Art of Mankind.* London: Thames and Hudson, 2012.

_____. *World Textiles: A Concise History.* London: Thames and Hudson, 2003.

Scott, Sharon M. "Muñecas y Mascaras: Dolls of the Zapatista Rebellion."www.zapatistadolls.com (accessed June 18, 2012).

Selby, Tina. "Knitter's 5,000 hats for soldiers serving in Afghanistan." www.bbc.co.uk/news/uk-wales-17471716?print=true (accessed July 2, 2013).

Serjeant, R.B. *Islamic Textiles: Material for a History up to the Mongol Conquest.* Beirut: Librairie Du Leban, 1972.

Shaw, Robert. *American Quilts: The Democratic Art 1780–2007.* New York: Sterling, 2009.

Shevill, Margot Blum. "The Communicative Power of Cloth and its Creation." In *Textile Traditions of Mesoamerica and the Andies,* edited by Margot Blum Schevill, Janet Catherine Berlo, and Edward B. Dwyer. Austin: University of Texas Press, 1991.

Simonsen, Thordis. *Memories of the Hmong.* Denver: Denver Museum of Natural History, 1985.

Sinaiko, Eve. "The Blank Space on the Gallery Wall: The Art of Vietnam Veterans in Context." In *Vietnam: Reflexes and Reflections,* edited by Eve Sinaiko. New York: Harry N. Abrams, 1995.

Slatking, Wendy. *Women Artists in History.* New York: Prentice Hall, 1997.

Smith, Linell. "Rug project gives women a connection." *The Baltimore Sun* (July 26, 2003). http://articles.baltimoresun.com/2003-07-26/features/0307270056_cameron-rugs-kilim (accessed July 22, 2013).

Snook, Margaret. "The Story of the Textiles." *Threads of Hope.* http://www.tohtexas.org/textiles.php (accessed July 7, 2012).

Soldier On. http://soldieron.org.au (accessed September 28, 2013).

Stafford, Cora E. *Paracas Embroideries.* New York: J.J. Augustin, 1941.

Steele, Valerie. "Clothing" Microsoft Online Encyclopedia, 2000. http://encarta.msn.com (accessed October 28, 2012).

Stokstad, Marilyn, ed. *Art History.* New York: Prentice Hall and Harry N. Abrams, 1953.

Stone-Miller, Rebecca. *To Weave for the Sun: Ancient Andean Textiles in the Museum of Fine Arts, Boston.* London: Thames and Hudson, 1992.

Stout, D.B. *San Blas Cuna Acculturation: An Introduction.* New York: The Viking Fund, 1947.

Sullivan, Michael. *The Arts of China.* Berkeley: University of California Press, 1999.

Swan, Susan Burrows. *A Winterthur Guide to American Needlework.* New York: Crown, 1976.

Taber, Barbara, and Marilyn Anderson. *Backstrap Weaving.* New York: Watson-Guptill, 1975.

Tacitus. *The Annals.* Trans. Alfred John Church and William Jackson Brodribb. In *The Great Books of the Western World,* vol. 14. Chicago: Encyclopaedia Britannica, 2007.

Tamura, Shuji. *The Techniques of Japanese Embroidery.* Ida, WI: Krause, 1998.

Taylor, Claire, ed. *Identity, Nation, Discourse: Latin American Women Writers and Artists.* Newcastle Upon Tyne: Cambridge Scholars, 2009.

"Teddies to help out in war zones." http://www.n ews.bbc.co.uk/hi/uk_news/england/wear/796. 4208.stm (accessed July 7, 2013).

Terri. "Nambu World: Senninbari (Thousand Stitch Belts)." Updated February 4, 2008. http://mem bers.shaw.ca/nambuworld/senninbari.html (accessed June 22, 2012).

"Textiles and the Art of Embroidery." Museu Nacional Machado de Castro. http://mnmachado-decastro.imcip.pt/en-GB/4%20coleccoes/texti les/contentdetail.aspx (accessed August 4, 2012).

Thien, Tin Myaing. *Old and New Tapestries of Mandalay*. London: Oxford University Press, 2000.

Thomson, F. P. *Tapestry: Mirror of History*. New York: Crown, 1980.

Tice, Karin. *Kuna Crafts, Gender, and the Global Economy*. Austin: University of Texas Press,1995.

Todd, Barbara. ART MUR. http://www.artmur. com/en/barbara-todd (accessed July 24, 2012).

"Tramway Underpants." Australian Museum of Clothing and Textiles. http://sites.google.com/ site/amcatmuseum/collection-highlights (accessed September 25, 2013).

"Tribes of Afghanistan." Bukhara-carpets.com. www.bukhara-carpets.com/making/Afghan istan_tribal_carpets_tribes.html (accessed July 8, 2007).

Trouillot, Michel-Ralph. *Silencing the Past: Power and the Production of History*. New York: Beacon Press, 1995.

Tuma, Mary. http://marytuma.com/bio.html (accessed October 23, 2012).

Turbayne, Jessie A. *Hooked Rugs: History and the Continuing Tradition*. West Chester: Schiffer, 1991.

"Turkmenistan: Native Carpet Weaving an Endangered Tradition." http://www.rferl.org/content/ article/1071064 (accessed March 24, 2013).

Udall, Sharyn Rohlfsen. *Carr, O'Keefe, Kahlo: Places of Their Own*. New Haven: Yale University Press, 2000.

Ugwu, Catherine. "The Art of Conflict." In *Global Encounters in the World of Art: Collisions of Traditions and Modernity*, edited by Ria Lavrijsen. 67–77. Netherlands: Royal Tropical Institute, 1998.

United Nations. http://www.un.org/Depts/Carto graphic/map/profile/easteuro.pdf (accessed June 19, 2013.

Vadim. "Tajik textiles with the names of Putin and Bin Ladden." *Neweurasia.net* (March 30,2008. http://www.neweurasia.net/business-and-econo mics/tajik-textile-with-the-names-of-putin-and-bin-ladden (accessed March 24, 2013).

Van Doren, Lisa, Curator. *Story Rugs: Tales of Freedom, The Work of Dale Gottlieb*. Bellingham, WA: Whatcom Museum of History and Art, 2003.

Vastokas, Joan N. "Contemporary Aboriginal Art in Canada." *The Canadian Encyclopedia*. http:// thecanadianencyclopedia.com (accessed June 26, 2012).

Veloso, Bryan. "M1 pencil blog." October 16, 2010. In *Militaria IJA*. (accessed June 22, 2012).

Vickers, Jennifer. http://jbvickers.wordpress.com/ portfolio (accessed September 23, 2013).

Virgil. *The Georgics*. Trans. C. Day Lewis. In *The Great Books of the Western World,* edited by Mortimer J. Adler. Chicago: Encyclopaedia Britannica, 2007.

Vosters, Helene. "Call for Performers." http://he-lenevosters.com (accessed November 15, 2013).

_____. "Piece/Peace Work: Engendering 'rationalities of care' through a *thread-by-thread* deconstruction of militarism." *Performance Research: A Journal of the Performing Arts* 18 (2013).

Wakakewa, Midori. "War-Promoting Kimono." In *Wearing Propaganda: Textiles on the Home Front in Japan, Britain and the United States, 1931– 1945*, edited by Jacqueline M. Atkins. 183–203. New Haven: Yale University Press, 2006.

"Wall Carpets." The EWMN Center. http://www. ewmncenter.com (accessed December 11,2012).

Ware, Joyce C. "The Afghan War Rugs." *Fiber Arts* 17 (Summer 1990): 39–42.

Wegner, Dietrich H. G. "Pile Rugs of the Baluch and Their Neighbors." Trans. Lola Froehlich. *Oriental Rug Review* 5 (July 1985): 1–38.

Weigle, Marta. *Spiders and Spinsters: Women and Mythology*. Albuquerque: University of New Mexico Press, 1982.

Weir, Shelagh. *Embroidery from Palestine*. Seattle: University of Washington Press, 2006.

Wheeler, Eileen, "Delineating Women's Historical Lives through Textiles: A Latvian Knitter's Narrative of Memory." Paper presented at 2012 Textile Society of America Conference, Washington, D.C., September 2012.

"Why the poppy." BBC. www.bbc.co.uk/remembr ance/how/poppy.shtml (accessed September 28, 2013).

Williams, Yona. "Aztec Goddesses of Fertility: Cihuacoatl and Xochiquetzal" http://www. unexplanable.net/ancients/aztec-goddesses-of-fertility-Cihuacoatl-Xochiquetzal.htm (accessed June 27, 2012).

Winn, Peter. *Weavers of Revolution: The Yarur Workers and Child's Road to Socialism*. New York: Oxford University Press, 1986.

Winters, Rebecca. *Buibere: Voice of East Timorese Women*, vol. 1. Darwin NT, Australia: Night Cliff, 1999.

Woolf, Virginia. *A Room of One's Own*. San Diego: Harcourt, Brace and World, 1957).

Worthpoint. http://www.worthpoint.com/wortho pedia/kimport-greece-greek-all-cloth-30s-1338 03205 (accessed March 22, 2013).

"Wounaan and Embera Baskets." www.panart.com/bask_info.htm (accessed June 15, 2012).

"WWI Knitted Sock Tradition Kept Alive in Australia." Rowan, http://www.knitrowan.com/industry-news/article/wwi-knitted-sock-tradition-kept-alive-in-australia.htm (accessed September 26, 2013).

Yang, Sunny. *Hanbok: The Art of Korean Clothing.* Elizabeth, NJ: Hollym, 1997.

Young, James E. "Living with the Fabric Arts of Memory." In *Weavings of War: Fabrics of Memory.* Ed. Ariel Zeitlin Cooke and Marsha Mac-Dowell. East Lansing: Michigan State University Museum, 2005.

_____. *The Texture of Memory: Holocaust Memorials and Meanings.* New Haven: Yale University Press, 1993.

Zaman. Niaz. "Women's Words/Women's Voices in the Kantha." In *Kantha,* edited by Darielle Mason. 114–137. Philadelphia: Philadelphia Museum of Art, 2009.

Ziebart, Eve. "The Weavings of War." (November 12, 1998). http://www.digizen.net/member/janus/post2.html (accessed April 29, 1999).

Index

Numbers in **_bold italic_** indicate pages with photographs.

Index

Numbers in *bold italic* indicate pages with photographs.